Oil Crusades

12 APR 2008

10 DEC 2009

PORTSMOUTH CITY

04 JUL 2011

05 DEC 2011

WITHDRAWN

D0493878

This book is due for return by the last date shown above.
To avoid paying fines please renew or return promptly.

Portsmouth
CITY COUNCIL
LEISURE SERVICE CL-1

Oil Crusades

America through Arab Eyes

ABDULHAY YAHYA ZALLOUM

Pluto Press

LONDON • ANN ARBOR, MI

First published 2007 by Pluto Press
345 Archway Road, London N6 5AA
and 839 Greene Street, Ann Arbor, MI 48106

www.plutobooks.com

British Library Cataloguing in Publication Data
A catalogue record for this book is available from the British Library

Hardback
ISBN-13: 978-0-7453-2560-6
ISBN-10: 0-7453-2560-2

Paperback
ISBN-13: 978-0-7453-2559-0
ISBN-10: 0-7453-2559-9

Library of Congress Cataloging in Publication Data applied for

10 9 8 7 6 5 4 3 2 1

Designed and produced for Pluto Press by
Chase Publishing Services Ltd, Fortescue, Sidmouth, EX10 9QG, England
Typeset from disk by Newgen Imaging Systems (P) Ltd, Chennai, India
Printed in the United States of America

Contents

WAR is a racket. It always has been. It is possibly the oldest, easily the most profitable, surely the most vicious. ... It is the only one in which the profits are reckoned in dollars and the losses in lives.

Who Makes the Profits?

Take our friends the du Ponts, the powder people—didn't one of them testify before a Senate committee recently that their powder won the war? Or saved the world for democracy? Or something? How did they do in the war? They were a patriotic corporation. Well, the average earnings of the du Ponts for the period 1910 to 1914 were $6,000,000 a year. ... Now let's look at their average yearly profit during the war years, 1914 to 1918. Fifty-eight million dollars a year profit we find! Nearly ten times that of normal times, and the profits of normal times were pretty good.

Take one of our little steel companies that patriotically shunted aside the making of rails and girders and bridges to manufacture war materials. Well, their 1910–1914 yearly earnings averaged $6,000,000. Then came the war. And, like loyal citizens, Bethlehem Steel promptly turned to munitions making. Did their profits jump—or did they let Uncle Sam in for a bargain? Well, their 1914–1918 average was $49,000,000 a year!

Who Pays the Bill?

We all pay them—in taxation. We paid the bankers their profits when we bought Liberty Bonds at $100.00 and sold them back at $84 or $86 to the bankers. These bankers collected $100 plus. It was a simple manipulation. The bankers control the security marts. It was easy for them to

depress the price of these bonds. Then all of us—the people—got frightened and sold the bonds at $84 or $86. The bankers bought them. Then these same bankers stimulated a boom and government bonds went to par—and above. Then the bankers collected their profits.

But the soldier pays the biggest part of the bill.

Marine Major General Smedley Darlington Butler
(twice decorated with the Medal of Honor),
War Is a Racket (1935)

Acknowledgments

I HAVE LED A busy life over my 70 years as a workaholic who averages 16–18 hours' work a day. My first acknowledgment therefore is to God for the good health and energy with which He endowed me, which have made my working practice possible. For the past ten years I have devoted 4–6 hours a day to reading, researching, and writing, reflecting on my firsthand experiences as well as the experiences of others. I first began to record these reflections after the age 60.

My parents, who had only a limited education themselves, insisted that I pursue my university education in the United States, an onerous undertaking for them, especially in the 1950s for those who earned their living in the troubled lands of the Middle East to be spent in the much more expensive US. They gave me all their support and stretched their resources until the mission was accomplished. I am eternally grateful to them.

I am grateful to an intelligent, loving, and devoted wife, who took on the lion's share of the responsibility for raising our five children and raised them well. In my culture children and family are the most valuable of our worldly assets.

I am grateful for the assistance of many for their contributions to the publication of this book. I start with Roger van Zwanenberg, Chair of Pluto Press, with whom I brainstormed first by email and later face to face. Roger has unique experiences in this world which he is pursuing through his progressive Pluto Press.

Knowing the United States and the West for more than half a century, almost a quarter of the life of the American Republic before it became an empire, living in and experiencing

the worlds of Islam and the West, and traveling extensively in Africa and large parts of Asia, including India and China, I learned that the "conventional wisdom" promoted by the establishment and corporate media is in many instances no wisdom at all. I learned that it is not only people that lie, but also governments, corporations, and even history books. I learned that a religious police is not only a feature of some Middle Eastern countries, for "thought police" exist in a more sophisticated guise even in the self-proclaimed bastions of liberty and freedom. Mainstream corporate media, controlled by five corporations mainly in the US, broadcast establishment views and narrowcast everybody else's. I learned that the grass is not always greener on the other side of the fence, as one of those conventional wisdoms claims.

Preface

Permit me to control the money of a nation and I care not who makes its rules.

> Mayer Rothschild, founder of the
> Rothschild dynasty

A S A YOUNG STUDENT in elementary schools in Jerusalem, when it was the capital of Palestine prior the creation of Israel in 1948, our history teacher taught us about the Balfour Declaration—the document in which Lord Balfour, the British Foreign Secretary, wrote to another British peer promising to create a Jewish homeland in someone else's country. To my young, inquisitive mind I wondered how a British politician, Lord Balfour, could promise a British financier, Lord Rothschild, someone else's country—which happened to be mine! This relationship between financiers and politicians puzzled me and I longed to find an answer.

After I graduated from high school my parents insisted I go to America for my university education. That was where a good education in the land of equality, freedom, and the pursuit of happiness could be found—or so they were told. Unlike other imperial powers, the US government, strong as it was, never waged war—except "to end all wars"!

At the age of 18 I left East Jerusalem airport bound for Beirut, where I boarded a ship that sailed first to Port Said and Alexandria in Egypt, and then to Europe, where I boarded the *United States*, then America's fastest and finest transatlantic ocean liner. On arrival in the US, I went by train from New York to Austin, Texas.

On the bus to the university campus I thought it odd that African-Americans occupied the rear seats only. It must be a

coincidence, I said to myself. Then, in the long registration line, I was aware of the absence of black students. When I inquired further I was told that "negro" students were not admitted to that state university. To my surprise, when I went downtown, "Whites Only" or "No Negroes" signs were common features in restaurants, parks, and public toilets. However, history books taught that, almost a century before I arrived in the United States, Abraham Lincoln was supposed to have fought a war to free those very people. But 1,400 year earlier, the Prophet Mohammad had preached that all people are equal regardless of color, creed, or race. And he practiced what he preached. His council was multiracial—among its most trusted members were Bilal, a black African, Suhaib, a Roman, and Suleiman, a Persian.

My sense of shock is best expressed by quoting from Colin Powell's memoirs, *My American Journey*:

> While we were training in the north Georgia mountains the only black church was some distance away in Gainesville. I wanted to go to services on Sundays, and the Army thoughtfully provided me with a half-ton truck and a driver, a white corporal, to take me to Gainesville. There I sang and swayed with the rest of the Baptist congregation. The next Sunday, the corporal pointed out that because he had to drive me to church, he could not attend services himself. Would it be all right, he wanted to know, if he joined me? The minister was a kindly man and said it would ordinarily give him great pleasure But his presence in a black church might not sit well with the local white folks. It might be wiser if the corporal waited in the truck.
>
> What my father had feared ... the reality I wanted to ignore, was forcing its way into my life, the lunatic code that made it wrong for two men to sit together in a house of God, or share a meal in a restaurant, or use the same bathroom. (1996, p. 41)

I was asking similar questions four decades before Powell did.

In an optional history course I took, I was very surprised to discover that during World War II all Japanese in America were held in detention camps, including American citizens of

Japanese descent, simply because of their race. But I had thought detention and concentration camps were exclusive to the Nazis. Then I learned that during World War I the FBI imprisoned anyone who distributed anti-war leaflets, and I had thought such acts were only practiced under communism!

I graduated in engineering, then in business administration and advanced management from top universities, including Harvard. I was appointed the first Arab operations manager in an OPEC oil company, I set up my own consulting company to cater for petroleum projects management, I was involved in several oil companies' creation from their inception, and I formed my own group of companies.

In the early 1970s the US withdrew from its commitment to the Bretton Woods Agreement of 1944 which had fixed exchange rates between currencies, after which it guaranteed a fixed rate between various currencies and the dollar, and then between the dollar and gold at $35/1 oz gold. Nations, central banks, and individuals now bought dollars on this basis. When the US unilaterally withdrew from the Bretton Woods Agreement the price of gold shot up tenfold to $350 dollars/1 oz. The dollars I had would now purchase just 10 percent of the gold I was promised under Bretton Woods. Who had stolen 90 percent of my gold?

When I started to delve deeper I noted that financiers functioned globally long before the term globalization became common currency. Take Mayer Rothschild, the patriarch of the Rothschild dynasty. Based in Germany, he had branches in London, Paris, Vienna, and Frankfurt and he installed a son in each branch. Through the Morgans and the Rockefellers they covered America and then much of the world. Capitalism, as the name implies, centers on capital and money, and those who own the money own capitalism then and now. Consider George Soros. He was able to take on the Bank of England in the early 1990s and make billions of dollars in one week. In his book *The Crisis of Global*

Capitalism (1998, p. 196), Soros wrote: "When I sold sterling short in 1992, the Bank of England was on the other side of my transactions and I was taking money out of the pockets of British taxpayers. But if I tried to take the social consequences into account, it would have thrown off my risk/reward calculations and my chances of being successful would have been reduced." Shortly afterwards, Soros and other moneylenders targeted Thailand, then Indonesia and most of Southeast Asia and the developing world. Again, Soros stated that, in Indonesia for instance, progress that had been made in 30 years was wiped out in the short duration of the Southeast Asian crisis. A handful of these financiers or hedge fund managers—a better and more marketable term— can sit at their desks in New York and decide to destroy any economy. Then they can buy the ruins for next to nothing. Using the tools of the information age and the wealth of information at their fingertips, they possess info-financial nukes that combine the power of information and finance to destroy an economy at the press of a computer key. I could not help comparing their actions to those of the Rothschilds who financed both sides, England and France, in the Napoleonic Wars during the first decade of the nineteenth century. Thanks to early intelligence they knew the outcome of the battle of Waterloo before anyone else did. Staging a panic, the Rothschilds sold stock on the London Stock Exchange, which others followed on the assumption that the Duke of Wellington had lost the battle. They then bought back the stock at rock-bottom prices. Much later, Nathan Rothschild commented that "It was the best business I have ever done" (cited in Jim Marrs, *Rule by Secrecy*, 2001, p. 79).

Close scrutiny of history shows that US presidents have lied to get the American people to go to war. And once the Americans learnt of these lies it was considered unpatriotic to voice any opposition while the troops were away fighting. A vicious circle! Civil liberties were suspended during war.

A national security state dominated most of the twentieth century and a single FBI Director-General, J. Edgar Hoover, terrified presidents for half a century.

Moneylenders owned the three "M"s—money, media, and marketing—of goods and politicians. That reduced democracy to a hollowed-out process—a one dollar/one vote democracy. In short, those who own the money control the votes, the politicians, and the country.

According to the super-capitalist Soros, "[The Nazi and communist] regimes had a common feature: They laid claim to the ultimate truth and they imposed their views on the world by force." They represented the good, others represented evil, and people were given a choice: they could be with them or against them. Soros's book attempts to view events from the perspective of an American capitalist, and, as its title implies, was designed to serve the few capitalists present in every nation. No wonder that with such values and such a system just 1 percent of Americans own more than 80 percent of their fellow Americans!!

Introduction

I N SEPTEMBER 2002 THE administration of George W. Bush published its National Security Strategy in preparation for its pre-emptive wars, starting with Iraq. The document stated: "The US national security strategy will be based on a distinctly American internationalism that reflects the union of our values and our national interests." Robert Kaplan, a well-known neoconservative, put it more bluntly: "We and nobody else will write the terms for international society."[1] But what happens if the marriage of US "values and national interests" is not backed by part or most of "international society"?

Andrew Moravcsik, professor of politics at Princeton University, and Michael Meyer, editor of *News Week Europe*, commented in the aftermath of Hurricane Katrina in *News Week World View*:

> This is the aspect of America that foreigners find hardest to comprehend—the seemingly deliberate choice by government to expose its citizens (especially its weakest) to jeopardy. The United States remains the world's most productive economy. It outspends all other countries combined on defense. But abroad, the American model is not a popular one, and less so since Katrina. Other developed democracies take medical insurance, decent education, efficient public transport and a social safety net as essential attributes of a just society. Yet America seems determined to eliminate even lesser protections.

Yet, it was an American president, Franklin D. Roosevelt, who had criticized the Nazi regime for just such an approach

in his famous October 1937 speech, in which he said that Nazi pre-emptive wars would create an age of terror and lawlessness "through unjustified interference in the internal affairs of other nations or the invasion of alien territory." Moreover, the American prosecutor at the war crimes tribunal in Nuremburg stated: "Our position is that whatever grievances a nation may have, however objectionable it finds the status quo, aggressive warfare is an illegal means for settling those grievances or altering those conditions."[2]

In the 1990s the US experienced the biggest speculative bubble in its history. At the beginning of the new century, between March 10, 2000 and the end of the first quarter of 2001, the value of stocks on the Nasdaq fell from $6.7 trillion to $3.3 trillion. Steve Jobs, founder of Apple Computers, told analysts that he believed the US economy was in meltdown.

When an economy is in trouble in the American capitalist order a war (whether started deliberately or accidentally) is always expedient, particularly if, as we know with the Project for a New American Century, the ground has already been prepared for US global domination. The American "establishment" promoted and assisted to power a self-described "war president." Where George W. Bush led, American oil and defense companies quickly followed. Halliburton's Dick Cheney became Vice-President, and Condoleezza Rice of Chevron Texaco became National Security Advisor. Abroad, Afghanistan's pro-American president Hamid Karzai and the country's US ambassador Zalmay Khalil zad, were both retained as consultants to the oil company Unocal.

In preparation for the invasion of Iraq Robert Jackson, a former weapons manufacturer and Lockheed Martin executive, established the Committee for the Liberation of Iraq. Among the founders were influential members of the American military industrial complex and included former Secretary of

State George Schulz (now of Bechtel) and many leading neoconservatives.

It should come as no surprise that when it came to awarding contracts for the postwar reconstruction of Iraq, all these companies found themselves at the head of the queue. The doctrine of free and fair trade is strangely absent when American interests are at stake. Chevron Texaco was assigned responsibility for the sale of Iraqi oil, and Bechtel and Halliburton's KBR were given construction contracts. These are just the tip of a much larger iceberg. A year after the invasion of Iraq, according to the *Financial Times*, Halliburton's revenues had increased by 80 percent and Bechtel's by 158 percent; between the first quarters of 2003 and 2004 Chevron Texaco's profits went up by 90 percent, and Lockheed Martin stocks increased by 300 percent between 2000 (the year George W. Bush was first elected) and 2004. According to Senator Ron Wyden, "The Iraq contract process looks like Dodge City before the marshals showed up."

While these corporations were prospering, servicemen and their families were sinking deeper into debt. The front-page headline of *USA Today* (August 31, 2006) read: "Pentagon sees risk in troops' loan debt: Payday lenders prey on military." The newspaper wrote: "As many as one in five of the armed services are being preyed on by loan centers set up near military bases that can charge cash-strapped military families interest of up to 400 percent or more, a new Pentagon report has found." This boom, which benefited just a handful of corporations, was paid for with the blood of mostly poor Americans and innocent Iraqis, Afghans, Palestinians, Lebanese, and others, and was financed by unprecedented deficits. War is indeed a racket.

America's economic supremacy, which accounted for 50 percent of the world's industrial output after World War II, has been eroded. US survival now depends on the inflow of $3 billion a day of foreign currency to finance its

deficits and its wars. The 2005 balance of payments deficit approached $800 billion and is now heading for $1 trillion a year. To compensate for this deficiency in economic might the American Empire is increasingly resorting to military muscle.

However, as I shall argue in this book, the Project for a New American Century is mission impossible, and in this regard I am not alone. One of the world's leading historians, Eric Hobsbawn, was reported in the *Harvard Crismon* (October 20, 2005) as saying: "The American empire may actually cause disorder, barbarism, and chaos rather than promote peace and order"; this empire will almost certainly fail. I echo Hobsbawm in asking: "Will the US learn the lessons of the British Empire, or will it try to maintain an eroding global position by relying on a failing political force and a military force which is insufficient for the present purposes for which the current American government claims it is designed?"

The Bush Doctrine claims that the American model and values are good for everybody the world over and promises pre-emptive strikes and cruise missiles to those who oppose them. However, most of the world does not believe that the American model and values are good for them; worse still, they don't believe they are good for the majority of Americans either. According to a BBC poll published in January 2005, 58 percent of non-Americans polled thought Bush's re-election was "a threat to world peace, among America's traditional allies the figure is strikingly higher! 77 percent in Germany, 64 percent in Britain and 82 percent in Turkey." In the Muslim world, support for the US and its values was below 10 percent in most countries.

Moravcsik, in an earlier article he wrote for the international edition of *NewsWeek*,[3] reported that statistics and facts favor other, non-American models such as the European or Japanese, which are more democratic, and provide a better education system, prosperity, and a social security safety net.

Europeans work fewer hours, take longer vacations, and are less anxious and more satisfied than Americans, who are burdened with debt. But after the collapse of communism, these systems were assaulted by the Washington Consensus with its aim of imposing the American capitalist model and values on them.

Let us review the facts: "Despite its wealth, America rates with poor countries in many measures of social well-being," according to NewsWeek. In the US child poverty is 22.4 percent, while in Denmark it is 5.1 percent, 4.4 percent in Belgium, 4.3 percent in Finland, 3.9 percent in Norway, and just 2.6 percent in Sweden. In terms of income equality Denmark comes first, followed by Japan second, the Czech Republic third, Finland fourth while the US lags far behind at 71st. Moravcsik's report appeared only in the international edition of NewsWeek, which prompted many Americans living abroad, who noted this deliberate narrowcasting, to write to the editor asking why such critical information had not been published in the American edition. The answer is that the American media are controlled by five corporations, the CEOs of which can decide behind closed doors what Americans may or may not read or watch. Thus, it is obvious to any observer that all the American networks bombard the population with exactly the same message in all 50 US states. Through modern media and communications, American democracy has been manipulated to become a one dollar/one vote, mass media plutocracy.

As for the American economic model, it is centered on the military-industrial complex which allocated the spoils of the Iraq war even before it had taken place! Wars are at its core. Yet the 2004 World Economic Forum's first five awards for the most competitive economies all went to European countries, with Finland, a socialist democracy with a peaceful economy, first. Furthermore, in 2005 Airbus Industries overtook Boeing in terms of sales of commercial planes.

American capitalism finds itself in a dilemma. On the
one hand, its economy is based on growth—growth fueled
mostly by oil and other natural resources which will run out
during the twenty-first century. A study conducted at the
Massachusetts Institute of Technology in the early 1970s,
which was published as *The Limits to Growth*, predicted that
the growth-based economic model, combined with capitalism's
present consumption patterns and world population growth,
is on a collision course with nature which will take place in
the middle of the twenty-first century. Many scientists and
consultants, including this writer, believe we are at a point
where maximum oil production has been, or is about to be,
reached and the decline of the Oil Age has already begun. No
substitute exists for oil, and thus the lifeblood of capitalism is
under threat. Resource wars have already begun, though they
are conveniently called a War on Terror to make them easier
to sell. Edward Peck, former Chief of Mission in Iraq and
deputy director of the White House Task Force on Terrorism
in the Reagan administration, said in an interview with Amy
Goodman (July 28, 2006):

> In 1985, when I was the Deputy Director of the Reagan White
> House Task Force on Terrorism, they asked us ... to come up
> with a definition of terrorism that could be used throughout the
> government. We produced about six, and each and every case,
> they were rejected, because careful reading would indicate that
> our own country had been involved in some of those activities.

The results of enforcing American capitalism's values on the
world is best expressed by the former nun, writer, and feminist
Karen Armstrong, who has written a number of books on
religion. She believes that the cultural, religious, and value
system in Muslim society differs from that of Western society.
When you subject a different culture to the same process of
so-called modernization and secularization or globalization,
"it is unlikely that the end product will conform to what the
West regards as the desirable norm," she says. "If the correct

ingredients of a cake are not available—if rice is used instead of flour, dried eggs instead of fresh, and spices instead of sugar—the result will be different from the cake described in the cookbook" (*Islam: A Short History*, 2000). Imposing American values on the world will result in just such a "cake," which Bush and his adherents will be forced to eat. Robert Fisk wrote in the *Independent* on December 1, 2006:

> More than half a million deaths, an army trapped in the largest military debacle since Vietnam, a Middle East policy already buried in the sands of Mesopotamia (Iraq)—and still George W. Bush is in denial …—Washington's project to reshape the Middle East in its own and Israel's image—is long dead, its very neoconservative originators disavowing their hopeless political aims and blaming Bush, along with the Iraqis of course, for their disaster.

Bush's doctrine of who's not with us is against us echoes George III, who said: "I wish nothing but good. Therefore, anyone who does not agree with me is a traitor and a scoundrel." He lost the American colonies in 1783. People the world over would like America to lead a global war on hunger and poverty, and as charity starts at home, would like to see this first in America.

Muslims, Arabs, and much of the world would also like America to read the Bible on the best way to fight terror. Thousands of years ago Isaiah said that it is only if you sow justice that you will reap peace.

1

The Beginning of the End?

B OOM TIME. THOSE TWO words perhaps best sum up the mood in the oil industry more or less since the beginning of the Oil Age to the present. Why? From the pioneering days of the earliest oil strikes, the industry's ability to produce oil has always kept one step ahead of demand. But times are changing. What has happened is that in recent years the gap between production capacity and demand has begun to narrow. Today, the gap is small, tomorrow it will be smaller still, and very soon it will have closed completely. It is not as if we have not been aware of this. For the past decade, politicians have been warned repeatedly by energy researchers that production cannot keep pace with demand. What makes the situation even more critical is that alternative energy sources will not be able to replace oil in time. It won't be long before oil dominates international politics in a way that hasn't happened before.

The problem is not that oil will run out tomorrow; although the supply of oil is likely to end one day, this won't be at least until the second half of the century. An immediate and more serious concern is what happens when oil production fails to meet demand. (In this regard, oil production includes the capacity of oil-producing states—OPEC members included—to respond to changes in demand.)

The economies of the world are structured in such a way that they need to grow every year in order to avoid collapse;

this is the rule of capitalism. Growth means that each year we need to spend more, trade more, and invest more. A slowdown in economic growth of 1–5 percent will cause a recession or a depression. A 5–10 percent reduction is likely to cause an economic crisis. Greater shortfalls could be catastrophic for the well-being of a country and indeed for the world economy as a whole. At the same time, central banks, finance ministers, and their economic advisors are keen to manage trade, spending, inflation, interest rates, and so on so that their economies do not grow at an unsustainable rate. Energy is key to all this because expanding economies need a constant (or increasing) supply of energy, and they need to be able to manipulate energy supplies to respond to the demands of their economies. Moreover, the government of a country like the US, which consumes more of the world's energy than any other country, will never be content with controlling only its own energy needs; it will want to influence world energy supplies, because they hold the key to the United States' continued economic growth. In particular, it wants to be able to exert a strong influence on the countries of the Middle East, where the world's largest oil reserves are found. This is why the US government is leading attempts to identify the point at which demand for energy (and oil in particular) is likely to catch up with and then exceed available supplies.

Before he joined the US government as George W. Bush's vice-president, Dick Cheney was chief executive of Halliburton, the world's largest company providing services to the oil and gas industry. Halliburton is also the principal recipient of US government contracts in Iraq. In 1999, at a meeting at the Institute of Petroleum in London,[1] Cheney gave a frank assessment of why the supply and demand for oil are going through a critical period, that demand is expected to reach critical levels, and that the Middle East not only has the world's biggest oil reserves but also the cheapest to produce.

It is worth quoting some of his remarks:

> Producing oil is obviously a self-depleting activity. Every year you've got to find and develop reserves equal to your output just to stand still, just to stay even. This is as true for companies as well in the broader economic sense it is for the world. A new merged company like Exxon-Mobil will have to secure over a billion and a half barrels of new oil equivalent reserves every year just to replace existing production. It's like making one hundred percent interest.
>
> For the world as a whole, oil companies are expected to keep finding and developing enough oil to offset our 71 million plus barrels a day of oil depletion, but also to meet new demand. By some estimates there will be an average of two percent annual growth in global oil demand over the years ahead along with conservatively a three percent natural decline in production from existing reserves. That means by 2010 we will need in the order of an additional 50 million barrels a day.
>
> While many regions of the world offer great oil opportunities, the Middle East with two thirds of the world's oil and the lowest cost, is still where the prize ultimately lies, even though companies are anxious for greater access there, progress continues to be slow.

To put Cheney's comments in context, the world will need an additional 50 million barrels of oil a day by the year 2010, the equivalent to five times the amount of oil produced by Saudi Arabia, the world's leading oil producer, which also has the world's largest oil reserves. Indeed, the combined oil production of Saudi Arabia, Iran, Iraq, Kuwait, Qatar, and the United Arab Emirates is only 22.4 million barrels a day. In other words, the world, according to Cheney, needs more than twice the combined current output of the Gulf nations to meet demand by 2010.

The oil industry is well aware of this. Harry J. Longwell, director and executive vice-president of Exxon-Mobil, has said as much: "The catch is that while demand increases, existing production declines. To put a number on it, we expect that by 2010 about half the daily volume needed to

meet projected demand is not on production today, and that's the challenge facing producers."[2] And Jon Thompson, president of Exxon-Mobil, told shareholders in 2003: "By 2015, we will need to find, develop and produce a volume of new oil and gas that is equal to eight out of 10 barrels being produced today."[3] That means an additional 60 million barrels a day will be needed by 2015. See Tables 1 and 2.

Cheney's speech was delivered seven years ago. But what if we look at the present? What are the present-day trends in the ability of energy suppliers to meet demand? There is considerable debate among academics, policy analysts, governments, and the oil industry on the precise nature of the trends and what they mean. But again, given the centrality of energy to US economic growth, it is worth keeping the focus

Table 1 Production capacity of oil in millions of barrels per day

Country	2002 (estimates)	2025 (projected)
Saudi Arabia	9.2	16.3
Iran	3.7	5.0
United Arab Emirates	2.9	5.4
Iraq	2.0	6.6
Kuwait	2.1	5.2
Qatar	0.8	0.8

Source: International Energy Outlook 2005, Energy Information Administration.

Table 2 Oil and natural gas reserves (2005) in billions of barrels/trillion cubic feet

Region	Oil	Gas
US	21.8	204.4
Middle East	743.4	2,565.4
Latin America	103.4	250.8
Africa	102.5	485.8
Eurasia	77.8	1,952.6
Asia & Oceania	35.9	391.6
Western Europe	16.3	200.6

Source: Oil & Gas Journal, Vol. 103, No. 47 (Penn Well Corporation, December 19, 2005).

on US sources for the answer, because the US has most to gain
from the most accurate data.

As it happens, US civil servants have been hard at work,
and they are looking increasingly troubled by what they are
finding. US (and other) government briefings are known for
their strictly measured tone and for the fact that they very
rarely voice strong opinions, preferring instead to evaluate all
sides of an issue, and leaving it to the politicians to draw the
final conclusions. This is what makes the following quotation,
taken from a study conducted for the US Department of
Energy in February 2005, all the more remarkable, because it
makes no bones about the impending energy crisis for the US:[4]

> The peaking of world oil production presents the US and the
> world with an unprecedented risk management problem. As
> peaking is approached, liquid fuel prices and price volatility
> will increase dramatically, and without timely mitigation, the
> economic, social and political costs will be unprecedented.
> Viable mitigation options exist on both the supply and demand
> sides, but to have substantial impact, they must be initiated
> more than a decade in advance of peaking.
>
> Dealing with world oil production peaking will be extremely
> complex, involve literally trillions of dollars and require many
> years of intense efforts.
>
> Peaking will result in dramatically higher oil prices, which
> will cause protracted economic hardship in the United States
> and the world.
>
> Mitigation will require a minimum of a decade of intense,
> expensive effort ... Intervention by governments will be required,
> because the economic and social implications of oil peaking
> would otherwise be chaotic.

It could be argued, of course, that it is in the oil industry's
interests to talk up an impending "crisis" as this will tend to
drive up oil prices. Indeed, with world oil prices showing no
signs of leveling off, the industry is currently enjoying some-
thing of a profits windfall. But even if we turn to academic
sources and the non-industrial research literature, it becomes
clear that the gap between supply and demand is closing.

The size of the gap is (as ever) open to debate; but the point when production will hardly equal maximum production supply—what some specialists call "peak oil"—is imminent.

> What our society does face, and soon, is the end of the abundant and cheap oil on which all industrial nations depend.

These words come neither from the US government, nor from a representative of the oil industry. They were written by two influential geologists, Colin Campbell from the UK and Jean Laherrère of France, in a seminal article, "The End of Cheap Oil," published in *Scientific American* (1998).[5]

Today, their words may not sound revolutionary, but they need to be read in the context of the 1990s, which, if anything, was a disastrous decade for the oil-producing states and for many oil companies. Take 1998, the year in which their article was published. Large parts of the world economy were in recession and the nominal price of oil was just $12 a barrel. The revolution in communications was only just beginning to take off, but few analysts were able to forecast the way it would contribute to economies. And few analysts (particularly in the oil industry) were saying that future oil supplies might be something to worry about. See Table 3.

It is in this context that Campbell and Laherrère declared that the supply of conventional oil would not be able to keep up with demand. Indeed, they were among the first to argue that what matters is not whether there is enough oil underground or under the seabed, but whether demand can be met. In their estimation, the supply/demand mismatch will begin in around 2010. In doing so, they helped to transform what until then had been a debate about geology into an economic one.

The authors had three main arguments to support their case:

- oil companies were overstating the extent of reserves;
- oil production would not remain constant; and
- the quantity of oil in any known well will rise to what is called "peak" production and then taper off.

Table 3 Nominal crude oil
prices in US dollars per barrel,
1973 to the present

1973	3.05
1975	10.73
1977	12.39
1979	17.25
1981	32.51
1983	29.04
1985	27.01
1987	17.73
1989	17.31
1991	18.62
1993	16.33
1995	16.86
1997	18.68
1999	17.47
2001	23.12
2003	28.10
2005	50.64

Source: Organization of Petroleum
Exporting Countries, *Annual
Statistical Bulletin 2005.*

Campbell and Laherrère were attacked at the time—
particularly by oil company analysts—for needless alarmism,
but the intervening decade has shown that they were largely
right.

Campbell and Laherrère's estimate of the future of global oil
was underscored in a November 2004 report from the London-
based Oil Depletion Analysis Centre (ODAC),[6] which analysed
68 "mega-projects," due to begin between 2004 and 2010. In
theory, these projects will add around 12.5 million barrels a day
to world supplies by the turn of the decade. But recall that
Cheney had estimated that 50 million extra barrels of oil will be
needed to meet global demand before 2010, and you will begin
to understand the depth of US government concern.

Again, it is worth reiterating that there is probably enough
oil to last several more generations. It is the production
capacity (drills, pipes, oil refineries, etc.) that does not exist

to meet the world's insatiable appetite for the fuel that drives the world's economies that will very shortly be encountered, followed by the quantitative shortage of available supplies even if those production facilities did exist.

So where is the demand coming from and who is likely to meet it in the short term? In 1998, Campbell and Laherrère would not have been able to foresee the rise of Brazil, China, India, and the nations of Southeast Asia as major players in the world economy. Indeed, in the late 1990s, some of what later became known as the "tiger" economies of Southeast Asia were in deep trouble. All this is a far cry from the situation today. In 2000, China and India between them consumed 7 million barrels of oil a day. This is forecast to rise to 18 million barrels by 2030. A similar increase is expected among the countries of the OECD, which will increase consumption from 45 million barrels to 58 million; but the lion's share will go to the US and Canada, which will increase consumption from 22 million barrels to 31 million. In other words, by 2030, the North American economy will need close to the same amount of additional oil as India and China. The other non-OECD countries, however, will need much more: their consumption is projected to rise from 12 million barrels in 2000, to 36 million barrels in 2030. Global demand for oil is currently rising at more than 2 percent a year.

The ODAC study did more than assess future oil projects; it also looked at current production capacity and found that most of the world's oil producers were already operating flat out to meet demand increases for 2005. What this means is that there is very little spare production capacity, little slack, and that further supplies will need to come from new projects—either that or we will continue to see sharp oil price rises. Even if demand were to increase by 2 percent annually, Cheney's 1999 estimate of available supplies suggests there will be a shortfall of more than 2 million barrels a day by 2010—roughly equivalent to losing all of Kuwait's current daily production.

Quoting BP's 2004 *Statistical Review of World Energy*, the ODAC report says: "18 major oil-producing countries are now past their peak production, and their combined annual output dropped by over a million barrels a day in 2003. This group of countries now accounts for almost 29 percent of total world production." The study came to the alarming conclusion that the gap between supply and demand might begin to open up as early as 2007.

With production at an all-time peak and spare capacity to meet increases in demand at an all-time low, it is worth dipping briefly into the well of world oil reserves because one reason why production capacity cannot increase rapidly is that many established oilfields are beginning to run dry. More importantly, the oil that they produce is not being replaced in time. Many of the world's oil-producing countries are struggling to maintain production or have already seen production pass its peak. These include the countries of the North Sea, Latin America (excluding Brazil), North America (excluding heavy oil), Africa (excluding offshore oil in deep waters), and even most of the non-OPEC counties of the Middle East. Only Libya and Algeria are believed to have the potential for sizeable new discoveries.

Four examples from around the world will help to illustrate how large, established reserves are reaching the end of the line.

1. Production at the Cruz Beana field in Colombia, among the largest discoveries in the Western Hemisphere, has declined from 500,000 barrels a day in the 1970s to 200,000 barrels in 2002.
2. In the North Sea, BP and Shell are beginning to wind down operations after 30 years' exploration. The Forties Field, for example, which used to produce 500,000 barrels a day, is now down to just 50,000 barrels.
3. One of the world's largest ever discoveries, in Alaska, has been pumping 1.5 million barrels a day for twelve years.

After peaking in 1989, it began to decline quickly and now produces just 350,000 barrels a day.

4. Russia's Samotlor field has declined from 3.5 million barrels a day at its peak to 325,000 a day now. Production at this field may increase if it adopts more advanced Western technology, but this is unlikely to have a major impact on the global picture.

Oil is a notoriously capital-intensive business. To give you an idea of the sums involved, in 2003, BP spent $14 billion on capital expenditure alone, a figure that exceeds the 1999 GDP of some 80 countries. In the same year Shell spent $4 billion disposing of what it calls "underperforming operations." The company's oil and gas development in the far east of Russia will cost $10 billion. Between 1996 and 1999, the 145 energy companies that are quoted on the world's stock markets between them spent $410 billion maintaining their present production rate of 30 million barrels of oil per day. Between 1999 and 2002 the Big Five—Exxon-Mobil, Shell, BP, Chevron Texaco, and TotalFinaElf—spent $150 billion maintaining a combined production capacity of 16 million barrels a day.[7] Oil from the Middle Eastern states is comparatively cheap in terms of capital investment and is also the cheapest to produce. In the coming years it will become even more attractive as non-Middle Eastern sources continue to decline—and thus become more expensive. Iraq's oil is regarded as the last known source that will reach this point. Little wonder, then, that George W. Bush, a Texan oil politician, chose to invade Iraq.

But what is already one of the world's most expensive industries is set to get a lot costlier. This is largely because as oilfields begin to decline, the cost (in terms of money and energy used) of extracting oil becomes more expensive, which is another factor impeding the ability of oil producers to respond quickly to increases in demand. In the early years of the twentieth century, for example, one barrel of oil was used

to extract the equivalent of 28 barrels. Today, that ratio has dropped to 1:2 and is approaching 1:1. When this happens there will be no net gain in oil extraction.

For all the furor over their 1998 article, one of Campbell and Laherrère's conclusions barely got a mention in the ensuing public debate. Two years before the second Bush administration took charge of the White House, the two geologists wrote:

> The switch from growth to decline in oil production will thus almost certainly create economic and political tension. Unless alternatives to crude oil quickly prove themselves, the market share of the OPEC states in the Middle East will rise rapidly. Within two years, these nations' share of the global oil business will pass 30 per cent, nearing the level reached during the oil-price shocks of the 1970s. By 2010 their share will quite probably hit 50 per cent.

Eighty percent of the world's known oil reserves are in OPEC countries, which are dominated by Middle Eastern states. What Campbell and Laherrère were diplomatically saying was that in the oil economy of the next five decades, it is the predominantly Muslim states of Iraq, Iran, Kuwait, Saudi Arabia, and the United Arab Emirates that will hold the key to world energy supplies, much more so than they do at present. Another way of putting this is that the additional 9 million barrels that the North American economy will need every day in 2030 will have to be supplied by OPEC members.

What worries the US government is not the rising economic growth of non-OECD countries—indeed, the White House sees such growth as a triumph of US-inspired globalization, which mostly benefits the US economy and the country's multinationals. No, what worries the US government most is that the Middle East, a region over which it desperately wants to have more control, will have the ability to influence, if not control, US energy security. This scenario is what is giving many US analysts, businessmen, politicians, and

researchers sleepless nights. But realistically speaking, there is not very much the US government can do—except perhaps try to invade more oil-producing countries.

Should we be on our guard? The answer is most certainly yes. The insatiable US economy needs oil and the US, in its current state of unilateral militarism, is well placed to access energy sources elsewhere in the Middle East now that it has a toehold in Iraq. At the same time it is equally well placed to have a greater influence in other developing countries—not just in Iraq, but elsewhere too.

Antonio Juhasz wrote in the *Los Angeles Times* on December 8, 2006:

> While the Bush administration, the media, and nearly all Democrats still refuse to explain the war in Iraq in terms of oil, the ever-pragmatic members of the Study Group share no such reticence,
>
> Page 1, chapter 1 of the Iraq Study Group report lays out Iraq's importance to its region, the US and the world with this reminder: "It has the world's second largest known oil reserves." The group then proceeds to give very specific and radical recommendations as to what the United States should do to secure those reserves. If the proposals are followed, Iraq's national oil industry will be commercialized and opened to foreign firms.
>
> Recommendation no. 63, which calls on the US to "assist Iraqi leaders to reorganize the national oil industry as a commercial enterprise" and to "encourage investment in Iraq's oil sector by the international community and by international energy companies." This recommendation would turn Iraq's nationalized oil industry into a commercial entity that could be partly or fully privatized by the foreign firms.
>
> This is an echo of calls made before and immediately after the invasion of Iraq.
>
> The US State Department's Oil and Energy Working Group, meeting between December 2002 and April 2003, also said that Iraq "should open to international oil companies as quickly as possible after the war." Its preferred method of privatization was a form of oil contract called a production-sharing agreement. These agreements are preferred by the oil industry but rejected

by all the top oil producers in the Middle East because they grant greater control and more profits to the companies than the governments. The Heritage Foundation also released a report in March 2003 calling for the full privatization of Iraq's oil sector. One representative of the Foundation, Edwin Meese III, is a member of the Iraq Study Group. Another, James J. Carafano, assisted in the Study Group's work.

This is a crucial issue, with trillions of dollars at stake, because only 17 of Iraq's 80 known oilfields have been developed. Recommendation no. 26 of the Iraq Study Group calls for a review of the constitution to be "pursued on an urgent basis." Recommendation no. 28 calls for putting control of Iraq's oil revenues in the hands of the central government. Recommendation no. 63 also calls on the US government to "provide technical assistance to the Iraqi government to prepare a draft oil law."

2

God, Geology, Geopolitics, and Geography: A Brief History of Oil

I N SOME WESTERN EYES, the oil-rich countries of the
Middle East may seem showcases for ostentatious wealth,
peopled by "oil sheiks" tirelessly piling up their petrodollars.
And there is no argument about oil transforming the fortunes of
many governments and people in the Arab world. However, the
reality is, as always, complex.

Arab oil was earmarked for the West from the moment the
US, Britain, and Western European countries were granted
exploration concessions. The deserts of the Middle East
became a giant playground in which the governments and
corporations of richer countries bullied a group of poor,
mostly Muslim people into handing over oil exploration rights
for a song. Any means were used, and many may find the
following statistics staggering. The combined revenues of all
OPEC countries from oil in 2003 was about $240 billion, less
than the revenue of Wal-Mart for the same year. The total
assets of the 480 Arab financial institutions and banks of all
the Arab countries, including the oil-producing states, in
2004 amounted to $780 billion, less than two-thirds (about
62 percent) of the assets of just one American bank, Citigroup.
Most of the petrodollars were recycled back to Western banks

and American Treasury bills. This is at a time when there were 60 million unemployed in these countries—roughly 20 percent of the total population! The little man was trampled underfoot by a combination of political power allied to corporate power—first British, then, increasingly, American. There has, however, been a strong unifying element.

That element is what I call the "four 'G's"—God, geography, geopolitics, and geology, which combine Western policies towards Muslims—which have dominated not just the story of oil in the Middle East, but also the relationship between the West and the Arab world.

The West's attitude to "Arabia" has deep roots, going all the way back to the Muslim defeat of the Roman Empire a few years after the death of the Prophet Mohammad. Muslim advances in parts of Western Europe during Islamic rule in Spain, and into Eastern Europe as far as the gates of Vienna under Ottoman rule, fed Islamophobia in the West, which persists to this day.

Geography has played a pivotal role in this fraught history. It was the Ottoman Empire's geographic setting on the Silk Route, which dominated trade between Europe and Asia, that prompted Christopher Columbus to look for new trade routes to the east by sea in the fifteenth century. More recently, at the end of the eighteenth century, Napoleon Bonaparte invaded Egypt. The self-styled emperor was among the first to promote the creation of a Jewish homeland in Palestine, although ultimately his invasion failed.[1]

This geopolitical prompt spurred the British to respond to what they saw as French attempts to upset the balance of world power and to interfere with British naval and trading routes. At that time, Britain possessed the world's most powerful navy and wanted free access to India, the jewel in its imperial crown. His Majesty's navy would also be one of the factors behind the rising importance of geology—specifically, oil prospecting—in the region. And for the next century,

Britain became an even stronger influence on the politics, economics, and peoples of the Middle East.

God, or religion, emerged much earlier, as the tolerance of Christians for Islam began to wane in medieval Europe. The Crusades and the later expulsion of Muslims from Spain were only the start. Now, as countries of the West assume the imperial role, their policy is to see that no Muslim movement should ever be able to recreate a pan-Islamic *Khilafa* (Caliphate state) like that of the Ottoman Empire, in which it is the values of Islam and not nationalism that are used to guide all aspects of statecraft.

Church and State

Yet within the Islamic tradition, the Ottoman Empire's close alliance of faith and statecraft was the norm. From Turkey to the Middle East, Egypt and most of North Africa, civil and criminal laws were based explicitly on the Qur'an, the traditions of Mohammad, and precedents set by a group of Islamic theologians in the first centuries of Islam. This made the Ottoman Empire distinct from, say, the British Empire, in which religion played an important but not direct role in government and the judiciary.

The "God factor" also emerged in attempts to convert Muslims to various branches of Christianity. The Jesuits, for instance, arrived in greater Syria (today's Syria, Lebanon, Jordan and Palestine) as early as 1625, but were eventually suppressed under the Ottomans. Missionaries became very active in the nineteenth century, more often than not following Western armies, and less often traveling incognito with Western intelligence operatives.

America's first encounter with the Middle East—then known as "the Orient"—was through American missionaries who first entered the region in 1820. Here they had no success in converting Muslims—most of their converts were

already Christians, members of regional sects, such as the Maronites.

The Yale-educated missionary Eli Smith was one of this wave of typically zealous American missionaries. In 1834 he cannily moved his mission's press to Beirut. At that time, presses were the principal medium of the age, the equivalent of the television today, a tool to effect cultural transformation. The laborious task of translating the Bible was secured through the services of two Christian Lebanese, Nasif Yazeji and Butrus Bustani, both Christian converts. But the mission went much further, establishing an educational system and building 33 schools by 1860 attended by 1,000 pupils. The Syrian Protestant College was founded in 1866 by an American, the Reverend Daniel Bliss. In 1920 it received a new charter as the American University of Beirut, thus disguising its missionary origins.

In essence, this mission's aim was to foster Arab nationalism through its educational system as a way of breaking the link in Islam between religion and government. The strategy succeeded. Islam had been what bound the various *Vilaya* (provinces) of the Ottoman Empire together; Arab nationalism, on the other hand, tore them apart. Most of the Arab nationalist movements were begun by Arab Christians, many of whom were products of the American educational system, in particular the American University of Beirut. The founders of the Ba'ath Party, Michel Aflak, the Arab Nationalist Party, George Habash, the Syrian Nationalist Movement Party, Antoine Sa'adah, and the Popular Front for the Liberation of Palestine, Nayef Hawatmeh, were all Christians. The first secret society formed in Lebanon to promote Arab nationalism was wholly made up of missionaries and Arab Christians.

Among the flood of missionaries were others with different, but ultimately equally divisive, aims. Charles R. Crane, for instance—one of the first Americans to visit the kingdom of Saudi Arabia under Ibn Saud—was an American

multimillionaire who was also Middle East advisor to successive US presidents, from Taft to Roosevelt. He also had an interest in oil: his son Richard was married to the daughter of Andrew W. Mellon, whose family was among the major shareholders of the Gulf Oil Company. Crane first attempted to visit Ibn Saud in the late 1920s, when Ibn Saud was fighting the Ikhwan, a religious and military brotherhood in the region, at Sibilla. As Anthony Cave Brown put it in *Oil, God and Gold*:

> An American missionary, the Reverend Henry Bilkert, was riding with Charles R. Crane ... They were motoring along the camel track from Kuwait to Riyadh to call on Ibn Saud ... just short of the Hamsa Ridge they were ambushed by Ikhwan, the "Soldiers of God" of Wahhabi theocracy ... Bilkert was shot dead.[2]

Perhaps unsurprisingly, Crane abandoned the journey and did not return to Saudi Arabia until February 25, 1931.

When he finally met Ibn Saud, Crane persuaded him to employ the geologist Karl S. Twitchell to prospect for oil and gold. Ibn Saud gave Twitchell a security force of 30 soldiers mounted on camels. Twitchell found what he thought were King Solomon's mines near Madina and after exploring the province of Hasa, he became convinced that the geological structure known as the Damman Dome held vast reserves of petroleum. When he conveyed this information to Standard Oil of California, they paid him £75,000 and retained him as an advisor. Crane also employed a Palestinian Christian, George Antonius, as "the representative of [his] private intelligence service in the Levant." Thus, the Middle Eastern missions may have begun with a belief in divine guidance, but ended up firmly in the clutches of Mammon.

Geological Rumblings

Twitchell was hardly in the vanguard of geological exploration in the region. Geology had already begun to emerge as a

prime element in regional events by the late nineteenth century. The British Navy, which as we have seen was the pillar of the British Empire, wanted to develop sources of oil to fuel its fleets. So, as early as 1878, two British admirals created a shadowy British corporation, XY Prospecting, to develop oil in Arabia and the Dead Sea region.[3]

Concessions were secured from Persia (now Iran), and oil was struck in 1908. The Anglo-Persian Oil Company was created to assume concession rights and operate and produce the oil. A few months before the start of World War I, the British Admiralty acquired large stockholdings in the company and appointed admirals to its board. Abadan Island became the port for the export of crude oil, and the Abadan refinery became the principal supplier to His Majesty's fleet.

At about the same time, British and German companies incorporated the Turkish Petroleum Company (50 percent Anglo-Persian, 25 percent Shell, 25 percent Deutsche Bank) in London, aiming to seek an oil concession from Mesopotamia (now Iraq), which was then under Ottoman rule. In June 1914 the concession was granted by the Grand Vizier, but this was not ratified and so never became a legally binding concession.

Proceedings were perhaps made easier for Britain by the Lansdowne Declaration. This had been issued in May 1903 when Lord Lansdowne, the British Foreign Secretary, warned that the British Crown "regards the establishment of a naval base or of a naval fortified port in the Persian Gulf by any other power as a very grave menace to British interests, and we should certainly resist it with all the means at our disposal."[4] Thus, the Gulf was declared a British lake.

To enforce the Lansdowne Doctrine, a powerful fleet of 16 British warships was stationed at Bahrain, political and intelligence officers were planted in the various Gulf sheikdoms, and the sheikdoms themselves were declared British protectorates. Pledges and treaties were made with the

Gulf rulers, similar to the December 1915 pledge by Ibn Saud,

> that he would not, now and forever be antagonistic to the British
> Government in any war, and that he would refrain from entering
> into any correspondences, agreement or treaty, with any foreign
> nation or power, and further to give immediate notice to the
> political authorities of the British Government of any power to
> interfere in [Saudi Arabia].[5]

At the start of World War I, the Ottoman Empire was already
fatally weakened. Yet even in this imperiled state it continued
to pose a threat to Britain, first by allying itself with Britain's
adversary, Germany, then by threatening British interests in
two places under its rule, the Suez Canal and Iraq. To protect
the Anglo-Persian oilfield and Abadan, the Raj of India,
which had administrative control over the Gulf region,
deployed an army to seize Iraq's main port of Basra. This, the
so-called Mesopotamian campaign, lasted for four years and
resulted in the loss of more than a quarter of a million British
troops. Called "one of the nastiest little conflicts" of the
twentieth century, it also showed how precious the Gulf area
was to the British.[6]

Dismembering an Empire

The Committee of Union and Progress (CUP, or the Young
Turkey Party), whose members were also known as the
Young Turks, played a pivotal role in dismembering the
Ottoman Empire and abolishing the Muslim *Khilafa*. Most
were from Salonika, then part of the Ottoman Empire, now
in Greece. Professor David Fromkin, at the Department of
International Relations, Boston University, wrote that Gerald
FitzMaurice, the British Embassy's Oriental specialist in
Istanbul who was closely following the Young Turks' activi-
ties against the Ottoman *Khilafa* Sultan Abdulhamid and his
"interpretation of the events of 1905, was colored by the fact
that they [i.e. the Young Turks] had occurred in Salonika,

about half of whose 130,000 inhabitants were either Jews or
Dunmehs [members of the Jewish sect who converted to
Islam in the seventeenth century]. Salonika was also a city
where there were Freemasons lodges ... Fitzmaurice conc-
luded that the CUP was a Latin-influenced international
Jewish Freemason conspiracy" (*A Peace to End All Peace*,
1989, p. 41).

The British ambassador to Turkey, Gerard Lowther,
referred to the CUP as "the Jew Committee of Union and
Progress." What is beyond doubt is that most of the
CUP leadership, including Mustapha Kemal Atatürk, were
Freemasons. Interestingly, many of the leaders in the Arab
secret societies within the Arab provinces of the Ottoman
Empire were also Freemasons. Even though they had differ-
ent tactical agendas and stated goals, both the Young Turks
and the Arab secret societies, knowingly or unknowingly to
most of their members, ended up achieving the same strategic
goal of the West, namely to abolish the Muslim union of state
and religion once and forever, and to dismember the
Ottoman Empire provinces.

Lowther sent an official report to the British Foreign
Secretary, Charles Hardinge, in which Lowther paid attention
to the fact that the slogan of the CUP—"Liberty, Equality,
and Fraternity"—was the same as those of the French and
Italian Freemasons. In his detailed report, he alleged that the
Jews had taken over a Freemason network, and through it
had taken control of the Ottoman Empire. Among the ring-
leaders of the Jewish Freemason conspiracy, according to
Lowther, was the US ambassador to Turkey, Oscar Straus,
whose brother owned the New York department stores
Macy's and Abraham & Straus (*A Peace to End All Peace*,
pp. 41, 42). According to Fromkin, "the report won wide
acceptance among British officials."

Christian missions were not the only wedge cleaving the
Ottoman Empire. What religion had begun, geopolitics and

geology would conclusively finish: the inevitable result of World War I was the disintegration of the empire and its Caliphate system. That had been at the top of the British agenda.

In the last decades of the Ottoman Empire, what was known as the Hijaz region of modern Saudi Arabia, including the holy city of Mecca, was ruled by Sharif Husain. Husain traced his ancestry to the Hashemite family, of which the Prophet Mohammad was a member, and was also a representative in the Ottoman parliament. He was thus a prime political and diplomatic target for the British in their attempts to destabilize the Ottoman Caliph. Husain was promised that he would be crowned king of all Arabia if he cooperated with the British to defeat the Ottomans. Colonel T. E. Lawrence and Husain's son Faisal together engineered what became known as the Great Arab Revolt. The Turks were duly defeated by a coalition of tribes from Arabia and Syria, and British forces moved in and took control. As is common in imperial history, Sharif discovered that he had been double-crossed. Instead of entering the newly independent nation as its king, he was exiled to Cyprus. The Ottoman territories were partitioned jointly by the French and the British and a large part of Arabia was given to the family of Husain's great rival, Ibn Saud. In one fell geopolitical swoop, the British and French hastened to occupy most of the resultant territories. When they left, they ensured that most of the states so created incorporated mandatory secularism in their constitutions in an attempt to ensure no resumption of Islamic rule.

We have seen how the Ottoman Empire, as one overarching Islamic state, had its own socioeconomic vision. The Islamic model differs from capitalism in that it discourages excessive accumulation of wealth, and from socialism in that it recognizes individual rights to property and ownership. Societal harmony is therefore to be ensured through a sense of shared responsibility. For this reason, in Muslims' eyes, it is capitalism

and Islam that are really in opposition, not Islam and Christianity.

Muslims concede that governmental practice under Ottoman rule was less than perfect. The rulers in particular were unable to develop management systems capable of enforcing their Islamic vision. But it would have been far, far better to reform an Islamic ethos from within rather than destroy it and replace it with something totally alien—which is what happened at the end of World War I.

When the architects of the secret Sykes–Picot Agreement between Britain and France to carve up the Ottoman Empire after World War I charted the new states of the Middle East, one of the most shameful chapters of regional history began. These two Western powers created a new geography of small, dependent states, without regard for any balance between their populations and available resources, and with an eye to controlling from without the prime economic resource of the region. The partition of the Arab world into mini-states and quasi-states ensured that states with oil resources were assigned to areas of sparse populations to ensure their dependence on the colonial powers, while states with dense populations were assigned to areas of scarce resources. In essence, they destroyed the future of that generation and cast a long, cold shadow over the future of generations to come.

The three Ottoman provinces of Mosul, Baghdad, and Basra became one country, present-day Iraq. Kuwait, previously part of Basra province, became a British protectorate and a separate entity. Iraq was left with no deep water harbor on its Gulf coast and a very small coastline, as a way of controlling its future oil shipments. The areas between Iraq, Saudi Arabia, and Kuwait were kept in what the British called neutral zones. Trade routes in and out of the Gulf were divided in such a way that no one country had good access— except, of course, the occupying British and French—a recipe for future conflicts among neighbors.

Qatar's borders were drawn up in such a way that it had no land access except to Saudi Arabia, but not the Trucial Coast. The tip of the Strait of Hormuz was given to Oman, with no land connection to the Omani mainland, while Saudi Arabia was given a small stretch on the Gulf coast, enough to allow (and disrupt when needed) future oil shipments; and the southern part of the Saudi Arabian peninsula was separated from the sea by Aden, a British protectorate. The eastern tip of the Gulf of Aden, which controls the Red Sea, was split between Aden and Yemen; the western side, by three other different entities. The tip of the Gulf of Aqaba was split among four countries: Jordan, with its sole sea outlet a stretch a few miles long, Saudi Arabia, Egypt, and Palestine (now Israel's Eilat).

It didn't end there. The Mediterranean's eastern coast was divided into new states of minorities that can only survive through an alliance with and dependence on Western powers. Syria was given access to the sea at Latikeya, an area populated by the Allawite, a minority sect. The French proposed the creation of an Allawite state before World War II, but it was obvious that such a state would not be viable. Eventually, through Syria's Ba'ath Party, the Allawites were assisted to power and took control of the country. The Allawites now make up about 10 percent of the Syrian population, and former president Hafez Al-Assad and the current incumbent, his son Bashar Al-Assad, are members.

Immediately south of the Syrian Latikeya coastal strip, Lebanon was designed to become a Christian Maronite state. And to the south of Lebanon Palestine was promised as a Jewish homeland. Thus, the whole of the eastern Mediterranean coast was isolated from the heartland of greater Syria and Iraq. The new, artificial arrangement also prevented any land link between the Asiatic Muslim Middle East and Muslim Arab North Africa.

Enter America

The end of the Ottoman Empire heralded the end of another and larger empire—Britain's. America had never been happy with what its oil companies collectively regarded as the restrictive practices of the Turkish Petroleum Company, and were constantly demanding a bite of the cherry. The end of World War I gave them that opportunity.

In April 1920, representatives from Britain and France met at San Remo on the Italian Riviera. There, they decided that France should take over Deutsche Bank's share of the Turkish Petroleum Company as reparation for war damages and also as compensation for giving up Mosul. (Under the original Sykes–Picot Agreement, Mosul was to have been part of France's sphere of influence.)

No sooner did news of this meeting reach the headquarters of the American oil companies than they began pressing the US State Department to reject its outcome. The British government was initially pressured to allow Standard Oil of New Jersey prospecting rights in the former Ottoman territories. America persisted until 1927, when the British and French conceded.

The result was that the Turkish Petroleum Company folded and a new company—the Iraq Petroleum Company (IPC)—was formed to replace it. The shares were divided equally—23.75 percent each to Anglo-Persian, Shell, the French, and the Americans. The remaining 5 percent went to Calouste Gulbekian, an Armenian broker who had helped put the deal together.[7] IPC's first oil well opened in October 1927 near the city of Kirkuk and flowed at the then unprecedented rate of 95,000 barrels a day. At last, the US had its foot in the door that opened onto the enticing vista of Middle Eastern oil.

It didn't stop there. The second American encounter with British interests came in Bahrain. Members of the IPC consortium agreed to dominate the Middle East in what became

known as the Red Line Agreement, which covered almost all the Middle East except Kuwait. However, this agreement did not include Standard Oil of California, another major American oil company, which was not part of the IPC and could, in theory, carry out its own explorations. In 1929 the company sent Fred Alexander Davies to Bahrain to assess the prospects of oil there and at Hasa on the Arabian Peninsula.

The company struck a potentially lucrative deal with Ibn Saud over the heads of the British. It is ironic that the company was greatly helped by a former British diplomat, Harry St John Philby, who had become a close advisor and confidant to the Saudi ruler. (Philby, a colorful character, was the father of the British double agent Kim Philby.)

In May 1932, the California company struck oil at Bahrain at 2,000 feet, which reinforced the belief that the Damman Dome sedimentary formation started in the Caucasus in southern Russia, and extended all the way to the Arabian Peninsula. The geologist Karl S. Twitchell, who had been working for Ibn Saud for some years, had already reported encouraging findings from his surveys of the formations, and was retained as consultant by Standard Oil.

The deal looked highly attractive to Ibn Saud: his new country at the time was among the poorest in the world, with no infrastructure to speak of. Philby handled the negotiations and managed to improve the Americans' offer by alerting Anglo-Persian of the impending deal between Saudi Arabia and Standard Oil. The final terms brokered by Philby included an advance payment of £5,000 in gold; payment to Ibn Saud for leasing the required land needed for exploration and the oil production; 30 percent of all profits from any finds; and an advance against those profits of £100,000, to be paid in gold. The Americans promptly retained him on a lucrative consultancy.[8]

A new company, the Californian Arabian Standard Oil Company, was formed (this later became the Arabian American

Oil Company—Aramco). Davies was appointed president.
The Damman Dome did not disappoint, and the first oil from
Saudi Arabia was pumped to the US tanker SS *Schofield* in
May 1938.

The Reins Change Hands

The next challenge to British supremacy came in Kuwait
from America's Gulf Oil Company. As with the other Gulf
sheikdoms under British "protection," the British govern-
ment included in all agreements with them a "nationality
clause," which excluded from oil concessions any company
that was not British or appointed by the British government.
Such a pledge had been secured from the ruler of Kuwait in
1913. However, Gulf Oil had already acquired a concession
for prospecting in Kuwait, and under pressure from the US
State Department, the British government set aside its nation-
ality clause and a bidding war for Kuwaiti oil flared·up
between Anglo-Persian and Gulf Oil. Andrew Mellon, whose
family owned majority shares in Gulf Oil, was appointed US
ambassador to London and, to stop the bidding process,
reached an understanding with Anglo-Persian.

The companies jointly approached the ruler of Kuwait as
the Kuwait Oil Company, and signed an agreement with the
protectorate in December 1934. The new company struck oil
at Burgan field—then the world's biggest—several years later.

These were crucial times for US ambitions. In Britain the
British geopolitician Peter J. Taylor asserts that "the geo-
political order that preceded the Cold War has been termed the
World Order of the British Succession."[9] Both Nazi Germany
and the US were involved in the struggle for world hegemony
to succeed the geopolitical order of *Pax Britannica*. Taylor thus
interprets "the two world wars as contests for the British suc-
cession between Germany and the USA." At the end of World
War II, the British Empire gave way to the American.

The minutes of the secret, closed meetings that were held between the US State Department and the US Council on Foreign Relations, beginning in 1939, explicitly detail the role of the US as successor to Britain: "the British Empire as it existed in the past will never reappear and ... the United States may have to take its place ..." They go on to state the US "must cultivate a mental view toward world settlement after this war which will enable us to impose our own terms, amounting ... to Pax Americana."[10]

Isaiah Bowman, Franklin Delano Roosevelt's chief geopolitician, defined the foreign policy objectives of the US as the pursuit of global policy of American *Lebensraum* in response to Nazi Germany's pursuit of *Lebensraum*.[11] Bowman, in collaboration with Hamilton Fish Armstrong, even commissioned an article from the founder of British imperial geopolitics, Sir Halford MacKinder, on the danger of a strong Soviet Union. It was published in *Foreign Affairs*, the magazine of the Council on Foreign Relations, as "The Round World and the Winning of Peace."[12] MacKinder essentially argues for the transformation of the British Empire into an American dependency and the establishment of American hegemony in Europe.

A US State Department memorandum of April 1944 clarified the philosophy behind this concept of Western "access to resources,"[13] which involved "the preservation of the absolute position presently obtaining, and therefore vigilant protection of existing concessions in United States' hands coupled with insistence upon the Open Door principle of equal opportunity for the United States companies in new areas." In other words, equal access for American companies to world resources, but not for others, and US domination of industrial production in the Western Hemisphere while US holdings were diversified elsewhere. Oil, perhaps inevitably, topped the list of strategic resources, and with it the fierce determination on the part of the US to control Middle Eastern reserves.

Growth Factor

The success of the US in challenging the British in their own sphere of influence, where they had hand-picked rulers, political and intelligence networks, troops on land and a navy in the Gulf, was indeed astounding. Not only had they secured a share of Iraqi oil, they now had half of Kuwait's, all of Bahrain's, and all of Ibn Saud's. Only Iranian oil remained under sole British ownership. But not for long.

For most of the first half of the twentieth century, the Americans accepted the fact that Iran was in the British sphere of influence. The British were the people Iranians loved to hate, as they saw them as the colonialists who were exploiting their oil wealth. Educated Iranians working in the oil industry were receiving much smaller salaries than their British counterparts. Anglo-Persian (which became Anglo-Iranian and then BP) reported £250 million in profits between 1945 and 1950, while the Iranian government received only £90 million, less than the taxes Anglo-Iranian then paid to the British government.

But British domination in Iran was not to last. After World War II, when a third war—the Cold War—was beginning, a trait peculiar to empires was becoming ever more evident in the US. According to the American historian Howard Zinn, one of the main reasons why the US goes to war, the Cold War included, is expansionism.[14] Assuming the mantle of the new imperial power, the US propelled Iran to the top of its foreign policy agenda.

George McGee was selected as the man for the job. Then aged 37, the US Assistant Secretary of State suggested to Britain that it increase Iran's share of royalties from its oil. The British tried to brush McGee aside, but the 1933 agreement between Iran and Anglo-Iranian was eventually amended through a supplementary agreement in the summer of 1949, which gave larger royalties to Iran. The new share,

however, while acceptable to Mohammed Reza Shah Pahlavi, Shah of Iran, and to Anglo-Iranian, did not satisfy the Iranian parliament, the *Majlis*, which called for the agreement to be canceled and recommended that the Anglo-Iranian Oil Company be nationalized. Iran's prime minister resigned and the Shah quickly replaced him with the Army chief of staff.

While Anglo-Iranian's chief executive Sir William Fraser blamed the Americans for his company's troubles, Mohammed Mossedegh, chairman of Iran's parliamentary oil committee, captured the mood of his countrymen by repeating the call for nationalization of Anglo-Iranian. The new prime minister came down against nationalization in a speech to parliament in March 1951 and was assassinated shortly afterwards.[15]

On April 28, 1951, the *Majlis* chose Mossadegh as the new prime minister, with a remit to begin the process of nationalizing Anglo-Iranian immediately. The Shah signed the law and it came into effect on May 1, 1951. Anglo-Iranian was no more; in its place was the Iranian National Oil Company.

The Americans initially saw Mossadegh as a national leader. But more than that, they saw in the nationalization of Iranian oil an opportunity to break the last British stranglehold on oil in the Middle East. It was a business opportunity ripe for the taking.

Meanwhile, Britain was not about to take the Iranian nationalization lying down, and the Cabinet discussed the possibility of armed intervention. It concluded than no military action was worse than no action at all. This alarmed Washington. The US State Department advised against military action as counterproductive, but rather than openly oppose Britain, Washington supported Britain's decision to oust Mossadegh in a coup, known as "Operation Ajax," jointly orchestrated by the CIA and MI6.[16] The Shah, who had fled first to Baghdad and then to Rome, returned to Tehran.

Washington's gamble paid off: in supporting Britain, it had earned itself a place at the top table when the time came to

resolve what to do about the decision to nationalize Iran's oil. The result was the creation of an Anglo-American consortium of oil companies to replace Anglo-Iranian. The consortium agreement was signed by the Shah in October 1954. American companies now owned 40 percent of the new company, while Anglo-Iranian (now BP) owned another 40 percent. Shell was given 14 percent and the French CFP 6 percent. The intention clearly was that all the oil companies operating in the Gulf would jointly control oil production from the Gulf.

It could have been awkward for the US. American oil companies were facing anti-trust investigations at the time for forming an internal cartel. But the National Security Council requested that the Justice Department drop the case, and the administration gave the all-clear to proceed in Iran effectively as a cartel, with the assurance that they would not be prosecuted for anti-trust law violations.

During the crisis, Iran's newly nationalized oil was boycotted by importers. Oil exports from other Gulf countries increased to ensure that the volume of oil leaving the region remained constant. This collusion between the major oil companies in deciding global supply of oil would continue— often without the knowledge of the producing countries themselves. When Iraqi oil was boycotted in the late 1950s, during the era of Abdul Karim Kassim—who nationalized all the "unproduced" areas of the IPC's concession—the same companies cooperated to compensate for this. The tactic was used again when Iraqi and Kuwaiti crude oil was boycotted following Iraq's invasion of Kuwait in the first Gulf War.

Troubled Victories

By the 1950s, most of the major oilfields in the Middle East were already in production, except for Abu Dhabi, Dubai, Qatar, and Oman. But these countries were only waiting in

the wings to mark up some spectacular records in oil reserves and production.

The IPC consortium had secured a petroleum concession from Sheik Shakhbut, the ruler of Abu Dhabi in 1939, but oil was not found until 1958, when Abu Dhabi was part of the Trucial Coast States under British protection. IPC also held the Dubai oil concession from 1937 to 1961, while CFP and Hispanoil obtained a concession in an area not covered by IPC in 1954. The Continental Oil Company acquired the IPC concession in 1963, forming the Dubai Oil Company. Oil was discovered in Dubai in 1966; its reserves are expected to run out by 2015.

Today, the United Arab Emirates is made up of seven emirates including Abu Dhabi and Dubai, and holds the fourth largest reserves in the world: its sustained capacity of 2.6 million barrels will rise to 3 million barrels by 2010. It also has 6.1 trillion cubic meters of gas, making it the fifth largest after Russia, Iran, Qatar, and Saudi Arabia.

After considerable corporate battles between American oil companies and the IPC consortium, in 1935 the Sheik of Qatar assigned the concession to Anglo-Persian, which in turn assigned it to a subsidiary of IPC, renamed Qatar Petroleum Company. Dukhan oilfield was discovered in 1939 and production started in 1940. A Shell Oil subsidiary obtained an offshore concession in 1952. After more offshore claims and discoveries and the independence of Abu Dhabi and Qatar, the Abu Dhabi National Oil Company (ADNOC) and the Qatar National Petroleum Company (QNPC) were established in 1971. Eventually, the Iranian model was used by all producing countries in the Gulf.

Oman's oilfields produce less than those of its neighbors, making production a much more costly business, and its reserves are modest by Middle Eastern standards—just 5 billion barrels. With the exception of Syria and Yemen, other countries of the Asiatic Middle East produce little or no

oil, and Syria has little capacity to export. Yet within the past few years, Syria has signed several concessions with other countries, including the Chinese CNPC.

After World War II, major oil discoveries were made in Africa, the North Sea, and Alaska. There were then so many entrants to the world of oil production that some form of organization for regulating it became a corporate necessity, and the Organization of the Petroleum Exporting Counties (OPEC) came into being.

Through it all, American oil companies enjoyed one victory after another. From nothing, they had collectively emerged as the leading oil power of the Middle East in a mere four decades. Britain's apparently unassailable might had given way to America's, and the US grew into a formidably potent force in the world. As we shall see in the following chapters, its influence was by no means benign. It was—and behaved—as shamelessly as all empires are wont to do.

3
The Scramble for Oil in Iraq

T HE DEVELOPMENT OF IRAQI oil had a traumatic birth. Continual political intrigues, secret agreements, deceptions, and wars have all played a part, and throughout, it is the Iraqi people who have been the victims, while colonialists, their proxies, and neo-colonialists have reaped the rewards. Both the historical events and their imperial justifications have shown remarkable similarities between twentieth-century British imperialism and the empire-building of the US in that century and in this. And oil has flowed through it all.

Baghdad (which comes from the ancient "bagh" meaning God, and "dad" meaning gift) was savagely destroyed twice in its history, first by the Mongols in the thirteenth century and later by the Americans in the twentieth and twenty-first centuries. Again, there are haunting, and tragic, echoes.

The Mongols massacred 100,000 people in Baghdad, equaling the number of Iraqis massacred within two years of the 2003 invasion by the US. When the University of Baghdad was bombed by the US air force, when treasures in the Baghdad museums were looted, stolen, and destroyed while US Marines looked on, when the sewerage and drinking water systems were destroyed, it echoed Mongol methods. It is said that in the thirteenth century, the River Tigris ran red and blue—red from blood and blue from the enormous number of books dumped in the river.

It is unknown to many in the West that prior to the Mongol invasion, Baghdad was a world center of culture and education, where Muslim scholars had made significant contributions to the sciences and the humanities, especially in mathematics, astronomy, literature, and medicine. Among the well-known Muslim scholars educated in Baghdad was Al-Khawarizmi, the father of algebra. The university at Baghdad, known as the House of Wisdom, attracted scholars of various religions and cultures from all over the world. Here, translated and conserved Greek manuscripts were stored, including the works of Aristotle, Pluto, Euclid, Pythagoras, and Hippocrates.

The Mongols were honest about their aims: they were after the spoils. Successive US administrations have not been as candid about their mission in Iraq. They claimed to be there as liberators, but like the Mongols, they came for the spoils—in their case, oil.

America's presence in Central Asia is simply one link in a region-by-region plan that first emerged in 1992, during the presidency of George Bush Senior. At this time it became clear that American policy since the collapse of the Soviet Union had global imperialism as its central goal. The CIA and the strategists of the country's far-right power elite were well aware in 1992 that the major oilfields outside the Middle East and possibly the former Soviet Union were rapidly being depleted. Controlling access to oil had reached peak importance, and the US government reasoned that now was the time for its huge military machine to grind into a new phase of action.

This grandiose strategy was set out in the so-called "Wolfowitz Doctrine," the Pentagon's Defense Planning Guide, which had been authored by US Undersecretary of Defense for Policy, Paul Wolfowitz. Leaked to the *New York Times* in March 1992, it was widely recognized—and decried—as imperialist, favoring pre-emptive military action

to suppress threats and impede other countries from attaining superpower status.[1] Unsurprisingly, a number of its recommendations later emerged in the Bush Doctrine, the policy route favored by George W. Bush.

It was little wonder that after the leak, Bush Senior ordered the Defense Planning Guide to be suppressed. In the section related to the Middle East, Wolfowitz wrote:

> In the Middle East and Southwest Asia, our overall objective is to remain the predominant outside power in the region and preserve US and Western access to the region's oil. We also seek to ... safeguard our access to international air and seaways. As demonstrated by Iraq's invasion of Kuwait, it remains fundamentally important to prevent a hegemon or alignment of powers from dominating the region. This pertains especially to the Arabian Peninsula. Therefore, we must continue to play a role through enhanced deterrence and improved cooperative security.[2]

General Norman Schwarzkopf, who led the 1991 Gulf War, had foreshadowed Wolfowitz's document in 1990 when he told Congress: "Middle East oil is the west's lifeblood. It fuels us today, and being 77 percent of the free world's proven oil reserves, is going to fuel us when the rest of the world runs dry."[3]

Hell in the Gulf

After Iraq's invasion of Kuwait in 1990, the US reciprocated with a two-pronged economic and military attack. Just days after US troops invaded and under pressure from Washington, the UN Security Council imposed the most prohibitive economic sanctions it had ever approved—including sanctions on all food imports.

The military action was one of crushing intensity. On January 16, 1991, the Pentagon unleashed six weeks of incessant air and sea bombardment. Planes from the US, UK, France, Canada, and other countries dropped 88,500 tons of

bombs which destroyed the country's infrastructure, including factories, bridges, power stations, irrigation facilities, sewerage systems, and everything else in the vicinity. This was followed by a four-day "ground war."

When Martti Ahtisaari, a special rapporteur to the UN and later president of Finland, visited Iraq just after the Gulf War, he wrote: "Nothing we had seen or read could have prepared us for this particular devastation, a country reduced to a pre-industrial age for a considerable time to come."[4] So it seemed the US had achieved its aim: the US Secretary of State at the time, James Baker III, had promised exactly that to Tariq Aziz, the Iraqi vice-president and principal negotiator at Geneva, a few days before the invasion.

But the question must be asked: if the US was only interested in ousting Iraqi forces from Kuwait, why did it engage in the massive destruction of Iraq's civilian infrastructure? And if the aim was the removal of Saddam Hussein from power, which was within their grasp after the war, why did US policy suddenly take an about-turn? The deployment of US and allied forces was devoted not to toppling Saddam, but, in effect, to keeping him in power. What for?

In 1991, Bush Senior called for the people of Iraq to overthrow Saddam. He was not, however, referring to the Kurds, Shi'ites, or any democratic forces, but to the Iraqi army or the Ba'athist Party. Former CIA director William Webster later explained: "If we had been fortunate, the troops in his Army and the cadres in his party might have moved to take him out."[5] Washington's fear of popular revolution was obviously far greater than its desire to get rid of Saddam.

The motive driving the first Gulf War—the most savage exercise of exploitative power any country has had to endure in recent history—was, in a word, oil. And the Gulf War was only the beginning. The US, which far exceeds Iraq in terms of population and economic power, would wage two more wars against this third world power portrayed by Washington and its corporate media as a menacing superpower.

The Power of Three

Many analysts believe that Iraq's invasion of Kuwait had been encouraged by the US. One year after the start of the Gulf War, I was on a flight to Istanbul for a holiday with my family. The date was January 5, 1992. Donald van Etten, a history professor at the University of California, was on the same plane, also on his way to Turkey for a holiday. He wondered how I felt about the Gulf War.

I told him I believed it must have been impossible for the US not to "see" the movement of 100,000 Iraqi troops and over 5,000 tanks and vehicles during the Kuwait invasion. The US had all the human, electronic, and other means needed to pinpoint the zero hour of invasion and nip it in the bud. Its government's apparent passivity in this regard had been bolstered by the actions of the then US ambassador to Baghdad, April Glaspie. She had told the Iraqi leadership that its dispute with Kuwait was an Arab–Arab affair on which the US would take no position. She left for Washington a week before the US invasion, and stayed there.

Van Etten replied that the US could have chosen not to act, as I was suggesting, if it had thought that the Kuwait invasion would serve its interests. He mentioned that he had written a study called *Rock and Stitch* showing not only that the US government knew in advance about the bombing of Pearl Harbor in 1941, but also that it engineered it. Certain provocations by the US were intended to precipitate an attack on Pearl Harbor to enable it to enter World War II, as van Etten has written.

> "We were sitting ducks," one Pearl Harbor survivor described the general feeling aboard the ships tied up next to Ford Island in December 1941. They were. The "ducks" were not allowed to find shelter on the West Coast or to hide in the wide ocean. They were kept in Pearl Harbor where they lay a tempting target. They served that purpose and their country. The ships and men sacrificed at Pearl Harbor saved the world from the Axis domination. There has been no greater instance of a few serving in sacrifice for the survival of many.

It was only the fact that they did not know they were bait for a trap and did not volunteer for that doomed duty to save the society they served that denied them their rightful honor. The military men in Hawaii were innocent of any crime of unpreparedness because they were ignorant of all the circumstances preceding the attack. Franklin D. Roosevelt was not ignorant and therefore not innocent.

... Franklin Delano Roosevelt not only knew that Pearl Harbor was imminent, he purposely precipitated the event. Without Roosevelt's Machiavellian maneuverings, the December 7, 1941 attack by Japan on Pearl Harbor would not have taken place.

The second Gulf War is what could be dubbed the "No-Fly Zone War," allegedly begun to protect the Shia in the south and the Kurds in the north. However, for those who know the sites of Iraq's oil reservoirs and production facilities as I do, it is not difficult to conclude that it is no coincidence that Iraq's oil production facilities just happen to lie under the No-Fly Zones.

During this conflict, which lasted from the end of the Gulf War proper in 1991 to 2003, all air and other defenses in these regions were destroyed by the US and British air forces. Although largely ignored by the American and British media, this war escalated steadily. In December 1998, for instance, a massive four-day attack, "Desert Fox," took place. Within the first eight months of 1999, American and British forces launched 1,100 missiles against 359 Iraqi targets, according to a *New York Times* article of August 13, 1999.[6]

By the end of the 1990s, some 22,000 US military personnel, 200 military planes, and 19 warships had been deployed. It is believed that at least 500,000 Iraqi children died in this war, a result of a combination of the health effects of sanctions and missile strikes.[7] When Madeleine Albright, President Clinton's Secretary of State, was asked if this price was worth America's pursuit of its objectives in Iraq, her notorious answer was, "I think that is a very hard choice, but the price, we think ... is worth it."[8]

At 05:34 Iraq time on March 19, 2003, the third war—the war of occupation—began with a bombardment by US stealth bombers and Tomahawk cruise missiles. The "Shock and Awe" operation (renamed "Operation Freedom") culminated on April 5 with the military occupation of Baghdad.

Shadows of the Past

The George W. Bush administration's occupation of Iraq has triggered a new conflict in the Gulf: a war of resistance. Some Iraqis living outside Iraq and some within had found in the US an ally of convenience, just as the Filippinos, who were waging a war of liberation against the Spanish at the end of the nineteenth century, thought that the invading Americans were allies of convenience. But once the Spanish-American War was won in 1898, and American motives of occupation became transparent, the revolution headed by Emilio Aguinaldo started all over again. The war of resistance continued unchecked until the capture of Aguinaldo in 1901. It will be the same in Iraq.

The Spanish-American War is just one of a number of precedents showing that occupation by force is an arm of US capitalism. But it is by no means the first. For that, we need to look at an American document written earlier in the nineteenth century.

In 1823, President Monroe enacted what later became known as the Monroe Doctrine. Among other points this stated that no European state should ever colonize any part of the Americas. He also set out the notion that the US would consider any attempt at colonization as a threat to its national security. President Theodore Roosevelt would later append his own addition, famously summed up as: "Speak softly and carry a big stick."[9]

Later US presidents modified the doctrine to suit their own visions of American power, but the Monroe Doctrine

remained the standard which would guide their actions in international affairs. As mentioned elsewhere in this book, in 1962 President Kennedy's Secretary of State Dean Rusk presented to a Senate committee a list that showed 103 American interventions in the affairs of other countries between 1798 and 1895 alone. Rusk's history lesson was in essence a defense of the administration's attack on Cuba—the abortive Bay of Pigs invasion in 1961. In 1963 Dean Acheson, Truman's former Secretary of State and later an advisor to the Kennedy, Johnson, and Nixon administrations, bluntly stated that the survival of states is not a matter of law.[10]

And so it is with George W. Bush. Many have seen the Monroe Doctrine as granting the US hegemony, and the "right" to intervene in the Western Hemisphere when it judges such intervention to be in its own interests, regardless of the impact that this will have on others. Certainly, there is little discernible difference between this and the Bush Doctrine, which gives the US the self-proclaimed "right" to engage in pre-emptive wars at its discretion. The main difference seems to be that the original theater was merely a hemisphere; now it is the whole world.

Uncanny Similarities

When Bush misconstrued facts to initiate his administration's war of occupation by claiming a link between Saddam and 9/11, and invoked God in support of it, he unwittingly sounded other historical echoes.

The official reason why the US began the Spanish-American War was the claim that Spain had sabotaged the American destroyer USS *Maine* at Havana. The claim was investigated, but only after the occupation of Cuba and other Spanish territories was it shown that the explosion on the *Maine* was probably a "technical accident" and had not been perpetrated by Spain. The real trigger for this war was America's

expansion into Far Eastern markets, especially China. This is where the Philippines enters the picture: to secure access to the Orient, the US set about occupying this strategically located island nation.

Just as with George W. Bush in Iraq, the invasion of the Philippines was given both a holy and human face. Congress passed the resolutions necessary for action, spurred on by public opinion. Here is what Senator Albert Beveridge had to say on January 9, 1900:

> Mr. President, the times call for candor. The Philippines are ours forever ... and just beyond the Philippines are China's markets ... We will not renounce our part in the mission of our race, trustee under God, of the civilization of the world ... The Pacific is our ocean ... Where shall we turn for consumers of our surplus? Geography answers our question, China is our natural customer ... The Philippines give us a base at the door of all the East ... It has been charged that our conduct has been cruel ... Senators must remember that we are not dealing with Americans or Europeans. We are dealing with orientals.[11]

Another striking similarity between the two wars was that both exploited an ignorant public through the corporate media—newspapers then, specializing as they did in sensationalist journalism. The hollowness of the rhetoric did not fool everyone, however. One sergeant in the First Nebraska Regiment, Arthur H. Vickers, wrote in a letter home after hostilities had broken out between the American occupation forces and the Philippine national resistance: "I am not afraid, and am always ready to do my duty, but I would like someone to tell me what we are fighting for."[12]

The past also mirrors the present in the brutality of the invasions. Captain D. Stewart Elliott of the Kansas Regiment wrote on February 27, 1899:

> Talk about war being hell ... Caloocan was supposed to contain seventeen thousand inhabits. The Twentieth Kansas swept though it, and now Caloocan contains not one living native. The

village of Maypaja, where our first fight occurred on the fourth, had five thousand people on that day: now not one stone remains upon top of the other.[13]

Echoes of Falluja? I would say so.

But perhaps most disturbing of all is how the presidents involved justified the invasions. Both Bush and McKinley used God for gold. McKinley told a group of White House visitors how he had received a divine message to occupy and annex other people's lands:

> The truth is I didn't want the Philippines, and when they came to us as a gift from the gods, I did not know what to do with them ... I sought counsel from all sides—Democrats as well as Republicans—but got little help. I thought first we would only take Manila; then Luzon, then other islands, perhaps, also. I walked the floor of the White House night after night until midnight, and I am not ashamed to tell you, gentlemen, that I went down on my knees and prayed Almighty God for light and guidance more than one night. And one night late it came to me this way—I don't know how it was, but it came ... that there was nothing left for us to do but to take them all, and to educate the Filipinos, and uplift and civilize and Christianize them ... And then I went to bed and went to sleep and slept soundly ...[14]

Bush's reliance on special guidance is even more marked. One week before the US invaded Iraq, on March 10, 2003, Howard Fineman wrote in *Newsweek* as part of a special report, "Bush and God":

> George W. Bush rises ahead of the dawn most days ... he goes off to a quiet place to read alone. His text isn't news summaries of the overnight intelligence dispatches ... It is not recreational reading ... Instead, he's told friends, it's a book of evangelical mini-sermons (*My Utmost for His Highest*). The author is Oswald Chambers, and under circumstances, the historical echoes are loud. A Scotsman and itinerant Baptist preacher, Chambers died in November 1917 as he was bringing the Gospel to Australian and New Zealand soldiers massed in Egypt (in the Army of General Allenby). By Christmas they had helped to wrest Palestine from the (Muslim) Turks. Now there is talk of

a new war in the Near East, this time in a land once called Babylon ... Later that day ... Bush told religious broadcasters that ... the United States was called to bring God's gift of liberty to every human being in the world.

Where Britain Led ...

But there was yet another historical parallel: the British invasion and occupation of Iraq at the turn of the twentieth century. As we will see, this set the tone for the West's treatment of Iraq to the present day. In this context, it is worth noting that it was the British Royal Air Force, which was among the first to adopt weapons of mass destruction—chemical weapons—against Iraqi rebels, who were being called "insurgents" as early as 1920.

Up to the end of the Victorian era, British control in the Gulf focused on securing a land route to India, while its control of other areas around the Suez Canal and the Red Sea was aimed at securing the sea route. However, when Sir Marcus Samuel, founder of Shell, presented his case that oil was essential for the continuing supremacy of the Royal Navy, oil became the force driving British strategy in the region.

With good prospects of finding oil in Iran, Iraq, and other areas in the Gulf and Arabian Peninsula, oil became the primary motive for all the British Empire's political and geopolitical activities. That it was plentiful in the region was obvious. Oil seepages were common, and history's first reference to petroleum was made 5,000 years earlier in the city of Hit, a few miles from Baghdad. But the discovery of oil in the Middle East using modern technology was first made at Iran's Masjed-I-Suleiman oilfield in 1908, some 49 years after the world's first oil well was drilled in Pennsylvania in 1859.

The event had a massive impact on Iraq, the Gulf, and all of what is now called the Middle East. Until then, the entire area had been under the nominal rule of the Muslim

ruler (Caliph) of the Ottoman Empire. According to
The Encyclopaedia of the Orient,[15] this empire was

> based around the Turkish Sultan, lasting from 1300–1922, and
> covering at its peak (1683–99) an area including today's
> Hungary, [what was] Yugoslavia, Croatia, Bosnia, Albania,
> Macedonia, Greece, Romania, Moldova, Bulgaria, Southern
> Ukraine, Turkey, Georgia, Armenia, Iraq, Kuwait, Cyprus, Syria,
> Lebanon, Israel, Palestine, Jordan, Eastern and Western Saudi
> Arabia, Oman, Bahrain, Eastern Yemen, Egypt, Northern Libya,
> Tunisia and Northern Algeria. The Turkish Empire was not [an
> empire] as such, since Turks did not profit more from the bene-
> fits of the state than the peoples of non–Turkish territories ...
> while the Ottoman Empire at its death bed had few friends, it still
> had offered its inhabitants many benefits through most of its
> existence. For Muslims, it was considered as a defense against the
> non-Muslim world. For non-Muslims it had offered a better
> life and more security than Christian states up until the
> 18th century. And it offered peace and relative harmony to all its
> inhabitants despite cultural and ethnic differences.

I said earlier that the West wanted to destroy the Ottoman
Empire by promoting nationalistic sentiment among its dif-
ferent peoples, who included the Turks, Greeks, and Arabs.

As part of the Ottoman Empire, Iraq was viewed as yet
another country ripe for exploitation and colonization under
the so-called Westernization process then and what I would
regard as globalization now. Even its name, Mesopotamia
(which means the land between two rivers), was changed.
Gearing up for a new oil quest, geologists visited Iraq under
different guises—British archeologists or German engineers.
During the construction of the railroad from Turkey to Basra
across Iraq in the late nineteenth and early twentieth cen-
turies, the Germans were so convinced that oil existed in the
Vilayet province of Mosul that they sought an exploration
concession to land a few miles either side of the railroad. So
German banks acquired a concession from the Ottomans in
1904, even before oil was found at Masjed-I-Suleiman.

After that discovery, in 1912, German and British diplomats, with German and British banks and British and Dutch oil companies, thrashed out an agreement to form a company. Called the Turkish Petroleum Company (TPC), this was a British–Dutch–German interest in which Turkey's only involvement was the use of its name. The TPC's central aim was the exploitation of Mosul oil.

But it was to change hands just two years later. In March 1914, the owners of TPC held a final meeting. It was agreed that half of TPC shares would be owned by the Anglo-Persian Oil Company (APOC, later BP), Royal Dutch Shell would own 22.5 percent of the shares, and the same percentage would go to Deutsche Bank. The remaining 5 percent was assigned to the Armenian businessman Calouste Gulbenkian who helped negotiate the concession and the company, but who had no voting rights. That same year, the British government acquired majority shares—51 percent—of APOC, which meant that the majority of Persian (Iranian) oil would in effect be owned by the UK.

A First-class War Aim

As soon as World War I broke out in August 1914, the British Secretary of the War Cabinet, Sir Maurice Hankey, wrote to Arthur Balfour that Iranian and Iraqi oil constituted a "first-class British war aim."[16]

On November 6, 1914, the British sent troops to protect the APOC refinery in Abadan. They occupied the peninsula of Fao in Iraq and, two weeks later, the city of Basra. That same month, Britain declared Kuwait a British protectorate. The Ottoman army put up only minor resistance to dislodge the British, as the main Ottoman forces were camped near Baghdad.

In April 1915, the newly arrived British commander John Nixon ordered his field commander, Major-General Charles

Townshend, to defeat the Ottoman army in Kut and
Baghdad. Townshend's advance along the Tigris again met
with little resistance, but in the first main battle between the
two armies, at Ctesiphon, 25 miles south of Baghdad, British
losses were so great that they retreated to Kut, where they
dug fortified positions. The Ottoman army outmaneuvered
the British, laying siege to them between December 1915 and
April 1916. According to conservative estimates, there were
23,000 dead and wounded among Townshend's men and
8,000 were taken prisoner.

In March 1917 General Frederick Maude, with a superior
army, was able to occupy Baghdad, famously proclaiming
that the British came as liberators, not conquerors. According
to some estimates, the British lost 92,000 men in the
Mesopotamian campaign. It was much higher according to
other sources. In his book *Oil, God and Gold*, Anthony Cave
Brown wrote:[17]

> It was called the Mesopotamian Campaign, and it lasted four
> years. The British imperial forces lost 262,000 men, dead,
> wounded and taken prisoner, in one of the nastiest little conflicts
> of the century demonstrating how important the British regarded
> the Gulf and its oil.

Around this time Britain and France, under the secret
Sykes–Picot Agreement, were busy partitioning the Ottoman
Empire into mini-states and quasi-states; Russia and Italy
would join them later. Under the agreement, Basra and
Baghdad provinces were assigned to the British and Mosul to
the French. After the war, however, Britain confiscated the
German share of TPC. Britain was then given a mandate over
Iraq by the League of Nations. In 1920, under the so-called
San Remo Agreement, France ceded Mosul in exchange for a
25 percent interest in TPC and a larger portion of Syria. Iraq
itself was assigned a 20 percent share in a supplementary
agreement.

Less than a month after San Remo, the US ambassador to London delivered a strongly worded note expressing his government's concerns. With the US advocating an "open door policy" for its oil companies and interests in Iraq,[18] American involvement in Iraq and its oil began.

The British initially ignored US protests, claiming that 82 percent of the known oil reserves of the world were already under American companies' control and they initially denied access to American geologists trying to enter Iraq. The US continued to pile on the pressure until Britain finally relented and assigned some shares to American oil companies. A syndicate of seven American oil companies, called the Near East Development Company (NEDC), was created specifically for the purpose of joining TPC. In 1924, the TPC shares were revised to incorporate NEDC into its structure.

Meanwhile, the French formed a new company— Compagnie Française des Pétroles (CFP)—specifically to manage Iraq oil. CFP, APOC, Royal Dutch Shell, and NEDC were assigned 23.75 percent of the newly reorganized TPC, and the remaining 5 percent was again reserved for Gulbenkian, who now acquired voting rights as well. (Gulbenkian later became known in the oil fraternity as "Mr Five Percent" because of this practice.)

And what of Iraq's 20 percent? It evaporated to accommodate the Americans. In January 1923 the Iraqi government was forced to forgo its share in TPC.

The issue of Mosul, apparently settled between Britain and France, was not officially recognized by Turkey, in part because it was seen as being on Turkish soil and was used by the Americans as a means to get NEDC in. After Britain and France admitted NEDC to TPC, the League of Nations settled the issue by instructing Turkey to accept the so-called "Brussels Line" as the boundary between Iraq and Turkey. Mosul thus became part of the newly delineated and named

state of Iraq. The British-installed Iraqi government signed an agreement in March 1925 allowing TPC access to oil in Mosul.

Kirkuk is now a city, but at the time was under the Ottoman Empire in the province of Mosul. It was known to have potential oil reserves because of abundant surface seepage. The first oil well was drilled at Baba Gurgur in October 1927. When the drillers struck oil, it proved to be one of the world's biggest wells. There was a blowout: two drillers were killed, the countryside was flooded with oil and poisonous gas, and it took several thousand Iraqis digging ditches over seven days to control the flow. Somehow, it seemed to be the perfect metaphor for what oil would mean for Iraq.

The Postwar War

By the end of World War I, the British presence in Iraq amounted to around 100,000 men. But resistance to occupation never stopped. In his article "How the British Bombed Iraq in the 1920s," Henry Michaels wrote: "Confronting a financial crisis after World War I, in mid-February 1920 Minister of War and Air Winston Churchill asked Chief of the Air Staff Hugh Trenchard to draw up a plan whereby Mesopotamia [i.e. Iraq] could be cheaply policed by aircraft armed with gas bombs, supported by as few as 4,000 British and 10,000 Indian troops."[19]

Later, in 1920, the uprising intensified, and "was only put down through months of heavy aerial bombardment, including the use of mustard gas," wrote Michaels. The order, issued by Wing Commander J. A. Chamier, specified: "The attack with bombs and machine guns must be relentless and unremitting and carried on continuously by day and night, on houses, inhabitants, crops and cattle ..."

Michaels relates how Arthur ("Bomber") Harris, an RAF squadron commander, reported after a mission in 1924 that

the "Arab and Kurd now know what real bombing means, in casualties and damage: they know that within 45 minutes a full-sized village can be practically wiped out and a third of its inhabitants killed or injured."

Not all were as exultant. As T. E. Lawrence (Lawrence of Arabia) wrote for the *Sunday Times* in "A Report on Mesopotamia" in the August 1920:

> The people of England have been led in Mesopotamia into a trap from which it will be hard to escape with dignity and honor. They have been tricked into it by a steady withholding of information ... Things have been far worse than we have been told, our administration more bloody and inefficient than the public knows ... We are to-day not far from a disaster.

Lawrence went on to say:

> Yet our published policy has not changed, and does not need changing. It is that there has been a deplorable contrast between our profession and our practice ... We said we stayed to deliver the Arabs from the oppression of the Turkish Government, and to make available for the world its resources of corn and oil. We spent nearly a million men and nearly a thousand million of money to these ends. This year we are spending ninety-two thousand men and fifty millions of money on the same objects.

Lawrence added that the British government was "worse than the old Turkish system," keeping 14,000 local conscripts, and deploying 90,000 men in the country, with ample military equipment to sustain them. "We have killed about ten thousand Arabs in this rising this summer," he wrote.

The parallels with today are striking. Indeed, you could say that things have hardly changed. Ayad Allawi, Iraq's provisional prime minister installed by the US occupation authorities, was reported in the November 27, 2005 edition of the *Observer* to have claimed that torture and human rights abuses are now worse than they were under Saddam Hussein. Lawrence was claimed by some to be an agent of His Majesty's government at the time he was writing; Allawi, too,

worked with Western countries against the regime of Saddam
Hussein. It is interesting to see how two men who helped
imperial powers in different centuries instigate regime change
in the Middle East, specifically in Iraq, both came to the
conclusion that the older regimes were less brutal than the
British and US occupations which proclaimed themselves as
liberators.

In June 1929, the TPC was renamed the Iraq Petroleum
Company (IPC). The Kirkuk oilfield had proved to be one of
the world's largest, with an estimated 16 billion barrels. The
IPC charter contained "a self–denial clause" in which all
partners agreed not seek any concession individually in any
former Ottoman Empire territory (except Kuwait and Egypt).
Instead, concessions were to be sought collectively by IPC
on behalf of all partners. This came to be known as the
"Red Line Agreement," in part because the ever-present
Gulbenkian had used a red pen to mark the boundaries of the
former Ottoman territories concerned. By this stage, the US
and its oil companies had little share in the post-Ottoman
spoils, but were keen for a larger slice of the pie. Although
they did not favor it initially, the Americans then moved to
secure concessions outside the Red Line by introducing their
own companies, initially from the Standard Oil group in the
US, who were not partners to IPC, to secure concessions in
Kuwait, the Gulf, and Saudi Arabia.

America Ups the Ante

It was only after the end of World War II that Standard Oil of
Jersey and Standard Oil of New York—the two companies
formed from the break-up of Standard Oil—in coordination
with the US government, began to apply pressure to have the
Red Line Agreement canceled. At the same time they reached
an agreement to prospect for oil in Saudi Arabia through a
new Arabian–American oil company, Aramco.

The Americans continued to argue that the Red Line Agreement had become null and void after World War II. At the end of the war the British seized CFP's 23.75 percent share in IPC following Germany's occupation of France and the short-lived Vichy regime. CFP in turn brought a lawsuit against the two partner American companies, and to complicate things further the American companies filed a countersuit against the French, in part because they believed the Red Line Agreement to have ended. To avoid further bad publicity, the Americans and the French reached an agreement in which Iraqi oil production would no longer be restricted to control markets. Gulbenkian's 5 percent share in IPC, which had been confiscated when he collaborated with the Vichy government, was restored to him. So all issues were settled after World War II, but it is hardly surprising that Gulbenkian once likened oil companies to cats—"One cannot know when they are fighting or making love."[20]

The Red Line Agreement was eventually canceled because after World War II it served no one's interests—particularly its policy of restricting supplies. For the pseudo-independent Iraqi government, CFP, and Gulbenkian, supply restrictions acted as a brake on their revenues. For the Americans, British, and Dutch, canceling the agreement opened the door to unchallenged prospecting and the likelihood of finding much bigger oil reserves elsewhere in the Middle East.

At the same time, by the end of World War II, Britain's waning power had become more and more evident, and by the late 1940s, the US was ready to step into its imperial shoes. In 1948 George Kennan, the US State Department's policy planning staff director and a key figure in the emergent Cold War, said:

> The US has about 50 percent of the world's wealth but only 6.3 percent of its population. In this situation we cannot fail to be the object of envy and resentment. Our real task in the coming period is to devise a pattern of relationships which will permit us to maintain this position of disparity without positive

detriment to our national security. To do so we will have to dispense with all sentimentality and daydreaming, and our attention will have to be concentrated everywhere on our immediate national objectives. We need not deceive ourselves that we can afford the luxury of altruism and world benefaction. We should cease to talk about such vague and unreal objectives as human rights, the raising of living standards and democratization. The day is not far off when we are going to have to deal in straight power concepts. The less we are then hampered by idealistic slogans, the better.[21]

The US lost no time in flexing its muscles. It orchestrated the 1951 episode in which Mohammed Mossadegh, prime minister of Iran, was ousted in a coup widely believed to have been planned and executed by the CIA. Afterwards, Iranian oil was transferred from 100 percent British ownership to a settlement allowing American oil companies a large slice of the Iranian pie. The Shah's reign was then restored.

But it was 1958 that proved the real turning point in Iraqi history. That year, the Hashemite monarchy of Iraq ended and a new republican era was supposed to have been ushered in—while a 30-year period of covert American intervention began, which was only to end with the all-too-visible intervention of the 1991 Gulf War.

Saddam and the West

Many in the English-speaking world regarded Saddam Hussein as an evil dictator, a bogeyman in the mold of Hitler and Stalin, the object of derision and ridicule, who deserved the worst possible fate. What is also beyond dispute, however, and what few in the West know, is that their own governments and their own intelligence agencies played a large part in bringing his Ba'ath Party to power and making sure he lasted as long as he did.

In 1921—after it had successfully crushed the Iraqi rebellion—the British declared Iraq a monarchy and enthroned

Faisal I. Faisal had fought the Ottoman army in the Arabian Peninsula and Greater Syria, when T. E. Lawrence had been his companion, advisor, and handler. The son of Sharif Husain bin Ali of Mecca, Husain was promised the kingdom of Arabia by the British after the Ottomans were defeated. But instead, under the terms of the Sykes–Picot Agreement, the British dismembered the Ottoman territories promised to Husain.

Faisal was a figurehead in Iraq, with the British holding all real power. They needed a rubber stamp on behalf of the Iraq citizens, so they also created an Iraqi assembly. In 1924, that assembly—under great pressure and with great reluctance—agreed to a treaty with Britain whereby it maintained military bases and reserved the right to vote over the Iraqi legislation, a step that was repeated by the American occupation of 2003 under Paul Bremer. In the British "democratization" of Iraq, just as with US occupation today, an Iraqi government and parliament were supposedly governing Iraq. In 1932, the British mandate was terminated.

Faisal I died in 1933 and was succeeded by his son Ghazi, who died in an automobile accident in 1939. Ghazi's infant son Faisal II was then proclaimed king. Prince Abdal Elah, a British "ally," ruled the country as regent, with another British "friend," Nuri Al Said, as prime minister.

In April 1941, after the country had witnessed seven military coups, Rashid Al Gaylani, who was anti-British, seized power and ousted Abdul Elah. The British sent more troops to their garrisons at Basra, defeating Al Gaylani by June. Abdul Elah was then reinstated and continued to collaborate closely with the British. Iraq joined the anti-Soviet Baghdad Pact, which also included the US, Britain, Turkey, Iraq, and Pakistan, in 1955.

The 1958 coup came in midsummer. General Abd Al Karim Kassem (also spelt Kassim and Qasim) proclaimed Iraq a republic, and Faisal II, Abdul Elah, and Nuri Al Said

were all assassinated within the first few hours. Iraqi partici-
pation in the Baghdad Pact was brought to a halt; Iraq was to
formally terminate its membership in 1959. In forming his
government, Kassem shared power with members from many
political parties, including the Communists, thereby becoming
an obvious target for assassination by the West.

In 1959, a 22-year-old Iraqi joined a CIA plot to assassinate
Kassem. His name was Saddam Hussein. Whether Saddam
knew of CIA involvement or was unknowingly following his
Party's elders who did know about it is open to debate. It also
remains a possibility that an alliance of convenience was
forged between the Ba'ath Party elders and the CIA.

On October 7, 1959, Kassem's convoy came under attack.
Saddam killed Kassem's driver, wounded Kassem, and was
wounded himself in the crossfire with Kassem's bodyguards.

In February 1963 Kassem was killed in a Ba'ath Party coup
that was, according to Roger Morris, sponsored by the CIA.
As Morris wrote in the *New York Times* of March 14, 2003:

> Forty years ago, the Central Intelligence Agency, under President
> John F. Kennedy, conducted its own regime-change in Baghdad,
> carried out in collaboration with Saddam Hussein.
>
> The Iraqi leader seen as a grave threat in 1963 was Abdel
> Karim Kassim ... America's anti-Kassim intrigue has been widely
> substantiated, however, in disclosures by the senate committee on
> intelligence and in the work of journalists and historians like
> David Wise, an authority on the CIA ... But without significant
> opposition within the government, Kennedy ... pressed on. In
> Cairo, Damascus, Tehran and Baghdad, American agents
> marshaled opponents of the Iraq regime. Washington set up a
> base of operations in Kuwait, intercepting Iraq communications
> and radioing orders to rebels ... Then on February 8, 1963, the
> conspirators staged a coup in Baghdad ... Kassim gave up, and
> after a swift trial was shot.[22]

One of Kassem's crimes as far as the CIA was concerned was
his Petroleum Law No. 80, which took all undeveloped Iraqi
territories out of IPC hands. As all the oil until then had been

produced from only 1 percent of Iraq's territory, Kassem had confiscated 99 percent of the land from the IPC concession. As for a CIA–Ba'ath connection in Iraq, John K. Cooley, in his book *An Alliance against Babylon*,[23] quoted King Hussein of Jordan addressing the editor-in-chief of *Al Ahram* newspaper of September 27, 1963: "Permit me to tell you that I know for a certainty that what happened in February 1963 had the support of American intelligence" (p. 93).

The Iran–Iraq War

We need to go back a few years to 1974 when there were heavy armed clashes all along the Iran–Iraq border over the disputed Shatt Al Arab waterway dividing the two countries. The next year, an agreement to share the waterway was reached and presented to the Shah by Saddam Hussein, then second-in-command in the Iraqi power structure under Al Bakr. In return, the Shah agreed to stop arming Iraqi Kurds.

After the 1979 Islamic revolution under Ayatollah Khomeini and the deposing of the Shah, the US and its allies encouraged Iraq to seize the opportunity and destabilize the Khomeini regime. The incentive was that Shatt Al Arab might become an exclusively Iraqi waterway. Al Bakr was opposed to the scheme, but Saddam supported it. Saddam became president in 1979 when Al Bakr resigned, and opposing members of the Ba'ath Party were executed shortly thereafter.

In 1980, with American students held hostage in the American Embassy in Tehran, the US was eager to strike a blow against the Islamic revolution. President Carter's attempt to free the hostages in a special operation ended in disaster. Meanwhile, the oil sheiks of the Gulf were fearful that the revolution was threatening their overthrow as it had that of the Shah.

Saddam Hussein now revoked his agreement on Shatt Al Arab. Iran advocated his overthrow, and it was claimed that

the Iranians made some attempts to assassinate Iraqi officials. But what tipped the balance towards all-out war was the tacit approval of Washington for Saddam's anti-Iran activities and the promise of the oil sheiks and Saudi Arabia to finance Saddam's war against Iran. The final go-ahead came during Saddam's state visit to Saudi Arabia in August 1980, the first ever by an Iraqi president. According to investigative reporter Bob Parry, in his article "Missing US–Iraq History,"[24] "Saudi leaders also say they urged Saddam to take the fight to Iran's fundamentalist regime, advice that they say included a 'green light' for the invasion from President Carter." Saddam invaded Iran on September 22, 1980, a mere six weeks after his state visit.

The Iran–Iraq War ground on for eight years. The United States' official line was one of neutrality, but in reality it stayed true to Kissinger's famous dictum that in wars there is normally a loser and winner, but in the Iran–Iraq War they should be two losers.

First through its allies, and later directly, the US was supplying Iraq with satellite and other intelligence to inflict maximum damage on the Iranians. Yet at the same time, the US was providing Iran with spare parts and arms, as was disclosed in the Iran–Contra affair. Dual-use technology was sold to Iraq and the deep pockets of the oil sheiks were plundered to pay for them. An article in the September 23, 2002 issue of *Newsweek*[25] disclosed that in the 1980s President Reagan allowed sales of computer databases to Iraq that could have used to track political opponents, along with shipments of materials that could produce anthrax and arsenals of biological weapons.

As Reagan's envoy, Donald Rumsfeld visited Iraq and met Saddam Hussein twice: in 1983 and 1984. According to reporters Murray Waas and Craig Unger in an article from the November 2, 1992 issue of *New Yorker*, it is also believed that Bush Senior, while Reagan's vice-president, advised Saddam,

through Arab intermediaries, to intensify his bombing campaign against Iran—apparently to boost Iran's demand for anti-aircraft weapons manufactured in the US.

Territorially, the Iran–Iraq War left both countries at the point they were in when the war began in 1980. But it left the Iraqi economy in tatters and deeply in debt, whereas it had had a $30 billion surplus before the war started. Furthermore, 1 million Iraqis had been killed or wounded, and there were many prisoners of war. Iran suffered similar losses. So Kissinger's remark was realized: both countries emerged from the war as losers. At the same time, the US was increasing its visible presence in the Gulf. It is quite probable that the occupation of Kuwait and the 1991 Gulf War were a result of the Iran–Iraq War.

Saddam felt the oil sheiks owed him a lot during the conflict with Iran. To restore his economy he wanted them to write off Iraq's debts. But they were not willing to do so. Then he asked for a $10 billion loan from Kuwait, which it refused. In fact, Kuwait was driving down world oil prices as it was producing huge quantities of oil from its share of the Rumaila field beyond its OPEC quota. Only a small part of this oilfield is within Kuwaiti borders—most lies under Iraqi land. Saddam was infuriated, as each $1 drop in the price of oil meant a $1 billion fall in revenue to Iraq.

That Saddam sent troops south to the Kuwait borders was evident not only to American satellites, but even to Western reporters. But Saddam had been misled. April Glaspie, US ambassador to Baghdad, had told him that Arab–Arab conflicts were not a concern of the US, and an administration official when asked in Congress about America's reaction if Kuwait were to be invaded, replied: "We have no defense agreement to defend Kuwait."

In this context, an affidavit[26] filed in a Florida courthouse has considerable bearing. This sworn declaration by a former national security official in the Reagan administration,

Howard Teicher, was filed in connection with a criminal trial in Miami, in 1995. According to Teicher, the Iran offensive of 1982 worried Washington and it decided to give enough aid to prevent Iran from winning the Iran–Iraq War.

In his sworn statement, Teicher wrote:

> In June, 1982, President Reagan decided that the United States could not afford to allow Iraq to lose the war to Iran. President Reagan decided that the United States would do whatever was necessary and legal to prevent Iraq from losing the war with Iran. President Reagan formalized this policy by issuing a National Security Decision Directive ("NSDD") to this effect in June, 1982. I have personal knowledge of this NSDD because I co-authored the NSDD with another NSC Staff Member, Geoff Kemp. The NSDD, including even its identifying number, is classified.

Teicher said that the NSDD that Reagan signed authorized covert US assistance to Saddam Hussein's military. This included "billions of dollars of credits," as well as US military intelligence and advice, ensuring Iraq had the necessary weaponry and strategic operational advice.

The effort to arm the Iraqis was spearheaded by CIA Director William Casey and involved his deputy, Robert Gates, according to Teicher, while the CIA, "including both CIA Director Casey and Deputy Director Gates, knew of, approved of, and assisted in the sale of non-U.S. origin military weapons, ammunition and vehicles to Iraq."

Regarding Rumsfeld's 1984 visit to Baghdad, Teicher wrote: "I traveled with Rumsfeld to Baghdad and was present at the meeting in which Rumsfeld told Iraqi Foreign Minister Tariq Aziz about Israel's offer of assistance." "Aziz refused even to accept the Israelis' letter to Hussein offering assistance because Aziz told us that he would be executed on the spot by Hussein if he did so."

Teicher added:

> In 1986, President Reagan sent a secret message to Saddam Hussein telling him that Iraq should step up its air war and

bombing of Iran. This message was delivered by Vice President Bush who communicated it to Egyptian President Mubarak, who in turn passed the message to Saddam Hussein. Similar strategic operational military advice was passed to Saddam Hussein through various meetings with European and Middle Eastern heads of state. I authored Bush's talking points for the 1986 meeting with Mubarak and personally attended numerous meetings with European and Middle East heads of state where the strategic operational advice was communicated.

The Clinton administration attacked Teicher and his affidavit, then they declared them to be secret documents and they were locked under court seal.

Secret Strategy

Washington's secret war strategy aiming to control oil the world over has now expanded with its current war—the War on Terror. American global wars today are waged to serve the interest of the few, and certainly not the majority of Americans. None of this is new to those in the know. As far back as 1961, the British economic historian Arnold Toynbee wrote:[27]

> America is today the leader of a world-wide ... movement in the defense of vested interests. She now stands for what Rome stood for. Rome consistently supported the rich against the poor in all foreign communities that fell under its sway, and since the poor, so far, have always and everywhere been far more numerous that the rich, Rome's policy made for inequality, for injustice, and for the least happiness of the greatest number.

Does the US fit the definition of a rogue state? In his study *The USA—A Rogue State?*[28] Bill Dillon concludes:

> The term rogue state has two uses: as propaganda rhetoric denouncing the behavior of states we don't like, and a literal definition that applies to states that have chosen not to regard themselves as bound by international norms. These norms are partially codified by the UN charter, International Court of

Justice decisions and various conventions and treaties. By this literal definition it is clear that we have indeed chosen to be a rogue state!

George W. Bush is not the first US president to espouse unilateralism. Nor is unilateralism the preserve of the Republicans. Strategic policies are decided by the permanent power structure that regards itself as having the power to make or break a leader anywhere in the world. In 1993, Bill Clinton informed the UN that "the US will act multilaterally when possible, but unilaterally when necessary." In 1999, Clinton's Secretary of Defense William Cohen declared that the US is committed to "unilateral use of military power" to defend its vital interests, which include "ensuring uninhibited access to key markets, energy supplies, and strategic resources."[29] How does this differ from the Bush Doctrine of unilateralism and pre-emptive strikes?

In real terms, "uninhibited access to key markets, energy supplies, and strategic resources" means what the renowned Indian writer Arundhati Roy described as:[30]

> poor countries that are geopolitically of strategic value to the Empire, or have a "market" of any size, or an infrastructure that can be privatized or, God forbid, natural resources of value—oil, gold, diamonds, cobalt, coal—must do as they're told or become military targets. Those with the greatest reserves of natural wealth are most at risk. Unless they surrender their resources willingly to the corporate machine, civil unrest will be fomented or war will be waged.

4

Black Gold and the Dollar

FOR THE WEST AND East alike the early 1970s were a transformative period, and the ebb and flow of oil drove much of the process. But whereas oil had generated enormous wealth since the nineteenth century, now it would become intertwined with money itself and instrumental in refashioning world financial markets.

A series of crucial events, which may appear superficially unrelated, led to this metamorphosis. First was M. King Hubert's forecast that US oil production in the "lower 48" states would peak in 1970 and gradually drop thereafter. This was duly fulfilled, and in 1970 the US became a net importer of oil. The following year, the country registered its first trade deficit.

The amount of US dollars circulating abroad in 1971 was approaching $300 billion. The country's gold reserves held at Fort Knox, however, were worth a meager $14 billion at the official price of $35 an ounce—a standard set by the Bretton Woods system of monetary management. This agreement, established in 1944, regulated commercial and financial activities among the world's top industrial nations—in essence, it pegged all currencies to the dollar, and the dollar to gold.

For the US the imbalance was a catastrophe waiting to happen. Any country that wanted to exchange their dollars for gold could do so at any time—in theory at least. The gap between printed dollars in circulation and gold reserves became common knowledge. The overprinting of dollars to

finance the Vietnam War and the Cold War without sufficient gold reserves made the Bretton Woods fixed exchange system unsustainable Then, on August 15, 1971, Nixon announced America's unilateral decision to cancel its Bretton Woods commitment and formally suspend the option of converting dollars into gold.

The Death of Money

Nixon's decision forced the world off a gold standard and onto a dollar standard, from a fixed-rate system to a "floating no-system," as Helmut Schmidt, German Chancellor Willy Brandt's defense minister, called the new financial order. To many, the US had committed the biggest act of economic extortion the world had seen. As gold skyrocketed to $350/oz, ten times its official price, it was soon realized that anyone wanting to exchange gold for dollars would now receive just 10 percent of the value that was guaranteed under the Bretton Woods Agreement, which was the basis on which central banks and individuals alike bought dollars.

The money economy was now separated from the real economy that produced real goods and services. A new, speculative economy was unleashed, and with it a permanently unstable monetary system. This single decision heralded the "death of money" as people had understood it for some five millennia, and "casino" economics took over and burdened the productive economy. The world of long-term economic and trade activities measured against a fixed standard was dead.

One of the basic assumptions of American capitalism remained, however: unchecked economic growth. In 1972, the landmark study *Limits to Growth*[1] set out the unsustainability of this notion vis-à-vis the population explosion as well as the finite quantities of natural resources such as oil and gold. The report pointed out that the existing

system based on limitless resources could collapse within a century, especially when population growth was taken into consideration.

The White House was not deaf to this message. In 1972 Nixon named John D. Rockefeller III chairman of a new presidential commission on "Population and the American Future."

The commission's conclusions laid the foundation for a National Security memorandum issued by Henry Kissinger in April 1974.[2] This identified population growth in developing countries rich in natural resources as "a US national security concern of the highest priority." It went on to call for the depopulation of areas known to have large reserves of strategic resources necessary for US corporate growth. No restraint on the part of the corporations themselves was mentioned. Interestingly, most of the countries listed in this memorandum—Bangladesh, Pakistan, India, Indonesia, Nigeria, the Philippines, Turkey, Egypt, and Ethiopia (with Iran and Syria added later)—have large Muslim populations or are exclusively Muslim.

The paradox here is that the oil resources most needed for capitalism's growth happen to lie beneath Muslim lands. As early as World War I the imperial powers that subdivided the Ottoman Empire's Middle East drew the new boundaries of post-Ottoman states in such a way that the states with abundant resources ended up with relatively small populations. On the other hand, states with large populations had comparatively little by way of natural capital.

A new world financial order now came into being. Under the new system, the dollar would be linked indirectly to "black gold": oil. But this required sweeping changes. Since the Middle East holds the world's largest reserves, Nixon instructed Kissinger to request Israel to withdraw from the occupied territories in 1967 in return for recognition by its neighbors, according to Security Council Resolution 242.

It appears, however, that Kissinger had other plans in mind. Nixon's preoccupation with Watergate made Kissinger *de facto* president, and he started to unroll his plans by preparing a staged Arab–Israeli war, then quadrupling the prices of oil, and, last but not least, imposing on the world the dollar as the only acceptable currency for oil trading. Thus, a new demand for the dollar was created which would allow the printing presses to continue printing dollars as long as oil is the principal source of energy. For this purpose, the Bilderberg conference[3] of May 1973 was convened.

At Bilderberg, Walter Levy's study featured the actions needed to cope with a 400 percent increase in oil prices a full six months before the event took place—and the participants' management plan for the flood of petrodollars resulting from the 400 percent oil price increase.

1973 was an eventful year. In June David Rockefeller initiated the Trilateral Commission. The stated aim of this private group of representatives from Japan, Europe, the US, and Canada was to foster closer cooperation between their regions to manage the changes resulting from the post-Bretton Woods financial order and to share leadership responsibilities in the wider world. Not an odd goal at a time of considerable political friction: but such a body would also, of course, be useful as a way of managing the effects on the international finance and trade system of the rise in oil prices. The agenda of the Trilateral Commission became the agenda of the US administration, starting with President Carter himself and many of his key staff were trilateralists, including Vice-President Walter Mondale, the Secretary of State, and National Security Advisor.

The third major event in the post-Bretton Woods order that occurred in 1973 was the Arab–Israeli war. The October War between Israel and the Egypt–Syria coalition ended with an oil embargo and, consequently, the anticipated increase in oil prices. But the hike did more than enrich the oil companies; it made the Alaska and North Sea discoveries viable as the

old prices were below the cost of production in those areas. It also created demand for the US dollar.

Gold may have gone, but now the dollar was backed by oil. At the same time, oil was creating a demand for dollars. Nor has this situation altered much in the intervening years. At the beginning of 2006, oil was $60 a barrel. At the world consumption of 82 million barrels a day, the US Treasury is churning out almost $5 billion in dollar currency every day, backed mostly by oil and a supposedly strong economy. Such an economy now suffers from an unprecedented debt burden which many economists believe is unsustainable. It is little wonder that the US now wants its troops to sit tight on these oil resources, especially in the Muslim Middle East.

Guns and Oil

Throughout 1973, war games and military plans were discussed in the upper echelons of government in Washington with the aim of physically occupying the oilfields of the Middle East. It was felt that the time was premature, but the plans were made nevertheless, the central command formed, and a step-by-step control implemented. Huge airbases and military cities were built using the petrodollars of the oil producers, and a US naval presence in the Gulf was gradually increased. As we shall see later in this chapter, it was a plan of phenomenal—even unprecedented—scale.

According to Robert Dreyfuss writing in *Mother Jones*:[4] "In the geopolitical vision driving currents U.S. policy toward Iraq, the key to national security is global hegemony—dominance over any and all potential rivals. To that end, the United States must not only be able to project its military forces anywhere, at any time. It must also control key resources, chief among them oil—and especially Gulf oil."

Dreyfuss quotes Chas Freeman, US Ambassador to Saudi Arabia during the first Bush administration, as saying that

the new administration likewise "believes you have to control resources in order to have access to them." And given that President Bush today is denied sufficient access to oil in Alaska and elsewhere, "Iraq's crude is readily accessible and, at less than $1.50 a barrel, some of the cheapest in the world to produce."

Fast-forward to today, with the Iraq's capital, Baghdad, surrounded by US military might. Is the Bush administration preparing to solidify a long, planned, decades-old strategy?

"It's the 'Kissinger Plan'," says former US ambassador to Saudi Arabia James Akins, who served under Secretary of State Kissinger. "I thought it had been killed, but it's back." In the wake of the oil shocks of the 1970s, Akins says, a "screwy idea" was floated to American newspapers and magazines outlining a takeover of the Arab oilfields. "Then I made a fatal mistake," Akins claims. "I said on television that anyone who would propose that is either a madman, a criminal, or an agent of the Soviet Union." A short time later, Akins was told that the "madman" was his boss, Henry Kissinger, who reportedly had introduced the proposal during a senior background briefing. James Akins was fired soon after that.[5]

Those who stood to gain in this post-Bretton Woods financial order were the multinational oil companies, American and British banks, and speculators on Wall Street and in the City of London. The losers were the developing countries, which had to surrender their dollars to an inexorable process that would eventually deposit them in New York banks. One country after another in South America, Africa, and Asia started to face chronic deficits in its balance of payments.

According to the International Monetary Fund (IMF), the deficit borne by these countries grew by 400 percent in 1974 over its 1973 level. They began to borrow from Western banks to pay for oil, and the loans became a significant burden on their national economies. A debt trap was thereby created in which poorer nations had to resort to the IMF to

avoid defaulting on their loan repayments. But the loans themselves were full of pitfalls. They came with conditions that effectively mortgaged the borrowing country's economy and imposed the notorious IMF "conditionalities"—agreed conditions that mandate free trade and open the door to the American financial community and transnational corporations. Under such pressure, a borrowing country's natural resources would be controlled or bought one after another, always at bargain basement prices, and the countries would gradually become hostages to the world financial community.

India is just one example. In 1974 India had $629 million of reserves, half of which were sufficient to pay for its oil bill at 1973 prices. But the bill came in at $1.241 billion. Overall, developing countries incurred a $34 billion debt in 1974—an unprecedented amount. OPEC dollars were recycled to the big banks of New York and London, and now those banks could decide which country would be granted a loan and on what terms. Meanwhile, debts continued to mount. Fully a third of the total annual budget of Jordan, for instance, is spent servicing its debt interest, while the debt itself is not reduced. At $60 a barrel, its oil bill amounted to about 20 percent of GNP in 2005. America's oil bill in the same period was a comfortable 2.5 percent of it GNP.

Richer developing countries also found themselves filling Western coffers. In January 1974, for instance, the US Treasury reached a secret agreement with Saudi Arabia, the largest recipient of petrodollars. The Saudi Central Bank (SAMA) appointed a Wall Street investment banker, David Mulford, as its "investment advisor." Mulford advised the Saudis to use their petrodollars mainly to buy US Treasury bonds.

Funding Frenzy

So the August 1971 decision to withdraw from Bretton Woods had a global impact. But Nixon's part in that story

was by no means the main one. The American economy had been teetering on an insubstantial pile of banknotes for more than a decade.

In 1957, under President Eisenhower, more funds were leaving the US than flowing in for the first time since the Bretton Woods system had been introduced in 1944. The reason lay elsewhere: American banks were finding it far more lucrative to invest abroad than at home, and their primary loyalty was always to their own balance sheets. Multinational corporations started to invest and build production facilities where cheap labor was found—in Latin America, Europe, and Asia. The profits were kept abroad.

Then there was defense spending, now taking a massive chunk out of the US economy. The country had to finance its military bases around the world as well as the war in Vietnam, where at its peak it had 589,000 troops. Another 600,000 military were deployed around the world, not to mention the thousands manning 600 warships in various fleets. Thousands of pilots and air force logistical personnel were posted overseas too. All needed dollars, and all those dollars stayed outside the US.

Lyndon B. Johnson, sworn in as president in 1963 after Kennedy's assassination, chose to print dollars beyond the value of gold stocks at Fort Knox rather than raise taxes to finance the war in Vietnam and the package of socioeconomic reforms known as the Great Society program. So more US Treasury bonds were sold and the federal budget deficit ballooned. From $3 billion in the early 1960s, it grew by 300 percent in 1967 and by 800 percent in 1968. By 1970, some $1.3 trillion were lodged in the London Euromarket. The US was simply printing paper money without sufficient gold reserves.

Around this time the French president, Charles de Gaulle, and his financial advisors became suspicious of the gap between the volume of dollars in circulation and the gold reserves at Fort

Knox. For this reason he wanted to develop independent economic and political policies for Europe and thus become more independent from Washington. With German Chancellor Konrad Adenauer, de Gaulle drew up the Franco-German Treaty. The Americans were alarmed and lobbied against it in Germany. Two days before the treaty was due to be presented to the German Bundestag, in 1963, Adenauer was voted out of office. The treaty was never ratified.

By that time, however, de Gaulle had succeeded in withdrawing France from US economic pressures. In 1961, under President Kennedy, the US had asked the central banks of the top ten industrialized countries to keep their dollars to ease the drain on its gold reserves and earn interest by investing in Treasury bonds—thus, in effect, financing America's wars. De Gaulle urged the US to devalue the dollar but this met with considerable opposition from the New York banks. Dollar liabilities abroad continued to soar, and with it the drain on US gold.

In 1968, it happened all over again. The US unveiled another scheme to the Group of Ten to create "paper gold"— a substitute the IMF termed "special drawing rights" (SDR). The French government opposed this, and Finance Minister Michel Debré insisted on a return to the Bretton Woods Agreement. France again asked for a 100 percent devaluation of the dollar against gold. Immediately afterwards, chaos descended on the country. Students at the University of Strasbourg rioted, and demonstrations and riots quickly spread across the country. American and British banks made a coordinated run on the French franc, draining French gold reserves by 30 percent before the end of 1968. Within a year de Gaulle was out of office.

These are the events leading up to today's casino economy. Even oil has become a speculative commodity. Now, an oil cargo leaving the Gulf bound for Rotterdam will be traded some 20 times before reaching its destination. According to

Joel Kurtzman, an economist and business editor at the *New York Times*, money itself is now light years away from its beginning in the temples of Sumer (now Iraq), 5,000 years earlier. As he writes in *The Death of Money*:

> Money is different. No longer is it a discrete object ... Money has been transmogrified. It is no more a thing ... It is a system ... In the new world of money, even the largest banks no longer need vaults. Instead, they store their money on disk drives and computer tapes, and they protect those funds not by hiring brawny guards but by employing brainy PhD mathematicians and software specialists to write secret codes.[6]

Kurtzman adds that the gulf between the real economy of products, trade, research, and services on the one hand, and the "financial economy" on the other, is huge: in the mid-1990s, the latter was 20–50 times larger than the former. "It is not the economy of trade, but of speculation."[7] In it, financiers and financial speculation houses rule supreme. Someone like George Soros can take on even the Bank of England and make billions, or tackle the Southeast Asian currencies and cause financial and economic chaos.

Enter the whiz-kids.

In the world of speculation, he who gets the information first will have an edge. Also, he who analyzes data faster can make a better "bet." So, the financial giants of Wall Street equipped their companies with the best scientists to run their computer programs. As Kurtzman notes:

> In 1990 at Jefferies & Company, an investment house headquartered in Los Angeles but with offices in New York and London, only two out of fifty people working on its automated trading system project had prior brokerage experience. The rest of the team was composed of mathematicians, economists, physicists, and computer designers. One of Jefferies' quants wrote the computer programs that NASA used to aim the Galileo spacecraft to Jupiter.[8]

Substantial rewards lured the top boffins. Goldman Sachs, for instance, hired Fischer Black, an MIT professor of economics,

in 1983. At MIT he was earning $43,000 a year. After three years at Goldman Sachs he was making more than $1 million a year. Another MIT mathematician, Lawrence E. Hilibrand, was hired by Solomon Brothers and in 1990 alone earned $23 million.

The budgets for sophisticated high-tech equipment and research were also huge. During the 1980s, Wall Street firms were spending an average of $3.4 billion annually on high-speed computers and other technology; by the early 1990s the figure was some $7.5 billion. When Thinking Machines Inc. introduced their powerful CM-5 supercomputers in November 1991, the first orders to roll in came from the top science centers of Los Alamos, Berkeley, the University of Pittsburgh's supercomputer center, and American Express, which ordered two.

This capacity to spend vast sums has made a handful of financial firms in Wall Street a virtual big players' cartel. Against their collective might, the reality for most developing countries is a state of extreme vulnerability.

Mexico is a prime example. When US interest rates were low between 1991 and 1994 and Mexico's were higher, American fund managers found an opening for arbitrage—that is, borrowing in the US, "investing" in Mexico, and pocketing the profits resulting from this interest differential. After Mexico underwent financial "reform"—meaning that fund managers could exit with their money any time they pleased—money started to flow into Mexico, and American financiers and fund managers created a stock market bubble.

Within two or three years, stock prices had risen fourfold. Offshore investors held about 50 percent of the Mexican stock market and some 25 percent of government debt. Then they left, and the bubble burst. US interest rates had started to pick up, and opportunities elsewhere were more tempting. Of all the investments that poured into Mexico, 75 percent went to financial markets and speculations and only 25 percent

was invested in the country's productive economy—and even that was mostly confined to multinational companies involved in intra-company trade and hence was isolated from the Mexican economy.

In early 1994, at the point when the US interest rate began to rise, Mexico had reasonable foreign reserves of $25 billion. But the constant hemorrhaging of financiers' "hot money" drained its foreign reserves until, by the end of the year, few were left and the Mexican peso had lost about half of its value in a matter of few weeks. The country was in economic freefall.

Meltdown in Mexico

Even before the crisis, Mexico had had two economies: one productive the other financial. The country's productive economy had been deregulated and opened up to please international financiers. So Mexico's garment industry lost out to Asian competitors, and its paper and confectionary industries lost out to American competitors. They had been caught unawares by deregulation. With the crisis peaking at the end of 1994, Mexico could have defaulted and many, including well-known American economists, thought that that was a viable option. Instead, it went down a now familiar road and sought assistance from the US and IMF.

It was judged that about $50 billion was needed to stop the freefall of the peso and restore economic order. The natural step for selling a US bailout package was to go to Congress. Robert Rubin, who left Goldman Sachs to become Secretary of the US Treasury, joined Federal Reserve chairman Alan Greenspan and deputy Treasury Secretary Lawrence Summers to devise a plan and lobby for it with Congress.

Wall Street was pushing hard, but Congress was in no hurry: Congressmen wanted to tie any aid to Mexican immigration. Besides, their voters were not keen on bailouts.

Richard A. Gephart, a Democrat and US Representative from Missouri, told President Clinton his $40 billion loan guarantees had no chance of getting through Congress. An emergency plan was worked out, this time without Congressional input, on the night of January 31, 1995, and was ready by dawn the next day. On February 1, Clinton called Congressional leaders to the White House and told them he was going to sign an executive order for the new bailout and that he expected their support. Since the new plan had been prepared and promoted to assist Wall Street, the Congressional leaders knew better than to oppose it. After the meeting, they had to leave the White House through a back door to avoid waiting reporters.

Not only had the plan been thrashed out behind closed doors; Clinton had also used his executive powers rather than legislative powers to bail out American financiers, not Mexico. Clinton made a public announcement justifying the plan and signing the order since the "risks of inaction are greater than the risks of action. This is the right thing to do."[9]

What precisely did Mexico's big bailout package consist of? First there was the Treasury's Exchange Stabilization Fund, worth $20 billion. Greenspan had earlier expressed the opinion that the Treasury had no right to use the fund in this way, as its purpose was to defend the dollar. Now he and everybody else thought otherwise. The rest was made up of $4.5 billion of short-term credit, to be provided by the Federal Reserve; $17.8 billion from the IMF; $10 billion in short-term credit from other industrial nations; $1 billion from Canada; and $1 billion from Latin America.

The fund had some very long strings attached, however: the IMF's infamous "conditionalities." Under these, Mexico had to surrender its policies regarding money supply, fiscal spending, future foreign borrowing, and domestic credit. It had to sell its best assets, including ports, railroads, petrochemicals, and telecommunications, to raise $12 billion, and the sales were to start immediately, regardless of the fact that

prices were depressed as a result of the crisis. It had to open its bank ownership to foreigners. And it had to pledge to deposit all revenues from its oil with the Federal Reserve Bank of New York.

Mexico's president at the time, Ernesto Zedillo, found the terms extremely harsh. He also felt he would be accused by the people of surrendering Mexican sovereignty, and that he was turning the country into "a colony of the United States." However, Mexico was obliged to sign the proposed agreement. The immediate results alone make a harrowing list:

- The economy contracted by 7 percent.
- VAT was increased to 15 percent.
- Real income was reduced by 33 percent.
- Inflation for the year was 40 percent and salary increases were capped at 7 percent.
- Interest rates rose from 15 percent to 130 percent within a few months.
- Some 30 percent of all loans in the country became non-performing.
- Eight of the country's 18 major banks failed; the rest had to be bailed out by the government.
- Some leading industrial groups went bankrupt.
- A total of more than 8,000 companies failed.
- Fuel prices rose by 48.5 percent.
- Electricity rates rose by 32 percent.
- A country of small farmers that exported foods when farming subsidies were in place now became an importer of food, dependent on the US.
- Crime rate increased substantially.
- Car loans from the Bancomer bank became non-performing—the repossessed cars would have filled a 75,000-place parking lot.
- Some 10 percent of Mexico's GDP was paid as interest to the loans.

Personal suffering was acute for millions. The family of a farmer who had failed to repay a bank loan, had his land repossessed by the bank, and then died from the stress, protested by bringing his body to the bank as payment.

The country's total productive economy suffered, except for exports. A $15 billion trade surplus with the US was achieved, thus ensuring loans repayment to the very people who had caused the economic meltdown in the first place.

The Plan for Arab Oil

Meanwhile, what of the US government's long-term plans to occupy the Arab oilfields? The plans that had been drawn up were meticulously detailed, and involved three major phases.

In Phase 1, which spanned the years 1974–90, a military infrastructure was created in the oil states, including complete military cities, airbases, and command centers, with a relatively inconspicuous US military presence. A fast deployment force that could move to man this infrastructure and wage war when the time is right was also created. These forces, and a central command, were set up before 1980—the year the Carter Doctrine was proclaimed. In this, Carter declared that the US would use military intervention if necessary to defend its interests in the Persian Gulf, and that the flow of oil is a national security issue. This was intended as a warning to the USSR following the Soviet invasion of Afghanistan that their ambition of reaching the warm waters of the Arabian Gulf would be opposed by all means. At the same time *War Games* was published showing that it was not only the Soviet threat that would be opposed but also threats from within the region. The May 7, 1979 issue of *Fortune* magazine published a war games scenario that described possible American military response and plans in the event of an Iraqi invasion of Kuwait, based on border and other

disputes. The *Fortune* magazine article, titled "If Iraq Invades Kuwait ...," reads:

> Iraqi armored forces, using primarily Soviet equipment, could overrun either nations quickly. Assistance, if requested, would initially involve US tactical air strikes against Iraq's armor and its air support—and possibly threats to destroy Iraq's oil facilities. To dislodge Iraqi ground forces would require marines from the 6th and 7th fleet and infantry from the 82nd and 101st divisions.

The *Fortune* scenario envisaged "an army in the sky" to move troops and the utilization of the US Air Force's strategic airlift fleet—the 70 giant C-5 and 234 smaller C-141 transports, plus 700 KC-135 tankers for in-flight refueling.

Immediately after the promulgation of Carter Doctrine the Gulf states, advised by American consultants with close links to the US national security establishment, started to build airports and naval bases for both civilian and military use. In the mid-1970s Abu Dhabi had an international airport that far exceeded its needs for a population of a few hundred thousand. Then, in the 1970s, dual-purpose international airports sprang up across the Gulf Emirates and the Iraqi borders. The huge Jebel Ali terminals in Dubai built in that period could accommodate the American Seventh Fleet in the event of war. This infrastructure was ready to be used for the deployment of more than 500,000 troops in preparation for and during "Desert Storm" operations against Iraq.

The US naval presence increased in the 1980s, during and allegedly because of the Iraq–Iran War, which was instigated, promoted, and maintained by the US and its regional allies.

Phase 2 took place from 1990 to 2003. This covered the period between the 1991 Gulf War and the 2001 US invasion of Afghanistan.

In 1990, the US was in a unique position. First, the Soviet Union had imploded, leaving the US as the world's sole superpower. Its moment for creating economic globalization and expanding its economic hegemony to encompass the whole

world now looked within its grasp. Its power also gave the US more reason than ever to control oil. In 1989 it was importing 45 percent of its oil, and studies indicated it would have to import over 65 percent by 2000. About 40 percent of the country's 1989 trade deficit was accounted for by oil imports. With the demise of the USSR, the Central Asian and Caspian Sea republics could now be "assisted" to independence, while their huge oil deposits could be controlled at the same time (a scenario that is taking place as I write).

And there was no doubt that the US was thirsty for oil. Nuclear power had dwindled and now supplied only around 7 percent of its total energy requirements, compared to nearly 42 percent for oil and 24 percent for gas.

In short, the US dedicated this decade to creating a new world order. The Gulf War allowed the US to keep sizeable forces in the bases. The "soft power" of the Clinton administration, using all means short of major wars, helped transform the economies of Russia and its former satellites into mafia-run capitalist economies, and transform Japan's economic model. To prepare Iraq for imminent occupation, No-Fly Zones were imposed and continuous war waged, coupled with an economic embargo.

Phase 3, which started in 2003, has seen a fully fledged war waged in Iraq. Perpetual war is seen as good for the capitalist economy, especially in its down cycles, and, yes, that economy entered the twenty-first century in shambles.

Boom of Illusions

The German economist Lothar Komp has gone further. He thinks the current world financial system is experiencing system failure—not recession. In the May 25, 2001 issue of *Economic Intelligence Review*, a Washington-based weekly, he writes: "There never was a 'US economic boom' during the 1990s ... instead, there has been the emergence of the

biggest speculative bubble in history, built on a 'boom of illusions' and cheap credits for consumers and stock market investors, as well as corporate takeovers."[10]

The figures certainly seem to support Komp. The number of layoffs in the US information technology sector in the second half of 2000 rose by 600 percent compared to the first half, for instance. Meanwhile, 210 Internet firms went bankrupt. The US automobile and retail sectors have fared badly too. In December 2000, 133,713 jobs were lost—the highest monthly tally in eight years. In January 2001, another 142,208 jobs disappeared, and in April 2001, some 166,000 layoffs were reported. The total number of job cuts in the first four months of 2001 was 421,000, the highest in five years.

Earnings also fell. The first quarter reports in 2001 of top US companies were the worst in ten years. Intel, the world's biggest PC microchip producer, and General Motors, the world's biggest automobile producer, reported an 80–90 percent collapse in quarterly profits. Lucent Technologies had a $3.7 billion loss; Daimler Chrysler, one of $3.3 billion. JDS Uniphase, the largest producer of fiber-optic equipment, reported a fivefold increase in losses.

US economic indicators—government statistics denoting the health of a country's economy—were far from promising, falling in the first quarter of 2001 to levels not seen for a decade or more. In April, 38 percent of industrial managers participating in a National Association of Purchasing Managers (NAPM) survey said they were worried or pessimistic—the highest figure since NAPM records began.

Perhaps more telling even than these figures are the estimates of the top executives in high-tech industries. In 2001 Apple chief Steve Jobs told analysts that he believed the economy was "going through a nuclear meltdown."[11] Hans Geyer, Intel vice-president, said in February of that year—commenting on the hundreds of billions spent by the telecoms industry just to buy new licenses—"We are facing a situation where the

industry is headed for bankruptcy, even before the first call has been made on UMTS [the next-generation mobile phones]."[12] Others echoed them: John Roth, chairman of the board of Nortel Networks, said at the Canadian Club in Toronto in February 2001 that is was "the most abrupt downturn the US has ever experienced";[13] Bill Aylesworth, chief financial officer of Texas Instruments, said that his company's 37 percent decline in first quarter orders in April was the sharpest deceleration ever seen in the semiconductor industry.[14]

That year also had John Chambers—CEO of Cisco, the biggest producer of Internet services—saying, "It makes no difference what the Federal Reserve or the latest statistics say, what we see now is absolutely not a soft landing." That April, Chambers compared what was happening to a "100-year flood" hitting the technology sector. "Not only did it occur in our lifetimes, but the magnitude was about five times what we thought possible … we never built models to anticipate something of this magnitude."[15]

The big picture shows a cumulative loss of trillions. Between March 10, 2000 and the end of the first quarter of 2001, the value of the Nasdaq market fell from $6.7 trillion to $3.3 trillion. The six largest Nasdaq companies dropped from a maximum of $2.362 trillion in 2000 to $914 billion.

Nasdaq stock market values of six largest companies

Cisco Systems	$590 billion	$118 billion
Microsoft	$640 billion	$360 billion
Dell Computer	$154 billion	$72 billion
Intel	$510 billion	$219 billion
Sun Microsystems	$208 billion	$62 billion
Oracle	$260 billion	$83 billion

The market capitalization of the 5,000 American companies in the Wilshire 5000 Index—designed to track the value of the entire stock market—plunged from $16.96 trillion to $11.6 trillion during this period.

Looking back, it is hardly surprising to see why the dot.com bubble burst: it was practically designed to do so. For instance, the value of VA Linux Systems—a computer company that had no earnings whatsoever, no track record, and no experience, and was not expected to make a dime in the foreseeable future—shot up by 700 percent on December 9, 1999, the first day of its initial public offering. This is how many of the legends of the so-called new economy were born.

If it is true that capitalism resorts to war in times of economic downturn, what would be a better time for war than 2003?

Next Stop, Central Asia

Bush's War on Terror—which is all too blatantly a war for oil—officially began after September 11, 2001. Was it a coincidence that the targeted countries were those with huge oil reserves and "transit" countries useful for pipelines and transport? The war against Afghanistan was waged to secure the Caspian Sea oil reserves—the largest unexploited reserves outside the Middle East—and to protect a future pipeline from that region to Turkey. This was commissioned in 2004.

In May 27, 2002, *Business Week* reported on the phenomenon, calling the build-up of an American presence in Central Asia since 9/11 "breathtakingly fast."[16] The article notes that in 2001 there were no US soldiers in Central Asia. "Today, roughly 4000 servicemen and women are building bases ... along a rim of peril stretching 2000 miles from Kyrgyzstan, at China's border, to Georgia, on the Black Sea ..." And Donald Rumsfeld, US Defense Secretary, had said US forces would stay there "as long as necessary."

There is no shortage of other indicators that the US is in for the long haul in this region, the article reports. US investment there has jumped to $20 billion and the energy giants have newly committed to the region: BP and Halliburton alone

will invest $12 billion. The emergent policy, it says, is focused on guns and oil—guns to protect the regions from Islamic militants, as well as to guard the oil.

The Caspian Sea's oil is no puddle. As the article reports, estimates of its extent range from a high of 200 billion barrels—similar to Saudi Arabia's—to fewer than 100 billion barrels, but that is "still on a par with the reserves of the North Sea and at current oil prices worth $2.7 trillion." Meanwhile, the Pentagon is sending "150 military trainers" to Georgia, where a 1,000-mile pipeline is planned, to carry a million barrels of oil to Turkey.

Few would argue that such a situation has built-in volatility. Whether the unholy mix of guns, oil, and dollars erupts in Central Asia with the same force it has in Iraq remains to be seen.

Kevin Phillips, in his book *American Theocracy: The Peril and Politics of Radical Religion, Oil, and Borrowed Money*,[17] expressed the mix of oil and national security well when he wrote:

> Since the elections of 2000 and especially of 2004, three pillars have become increasingly central: (1) the oil–national security complex, with its pervasive interests; (2) the religious right, with its doctrinal imperatives and massive electorate; and (3) the debt-dealing financial sector, which extends far beyond the old symbolism of Wall Street.

Phillips continued: "Not merely a symbol of US global power, petroleum has been its fuel for military might, twentieth-century manufacturing supremacy, and the latter day SUV gas-hog culture. Oil abundance has always been part of what America fights for as well as with."

5

Inside OPEC, Big Oil's Invisible Hand

I N 1911, AFTER A media blitz against Standard Oil's
ruthless business practices, the US Supreme Court
invoked the Sherman Act, antitrust legislation forcing the
company—the massive and unwieldy enterprise begun by
John D. Rockefeller in the last quarter of the nineteenth
century—to break up into several separate companies. Out of
this fragmented behemoth arose other giants that would
continue to dominate US and international oil production,
refining, and distribution. Their visible division satisfied the
law, but their practical and invisible cooperation behind the
scenes nationally and internationally made little difference to
consumers. After President Reagan's deregulation policies
and the collapse of communism, the Standard Oil companies
began to merge again.

The Standard Oil Company of New Jersey would become
Esso, then Exxon, and is now Exxon-Mobil. Another, the
Standard Oil Company of New York, became Socony, then
Mobil, and also now Exxon-Mobil. A third, the Standard Oil
Company of California, later became Socal and is now
Chevron. Exxon-Mobil, Chevron (including Texaco), along
with Shell, BP, and France's Total (including Elf) are now the
successors of what used to be known as the "Seven Sisters,"
the world's largest oil companies. All are headquartered in
the West, work hand-in-glove with their governments, and

pay handsome dividends to their shareholders. For decades, they looked to the Arab and Islamic east for the oil that is their lifeblood without giving much in the way of a share in their profits, or a voice to the governments, or (much less) the peoples of the countries where this oil is found.

Two wars and nearly half a century later, a challenge to the major oil companies finally emerged. When Iran, Iraq, Kuwait, Saudi Arabia, and Venezuela founded OPEC in 1960, the balance of power in the oil world seemed to be shifting. Unpopular among the media and governments of the West, OPEC looks unstoppable: now with six more oil-rich nations—Qatar, Indonesia, Libya, the UAE, Algeria, and Nigeria—it currently controls three-quarters of global crude petroleum reserves and some 44 percent of natural gas. Each new indicator of rocketing energy demand is another notch in OPEC's importance as a global player.

Even in the late 1940s, the West was aware of the need to cast its net as wide as possible—certainly beyond the Middle East—in the search to quench its thirst for oil. The 1960s, when OPEC came into being, simply upped the ante. This was the decade when discovering non-OPEC oil in the Western Hemisphere became a strategic security objective of Western governments and multinational oil companies alike.

But while OPEC seems to have established a new world order in oil supply and demand, the reality is murkier. Then and now, whose interests do its member nations really represent and serve?

Chasing New Horizons

After World War II, French governments in general and Charles de Gaulle in particular initiated a policy of seeking new oil sources, at least enough for France's own consumption. As the Compagnie Française des Pétroles (CFP) was busy with ventures in the Middle East, the government entrusted

two new state oil companies to do the work. The Bureau de Recherches des Pétroles (BRP) made its first discovery in Gabon, West Africa, while Régie Autonome des Pétroles (RAP) found oil in Algeria in 1956. By 1958, the first Algerian oil shipment had been exported to France.

BRP and RAP would merge to form Elf ERAP in 1965—destined to become one of the big players and to discover major gas reserves in France itself. But Africa proved a richer source in the 1950s. Huge reserves were found not just in Algeria and Gabon but also in Nigeria, where a Shell BP partnership discovered oil in the Niger River delta.

Algeria's near neighbor Libya promised to be another giant producer. Early indications of this were not lost on the US. During the war, aerial surveys by the US air force, flying from Wheelus airbase just east of Tripoli, one of America's biggest, suggested that further investigation and exploratory work could pay dividends. The reports were made available to American oil companies, and Libya welcomed them with open arms.

To encourage oil companies abroad, the country passed the Libyan Petroleum Law in 1955. This was more attractive than Gulf concessions, especially as it tied the government take to the market rather than the posted price. But unlike old concessions in the Gulf, it divided the country into blocks, allowing many companies to enter the bidding. By 1957, 17 companies—many of them independent—had successfully acquired 84 concessions in Libya. Much more was to come. In April 1959, Standard Oil Company of New Jersey discovered oil at Zelten, about 90 miles from the Mediterranean coast. By 1961, ten more huge fields had been discovered, and the first shipment of Libyan oil was exported.

But however tempting the acres of bubbling crude in Libya, a threat hung over this potential bonanza. Half the production of Libyan oil now lay in the hands of small independent oil

companies which had no transportation, refining, or marketing facilities. This meant they might dump their oil at any time, causing the global market price to crash. The major oil companies, recognizing a disaster when they saw one coming, were eager to head it off at the pass—particularly as the Soviets were just entering world oil markets, causing oversupply and depressing oil prices.

What they needed was an organization to control production in the oil-rich countries, and exercise nation-state sovereignty through which the small independent companies might be controlled. They knew this because they had been here before. In the 1930s, America's emergent oil giants had undergone a similar power struggle: they didn't have to reinvent the wheel when it came to deciding how to control the situation in Libya.

American Echoes

Columbus Marion ("Dad") Joiner was a legendary Texas oilman. In his youth, despite having just seven weeks' formal schooling, he built up a law practice and joined the state legislature. Later, he made—and lost—two fortunes in Oklahoma oil. In 1930 he was 70 but still determined. Against the judgment of all the major oil companies' geologists, Joiner decided to drill in east Texas.

On October 3, 1930 his well, Daisy Bradford No. 3, came in, spurting a column of oil and water above the derrick. The oil companies remained skeptical for months, but many independent, smaller ventures and the inevitable risk-takers rushed to the site. As it happened, they were right: in less than six months, the area was producing 340,000 barrels a day. Called the Black Giant, the reservoir was 45 miles long and up to 10 miles wide—the largest ever found—and by the start of June 1931 about 1,000 wells had been completed and production had reached 500,000 barrels a day.

Overproduction tilted the market drastically. The average price of crude in 1930 was $1 a barrel. By May 1931, the price had crashed to 15 cents, and briefly just 2 cents. Meanwhile, production costs averaged around 80 cents. A great imbalance between supply and demand occurred as east Texas oil controlled by the independents flooded the market. A price war ensued. The feud between major oil companies and the independents persisted and there seemed to be no end to the crisis, while production increased until it reached 1,000,000 barrels a day, in August 1931—about half the country's daily consumption.

The Texan oil boom disrupted more than the market. Big oil companies accused the wildcatters of creating social chaos and lawlessness out of their desperation to make money from the glut. And there was little to hold the situation in check. The Texas Railroad Commission was the only agency in the state to have any mandate on oil, but it had no real regulatory role in balancing supply with demand. Neighboring Oklahoma, however—now in the grip of its own boom—had more protection: its Corporation Commission had been entrusted in 1915 to regulate oil production to meet demand.

The oil frenzy of the early 1930s was to put Oklahoma's Commission to the test. In August 1931, as a US federal judge was determining the legality of the Commission's pro-rationing power regarding oil, on the grounds that it was not the business of the state to intervene in the supply and demand of market forces, Oklahoman Governor William Murray declared martial law in the Oklahoma City and Seminole fields, and ordered the state militia to occupy and shut down all oilfields until the price rose to $1 a barrel. The Governor of Texas, Ross Sterling, followed suit that same month.

Sterling was a founder and chairman of Humble Oil Company. The people of Texas, however—and unsurprisingly—championed the small independents, which would make any

action against them politically unpopular. Undeterred, Sterling went ahead, declaring east Texas to be in a state of insurrection and open rebellion. He sent several thousand Texas Rangers and national guardsmen into the region, where they shut down all production within a few days. The Texas Railroad Commission began issuing pro-rationing quotas for all producers, even though it lacked a mandate to do so. By April of the following year, the price of crude had soared to 98 cents a barrel.

At that point, the courts declared all pro-rationing orders to be illegal, and Sterling was compelled to pass a law through a special session of the Texas legislature. The Texas Railroad Commission was finally able to set quotas.

But state intervention alone was not enough. In May 1933, the price of crude crashed again and the posted price of the Texas Oil Company fell from 75 cents to just 10 cents a barrel. Two factors were driving overproduction. First, the Texas Railroad Commission was setting the legal quota of oil at close to twice what it should have been. Second, illegal oil above the quota—"hot oil"—was being produced, and an estimated 500,000 barrels were being smuggled across state lines. Then, several pipelines and oil facilities were dynamited by persons unknown. With the rot well and truly setting in, Texas turned to Washington for help.

The situation was now beyond the control of state authorities. On May 5, 1933 the price of oil crashed to 4 cents a barrel. Harold L. Ickes, Secretary of the Interior, started to assign quotas to the producing states and sent federal investigators to east Texas to ensure that the pro-rationing orders were properly enforced, with severe punishment meted out to violators.

In 1935, federal control ended when the Supreme Court overturned the legislation allowing the government to assign quotas and control the oil industry. In order to regulate production quotas to the producing states, the Interstate

Oil and Gas Compact Commission was formalized in 1935. Oklahoma viewed it as a cartel among producing states; Texas saw it as a treaty. To plug all excess capacities, a tariff was also enacted on imported foreign crude. Venezuela, 55 percent of whose oil was exported to the US, was the country most adversely affected.

Collusion or Regulation?

This frenetic period of US oil history offered a salutary lesson to American interests some quarter of a century later. A lack of regulations to control production, allocate quotas to producers, and rein in the independents had left their oil microcosm in chaos—and, they feared, would have the same effect in the international arena. Beyond the Libyan scenario in the 1950s, independents were also establishing themselves in the Middle East: the American Independent Oil Company and Getty Oil Company had entered the Saudi Kuwaiti neutral zone, and there was a newly acquired French AGIP concession in Iran. More, the USSR was flooding the market with cheap oil. The "mavericks" needed to be brought under control.

But there was another factor behind the big oil companies' urgency. They were now under investigation by the US Justice Department for colluding to control international production and markets. A different arrangement for coordination to oil supply and demand was pressing.

In 1928 the oil giants had signed the so-called "as-is" or Achnacarry Agreement by which they agreed to end competition among themselves, cease overproduction, divide up the world markets on an "as-is" basis (hence the name), and more. The Federal Trade Commission used its power of subpoena to obtain company documents, and in due course produced the most detailed historical analysis of international relationships among the companies ever published.

The report, *The International Petroleum Cartel*,[1] is a landmark study still used by students, according to Daniel Yergin in *The Prize: The Epic Quest for Oil, Money and Power*.[2]

The CIA, along with the US Defense and State Departments, wanted to spike the report immediately on the grounds of national security, claiming information contained in it would "greatly assist Soviet propaganda" and that people in the producing countries would be unhappy with its contents, especially the fact that the oil production rates that make up their basic resource and revenues were decided by foreign companies without their knowledge, so constituting an infringement of their sovereignty. President Truman classified the document as top secret. However, the Justice Department decided that the report implied the existence of an oil cartel dating back to 1928, and so constituted a call to legal action. According to Harvard Business School case study 9-383-096 Rev. 8/83, p. 9:

> The facts [argued the Justice Department] strongly suggest that the high policy represented by the [antitrust] Sherman Act has been consciously and persistently violated by activities long since determined by the Supreme Court to be illegal. The cartel should be prosecuted criminally if there is to be equal justice under the law, and if the respect for the law and its even-handed administration is to be maintained.[3]

A criminal and a civil case were filed against the American companies participating in the 1928 agreement. However, based on the recommendation of the Joint Chiefs of Staff and the National Security Council, and only a few days before the end of his presidency in January 1953, Truman requested that the Justice Department drop its criminal investigation. However, he did wish the civil antitrust case to continue. The case limped on until 1968, when the government finally "folded its tent" on it.

Except in the case of Libya, producing countries collect their share of production according to the posted price. They collect 55 cents for a barrel if the posted price is $1.10.

If the oil companies reduce the prices to, say, $1, the producing countries still receive 55 cents, but the oil companies take falls to 45 cents. Hence, with no regulation, the burden of falling prices falls on the oil companies, as the producing government's take is calculated on the posted price. This was the arrangement with the Gulf producers; Libya was the exception. So it can be argued that the creation of OPEC was of great interest to the major multinational oil companies in the West.

The Road to OPEC

From the start, OPEC appeared to be a club for the Gulf oil-producing states, established in response to growing concern that they were being exploited by the big oil companies. But it should be remembered that Venezuela was one of OPEC's founding nations and a Venezuelan, Juan Pablo Perez Alfonzo, was—along with a Czech journalist, Wanda Jablonski—a key figure in the lead-up to its creation. Both also had strong links with the US.

Perez Alfonzo had studied medicine at Johns Hopkins University and law in Venezuela. Eventually, after entering politics, he became Development Minister. In November 1948, he received a call from the American Ambassador in Caracas warning him that a coup was imminent and offering him the protection of the American embassy. The invitation smacked of a "special relationship." In the event, Perez Alfonzo failed to make it and was jailed during the coup. Shortly after his release, he moved to Washington.

Once there, he busied himself studying documents on the east Texas oil crisis at the Library of Congress. His ambition was to create an organization for the oil-exporting countries that would control production quotas. When Rómulo Betancourt, former President of Venezuela, toppled the regime of 1958 for a second term as head of state, he

invited Perez Alfonzo to return as Minister of Mines and Hydrocarbons. Perez Alfonzo accepted, and retained an American in the ministry to advise him on how the model of the Texas Railroad Commission could be used to set up a similar protective organization on the international scene.

In 1959, Egypt's capital, Cairo, was the recognized center of Middle East Arab decision-making, and the Arab Oil Congress was held there in April of that year. Perez Alfonzo attended as an observer. On the eve of this meeting, British Petroleum cut its prices. The move was seen as a provocation by the non-Western oil-producing nations and it provided a good reason why oil-producing and exporting countries needed to create an organization such as OPEC. The delegates were furious and demanded action from the oil-producing countries to counter similar reductions in future.

One can argue that BP normally coordinates oil prices with the other majors, and certainly knows what the outcome of its major decisions will be. The timing of the price increase just before conference might not have been innocent and was undertaken for a purpose. Perez Alfonzo, however, knew exactly what he wanted and how to go about making it happen.

Nor could Wanda Jablonski, also at the congress, be accused of ignorance. The daughter of a Czech geologist who worked for Socony-Vacuum Corporation (later Mobil), one of the Standard Oil companies, she knew most of the top brass in the oil business, including its Middle East manifestations. She was also editor of *Petroleum Week*.

Abdulla Tariki was one of the first US-educated Saudis. He graduated in geology and chemistry from the University of Texas and then worked as a trainee geologist with Texaco. In 1955, he was appointed director-general of the newly formed Saudi Directorate of Oil and Mining Affairs. Tariki perceived that his country was being taken for a ride and marginalized by the American consortium represented by the Arabian American Oil Company (Aramco), and he wanted to

do something about it. Among his ideas was Saudi control of prices and production rates.

Jablonski arranged for Perez Alfonzo to meet Tariki informally during the Cairo congress, during which the two men agreed to help convene a secret gathering of the major oil exporters at Cairo's Maadi Yacht Club. A gentleman's agreement was reached by which delegates would recommend the creation of an Oil Consultative Commission to their governments to protect oil prices and create national oil companies.

Within a few months, the new chairman of Standard Oil of New Jersey made a 7 percent cut in the posted price of oil without consulting any of the oil-producing countries. Tariki and Alfonzo responded by organizing another meeting. In September 1960, representatives from Saudi Arabia, Venezuela, Iraq, Iran, and Kuwait met in Baghdad and hammered out an agreement to form a new entity that could take on the oil companies, allowing them to manage production and prices. OPEC had been born.

One may ask at this point how Kuwait could participate in and sign the agreement at a time when it was still under direct British rule (Kuwaiti independence was declared in 1961) and its only producer was the Kuwait Oil Company, which was owned by the Gulf Oil Company and BP. Knowing the decision-making process in pre-independence days in Kuwait, one can safely assume that tacit agreement was secured from both Gulf and BP.

Deluge Days

A flood of oil followed in the years after that Baghdad meeting, much of it from Libya. By 1965 Libya had become the sixth biggest oil exporter in the world, and by 1969 it was producing over 3 million barrels a day—exceeding Saudi Arabia's production at the time. Middle East production as a whole shot up by 13 million barrels a day. With the deluge came an

inevitable slide in price, which persisted throughout the decade even after Libya joined OPEC in 1962. Between 1960 and 1969, prices fell by some 40 percent. Without OPEC quotas to ease the situation, the east Texas crisis might have been repeated.

Consumption was rising steeply too. Excluding the communist countries, world demand increased by 21 million barrels a day in the 1960s. For the US at least, the pace was crippling. The country's spare capacity for oil production was eroding as dependence on Middle East oil rose. This "surge" capacity had always been considered a vital part of national security and had come into its own during a number of crises, including World War II and the Korean, Suez, and Six Day Wars. Yet as early as 1955, one man at least had realized it was a finite resource.

M. King Hubbert, an American geologist at Shell's Houston research center, had predicted that US oil production would peak in 1970 and decline thereafter.[4] His forecast was very accurate: in 1971, production hit a high of 11.3 million barrels a day and has fallen steadily ever since. When the US State Department announced during a 1968 OECD meeting in Paris that the US would very shortly have no spare capacity, Europeans were shocked; the American oil security "cushion," on which Europe had depended during two world wars, was no longer available. Until 1963, the US had had an excess capacity of about 4 million barrels a day. By 1968 it was less than 1 million barrels a day, and in 1971 it would be zero. It became imperative for the US and Europe to have their own buffer supplies, independent of the politically volatile Middle East and OPEC.

In an unannounced policy move, the Seven Sisters geared up for exploration and production. France and the US, as we have seen, were concentrating their efforts in Africa in the 1950s, and in the 1960s the big players moved further afield in a drive to develop non-OPEC oil. Exxon alone allocated

$700 million to the search, striking oil in southeast Australia and discovering new fields in Canada's Mackenzie River delta as well as in the North Sea and Alaska. Exxon did not pioneer the Alaska oil find, but was brought in by Atlantic (later ARCO) because the latter lacked the finances required for its development as well as sufficient muscle in Washington to see off any opposition from environmental groups.

Even before the formation OPEC, from the 1950s, Shell and Exxon had jointly explored in the Netherlands. In 1959 they found gas at Groningen, which gave the Dutch economy a substantial boost. But the oil companies wanted an agreement among the Netherlands and the other countries surrounding the North Sea to allow any acquired concessions in the region to be concluded on undisputed grounds. This was finalized in 1964 with the Continental Shelf Act, which determined the legal boundaries of the North Sea.

By 1965, BP had found natural gas off the UK coast. As Britain was experiencing balance of payments problems at the time, they wanted to attract the oil companies and offered generous terms. The first oil from the North Sea was discovered by the American independent Phillips Petroleum in December 1969. In 1970, BP discovered the Forties Field north of Aberdeen, and in 1971 Exxon and Shell jointly discovered the giant Brent Field off the Shetlands. Technology had proved able to conquer the harsh conditions in the North Sea, but production costs were high—significantly higher than the price of crude.

Alaska was a project on an entirely different scale. In 1967 an ARCO–Humble joint venture had struck oil on December 26 at the Prudhoe Bay State No. 1 well. Another well drilled about six miles from the first confirmed that the field was the biggest ever discovered in North America, and third in the world after Saudi Arabia's Ghawar and Kuwait's Burgan. Prudhoe could deliver up to 2 million barrels per day.

While a start date of 1972 was initially set for the project, it was weighted with a raft of problems. The Alaskan

environment and weather posed serious technological cha-
llenges, as temperatures there could fall to below minus
60 degrees Fahrenheit. Transport was another issue. A pipeline
was mooted, but aside from the cost, it would demand many
engineering innovations. Objections from environmentalists
were another hurdle that needed to be overcome.

But then BP struck oil in Alaska. Now ARCO, BP, Standard
Oil of New Jersey (brought in by ARCO because of its
financial and political muscle), and other small companies
with positions in the North Slope joined forces to construct
the Trans-Alaskan Pipeline. They bought all the equipment
needed to start paving access roads to build the pipeline and
shipped them to Alaska.

One critical issue had to be resolved before Alaska Oil
could become economically feasible, however: the price of
oil. While Gulf Oil geologists, basing their recommendations
on technical assessments only, urged their management to go
ahead in Alaska, management declined: the production cost
would be over $5 a barrel, while the world selling price at the
time was barely half that.

At this point, a singular figure on the world stage joined
the cast. Henry Kissinger had spent the late 1960s advising
New York Governor Nelson Rockefeller in his bid for the
Republican presidential nomination. (Nelson was, of course,
scion of the family that had created Standard Oil and had
controlled it ever since.) In 1973, Kissinger was National
Security Advisor in the Nixon administration and Secretary
of State-in-waiting; what is more, like many of the West's
power elite, he regularly attended the meetings of a highly
influential body known as the Bilderberg group.

Magnates and Masterminds

The Bilderberg group took its name from the hotel where
the first meeting was held, at Oosterbeck in the Netherlands in
May 1954. Invitees were and are exclusively North Americans

and Western Europeans, most of them top transnational corporation executives, national leaders, and leading politicians. The organization is perceived variously as a secret "world government" at one end of the spectrum, and a networkers' club for the rich and famous at the other. What is relatively certain is that it is a powerful tool in Western attempts to dominate the world order. The American and European economical and political heavies who attend the group's informal conferences attempt to reach and formulate policy decisions, creating the consensus needed to formulate public agendas for future legislation and implementation. Given the collective clout of the participants, there are many avenues available to them for that purpose.

William Engdahl, in *A Century of War*,[5] documents that the Bilderberg meeting of May 1973 was held on Saltsjobaden off the coast of Sweden, at the villa of the immensely rich Wallenberg family (in 1997, they controlled the assets of corporations with annual sales of over $100 billion). Kissinger was there, along with top executives of the big petroleum companies, financial transnational institutions, and banks.

Among the luminaries were Robert O. Anderson, chairman of Atlantic Richfield Oil Company and fellow magnates Sir Eric Drake of BP, Exxon vice-president E. G. Collado, and CFP's René Granier de Lilliac; bankers Baron Edmond de Rothschild, Marcus Wallenburg, and Krister Wickman; and politicians including the Swedish Prime Minister Olaf Palme, the UK's Denis Healey, and Helmut Schmidt, then West Germany's Finance Minister. The oilmen represented all the companies that had discovered and developed Alaskan and North Sea oil. The White House was represented by Henry Kissinger and James Akins, an energy expert.

Kissinger had already spent considerable time preparing for this meeting. In January of that year, US Treasury Secretary George Shultz was appointed by Nixon as Assistant to the President for Economic Affairs. As a result Schultz, formerly a

Wall Street bond trader, became chairman of the Oil Policy Committee. In February, the White House Special Energy Committee was set up, composed of Kissinger, Shultz, and John Ehrlichman. This committee did much to prepare for the Bilderberg meeting.

This was the year when tensions between the Arab world and Israel were to culminate in the October War (also known as the Arab-Israeli, Ramadan, or Yom Kippur War). The Egyptian President, Anwar Sadat, had publicly stated, in 1972, that his country was committed to war with Israel, and he would repeat the threat in early April 1973. The "shuttle diplomacy" or mediated communication that was to follow was meticulously worked out by Kissinger. The US State Department believed that Israel would have to withdraw to its 1967 borders, but Kissinger had a different plan. As he wrote in *Years of Upheaval*:[6]

> My own starting point was at the other emotional spectrum ... though not practicing my religion, I could never forget that thirteen members of my family had died in Nazi concentration camps. I had no stomach for encouraging another holocaust by well-intentional policies that might get out of control.

His Agenda was also Different from the President's

Nixon shared many of the prejudices of the uprooted California lower middle class from which he had come. He believed that Jews formed a powerful cohesive group in American society; that their control of the media made them dangerous adversaries; above all, that Israel had to be forced into a peace settlement and could not be permitted to jeopardize Arab relations.

But Kissinger persisted in doing things his way. He opened negotiations with Sadat without the knowledge of the State or Defense Departments, or even the American diplomatic

mission in Cairo, for he had no desire to rely on the State Department's Middle East experts, whom he thought of as Arabists. He meant to bypass them all.

Keeping it Secret

When Sadat expelled tens of thousands of Soviet advisors from Egypt as part of his country's move away from the USSR, Secretary of Defense Melvin Laird urged Nixon to start negotiating secretly with Sadat, unaware that the channels had been wide open for some time. Kissinger meanwhile stepped up his own Egyptian connection. On a February 1973 visit to the US, Sadat's envoy Hafez Ismael worked out a schedule so he could meet Kissinger covertly after his official duties ended. Following meetings with Nixon and State Department representatives, Ismael, as Kissinger wrote in *Years of Upheaval*,

> would betake himself on 25 February to New York. From there he would proceed to a secret meeting site in the suburbs— a private home hired for the purpose—where he and I would confer for two days for a full private review of Egyptian–American relations.

Kissinger added: "Neither I, nor any member of my staff, was included in the State Department discussion, while the State Department did not even know of my secret meeting with Ismael."

Before Ismael arrived in Washington, Nixon had written to Kissinger: "The time has come to quit pandering to Israel's intransigent position. Our actions over the past had led them to think we will stand with them regardless of how unreasonable they are." Yet Kissinger's own plan was largely in line with Israel's decision, stated in June 1967, that the Egyptian and Syrian fronts could be discussed and negotiated, but not the West Bank and Gaza, which elements in the Israeli cabinet insisted should be annexed to Israel. Since these

territories had been part of Jordan before the 1967 war, Kissinger intended to exclude Jordan from his step-by-step negotiations, and planned for Sadat and other known Arab "friends" of the US to remove Jordan altogether from the Palestinian West Bank issue, as was done in Rabat, Morocco, some time later.

On March 6, 1973, the Saudis were briefed about Kissinger's secret meeting with Ismael on a "need to know" basis, since Saudi Arabia was the leading Arab oil producer and would have a role in the coming embargo and price increase.

That month Israel's prime minister, Golda Meir, visited the US. She categorically disagreed with Nixon's stance, and rejected any pressure to modify Israel's intransigent position. She also told Nixon that the Arabs had no military option and that Israel's position had never been better.

On April 11, a second meeting between Ismael and Kissinger took place. After their first meeting in February 1973 troops of mostly staunch American Arab allies began moving—including Saudi planes to Egypt and Moroccan troops to Syria. Knowledgeable sources agree that such decisions could never have been made without at least tacit US approval. On April 20 the CIA reported that military action was imminent.

The Bilderberg meeting, held less than a month later, was a well-timed opportunity to work out the political and financial details of the oil price hike, suggested in a paper presented by Walter Levy. Very shortly after the war that October, oil prices did shoot up, above the $5 a barrel production cost of Alaskan oil and the $7 a barrel production cost of North Sea oil. Production in both regions was feasible at last. What Gulf Oil management had thought would take more than a lifetime to achieve had been accomplished in a few months.

Alaska was no longer a mere pipedream. Although a US federal court ruled against building the pipeline on environmental grounds, this was subsequently overturned by

invoking an emergency law that took advantage of the post-embargo crisis following the October War. This invoked national security necessitating the development of oil production within US territories. The oil companies were finally given the go-ahead. By 1977 the 750-mile pipeline had been completed, and the first shipment to the port of Valdez followed soon after. In 1978 1 million barrels a day were flowing through it—shortly to increase to 2 million a day. Meanwhile, in 1975, North Sea oil began to flow into Britain.

Behind the Mask

The boost in prices following the October War had been a major windfall for all producing countries. Perhaps inevitably, many felt OPEC must have engineered it. As we have seen, OPEC had nothing to do with it, but the real manipulators of the price hike had found a convenient public scapegoat.

Where OPEC was concerned, however, the US and major oil company interests wanted to play it both ways. The organization may have had no part in the events leading up to the October War, but US involvement with Saudi Arabia has heavily influenced OPEC's activities. In coordination with the US, it used its spare capacity in what became known as "swing power." Therefore, in essence, the US controls OPEC and international oil through the swing power of Saudi Arabia—and this is considerable. Sheik Ahmad Zaki Yamani, who succeeded Tariki as Saudi Oil Minister, said: "To ruin the other countries of OPEC, all we have to do is produce to our full capacity; to ruin the consumer countries, we only have to reduce our production."[7]

This is power at a price. A student at the Saudi Petroleum College in Dhahran asked Yamani in January 1981:

> The Saudi citizen who looks at his country's current oil policy finds that the country is producing more than its economy needs and is selling at prices lower than current prices, even lower than

the prices received by other Gulf states. Such sacrifice is rewarded by hostile attacks and threats by the press, media and even certain high government officials in Western countries. Don't you think the time has come for us to stop sacrificing ourselves for the sake of the oil consumers?

A win–win situation may have been possible among equals. But OPEC has not always been managed in the interests of the exporting countries, except when th happened to coincide with those of the multinational oil companies. Some may conclude that OPEC is steered by an "enemy within."

6
Crusading for Israel

L ORD BALFOUR, IN HIS capacity as Foreign Secretary of Great Britain, promised another British peer, a financier, the creation of a Jewish homeland in someone else's land. This is how most Muslims and Arabs, and certainly Palestinians, view the 1917 Balfour Declaration. As for the Jewish biblical claims that Palestine was given by God to the Jews, Muslims do not believe that God is in the real estate business as they possessed most of the land titles before Balfour was born and Palestinians—as Muslims and Christians—have lived there for over 1,000 years. In fact, until the Balfour Declaration Palestinian Jews lived in harmony with their other fellow citizens and even resented waves of Zionist migrants to Palestine. If the aim of the creation of Israel was a safe and secure home for people of the Jewish faith, today Israel is neither safe nor secure despite the fact that Britain has been joined by the US as its chief imperial protector, and Israel is being armed to the teeth with weapons of every kind—as the July 2006 encounter with Hizbollah in Lebanon proved.

Alternative Plans for Palestine

For some advocates of a state for people of the Jewish faith, the location—Palestine—was less important than the principle that Jews be allowed an independent homeland. Other countries, such as Brazil, were considered as candidates.

Indeed, Theodore Herzl, the founder of the Zionism, believed that any available, secure, and fertile territory "would serve for the settlement of the Jews," according to the Israeli historian and writer Tom Segev in *One Palestine, Complete*.[1]

At the same time, Zionism, the name of the movement to create this homeland, did not have universal support among Jews—and this remains the case today. Israel was opposed by ultra-Orthodox Jews, including those living in Palestine. The Holy Land, according to them, would be redeemed only through divine intervention. They viewed the Zionist ideals of secular and political redemption as both unholy and unacceptable.

David Ben Gurion, the first Israeli prime minister, was Russian. Once in Palestine, he was alarmed to discover that the Jews of the country to which he had migrated were opposed to the enforced creation of Israel in Palestine. He commented: "A deep abyss separates the two parts of the Yishuv"—that is, the Jewish community in Palestine—and he called for a war against "the rabbis who are betraying their people."

Haim Weizmann, one of Ben Gurion's contemporaries and later Israel's first president, was also born in Russia. He, too, was concerned that members of the Jewish Orthodoxy were unhappy about plans for Israel. Members such as Chaim Margalit Kalvarisky, a Polish-born agronomist, had lived in Galilee since the 1890s. He belonged to the Jewish Colonization Association, which acquired land in Palestine and encouraged the building of settlements. After being in the job of effectively dispossessing Palestinians of Arab origin for some time, he concluded that they were not "a flock of sheep but rather human beings with hearts and souls." He strongly felt that the pro-Israel movement should strive to reach a political agreement with them. "We don't have to concede anything of our fundamental program." As long as the Jews didn't do to the Arabs what they didn't want done to

themselves by gentiles in the diaspora, and as long as they did not build their homes "on the ruin of others," there was a chance of détente, he said.[2]

But this never happened.

The World War I Years

During World War I, British troops stationed in Egypt were instructed to invade Palestine, which was then under Ottoman rule—in part to implement the terms of the Balfour Declaration of 1917. After two failed attempts to conquer Gaza, David Lloyd George appointed Edmund Allenby as Field Marshal in 1917. Allenby was an avid reader of the Bible and had a great interest in the history and geography of Palestine.

To many Westerners and to those of us in the Arab world this appeared to be another crusade. When Allenby's occupation of Palestine, including Jerusalem, was complete, he said that only now had the crusades ended. When Allenby defeated the Ottomans and entered Jerusalem, the bells of Westminster Cathedral pealed for the first time since war had been declared, and George V sent a personal telegram to Allenby. Major Vivian Gilbert wrote: "Only two bearers of the cross had succeeded in liberating the Holy City, the crusader Godfrey of Bouillon and Edmund Allenby."

Yet—and this comes as a surprise to many in Arab countries—early support for Israel within the British establishment, which possessed a strong streak of anti-Semitism, was highly cynical, and was based clearly on unashamed self-interest. None other than Lloyd George wrote that he supported the cause of Israel out of fear. The goodwill of the Jewish people was essential to winning the war, as they could influence the US to intensify its involvement in the war, and were the real power behind the Russian Revolution and could influence its outlook towards the warring

parties in the war, as Tom Segev describes in *One Palestine, Complete*.

Lloyd George was by no means the only one to repeat remarks that today would be regarded as anti-Semitic: the British Ambassador to Turkey reported that Kemal Atatürk came to power through "an international conspiracy of Jews, Freemasons and Zionists," who were "the real power" behind Atatürk's so-called Young Turks revolution.[3] The British Ambassador to Washington wrote of American Jews: "They are well-organized and specially in the press, in finances, and in politics, their influence is considerable."[4] Lord Robert Cecil, an undersecretary at the Foreign Office during World War I, believed it was impossible to "exaggerate the international power of the Jews."[5] Even Sir Mark Sykes, who negotiated the secret Sykes–Picot Agreement with the French, which dismembered the Middle East into mini-states, wanted Prince Faisal of Iraq to meet Weizmann and submit to his demands. He indicated that the reluctant Faisal should learn from what happened to the Spanish and Czarist empires, which had persecuted Jews. They vanished. Sykes wrote to Faisal: "Believe me, I speak the truth when I say that this race, despised and weak, is universal, is all-powerful and cannot be put down."[6] None other than Winston Churchill, according to an episode recounted in Segev's *One Palestine, Complete*, when in a state of inebriation, said that he would support the Zionists even if they did horribly stupid things.[7]

Resistance and Unrest

In May 1919, the Arabs of Palestine and the Jaffa city branch of the Muslim–Christian Association held a public assembly at the Zohor cinema in Jaffa. The assembly backed equality for all the people of Palestine, including Palestinian Jews, but opposed Jewish immigration. They declared that the movement to create Israel had no basis in Mosaic law and that it

made no sense for anyone to claim divine rights to Palestinian land. What mattered were land titles, and these were registered in the Department of Land and not in the Bible.

Gradually, over the years, resistance to immigration and settlements would grow from a few scattered instances into a general strike in 1936 that lasted six months. Then a general uprising escalated to a rebellion that neither the local British administration nor the Palestine Agency, an underground government during the British mandate, could suppress. The Agency was effectively a government within a government, and in case of conflict, events proved it had the upper hand.

A man who had arrived in Palestine with the British Army proved to be a key player in those events. Vladimir (Ze'ev) Jabotinsky was a Russian journalist, writer, and orator. His attachment to the cause of Israel was only matched by his hatred of Britain, so much so that he struck fear even in the hearts of mainstream supporters of Israel.

In 1923 Jabotinsky founded the World Union of Zionist Revisionists and its youth movement, Betar, in 1925. The Revisionists believed that mainstream pro-Israelis were far too moderate; and their stance and ideas would later become the basis of Israel's Likud Party. Jabotinsky thought the socialist-oriented Labor Party was a "gross cancer in the body of the Yishuv, growing ever more malignant." His extremism was duly noted by Ben Gurion, who at a public meeting in February 1933 warned the major pro-Israel party, Mapai, not to "underrate the severity of this Hitleristic peril in the Jewish, Zionist Street."[8] It is worth noting that successive Israeli governments continued their drift to the right to the extent that it is hardly possible to discern the difference between them now.

Before 1948, when the state of Israel was established, the Revisionists founded terrorist organizations which assassinated British and Arabs alike. In 1946, a group called Irgun blew up the King David Hotel in Jerusalem, which had been the base for

the British Secretariat, and killed or wounded more than 100 people. Future Israeli prime ministers Menachem Begin and Yitzhak Shamir were among the leaders of these organizations, and Begin was on the "most wanted" terrorist list of the British Palestine administration.

In the meantime, while the Arabs of Palestine continued to resist, the authorities were responding more and more brutally. In the 1930s, the Arabs of Palestine staged a rebellion. It took General Bernard Law Montgomery ("Monty") to suppress it. The British authorities created a Special Operations Unit in the late 1930s, under Ben Gurion himself, to handle it. One of its operations took place in the Arab village of Lubia in Upper Galilee. Segev describes it in *One Palestine, Complete:*[9]

> The unit's men sneaked into the village at night, silently in tennis shoes, pouring gasoline behind them to keep dogs from tracking them. Once in the village, they chose a house with its lights on. They peered in and saw three men and two women seated around a dead body laid out on the floor. The units' men fired their weapons into the room through the window. One member of this unit, Yigal Allon, would go on to become a famous Israeli soldier and a deputy prime minister of Israel. There had also been children in the house, it turned out. Three people were killed, two men and a woman were wounded, and three children were wounded, including a two-year-old boy and a ten-year-old girl.

Unable to curb growing Arab anger, the British sent their top counterterrorism expert, Sir Charles Tegart, with 25,000 soldiers and policemen to Palestine. This was the biggest military force to leave England since World War I. From the autumn of 1937, the British started to operate military courts handing out swift justice. And from the beginning of 1938 to the end of 1939, an average of one Palestinian Arab a week was sentenced to death; in one month, more than 30 were executed.

At the same time more extreme groups began to emerge in support of Israel. Charles Wingate, an officer in British

Intelligence, set up a private army known as the Special Night Squads, which operated in Galilee. They conducted special operations, but also guarded Iraq's oil pipeline to Haifa and the security fence Tegarat had built to prevent Arab resistance fighters crossing the borders from Syria and sabotaging the Iraq Petroleum Company pipeline which transported oil from Kirkuk, in Iraq, to Haifa, in Palestine.

Tzion Cohen, a member of Wingate's squads, wrote that after targeting a Palestinian Arab village, the squad would enter the village at dawn. After "rounding up all the men and forcing them to stand with their faces to the wall and their hands behind their backs," Cohen said, Wingate and his men would inflict the punishment because he did not want "to fan the Arabs' hatred to us". The villagers were lashed on their bare backs sometimes and were made to smear mud and oil on their faces. On occasion, Wingate would shoot and kill them. In the village of Hitin, the squad rounded up ten men and after haranguing them, shot and killed them all. The Palestine Jewish Agency footed most of the bill for the squads, according to documents unearthed by Segev.

Wingate and his techniques were admired in certain quarters and he became a hero to many. The Israeli Ministry of Defense issued a summary years after his death which is self-explanatory: "The teaching of Orde Charles Wingate, his character and leadership were a cornerstone for many of the Haganah's [the paramilitary organization that would form the basis of the Israeli army] commanders, and his influence can be seen in the Israel Defense Force's combat doctrine."[10]

Montgomery's part in the drama began in November 1938, when he arrived in Palestine to put down the revolt. He wanted to take the harshest measures. To Montgomery, the revolt was not an expression of an indigenous national movement, it was war. "He gave his men simple orders on how to handle the rebels: kill them," according to Segev. Such a doctrine remains in force to this day.

The Palestinian refugees' problem was the result of a calculated "transfer" policy put in place when the Israeli state was proclaimed. In his book *The Zealots for Zion*, Robert I. Friedman wrote:

> Ben-Gurion for many years considered transferring the Arabs to make way for a Jewish state. "We must expel Arabs and take their places," he wrote to his son Amos on Oct. 5, 1937. "And if we have to use force—not to dispossess the Arabs of the Negev and Tran Jordan, but to guarantee our own right to settle in those places—then we have force at our disposal."

Jabotinsky's preference was a Jewish state without Palestinian Arabs. "We should instruct American Jewry to mobilize half a billion dollar in order that Iraq and Saudi Arabia will absorb the Palestinian Arabs," he wrote to a supporter in November 1939. "There is no choice: the Arabs must make room for the Jews in Eretz Yisrael."

Israel Begins

After World War II, British influence began to wane, and the Americans started to play a bigger role in the region.

The collective minds of the US government remained keenly focused on the Palestine issue after the war. President Roosevelt set up a meeting with King Abdul Aziz Al Saud of Saudi Arabia on the USS *Quincy*. Oil and Palestine were on his mind. Roosevelt stressed that the Jews had suffered terribly at Hitler's hands and that he was committed to find a solution to their problem. The king said he sympathized and understood their suffering, but questioned why Arabs and Palestinians were being asked to pay for the barbarity of Europeans. "Give them [the Jewish people] and their descendants the choicest lands and homes of the Germans who oppressed them."[11]

In 1947, the British Foreign Secretary, Ernest Bevin, informed the House of Commons that Britain had failed to find a

solution to the Palestine problem, and under this pretext turned
the matter over to the United Nations. That November, there
was a majority vote in the UN for the partition of Palestine and
the creation of two states. Ben Gurion accepted partition, but
Menachem Begin denounced it.

President Truman and his administration played an impor-
tant role in securing the UN partition vote. On Friday, May 14,
1948, Ben Gurion declared a "Jewish state in Palestine to be
called Israel" and a few minutes afterwards, Truman was the
first head of state in the world to recognize it. However, it is
fair to say that it was not until the mid-1960s that unques-
tioned US support for Israel of the kind that is in evidence
today began. Until then, both the Eisenhower and Kennedy
administrations (and later Jimmy Carter's), for example, could
be skeptical of Israeli actions, and were not afraid of
telling Israel in no uncertain terms what they thought
of Israeli policies and actions. But while Kennedy's and
Carter's presidencies were relatively short-lived and weak,
Eisenhower in particular showed that a strong and widely
admired American president could stand up to Israeli
injustices—including by cutting off American aid.

On two occasions during the period 1953–61 Israel acted
as the aggressor toward its neighbors and toward Palestinians
living in the region. The first occurred in 1953, when Israel
tried to divert the waters of the River Jordan. The second was
in 1956 when Israel, in alliance with France and Britain, con-
spired to attack Egypt and overthrow President Gamal Abdel
Nasser after he nationalized the Suez Canal in defiance of
Israel and the Western powers. In both instances, Eisenhower
signaled American displeasure by temporarily cutting off
aid—an unthinkable act today.

Israel's secret water diversion plan involved using the
Palestinian village of Banat Ya'qub for a project that would
divert waters from the Jordan Valley to central Israel and the
north Negev. The UN, the US, and the Palestinians living in

that area were unaware of the plans. Earlier, Eisenhower had offered to implement an American-sponsored regional water usage plan, and Israel had promised to cooperate, but in reality, Israel wanted complete control of the flow of water in the region, despite its commitments to the Americans. A dispute ensued over the control of Palestinian territory near Banat Ya'qub.

Eisenhower and Secretary of State John Foster Dulles realized that Israel had openly deceived them, so the administration withheld $26 million under the Mutual Security Act and suspended economic aid until Israel agreed to cooperate with UN observers. Eisenhower also directed the Treasury to prepare an executive order removing tax-deductible status from contributions by Jewish Americans to pro-Israel organizations as the United Jewish Appeal (UJA). It is worth reiterating: these are actions that seem inconceivable in today's climate in which America regards itself as Israel's ultimate protector—no questions asked.

On August 26, 1955, Dulles said that the problem of Palestinian refugees could be resolved, but proposed that Congress approve an international loan to finance the resettlement or repatriation of Palestinian refugees. The loan would also help develop irrigation projects to assist refugees cultivate their land for crops. The Israelis were disturbed by Dulles' speech because he mentioned a possible boundary revision. On November 9, Eisenhower confirmed Dulles' position in a formal statement.

At that point, it became clear that the US could no longer be counted on to support Israel's efforts to expand its borders. So Israel turned to France and Britain for support.

On July 26, 1956, Nasser nationalized the Suez Canal because he felt that friends of Israel in America had cheated him out of US aid for the construction of the Aswan Dam which Egypt needed for irrigation and power. Nasser had been given the impression that US aid would be forthcoming.

However, friends of Israel in America pressured the Senate Appropriations Committee to block funding. On July 16, 1956, funding was officially denied—much to the chagrin of Eisenhower and Dulles. Nasser responded by seizing control of the canal and nationalizing the Suez Canal Company in order to obtain funds.

On October 29, 1956, Israel attacked Egypt and advanced toward the Suez Canal. On November 1, British and French forces also invaded Egypt and began their occupation of the canal zone, but growing opposition from Eisenhower, Dulles, and UN Secretary-General Dag Hammarskjöld, as well as Soviet threats of intervention, put an immediate stop to British and French support. But Israeli troops still occupied the Gulf of Aqaba and the Gaza Strip in defiance of a UN resolution.

Eisenhower told Dulles: "Foster, you tell 'em, goddamn it, we're going to apply sanctions, we're going to the United Nations, we're going to do everything that there is to stop this thing."[12] Hammarskjöld publicly condemned Israel for its retaliatory actions against Palestinians. He later died in suspicious circumstances.

Since Eisenhower left office, no president has succeeded in openly opposing strategic Israeli interests. In fact, by 2004 George W. Bush had actually turned most of US foreign policy directly over to pro-Israeli right-wing circles to advance their global agenda, which had become his own.[13]

Kennedy, Israel, and the Bomb

In many respects, Eisenhower's skepticism towards Israel was shared by President Kennedy. A central feature of Israel's history in the post-Eisenhower years was its desire to build the nuclear bomb. Kennedy wanted its government to abandon its nuclear ambition, but he had entered the White House after an extremely close election and had to adopt a more

cautious approach. Kennedy did not live to see his efforts come to fruition. Lyndon B. Johnson, who succeeded him, not only gave Israel major new weapons and foreign aid support, but never pressed Israel to give up the bomb.

In a highly revealing and well-documented book, *Israel and the Bomb*,[14] former Tel Aviv University professor Avner Cohen confirmed the rift in US–Israel relations during the Kennedy era over Israel's bomb project. Cohen's book is so revelatory that the Israeli newspaper *Ha'aretz* declared it would "necessitate the rewriting of Israel's entire history."

According to Cohen, the

> genesis of Israeli involvement in the JFK assassination was JFK's growing conflict with Israel over Israel's drive to build the nuclear bomb. While the history books have told us of John F. Kennedy's epic struggles with Fidel Castro and with the Soviets in the Bay of Pigs debacle and the Cuban Missile Crisis only in recent years have we begun to learn of Kennedy's secret war with Israel.

Cohen continues:

> On 5 July, less than ten days after Levi Eshkol became prime minister, [US] Ambassador Barbour delivered a 3-page letter to him from President John Kennedy ... Not since President Eisenhower's message to Ben Gurion, in the midst of the Suez crisis in November 1956, had an American president been so blunt with an Israeli prime minister. Kennedy told Eshkol that the American commitment and support of Israel "could be seriously jeopardized" if Israel did not let the United States obtain "reliable information" about Israel's efforts in the nuclear field. In the letter, Kennedy presented specific demands on how the American inspection visits to Dimona [site of the Negev Nuclear Research Center] should be executed. Since the United States had not been involved in the building of Dimona and no international law or agreement had been violated, Kennedy's demands were indeed unprecedented. They amounted, in effect, to American ultimatum.

Cohen's source for Kennedy's letter was the Israel State Archive in Jerusalem, which houses a copy of the original.

A number of dramatic disclosures were documented by Cohen using archive and other material. For instance, between 1955 and 1957, a heated debate broke out within Israel's small scientific and policy community over the feasibility and desirability of the nuclear weapons option. When Shimon Peres put together the Dimona deal which was secretly worked out in 1957 and obtained massive assistance from France, Ben Gurion gave the project the go-ahead. The US then "discovered" Dimona in late 1960, almost three years after it had been launched—so late that this amounts to one of the colossal blunders of US intelligence.

Cohen, who based his findings on a volume of newly declassified documents as well as interviews, reveals that Kennedy was the only US president who made serious efforts to curb the Israeli nuclear project. He suggests that Ben Gurion's resignation in 1963 may have been triggered in part by the pressure Kennedy was putting on him at the time.

The American scientists Kennedy dispatched to Dimona found no direct evidence that Israel was engaged in weapons-related activities. Cohen explains why. He also reveals that the CIA, from the early to mid-1960s, understood and presumed that Israel was determined to develop nuclear weapons. By late 1966, the CIA was circulating reports that Israel had completed the development phase of its nuclear program, and was only weeks away from having a fully assembled bomb. Such information was never shared with the inspection teams that visited Dimona, nor was it accepted by the State Department.

By late 1966, Israel had completed the development phase of their nuclear project. Yet Eshkol adamantly refused to allow a nuclear test, knowing that this would violate the unique understanding he had with the United States.

Cohen shows too how the Six Day War had an important nuclear dimension. New and little-known Israeli and American sources suggest that Israel had improvised two

nuclear devices. Cohen suggests that some time before the war, Israel had achieved a rudimentary nuclear weapons capability, and during the tense days of the crisis in late May it placed that capability on "operational alert." On the eve of the war, Israel had two deliverable explosive devices.

The advent of the Non-Proliferation Treaty (NPT) in 1968 set the stage for the most direct confrontation between the US and Israel on the nuclear issue during the Johnson era. Cohen reconstructs the details of this stand-off, whose two prime players were Ambassador Yitzhak Rabin and Assistant Secretary of Defense Paul Warnke.

A new set of American–Israeli understandings on the nuclear issue emerged in 1970, through meetings between President Nixon and Prime Minister Meir. The US was no longer pressing Israel to sign the NPT, and had also suspended visits to Dimona. National Security Advisor Kissinger played a central role in formulating the policy. In return, Israel committed itself to maintaining a low-profile nuclear posture: no testing, no declaration, no acknowledgment. With these "don't ask, don't tell" understandings, nuclear opacity was born. This mutual understanding persists today.

The Six Day War

Ten years after Suez, Israel attacked Egypt again, this time successfully. This was the Six Day War, which began on June 5, 1967. Much had changed over the decade. Israel's most influential adversaries in the US were either dead or had left public office. Eisenhower had retired years earlier and was now in failing health. John Foster Dulles had died in 1959. Dag Hammarskjöld had been killed in a plane crash in the Congolese province of Katanga in 1961. Kennedy, of course, had been assassinated in 1963. Israel's old ally, Lyndon B. Johnson, had become Commander-in-Chief of the United States. In July 1965, Johnson had appointed Supreme Court

Justice Arthur Goldberg, an ardent supporter of Israel, as US Ambassador to the UN as successor to Adlai Stevenson, who had died suddenly of a heart attack.

At this time, the Yemen War was eroding Arab unity. By 1967, Egyptian forces had suffered heavy losses and were considerably weakened after five years of conflict. These factors were to prove highly advantageous to Israel when the Six Day War began.

For Israel, the war was a watershed, transforming it from a small nation into a country with colonial aspirations. The country expanded dramatically, using military force to take the Old City of Jerusalem, the Sinai and Gaza Strip, the Jordanian territory west of the River Jordan known as the West Bank, and the Golan Heights on the Israeli–Syrian border. Along with the land came a new population—an additional 900,000 Arabs, who would become the discontented subjects of the new empire. Since 1967, the number of Arabs under Israel's military control has grown to over 1.75 million.

The relationship could go deeper still. As journalists Andrew and Leslie Cockburn document in their book *Dangerous Liaison*,[15] Israel won its war with more than a little help from the CIA: "The 1967 War was launched with American permission to 'break Nasser into pieces'." One former American NSA intelligence official told them: "Jim Angleton and the Israelis spent a year cooking up the '67 war. It was a CIA operation designed to get Nasser." Angleton was the CIA liaison with Israeli intelligence, and one of the most influential shadowy US figures in postwar intelligence politics.

The charge that the war began when Egyptian planes took to the air is a deliberate lie, the aim of which is to justify the pre-emptive Israeli air attacks that wiped out the Egyptian air force, according to the Cockburns. By June 7, the Israeli army was in Old Jerusalem, and two days later General Moshe Dayan had marched into the Golan Heights. One of the unexplained hits of the war came on June 8, when Israeli

forces attacked the USS *Liberty* off the Mediterranean coast, killing many American sailors. To many sources, including many of the *Liberty* survivors, it was a deliberate attack but Washington has remained silent about it ever since.

Menachem Begin, a minister in the Israeli war cabinet during the Six Day War, admitted in another context to the *New York Times* on August 21, 1982: "In June 1967 we had a choice. The Egyptian army concentrations in the Sinai approaches do not prove that Nasser was really about to attack us ... We decided to attack him."[16] Yitzhak Rabin, Israeli Chief of Staff, told a similar story: "I do not believe that Nasser wanted war," he told *Le Monde* on February 28, 1968. "The two divisions he sent into Sinai on May 14 would not have been enough to unleash an offensive against Israel. He knew it and we knew it."

In short, Israel, with the help of Washington, maneuvered Nasser into taking defensive steps, which gave Israel a pretext for a major offensive war and taking a huge chunk of territory in the name of "self-defense." Ezer Weizmann, then Chief of the Israeli air force, was even franker about Israel's postwar cachet and status. In an interview reported in *Ha'aretz* on March 20, 1972, he said the war was justified because it allowed Israel to "exist according to the scale, spirit, and quality she now embodies."[17]

Israel and the US Right

A new strategic partnership between the US and Israel was forged by the Six Day War. Before 1967, Israeli foreign policy centered on its relationship with France as its primary supplier of arms, nuclear, and other military technology. After 1967, all Israeli energy concentrated on building the myth of Israeli military superiority and showing how essential Israel was as a reliable Middle Eastern bulwark against the danger of Soviet subversion. Thus began what has become one of the

most destructive and powerful alliances in modern history. It is an alliance that has survived US administrations with relatively hostile or unimpressed heads of state. Nixon, as we have seen, was no friend of Israel. But ruthlessly targeted by the Watergate scandals, Nixon was driven from office, leaving day-to-day control in the hands of Secretary of State Kissinger, a champion of Israel.

Later, when Jimmy Carter attempted to broker a Middle East peace deal, which included modest demands for Palestinian statehood, America's Israel lobby 'fiercely attacked him and created a far-right Republican Party base which would become American neoconservatism. Carter was, of course, defeated by Ronald Reagan, a firm believer in Armageddon and a close friend of Israel. It is impossible to grasp how such a drastic foreign policy shift could occur between Eisenhower in the 1950s and the George W. Bush era, unless we understand the political power base the Israeli lobby has built up.

The most striking feature of the US–Israeli strategic link is the fanatical backing for the militant expansion of Israel from various, nominally Christian denominations and organizations in the US. Behind the religious façade is a well-organized political machine directly tied to Tel Aviv and Washington power centers. Who are they?

They may be Christian, but theirs is a doctrine quite different from the traditional Gospel of love and tolerance. They preach hate and war and ascribe to a militant belief system that has more similarity with those prevalent among twelfth-century Crusaders than modern Christians. As we saw earlier in this chapter, their beliefs also tally, in part at least, with those of the Jewish faith who believe the settlement of Jews in Palestine is essential for the Second Coming. These two strands—the anti-Islamic and the pro-Israeli—are evident in their evangelical pronouncements. In the months following 9/11, the conservative television evangelist Pat Robertson

repeatedly preached the notion that Muslims "are worse than the Nazis."[18] In November 2002, Robertson declared through his Christian Broadcasting Network that "Adolf Hitler was bad, but what the Muslims want to do to the Jews is worse." Despite public outcry, Robertson refused to retract his comments. He has also compared the Qur'an to Hitler's *Mein Kampf* as a blueprint for world domination.[19]

The Southern Baptist Convention's former president Jerry Vines called the Prophet Mohammad the vilest names imaginable.[20] The aim was to manipulate American public opinion, at a highly vulnerable moment, into hating the Islamic world in order to charge up Bush's so-called War on Terror.

Franklin Graham heads the Christian organization Samaritan's Purse, which supposedly conducts international relief efforts. He is also a close religious advisor to Bush, and in 2003 got permission from the US occupation authorities to bring his evangelical, anti-Islamic version of Christianity to Iraq to win "converts."[21]

The beginnings of the close relationship between far-right evangelism and the pro-Israel lobby came much earlier, however. In 1977, after the conservative Likud government of Begin realized that Carter was intent on human rights for Palestinians, including statehood, the Likud Party and their neocon allies in the US began to look for support elsewhere. The Israeli Labor Party had backed the proposal of land for peace, but Likud backed a Greater Israel, which would include the occupied Palestinian territories of the West Bank and Gaza, which they call Judea and Samaria.

In 1977, the Israeli intelligence services, under the direction of Hebrew University of Jerusalem professor Yona Malachy, quietly began to conduct a detailed profile of all the many different Christian organizations in the US. They classified them according to how they regarded the existence of Israel, in terms of their Christian belief.

The most fertile soil for their purpose, they found, was in the southern states—Southern Baptist, Methodist, or one of the growing number of "born-again" charismatic sects that proliferated in the American South after World War II. They were ripe for manipulation; all that was needed were some fine adjustments to their theology.

Malachy published his report, *American Fundamentalism and Israel: The Relation of Fundamentalist Churches to Zionism and the State of Israel*, in 1978.[22] He had found numerous American Protestant sects—in particular, the Seventh Day Adventists, Jehovah's Witnesses, Pentecostalists, and Premillennial Dispensationalists or Darbyites—who linked their theology to Israel, through a strange, literal interpretation of the Bible. Their ministers were typically trained at the Moody Bible Institute or the ultra-conservative Dallas Theological Seminary of John Walvoord in Texas. They diligently read the 1909 Scofield Reference Bible, whose footnotes "explain" Bible texts in arcane prophetic terms.

Likud leaders, with a number of Israeli religious leaders, went to work after 1977 to bring the most charismatic, and often the most corruptible, leaders of these groups to Israel. Begin began to attend Washington "prayer breakfasts for Israel" with fundamentalist ministers such as Jerry Falwell, then head of the Moral Majority, and Pat Robertson. When it was pointed out that some of them were anti-Semites, Begin reportedly snapped that he did not care, as long as they supported Israel in the US.

Fundamentalist Fallacies

The vast majority of American and international Christian churches are highly critical of any claims that try to link Christian theology to Israel. The Middle East Council of Churches, representing the Oriental and Eastern Christian churches in the Middle East, charges that they have

"aggressively imposed an aberrant expression of the Christian faith, and an erroneous interpretation of the Bible which is subservient to the political agenda of the modern State of Israel." Christian Zionism, they say, "rejects the movement of Christian unity and inter-religious understanding."[23] Yet, while a minority, its believers are a force to be reckoned with, and one with long roots. Although Herzl is credited with the movement for Israel in the nineteenth century, pro-Israel Christians existed even earlier. Some Protestant dissenting sects of the English Civil War period believed themselves to be "God's chosen people," the "lost tribe of Israel." They later included a number of prominent British Imperialists, including Lord Palmerston, Lord Shaftesbury, Lloyd George, and Lord Balfour. To them, the ideology of the faith justified British imperialism as a religious mission.

A closer look at that ideology shows why it meshes so well with imperialism. Today's pro-Israel Christians argue that Israel has been given to the Jewish people by God, and that in order for Christ's Second Coming to be realized, all Jews must return to Israel for the final battle of Armageddon between the forces of good and of evil. This may be one reason why George W. Bush declared the war in Iraq to be a war of good against evil.

Pro-Israel Christians acknowledge that the earth will be destroyed during these so-called "end times," but believe that they, the true believers, will be transported to Heaven in a holy rapture and, as a result, will be spared the messier aspects of a nuclear holocaust.

Ironically, behind their pro-Israel façade, people like Falwell and Robertson cynically use their links to Israeli Jews to push an anti-Semitic agenda of their own. Uri Avnery, leader of the Israeli peace group Gush Shalom, describes how the theology itself has inspired this hypocrisy:

> According to its theological beliefs, the Jews must congregate in Palestine and establish a Jewish state on all its territory so as

to make the Second Coming of Jesus Christ possible ... The evangelists don't like to dwell openly on what comes next: before the coming [of the Messiah], the Jews must convert to Christianity. Those who don't will perish in a gigantic holocaust in the battle of Armageddon. This is basically an anti-semitic teaching ...[24]

Essentially, Avnery is saying that they believe that any Jews who remain true to Old Testament beliefs will be killed.

This brand of neoconservatism has proved to be highly potent. It is, after all, the organized lobby of Christian born-again voters that is credited with securing the re-election of George W. Bush in 2004. On October 10, 2004, Daniel Akin, president of the South-eastern Baptist Theological Seminary, issued an open letter signed by 72 evangelical leaders urging the American people to "use Biblical values in their selection of candidates."[25] The letter cited gay marriage, stem cell research, and the Democrats' alleged defense of "terrorists" as reasons to vote Republican. The letter was signed by the most prominent members of the pro-Israel Christian right, backing Bush and Ariel Sharon as the "fulfillment of Bible prophesy."

These fanatical religious spokesmen claim they have direct communication with God. In an article entitled "Should We Go to War with Iraq?" published on the website *Prophecy Truths* on February 5, 2003, Roy A. Reinhold wrote of such an experience:

> Many people wonder whether this coming showdown with Iraq, by the USA and a coalition of nations, is worthwhile and whether it is the right thing to do ... On Saturday, February 1, 2003, I lifted my hands to begin praying and the Lord spoke to me ... I wanted to know whether God the Father's direction was to go to war or not go to war ... The Lord said, "I am saying go to war with Iraq."

Reinhold added, "I put the above on my message board and what everyone wanted to know was, 'what is God's reason(s)

for going to war with Iraq?' That question hadn't occurred to me, because I personally just accepted God's direction."

On the Brink of Armageddon

The pro-Israel evangelical lobby in America and their allies have a long-term agenda that may well trigger a new world war. Some neocons say that this war has already begun—with 9/11.

Along with Jerry Falwell and Pat Robertson, there were a number of others who began to gain followers in the 1970s— Hal Lindsey, for instance, who in his *Rapture* novel series wrote of the end of civilization in the battle of Armageddon waged in Israel. Eventually it emerged that many of them, including the avowedly anti-Islamic Falwell and Robertson, were intimately linked to the Israeli right wing. Some also had ties to the CIA. But all seemed to have bought into this bizarre apocalyptic view.

The late Grace Halsell grew up in Texas—soil that had also nourished the fundamentalism that had captured George W. Bush. But she wasn't drawn to it—in fact, quite the opposite. After working as a White House speechwriter for fellow Texan Lyndon B. Johnson, she later became a respected journalist who devoted her last years to courageously exposing the ties Falwell and his ilk had established with the Israeli right wing.

During the 1980s, seeking to understand the born-again phenomenon then sweeping across the US, Halsell went to Israel with a tour group led by Falwell. As she described it, "My inquiry led me to ask why does a Christian such as Jerry Falwell pray for the end of the world? Must we totally destroy this world in order to usher in a 'new heaven and a new earth?' "[26] The answers she found were alarming. She discovered that Falwell had become a close friend of the Israeli right. Halsell noted the curious fact that, rather than concentrate the tour on Christian sites in the Holy Land,

Falwell's tour was run by Israeli guides and toured only Israeli sites of interest. Moreover, Falwell was given a private Lear jet as a gift from the Israeli government to make his US tours that little bit easier.

Falwell and his fellow fundamentalists said they believed it was "God's will" that Israel move to establish greater domination in the Middle East, as that will bring the world that much closer to the biblical "Last Judgment," when "true believers" will be saved while the lost will perish. That battle, according to Falwell and his friends, will pit Jews against Muslims.

Halsell interviewed a number of Americans actively involved in trying to "speed up" Armageddon. One was Terry Risenhoover, an Oklahoma oilman and pro-Israel Christian who was close to the Reagan White House. Risenhoover was candid about his views. He financed people in Israel and elsewhere who were determined to rebuild the Temple of Solomon (also called the Third Temple) in Jerusalem. This had once occupied the site where one of Islam's most holy places, the Al-Aqsa (Dome of the Rock), now stands.

In 1985 Risenhoover was chairman of the American Forum for Jewish–Christian Cooperation. Fellow directors were Doug Krieger and an American rabbi, David Ben-Ami, a close friend of Ariel Sharon. Risenhoover was also chairman of the Jerusalem Temple Foundation, "whose sole purpose is the rebuilding of a temple on the site of the present Muslim shrine."

Risenhoover selected Stanley Goldfoot as his International Secretary of Temple Mount Foundation. Goldfoot was a former member of the underground terrorist Stern Gang (Lehi), who had been denounced by Ben Gurion as Nazis. He was also the person, according to the Israeli newspaper *Davar*, who placed the bomb that killed some 100 British in the King David Hotel in July 1946. Risenhoover boasted

about Goldfoot to Halsell, saying, "He's a very solid, legitimate terrorist. He has the qualifications for clearing a site for the Temple." A Goldfoot deputy, Yisrael Meida, told Halsell, "He who controls the Temple Mount, controls Jerusalem. Who controls Jerusalem, controls the Land of Israel."

In 1998, an Israeli newsletter posted on the *Voice of Temple Mount* website announced that its goal is the "liberation" of Muslim shrines around the Al-Aqsa mosque, and the building of a Jewish temple on the site. "Now the time is ripe for the Temple to be rebuilt," it announced. They then called on the Israeli government to "end the pagan [*sic*] Islamic occupation" of lands where the mosque stands.

In September 2000, Sharon led a large group of Israelis, protected by the police, onto the Al-Aqsa site in an act of deliberate provocation, which triggered the renewal of the Intifada. Sharon's friends had been secretly digging an underground tunnel to the Al-Aqsa site which allegedly would be used to dynamite it when the time was right.

The late Issa Nakhleh, an Arab Christian and former senior advisor to the UN Palestinian delegation, warned of a "criminal conspiracy" between Christian evangelists and pro-Israel terrorists to destroy the Al-Aqsa mosque.[27] He confirmed that terrorists were members of the Jerusalem Temple Foundation. Nakhleh added that the proposed projects of the Foundation, as outlined in a brochure, included "preparations for the construction of the Third Temple in Jerusalem."

He confirmed that among the Temple Mount conspirators was Washington insider Michael Ledeen, a man who later became one of George W. Bush's most important neoconservatives, and who is close to Bush's political advisor Karl Rove. Nakhleh said that Ledeen and his wife had published an article in the *New Republic* of June 18, 1984 titled "What do Christian and Jewish Fundamentalists Have in Common? The Temple Mount Plot."

Instating Religion

The patterns set up with successive presidents did not change during the first Bush presidency or the Clinton years. When George Bush Senior tried to control an Israeli expansionist policy by imposing conditions on a $10 billion loan to Israel, for instance, Israel worked to ensure his defeat and Clinton's victory in 1992.

The Clinton administration was packed with friends of Israel, including America's Ambassador to Israel, Martin Indyk. Yet the few times when Clinton attempted to act independently of Israeli interests he was savagely attacked, most often by Christian right networks in Congress, and their ally, Special Prosecutor Kenneth Starr, a member of the Christian right political network. These networks finally instigated an impeachment process against Clinton in 1998 for lying about an affair with a White House intern, Monica Lewinsky.

But it would take George W. Bush and his administration, who took over the White House in January 2001, to propel the pro-Israel Christian right into the big time. The man who advised Bush when he was Governor of Texas to follow the so-called "compassionate conservatism" agenda that so confused many voters was an influential Texas neocon professor and editor of *World* magazine, Marvin Olasky. Olasky's book *The Tragedy of American Compassion* is the only text Bush has ever cited as an inspiration for his domestic agenda.

Referring to himself and Bush, in contrast to the Democratic presidential candidate John Kerry, Olasky wrote: "The other thing both of us can and do say is that we did not save ourselves: God alone saves sinners (and I can surely add, of whom I was the worst). Being born again, we don't have to justify ourselves. Being saved, we don't have to be saviours."[28] There is a distinct echo here of the shocking comment Bush made to the veteran journalist Bob Woodward:[29] "I do not need to explain why I say things. That's the interesting thing

about being president ... I don't feel like I owe anybody an explanation."

Bush surrounded himself with people like Olasky and Rove. Rove has built a political machine around Bush which centers on the fanatical, active support of evangelicals and the 7 million pro-Israel Christians who regard aggression perpetrated by Israel and its leaders, such as Sharon and Olmert, as biblical prophecy for Armageddon.

Another tireless worker, Rabbi Yechiel Eckstein, has built his International Fellowship for Christians and Jews into a philanthropic powerhouse that donates tens of millions of dollars to Israel annually. He has forged close links with popular right-wing evangelical leaders such as Pat Robertson and Gary Bauer, as well as White House neocons like Elliott Abrams, who is in charge of Middle East policy on the National Security Council. Together, Eckstein and his allies have played an instrumental role in bringing pressure to bear on the Bush administration to abandon the so-called "road map" to peace and defend Sharon's brutal handling of the occupation.

When Sharon and Bush came to power in 2000, they began a cozy relationship. Eckstein also became an advisor to Sharon, who courted the support of evangelicals more aggressively than most of his predecessors. In the fall of 2002 Sharon told a crowd of 3,000 evangelical tourists in Jerusalem, "I tell you now, we love you. We love all of you!" That same year, Sharon invited Bush advisor Gary Bauer to Jerusalem for a private meeting with his cabinet. "I was given a great deal of access and a number of briefings on the various issues they're facing," Bauer later stated. "In my meeting ... I attempted to explain that they had a much broader base of support in the US than perhaps they realized, and they should be sensitive to the fact that more Americans than they think regard Israel as a natural ally."[30] To help make his point, Bauer gave Sharon a letter of support signed

by leading evangelicals, including Charles Colson, Falwell, and Focus on the Family president James Dobson. When the Bush administration criticized Israel's botched assassination of Hamas leader Abdel Aziz Rantisi in June 2003, Bauer e-mailed an alert to 100,000 followers calling for pro-Israel pressure on the White House. "We inundated the White House with e-mails and faxes arguing that Israel had the same right to defend itself as we did,"[31] Bauer said. And when Israel did kill Rantisi, the White House issued a statement of support for Israel's "right to defend herself."

Early that same March, Abrams met with leaders of a self-identified "theocratical" lobbying group, the Apostolic Congress, to allay their concerns about Bush's pending endorsement of Sharon's pullout plan for Gaza. And evangelical leaders like late Religious Roundtable director Ed McAteer have reportedly held numerous off-the-record meetings on policy toward Israel with White House public liaison officer Tim Goeglein, who was spokesman for Bush's 2000 presidential campaign.

Other high-profile appearances and approving statements were to come. In May 2004, at a meeting aimed at galvanizing support from Jewish voters, Bush told more than 4,000 delegates gathered at the annual conference of the American Israel Public Affairs Committee (AIPAC), the pro-Israel lobbying organization, that by "defending the freedom and prosperity and security of Israel, you're also serving the cause of America."[32] Earlier that year, at a less publicized gathering, Abrams and other Bush administration officials had a two-hour meeting with members of the Apostolic Congress, a powerful political group of Christian fundamentalists, to reassure them that the administration's support for Israel was unwavering.

While AIPAC and the Apostolic Congress may appear to have little in common, one overarching concern binds the two groups—the safety and security of Israel. According to

the *Los Angeles Times*, Bush's 39-minute AIPAC address "was interrupted repeatedly with cheering and applause [and] on two occasions, at least a third of the audience burst into chants of 'Four more years!' "[33]

While it is no longer news that Bush administration officials meet regularly with the pro-Israel Christian right, it was surprising to hear about this meeting because it was clearly meant to be kept out of the headlines. It came to light only after *Village Voice* reporter Rick Perlstein received "details" about it from "a confidential memo signed by Presbyterian minister Robert G. Upton." When Perlstein asked Upton about the memo and the meeting, the minister told him, "Everything that you're discussing is information you're not supposed to have." Not that Upton, the executive director of the Apostolic Congress, isn't proud of his easy access to the White House. "We're in constant contact with the White House," he told Perlstein. "I'm briefed at least once a week via telephone briefings ... I was there about two weeks ago ... At that time we met with the president."[34]

Tangled Intelligence: Mossad and America

The early ties between Washington and Tel Aviv grew from the special intelligence links between the CIA and Israeli intelligence agency Mossad, which the CIA's James Jesus Angleton personally nurtured in the 1960s. Among other things it coordinated both countries' intelligence for the Six Day War. When Angleton died, Israel erected a monument of thanks to him. The fusion of Israeli and US interests, however, was to take place over a period of decades, carefully and painstakingly built up around military and intelligence cooperation on a top secret level. Apparently more than with any other state, including Britain, the US relies on Israel to maintain crucial strategic operations around the world. The cooperation is so intimate that it might be compared to a

merger of two companies, one giant and bulky, the other small and agile. Each critically needs the other to pursue its strategic agenda.

Over the years, some of the details of the US–Israel special relationship have leaked out, often divulged by former Israeli intelligence insiders who, for whatever reason, have revealed details of their government's covert activities. Some have done it to try to save themselves.

Victor Ostrovsky, a former Mossad agent, published the sensational book *The Other Side of Deception* in 1994,[35] which detailed his insider's knowledge of Mossad operations. Among the allegations made were that Mossad was behind the murder of former German politician Uwe Barschel in the early 1980s and the mysterious death of the British media magnate Sir Robert Maxwell.

Ostrovsky also charged that Mossad played a key background role in the *putsch* against Mikhail Gorbachev, which brought the American puppet regime of Boris Yeltsin to power. Yeltsin's cohort of Russian oligarchs unsurprisingly included a group of new billionaires, among whom were oil czar Mikhail Khodovkorsky and Boris Berezovsky. They all carried Israeli passports. Ostrovsky claims that he wrote the book as a form of self-defense against another faction in an internal Israeli intelligence war.

One of the charges voiced by Ostrovsky is that Mossad was responsible in 1986 for the sabotage of a Jordanian peace initiative with Shimon Peres, as part of Likud-backed effort to make Jordan into "Palestine." Israeli secret intelligence has been charged with involvement in the arms trade, blood diamonds, and the drugs trade from Afghanistan to Panama, Uruguay, and Colombia. Israel sells weapons to any regime— military juntas, countries in the throes of civil war, and known human rights abusers. For example, the Guatemalan army received weapons from Israel between 1977 and 1981, a time when tens of thousands of people "disappeared" in

that country. And Israeli arms were shipped to the Medellin drug barons in Colombia, where "retired" Mossad chief of clandestine operations, Mike Harari, armed and trained the Medellin drugs cartel, according to Cockburn and others.

During the 1980s, in his capacity as trusted advisor to the Panamanian General Manuel Noriega, Harari oversaw a huge sale of Israeli weapons to Panama, allegedly paid for with the proceeds of the Colombian narcotics trade. Harari recruited Israeli "retired" military as Noriega's bodyguards. According to Noriega's former intelligence chief Jose Blandon, in his testimony as chief US government witness against Noriega in 1988, Harari was also working for US intelligence and the Reagan White House by secretly (and illegally) channeling arms to the Nicaraguan Contras. Those arms were, conveniently, paid for by proceeds of the South American cocaine and drugs trade in US cities.

Blandon told a US court, "Harari was part of the Noriega business. They moved the cocaine from Colombia to Panama." Blandon added that the CIA had known of the Noriega–Colombia drugs cartel ties since 1980, and that "since 1980 Israel has supplied arms to Central America." Naturally, Noriega was sent to a US prison. No word of Harari's role or Israel leaked into US media accounts, and Harari "retired" to Tel Aviv.[36] Among his mementos are letters of "appreciation" for his efforts to forge closer ties between Israel and Panama, signed by Shimon Peres and Prime Minister Yitzhak Shamir. Several days before Noriega was arrested during the US invasion of Panama in 1988, Harari was given US approval for "safe passage" to Israel, in an Israeli cargo plane reportedly loaded with documents and files.

By 1981, Washington and Tel Aviv had agreed to a Memorandum of Understanding which read: "US–Israeli strategic cooperation is designed against the threat to the peace and security of the region caused by the Soviet Union or Soviet-controlled forces from outside the region,

introduced into the region." That agreement provided for pre-positioning of US military supplies within Israel, technological support for the Israeli defense industry, and Pentagon purchases of Israeli defense products, including ultrasensitive Israeli software. That same year—1981—the Israeli air force, with American assistance, bombed Iraq's Osirak nuclear reactor.

Selling arms to countries boycotted by other arms exporters was the way Israel become a leading arms exporter. Israel often acts as a secret broker to sell US arms and weapons systems in areas where Washington might be "embarrassed" to directly sell its weapons.

Arms Trade Star

Israel's role as the "bad boy" of international arms sales was clear in the 1985 Irangate affair, when it acted as a proxy for the US by shipping US arms to Iran. The funds were then used to back the Contras in Nicaragua. According to the independent NGO Saferworld, UK-based arms brokers organized arms transfers from Israel to Rwanda during the genocide in 1994, despite a UN embargo.

The September 2004 issue of Israel's *High-Tech & Investment Report* boasted that Israel accounted for 12 percent of the world's military exports. "Israel's military export sales of $2.5–$3.5 billion represent a 10 percent–12 percent share of the world's military-related production," it read. "According to Israel Defense Ministry Director General Amos Yaron, total global military sales are estimated at $30 billion. Yaron said that 80 percent of Israel's military production is now destined for overseas customers." The article added that the principal customer in the past was the Israel defense forces, which bought some 80–90 percent of local military production. This change in allocation can be attributed to the Israeli Defense Fund's reduced demand for locally produced military

products. The article went on to say that Israel also exports "surpluses" of weapons and tanks no longer in IDF service, worth some $125 million annually.[37]

Israel's defense exports hit an all-time high in 2003, when contracts for defense industry deals with foreign armies reached $4.18 billion—a rise of nearly 70 percent over 2001. Today, Israel exports some 75 percent of its weapons production, indicating that the arms industry is hardly defensive in character.

Despite its tiny population, Israel is the world's fifth largest arms exporter. (The world's leading arms exporters are first the US, followed by the EU, Russia, and Japan.) Israel's greatest achievement is that while other countries manufacture and sell military hardware such as tanks, planes, and ships, Israel's specialty is electronics systems and high-tech military equipment. Only about 40,000 people are employed by the local industry, far fewer than the number employed in military industries in the US and Europe.

Israel's backlog of orders for weapons and defense equipment in 2002 was equal to Russia's in 2001. For the first time, Israel's arms exports in 2002 put it in third place, after the US and Russia. In 2001, it was in sixth place but did not lag far behind France. This speaks volumes about the nature of Israel, which is one of the most militaristic societies in the world. According to the German peace research organization Bonn International Center for Conversion, Israel ranks first in the world in terms of military spending per capita—$1,466 in 2003. (The US ranked third, behind Singapore.) In terms of number of weapons held per capita, Israel also achieved top ranking in the world, with 2.6 weapons for every man, woman, and child in the country.

In the Yom Kippur War of 1973, the Israeli army was threatened with invasion on two fronts: from Syria in the north and Egypt to the southwest. Experiencing difficulty in fighting simultaneously on two fronts, there was a moment in

this war when the Arab nations had a clear advantage. However, one week into the war, Nixon, on Kissinger's advice, sent two aircraft carriers from the Sixth Fleet with supplies. The 22,000 tonnes of the latest weaponry and munitions were enough to turn the war in Israel's favor.

Apart from the awesome support it receives from Washington, Israel has its own weapons program. Its F-15 and F-16 fighter jets have better digital technology than US aircraft, and the same holds for its force of around 4,000 tanks.

As far as mobilization is concerned, Israel has the capacity to call up reserves to active duty at a moment's notice, making it the strongest army in the world in its capability for rapid deployment. Similarly, its air force can fly 4,000 missions a day, every day, compared to the capacity of the US air force, which can achieve only 1,600 missions.

The exact size of the Israeli armed forces is classified. However, it is estimated that the air force has 459 combat aircraft, including 237 F-16s, 73 F-15s, and 50 F-4e 2000s, with 37,000 air crew. The navy has 53 patrol boats and four submarines, with 6,500 effective full-time sailors. As for land-based equipment, there are estimated to be some 3,800 combat vehicles, including 1,100 Merkava I/II/III, 800 Centurions, 600 M-60A3, 400 Magach, 7,300 each M-60A1 and M-48A5, and some 130,000 personnel. The total of around 173,500 military can be instantly boosted by 600,000 trained reservists.

The seeds of this militarism go back to the founders of modern Israel.

More recently, according to the UK group Campaign against Arms Trade, Israel has sold air-to-air missiles and F-7 fighter upgrades to the military junta in Burma, and in 1997 it upgraded Cambodia's MiG-21s and supplied avionics for L-39 trainers—at a time when the country was on the verge of civil war. China and Zambia are also customers of Israel, despite the fact that the US either embargoes or severely restricts its own arms sales to these countries. It was

also reported that the UN asked Israel to stop supplying Ethiopia and Eritrea with arms when they were at war with each other. Pariah state Zimbabwe has also become a customer with a $10 million order for riot control vehicles from the Beit Alfa Trailer Company.

Israel appears to work on the basis that weapons should be sold to anyone who wants them. David Ivri, an advisor to the Israeli Defense Ministry who was instrumental in bringing about the Israeli–Turkish accord, was asked by the *Jerusalem Post* in 1997 whether Israel takes human rights into consideration when it sells arms to other countries. Ivri replied: "Israel to this day has a policy of not intervening in the internal matters of any country in the world. We don't like it when others interfere in our internal matters. For this reason, our policy doesn't touch on such matters."[38] India is a case in point. Since it normalized relations with Israel in 1992, the two countries have agreed serious and substantial contacts around military and security issues. It has been alleged that Israel played a role in the development of India's nuclear program. In fact, *Jane's Defence Weekly* reported that India's top nuclear scientist, Abdul Kalam, visited Israel twice in 18 months before India's five nuclear tests at the Pokhran range in 1998. *Jane's* also revealed that Israel has recently upgraded its Jaguar bombers, made by India under license from the UK, to enable them to carry nuclear weapons.

Israel is now India's second largest supplier of weapons and military equipment, with military transactions signed or in the pipeline exceeding $3 billion. Defense analysts predict that Israel's exports are set to overtake those of Russia, India's traditional military trading partner. High-level visits, the most recent of which was from Israel's Foreign Minister Peres in January 2002, have secured this burgeoning friendship. The two countries now exchange intelligence on Islamic terrorism, and India has granted Israel access to its new reconnaissance satellite.

Turkey is also a major ally, despite the nominal role of the Muslim regime there. Israel and Turkey have in fact forged a military alliance that has redrawn the strategic map of the Middle East. One key target of this partnership is Syria. Israel hopes that pressure from Turkey along Syria's northern frontier will force Syria to the negotiating table over the Golan Heights.

This particular alliance began in May 1994, with a security and secrecy agreement 'and was secured by other treaties throughout the 1990s. Turkey and Israel also use each other's air space, and Israel has been willing to sell Turkey top-of-the-range military hardware.

American Aid to Israel

Israel's rise to prominence could not have happened without the support of the pro-Israel evangelical right in America and the financial and political backing of the US as a whole. The US is also a major supplier of arms to Israel. And astonishingly for the rich nation that Israel is, it is still the largest single nation to receive US economic, military, and development aid—$3.5 billion in military and economic aid, and an additional $9 billion in guaranteed loans in 2005, according to the influential American Israel Public Affairs Committee, the main pro-Israel lobby group in Washington.

This was admittedly a relationship that needed nurturing in the early years. As Norman Finkelstein points out in *Holocaust Industry*,[39] for some time after 1948, the US was reluctant to become a major source of arms to Israel, regarding Saudi and Arab oil ties to be far more strategic. But all that changed after the Six Day War, following the failure of the US and the Soviet Union to reach an understanding on limiting the supply of arms to the Middle East, and the arms embargo imposed on Israel by France. From then on, the US became Israel's main source of sophisticated weaponry and

their special relationship grew. Israel invested huge resources and manpower in this effort.

The two countries engaged in joint exercises and training programs, and the US assisted Israel in its project to produce its own Lavi fighter aircraft, shelved in 1987 due to cost overruns. In 1986, Israel joined the US Strategic Defense Initiative, also known as "Star Wars." And in 1987, Israel and the US signed a Memorandum of Understanding which formally acknowledged Israel as a non-NATO ally with the same rights as NATO allies. This allows Israel to tender for US military contracts—that is, highly privileged access to the innermost US military operations.

The 1991 Gulf War against Iraq was a major source of tension between Israel and the US, as the US courted Arab states and tried to appease them over Palestine. However, for refraining from retaliating against Saddam's Scud missile attacks, Israel was well rewarded in 1991 with $1.2 billion of additional aid. In fact, ironically, it seems likely that arms will be the reward for any future peace deals. It was also reported that the US had pledged $1.2 billion in additional aid to Israel to fully implement the 1998 Wye Accord, which set out a further Israeli withdrawal from the West Bank. (In the event, this was not achieved, so Israel did not receive the extra money.) When an agreement with Syria was under discussion, Israel presented the US with a $17 billion wish-list.

Israel is an advanced, industrialized, technologically sophisticated country. Its per capita income is nearly $18,000, putting it among the top 20 most prosperous countries. Despite this, Israel has benefited more than any other country from US assistance: some estimates put total US aid to Israel since 1949 as high as $92 billion. This includes Foreign Military Assistance (FMA) and Economic Support Funds (ESFs).

ESFs are provided on a grant basis and are available for a variety of economic purposes, such as infrastructure and

development projects. Although not intended for military expenditure, these grants allow the recipient to free up its own money for military programs. ESF aid to Israel has historically been considered "security assistance" since it is provided out of strategic considerations rather than development needs. In fact, Israel's annual ESF grant is explicitly provided to allow repayment of past military debt owed to the US.

Every year for more than two decades, Israel has received $1.8 billion in FMA plus $1.2 billion of ESFs from Washington. This equals more than a third of all Israeli military spending during the 1980s. Now it constitutes 20 percent of Israel's annual military budget. In 2001, Israel received $1.98 billion in FMA, which is half of all FMA budget requests. As if this weren't enough, at the beginning of 2002, the US announced that it would be giving Israel an extra $28 million to buy counterterrorism equipment. Since giving economic aid to an advanced industrial economy no longer seems appropriate, Israel's portion of ESF funding will be gradually phased out by 2008, to be compensated for by an increase in FMA funding to $2.4 billion a year. Because all but 26 percent must be spent in the US on goods and services, many Israeli firms will be forced to shift production to the US in order to qualify for dollar-based sales.

Israel also benefits from other American methods for transferring arms, such as surplus defense articles, a system whereby the US gives away older equipment at little or no cost. Following the 1991 Gulf War, the US gave Israel surplus Apache attack helicopters, Blackhawk transport helicopters, multiple-launch rocket systems, and Patriot tactical anti-missiles. By contrast, such surplus defense articles are sold at astronomical prices to Arab Gulf states.

"Offsets"—incentives that weapons manufacturers use to persuade countries to sign deals—are another practice that has been of considerable benefit to Israel. Lockheed Martin, for example, agreed to spend $900 million in Israel to secure

a $2.5 billion F-16 sale. Boeing agreed to a $750 million investment for the sale of F-15I fighters and Blackhawk helicopters. Israel even demands offsets on FMA-financed sales, which means that the US pays twice, first through taxation, then through the economy at large. US taxpayers are therefore subsidizing huge US arms companies while arming Israel to the teeth and sponsoring a regional arms race.

From 1997 to 2000, US arms sales to Israel were worth $9.87 billion. In 2001 alone, sales came to $2.95 billion. Although Israel is a customer to a number of American military manufacturers—Raytheon, American Ordnance, Boeing, General Electric and Sikorsky, to name but a few—by far its biggest supplier is Lockheed Martin, which has received at least $4.4 billion for arms sales to Israel since 1995.

Lockheed Martin has a number of outstanding orders from Israel for F-16s and related equipment, in particular for 52 F-16Is worth $2 billion, for delivery between 2006 and 2009, a follow-on to a $2.5 billion contract for 50 F-16Is signed in 1999. These are deals approved by the Pentagon and financed by US military aid. Little surprise that former Lockheed Martin vice-president Bruce Jackson was a key member of the neoconservative "educational" organization Project for a New American Century, which advocated war against Iraq back in 2000.

For its part, the US is a huge customer of Israeli-made military goods and many American companies have agreements with Israeli companies on upgrades, missiles, unmanned aerial vehicles, and the like.

The question is, why does Israel continue to be the largest recipient of US military assistance? Today, with the threat of Soviet expansionism replaced in Washington's eyes by the threat of Islamic fundamentalism, Israel has retained its strategic value. Since 9/11, Israel has presented its actions in the West Bank and Gaza as part of the fight against

international terrorism. But this has created a difficult balancing act for the US. While it successfully garnered support to conduct the war against the Taliban and al-Qaeda in Afghanistan, it is finding it difficult to drum up support from Arab countries for military action against Iraq because of its continued backing of Israel.

Despite continued White House support, the US Export Control Act stipulates that "US weapons sold abroad can only be used for legitimate self-defense." Given recent Israeli military strong-arm tactics and mounting criticism from European and Arab countries, even the US military trade press has voiced concern. On February 3, 2002, an editorial in *Defense News* stated:

> A strong argument can be made that precision attacks on arms caches and militants en route to terror operations are legitimate acts of self-defense. The wholesale destruction of homes, livelihoods and Palestinian national symbols—government offices, media outlets, police headquarters—is not.

Yet on May 2, 2002 the US Congress overwhelmingly passed a resolution supporting Israel's military campaign.

Despite Israel's impressive domestic military industry, the Israeli Defense Ministry has said that US supply is critical because "it is impractical to think that we can manufacture helicopters or major weapons systems of this type in Israel."[40] Without financial subsidies from the US and political support, Israel would have found it considerably more difficult to sustain its military occupation of Palestinian territory over the past 35 years.

Leading circles in the US political elite have found the partnership with Israel highly useful. The charge by some conservatives, such as Pat Buchanan, that US politics has somehow been subverted and taken over by sly Israeli agents is a myth. They would not have got near the front door of the Pentagon or the CIA if the US establishment had not invited them in.

Israel and America: The Future

Israel's pervasive military culture has won many admirers in the Pentagon and elsewhere in Washington, especially since the war. The US has condoned, embraced, and encouraged this culture through its steadfast financial and military support of Israel. Today, US taxpayers spend approximately $3 billion annually to subsidize, support, and arm Israel. Although Israel is a wealthy country, it receives more foreign aid—28 per cent—from the US than any other country.

The depth of America's relationship with Israel is not usually aired in public discussions, especially in the US, where most ordinary Americans have no idea how dependent their country's foreign and security policy has become on that of a foreign country with its own agenda.

In August 2006 British newspapers such as the *Guardian* and the *Independent* reported how American planes carrying weapons for Israel's blitzing of Lebanon and Palestine stopped off in Britain for refueling. In 2002, the Russian newspaper *Pravda* reported an item largely ignored in the Western media.[41] It read: "There is a secret military agreement between the USA and Israel by which Israel can use massive deposits of arms supplied by Washington in the event of a Middle East war."

Pravda continued:

> Over the years, Washington has supplied Israel with millions of tonnes of weaponry, currently $3 billion worth a year, much of which is stashed in underground bunkers. This huge cache of arms has munitions, fuel and even a hospital and should Israel need to access it one day; there is a secret military agreement with the USA which will allow them to do so. The exact terms are unknown.

After 1967, the US military-industry complex realized the enormous benefit of cooperating with Israel in operations to sell US weapons around the world, especially after the collapse

of the Soviet Union threatened an outbreak of peace and global disarmament. The global defense industry today is a $1 trillion annual business, and the US and Israel are dominant players. Israel also has numerous friends in and around Wall Street financial firms and banks, who gained enormous profits from being in the know about Israeli foreign policy goals.

This combination of US defense military interests, combined with multinational US oil and energy interests, with Wall Street finance and the CIA, explains in part the enormous influence of Israel on Washington policy over the past 30 years. The rest is amply explained by the 4–7 million members of pro-Israel evangelical organizations on the American right wing, and the perhaps 60–85 million Americans who vaguely believe in some vision of a final Armageddon. This small minority is effectively dictating US foreign and domestic policy since Bush became president.

Former Archbishop of Cape Town and Nobel laureate Desmond Tutu published his views on Israel in "Apartheid in the Holy Land," an April 2002 article in the *Guardian*:[42]

> In our struggle against apartheid, the great supporters were Jewish people. They almost instinctively had to be on the side of the disenfranchised, of the voiceless ones, fighting injustice, oppression and evil. I have continued to feel strongly with the Jews. I am patron of a Holocaust centre in South Africa. I believe Israel has a right to secure borders.
>
> What is not so understandable, not justified, is what it did to another people to guarantee its existence. I've been very deeply distressed in my visit to the Holy Land; it reminded me so much of what happened to us black people in South Africa. I have seen the humiliation of the Palestinians at checkpoints and road-blocks, suffering like us when young white police officers prevented us from moving about.
>
> On one of my visits to the Holy Land I drove to a church with the Anglican bishop in Jerusalem. I could hear tears in his voice as he pointed to Jewish settlements. I thought of the desire of Israelis for security. But what of the Palestinians who have lost their land and homes?

I have experienced Palestinians pointing to what were their homes, now occupied by Jewish Israelis. I was walking with Canon Naim Ateek (the head of the Sabeel Ecumenical Centre) in Jerusalem. He pointed and said: "Our home was over there. We were driven out of our home; it is now occupied by Israeli Jews."

My heart aches. I say why are our memories so short? Have our Jewish sisters and brothers forgotten their humiliation? Have they forgotten the collective punishment, the home demolitions, in their own history so soon? Have they turned their backs on their profound and noble religious traditions? Have they forgotten that God cares deeply about the downtrodden? ...

Israel will never get true security and safety through oppressing another people. A true peace can ultimately be built only on justice. We condemn the violence of suicide bombers, and we condemn the corruption of young minds taught hatred; but we also condemn the violence of military incursions in the occupied lands, and the inhumanity that won't let ambulances reach the injured.

The military action of recent days, I predict with certainty, will not provide the security and peace Israelis want; it will only intensify the hatred ...

But you know as well as I do that, somehow, the Israeli government is placed on a pedestal [in the US], and to criticize it is to be immediately dubbed anti-Semitic, as if the Palestinians were not Semitic. I am not even anti-white, despite the madness of that group. And how did it come about that Israel was collaborating with the apartheid government on security measures?

People are scared in this country [the US] to say wrong is wrong because the pro-Israel lobby is powerful—very powerful. Well, so what? For goodness' sake, this is God's world! We live in a moral universe. The apartheid government was very powerful, but today it no longer exists. Hitler, Mussolini, Stalin, Pinochet, Milosevic, and Idi Amin were all powerful, but in the end they bit the dust ...

No less than an American president shared Tutu's conviction that Israel's actions in Palestine are indeed apartheid as the title of his latest book, *Palestine: Peace not Apartheid*, suggests. In an interview with *Newsweek* (January 1, 2007, p. 120), titled "Revisiting Apartheid," Jimmy Carter, asked if

he agonized about using the word apartheid, replied:

> Not really. I didn't agonize because I knew that's an accurate
> description of what's going on in Palestine. I would say the
> plight of the Palestinians now—the confiscation of their land,
> that they are being completely against voicing their disapproval
> of what's happening, the building of the wall that intrudes deep
> within their territory, the complete separation of Israelis from
> Palestinians—all of these things in many ways are worse than
> some aspects of apartheid in South Africa. There is no doubt
> about it and no one can go there and visit the different cities in
> Palestine without agreeing with what I have said.

Newsweek asked Carter why his new book is under attack.
Carter answered:

> You and I know the power influence of AIPAC [the American
> Israel Public Affairs Committee], which is not designed to pro-
> mote peace ... but their purpose in life is to protect the policies
> of the Israeli government and to make sure those policies are
> approved in the United States and in our Congress—and they
> are effective at it ... And any member of the Congress who's
> looking to be re-elected couldn't possibly say that they would
> take a balanced position between Israel and the Palestinians, or
> that they would insist on Israel withdrawing to its international
> borders, or that they would dedicate themselves to protect the
> human rights of the Palestinians—it's very likely they would not
> be re-elected.

Carter added that the media in the US is not balanced and "any
sort of incisive editorial comment in the major newspapers is
almost absent."

Why Crusade for Israel?

Are people in the US really scared because of the powerful
pro-Israel lobby, as suggested by the Nobel Prize laureate
Reverend Desmond Tutu as quoted earlier? Or is it because
Israel and the US have strategic interests in common? John
Mearsheimer of the University of Chicago and Stephen Walt

of the John F. Kennedy School of Government at Harvard University seem to agree with the Tutu in their 87-page study. They conclude:

> For the past several decades, and especially since the Six-Day War in 1967, the centerpiece of US Middle Eastern policy has been its relationship with Israel ... Why has the US been willing to set aside its own security and that of many of its allies in order to advance the interests of another state? One might assume that the bond between the two countries was based on shared strategic interests or compelling moral imperatives, but neither explanation can account for the remarkable level of material and diplomatic support that the US provides.
>
> Instead, the thrust of US policy in the region derives almost entirely from domestic politics, and especially the activities of the 'Israel Lobby.' Other special-interest groups have managed to skew foreign policy, but no lobby has managed to divert it as far from what the national interest would suggest, while simultaneously convincing Americans that US interests and those of the other country—in this case, Israel—are essentially identical.
>
> Since the October War in 1973, Washington has provided Israel with a level of support dwarfing that given to any other state. It has been the largest annual recipient of direct economic and military assistance since 1976, and is the largest recipient in total since World War Two, to the tune of well over $140 billion (in 2004 dollars). Israel receives about $3 billion in direct assistance each year, roughly one-fifth of the foreign aid budget, and worth about $500 a year for every Israeli. This largesse is especially striking since Israel is now a wealthy industrial state with a per capita income roughly equal to that of South Korea or Spain.
>
> Other recipients get their money in quarterly installments, but Israel receives its entire appropriation at the beginning of each fiscal year and can thus earn interest on it. Most recipients of aid given for military purposes are required to spend all of it in the US, but Israel is allowed to use roughly 25 per cent of its allocation to subsidies its own defense industry. It is the only recipient that does not have to account for how the aid is spent, which makes it virtually impossible to prevent the money from being used for purposes the US opposes, such as building settlements on the West Bank. Moreover, the US has provided Israel with

nearly $3 billion to develop weapons systems, and given it access to such top-drawer weaponry as Blackhawk helicopters and F-16 jets. Finally, the US gives Israel access to intelligence it denies to its NATO allies and has turned a blind eye to Israel's acquisition of nuclear weapons.[43]

The injustice done to the Palestinian Arabs was well understood by Israel's early leaders. David Ben Gurion told Nahum Goldmann, president of the World Jewish Congress, as quoted by Mearsheimer and Walt:

> If I were an Arab leader I would never make terms with Israel. That is natural: we have taken their country ... We come from Israel, but two thousand years ago, and what is that to them? There has been anti-Semitism, the Nazis, Hitler, Auschwitz, but was that their fault? They only see one thing: we have come here and stolen their country. Why should they accept that?

Ben Gurion was right!

7
Oil and God

A MERICAN NEOCONSERVATISM COMES IN
many forms. The Bush Doctrine and the Project for a
New American Century may seem products peculiar
to our times, as the prefix "neo" suggests. But the phenomenon
is, in fact, nearly identical to a philosophy aired in the early
1940s by one of the most prominent conservatives of the day,
a media mogul with impeccable elite credentials.

In a 1941 *Life* editorial "The American Century," *Time*
magazine publisher Henry Luce announced the goal of
American world domination at the start of the war. He wrote:
"We must accept whole-heartedly our duty and our opportu-
nity as the most powerful and vital nation in the world and in
consequence to exert upon the world the full impact of our
influence, for such purposes as we see fit and by such means
as we see fit."[1] The editorial was reprinted and circulated
widely, appearing in full in the *Washington Post* and, for
good measure, in the mass-selling *Reader's Digest* to give it a
global audience. Although he did not include the point in this
editorial, Luce would soon argue, also in the pages of *Life*,
for pre-emptive nuclear war against the Soviet Union.

Inside the Establishment

It is interesting to note that George W. Bush echoed Luce's
words—"our duty and our opportunity"—in his West Point
address announcing the Bush Doctrine of pre-emptive warfare.

It hints that the American elite share a common, longstanding preoccupation with world domination and pre-emption. Pre-emption certainly seems to have characterized much US-inspired conflict: it can be argued that the Cold War, CIA covert wars, and overt American wars were mostly unprovoked, pre-emptively waged, and fought more often than not on false pretexts.

But there is another factor at work here. While the US and Britain seem eager to preach democracy to the Arab and Muslim world, their own practice of representative government relies on power elites who decide for the masses, just as anywhere else in the world. Among the power elite in America, there are two parallel institutions, both facets of what has, for decades, been called "the establishment." I would regard one of these as an unelected permanent establishment, and this is the more powerful of the two. It includes such bodies as the think-tank the Council on Foreign Relations, the Bilderberg conferences (see Chapter 3), the Trilateral Commission, and "Skull and Bones," Yale University's "secret" society. Both the American presidential candidates in 2004, George W. Bush and John F. Kerry, were members of "Skull and Bones," as was Henry Luce. A coincidence? From where I sit, and given my knowledge of those in power in America, I think not. The permanent establishment operates both overtly and covertly and makes decisions behind closed doors for Americans, and now for the world, on what is to be and what not to be.

The less important of the two institutions is made up of elected officials and is which I call the "temporary establishment." Members of this establishment are normally selected, trained, promoted, and financed by the permanent establishment, and campaign for election with an agenda that has already been decided for them by the permanent establishment. The lifeblood of elected officials comes from the permanent establishment, whether it is contributions for election campaigns,

public relations, or the qualified and loyal personnel needed to execute that agenda.

Carroll Quigley of Georgetown University, Washington, a Pentagon consultant, who taught international relations to Bill Clinton and others,[2] was quoted in Roger Morris's volume *Partners in Power*. Quigley, says Morris, "was especially impressed by the old foreign affairs establishment, part of a larger Anglo-American financial and corporate elite and what he called a 'power structure' between London and New York which penetrated deeply into university life, the press, and the practice of foreign policy."

Morris goes on to say that Quigley saw "the prestigious Council on Foreign Relations as à concerted, if not conspiratorial international network." He taught his students that the platforms of both the Republican Party and the Democratic Party are identical, and this is how he thinks it ought to be. A student of Quigley's commented to Morris: "It won't matter whom you vote for on November 3."

In his bestselling *Who Will Tell the People?*, William Greider expands on this theme:

> American democracy is in much deeper trouble than most people wish to acknowledge. Behind the reassuring facade, the regular election contests and so forth, the substantive meaning of self-government has been hollowed out ... At the highest levels of government, the power to decide things has instead gravitated from the many to the few, just as ordinary citizens suspect. Instead of popular will, the government now responds more often to narrow webs of power—the interests of major economic organizations and concentrated wealth and the influential elites surrounding them ... The rich and complicated diversity of the nation is reduced to a lumpish commodity called "public opinion" that is easily manipulated by the slogans and imagery of mass communications.[3]

The commonly held belief among ordinary Americans that a small elite is running the show goes back a long way. A mutual distrust between elite and public seems to have begun

with the Founding Fathers. William Polk, a former history professor at Harvard University, a high-ranking official of the Kennedy administration and author of ten books, wrote in "The Virtues and Perils of the American Political System":[4] "The people, the Founding Fathers believed, could not be relied upon, they were often lazy, ignorant and subject to manipulation by tyrants." One may assume that the system set up by George Washington, Benjamin Franklin, Thomas Jefferson, and the rest was not able to stand up in the face of the tyranny of corporate wealth and corporate media, as the people and politicians are now indeed manipulated.

Walter Lippmann, a media icon of the permanent establishment in the twentieth century, divided America's class system into a "special class"—"the responsible men" whose business was to define the national interest—and a largely ignorant "public," who must be steered by that special class. The economist and writer F. William Engdahl quotes Lippmann's view in *Century of Wars*:[5] "This elite would become the dedicated bureaucracy to serve the interests of private power and private wealth, but the truth of their relationship to the power and private wealth should never be revealed to the broader ignorant public. They wouldn't understand." He continues: "The general population must have the illusion that it is actually exerting 'democratic' power. This illusion must be shaped by the elite body of 'responsible men' in what was termed as 'the manufacture of consent'." This "dedicated bureaucracy" is what I call the temporary establishment.

A People Disenfranchised

That the people of the US only believe they exert political power is also stressed by Polk:

> Americans have rarely shown a commitment to using and defending their right to choose the representatives who will

enact the laws under which they must live. Low voter turn-out has been endemic. Even at the time of foundation of the nation, 3 out of each 4 of the 640,000 free adult males did not bother to vote even for delegates to ratify the Constitution.[6]

The Constitution, even when ratified, has been treated in a cavalier fashion over the course of US history. As Polk writes: "the consensus that the Constitution is the absolute law of the land has not, however, always been honored. Particularly in times of stress, provisions, especially those pertaining to civil liberties, have been set aside or violated." Five such periods are mentioned by Polk, in addition to the recent Patriot Act:

- The Aliens and Sedition Acts were signed in 1798, forbidding the publishing of any material that might incite opposition to the president or Congress. They were repealed after four years.
- In the Civil War years, 1861–65, the fundamental right of habeas corpus was suspended by President Lincoln.
- The Espionage Act of 1917 was used by Attorney General Alexander Palmer and J. Edgar Hoover to arrest without charge hundreds of dissidents after the Russian Revolution.
- During World War II, American-Japanese or Japanese residents were arrested and "incarcerated without due process of law."
- During the McCarthy period in the early 1950s, which was fueled and directed by the FBI, many prominent civil servants were sacked on the basis of false accusations. Even George Kennan, says Polk, "the father of both the Marshall Plan and the policy of Containment, was a major victim. When he was 'purged' from the State Department, as he describes in his memoirs, he could find no one to whom to say goodbye, so fearful of associating with him were his fellow officers."

The controversial Patriot Act was passed in 2001. It gives the Attorney General powers of arrest and monitoring of e-mail

and telephone communications, computer records and book-store purchases, and can allow detention without due process of law. Yet as we can see from the list above, the torture, secret prisons, and jailing of 9/11 suspects at Guantánamo Bay are just one chapter among many in American history.

But what about the neoconservatives themselves? An article in the *Christian Science Monitor*, entitled "Empire Builders,"[7] touches on some of the crucial figures among the neocons.

Irving Kristol is widely referred to as the godfather of neoconservatism. A member of the New York intellectual elite, a core group of critics who are mainly of Eastern European Jewish descent, he studied at City College, New York in the 1930s. Here he became a Trotskyite, but later moved from the extreme left to the extreme right. From 1947 to 1952, he was managing editor of *Commentary* magazine, later known as the "neocon bible."

Norman Podhoretz is another of neoconservatism's founding fathers, a scholar, writer, and speaker on social, cultural, and international issues. From 1990 to 1995, Podhoretz worked as editor-in-chief of *Commentary*. He has written nine books, including *Breaking Ranks* (1979), in which he argues that Israel's survival is crucial to US military strategy.

Paul Wolfowitz is a relatively recent neocon. He served as Undersecretary of Defense for policy from 1989 to 1993 in charge of a team of 700 who had major responsibilities for the reshaping of military strategy and policy at the end of the Cold War. With Lewis Libby (see below), he co-authored the 1992 draft *Defense Planning Guidance*, which called for US military dominance over Eurasia and the policy of pre-emptive war. This document became the core of the Bush Doctrine of 2002. Wolfowitz advocated extending the aims of the 1991 Gulf War to include toppling Saddam Hussein's regime. He served as deputy Undersecretary of Defense in the first George W. Bush administration and was nominated

to head the World Bank in 2005. Wolfowitz, a declared pro-Israeli, stated that the doors to Jerusalem are through Baghdad. As a former Secretary of Defense, he played a key role in managing the events that led to the Iraq invasion.

Chief architect of the "creative destruction" agenda to reshape the Middle East—starting with the invasion of Iraq—is Richard Perle. Perle outlined parts of his agenda in 1996 in *A Clean Break: A New Strategy for Securing the Realm*, a key report for Israel's right-wing Likud Party. Perle has also helped establish two think-tanks—the Center for Security Policy and the Jewish Institute for National Security—is a director of Israel's English daily *Jerusalem Post*, and was chairman of the Pentagon's Defense Policy Board until he had to leave the Department of Defense in March 2003 due to a "conflict of interest."

Another "new-style" neocon is Douglas Feith, until 2005 US Undersecretary of Defense for policy. Feith is well known for his support of Israel's right-wing Likud Party. In 1997, he was honored by the Zionist Organization of America along with his father, Dalck Feith, who was active in a Zionist youth movement in his native Poland for services to Israel and the Jewish people. Other members of this exclusive power elite are former CIA director William Woolsey, John Bolton, Richard Haass, Elliot Abrams, and Abram Shulsky.

There are two other major influences on group. The first is Leon Trotsky. As young men, all members of the group were influenced by Trotskyism, the central tenet of which is permanent revolution—an obvious inspiration for the idea of perpetual wars and pre-emptive war when they switched from the extreme left to the extreme right. The second influence is Leo Strauss, a German-Jewish immigrant who became professor of political science at the University of Chicago. Strauss preached "the natural right of the stronger," which is itself a natural precursor to the notion of the right to pre-emption.

Bankrolling Power

As we have seen in earlier chapters, there is a difference between previous transformational periods in American history and today's: the sheer speed of change, driven by the huge amounts of currency created and traded within a volatile global economy. The 1990s boom simply masked an economic meltdown that has now made it necessary for the US, with its astronomical deficits and costly wars, to find ever greener pastures to fuel its economy.

This urge has driven US policy for decades. The United States' desire for a world empire has long been an open secret among policymakers of the permanent and temporary establishments. George Kennan, former US Ambassador to Moscow and architect of the Cold War "containment" policy, was blunt about the real goal of the elite—world domination, or domination of as much of it as was possible in 1948.

So Leo D. Welch, later chairman of the Rockefellers' Standard Oil Company, was prescient when he called on Washington, in 1946, "to set forth the political, military, territorial and economic requirements of the United States in its potential leadership of the non-German world area, including the United Kingdom itself, as well as the Western hemisphere and the Far East."[8] In other words, Welch called on the US to make steps towards dominating the entire post-war world barely after the war had come to an end. Welch went on, "As the largest source of capital, and the biggest contributor to the global mechanism, we must set the pace and assume the responsibility of the majority stockholder in this corporation known as the world ... nor is this for a given term of office. This is a permanent obligation."

By far the most influential voice in this post-war planning period was that of a secret group organized by the private New York Council on Foreign Relations (CFR), the club for the US foreign policy elite since the Versailles Treaty talks set

up at the end of World War I. In 1940, a full year before Japan bombed Pearl Harbor and triggered the United States' declaration of war on the Axis Powers, the CFR's Economic and Financial Group wrote:

> The first and foremost requirement of the United States in a world in which it proposes to hold unquestionable power is the rapid fulfillment of a program of complete re-armament ... to secure the limitation of any exercise of sovereignty by foreign nations that constitutes a threat to the minimum world area essential for the security and economic prosperity of the United States.[9]

The CFR was a force to be reckoned with. It had been set up as an adjunct to the powerful banking interests of J. P. Morgan and the Rockefeller group. The treasurer of Standard Oil, Charles Pratt, donated his 68th Street mansion for the CFR's New York headquarters. The CFR established sister organizations and branches in Canada, South Africa, New Zealand, Australia, Sweden, the Netherlands, India, and Japan. Since the Rockefeller group and the J. P. Morgan group had drafted the legislation that created a private Federal Reserve System to control America's money and banking in 1913, the Rockefeller faction and the CFR has been decisive in its policy control. In the post-war period, William McChesney Martin, Arthur Burns, G. William Miller, Paul Volcker, and Alan Greenspan have all served as heads of the world's most powerful central bank, the Federal Reserve. All were first members of the CFR.

Today there are just over 3,000 members, prominent figures with a place in government, both major political parties, banking, and private industry. They control all major media from television to newspapers to radio—which the CFR recognized as a key factor from the start. For instance, Walter Lippmann, Thomas Lamont, and other CFR members recruited journalists for all major newspapers to mold public opinion. CFR members owned the major radio stations.

The largest radio network, RCA, was part of the Rockefeller empire. After the war, when the three major television networks in the US emerged, CFR members ended up controlling all of them.

Harvard professor Samuel Huntington, a CFR member and author of the 1996 *Clash of Civilizations and the Remaking of World Order*—which posits that post-Cold War conflict centers on the fault-lines between different cultures— co-wrote an essay in 1975 called *The Crisis of Democracy*,[10] in which Huntington described the "establishment" as the real basis of US power. He wrote that postwar America was governed by the president, together with key groups in government, and "the more important businesses, banks, law firms, foundations, and media, which constitute the private sector's Establishment." He made no mention of the voting public, the supposed core of democracy.

United Nations for the United States

In 1943, during World War II, the War and Peace Studies project, a secret CFR group within the US State Department funded by the Rockefeller Foundation,[11] drafted the idea of a post-war United Nations to replace the defunct League of Nations, which had been founded in 1919. A UN Security Council veto would allow the US to exercise *de facto* control over the new agency, and thus wield power over weaker countries while avoiding the kind of overt imperial occupation that had characterized the British, French, Dutch, and other empires. As the War and Peace Studies project saw it, the emergent American elite would go about it all in a more astute way.

After 1945, the UN was to become a part of America's "informal empire." To ensure they could have some control over its activities, the Rockefeller family donated land on Manhattan's East Side for the site of the UN's headquarters.

Fittingly, the building was located within sight of Chase Manhattan Bank and the Rockefeller Center.

Rather than use colonies to build its empire, this new brand of US imperialism would use the ideology of free markets and open trade to ensure that its industry and banks would dominate and continue to grow at the expense of its rivals. In his famous *Life* magazine "American Century" article, Luce had essentially let the cat out of the bag when he said, "Tyrannies may require a large amount of living space. But Freedom requires and will require far greater living space than Tyranny." So Nazi Germany needed its *Lebensraum* in the east in Poland and Czechoslovakia—and ultimately the raw materials of Russia—but the American free market economic model (which Luce called "freedom," as Bush does today) needed a global empire, a domination of world markets in ever-greater degree, to exist.

With agencies such as the UN, with its control of new organizations of economic and financial rule, the International Monetary Fund, World Bank, and later the General Agreement on Tariffs and Trade (GATT, signed in 1947), the US emerged from World War II at the pinnacle of its power. It controlled the vast bulk of the world's monetary gold and some 40 percent of the world's wealth and industrial capacity, and had also escaped the destruction of infrastructure and economic hardship of war.

The Soviets, Chinese, Europeans (Axis and Allies alike), and Japan, by contrast, were prostrate, struggling to emerge from the ruins of war in 1945. Some saw it as the greatest coup in world history, pulled off while few even noticed: the US had become the globally dominant state even as it was perceived to be a benevolent liberator.

Even in 1945 the wealth of the US was so great that the American elite allowed Europe, Japan, and a few select allies such as South Korea to prosper, as long as they joined Washington in looting the Third World, agreed with

the US State Department to call that looting "economic development," and paid lip-service to Washington's phony "war on communism," the Cold War.

The CFR is, in essence, a first-stop resource for this kind of fantastically high-level wheeling and dealing. One influential CFR member who ran the US Department of War during the 1940s[12] explained that "whenever we needed a man, we thumbed through a roll of Council members and put through a call to New York." Twelve of the 14 "wise men" on President Johnson's secret Senior Advisory Group on Vietnam were CFR members. In 1977, all but two of President Carter's top State Department appointees were CFR members too.

Not surprisingly, Kissinger is one of this select group. He came into the fold in 1957, as an ambitious young Harvard professor, when Nelson Rockefeller hired him to head a new CFR study group on nuclear weapons and foreign policy. Kissinger's entire political career developed from his links to the Rockefeller family, although he has tried to conceal that fact. His 1958 book, *Nuclear Weapons and Foreign Policy*, came out of his CFR project, and three years later he was hired as a White House advisor by President Kennedy on the strength of it.

Preordained Policy

In 1954, CFR members recognized that they required an organization that would implement and control non-military policy in postwar Western Europe. At the Hotel Bilderberg in Oosterbeck, CFR strategists organized an ultra-elite, annual series of policy discussions—"Bilderbergs." They were hosted by Prince Bernhard of the Netherlands, who was reported in *The Times* as being bribed by the Lockheed Corporation to influence the Netherlands' purchase of fighter aircraft.[13] Bernhard, a German by birth, had served during the war as an SS officer, and was close to SS chief Heinrich

Himmler. After the war Bernhard, now known as the "playboy prince," was a useful façade behind which the US could organize its European affairs via the Bilderberg group.

Although the members of the Bilderbergs have necessarily changed over the years, the conferences typically involve some 100 leading corporate and government leaders from North America and Europe, who meet once a year at a secret location to discuss pre-planned policy initiatives. They ban all media representatives. The May 1973 Bilderberg was a particularly momentous conference, as we have seen. The group met that year at the island retreat of Saltsjobaden, owned by the Swedish Wallenberg family, to plan how to manage the proposed 400 percent hike in the price of oil within the world economy six months before the 1973 October (Yom Kippur) war.

Through to the end of the Cold War and still today, the Bilderberg meetings have proved useful to the American establishment as a way of organizing policy change in Europe in favor of American "national interests"—really the interests of the CFR policy and the banking elite. At the time, there was enough loot from the dollar empire to share with the European G7 partners.

But Japan's economy was by then on a roll. By 1973, as the combined might of the CFR, the Bilderberg group, and Rockefeller family interests imposed their bold oil shock strategy, they decided they needed to engage Japan more directly. David Rockefeller personally financed the creation of another international private entity, the Trilateral Commission, to organize this. (The term "trilateral" refers to the three great centers of American power: North America, Western Europe, and Japan.)

The commission had as its first executive director Zbigniew Brzezinski, one of Kissinger's protégés. Brzezinski had been director of the Russian Studies Institute of Columbia University. Jimmy Carter, then Governor of Georgia,

was selected by David Rockefeller to become a Trilateral founding member, and his presidency (1977–81) was dominated by Brzezinski, CFR member Cyrus Vance (formerly president of the Rockefeller Foundation), and other members of the Trilateral Commission.

At the annual meeting of the Trilateral Commission in 1975, Samuel Huntington presented *Crisis of Democracy*. Huntington was blunt: "An excess of democracy means a deficit of governability ... little ability to impose on its people the sacrifices which may be necessary to deal with foreign policy and defense."[14]

But the CFR, Trilateral Commission, and Bilderberg group are only the more visible face of the American power elite. Behind them are hidden "lodges"—networks of private, secret societies—which organize worldwide behind a power agenda.

The Control of Global Media

Since World War II and the creation of the Psychological Strategy Board, the CIA and US State Department, the CFR, and the inner circles of the US elite have devoted enormous resources to controlling the media. Since the early 1990s the major media giants have been reorganized and centralized into a few hands. The giant among today's US media groups is AOL-Time Warner, which in turn controls CBS, CNN, HBO (the largest US pay-TV network), Time magazine group (the largest magazine publisher, which includes *Sports Illustrated* and numerous others), and Warner Brothers and other Hollywood film studios. AOL is also the largest private Internet provider in the US.

The second largest US media giant is the Walt Disney Company. Disney today controls several TV production companies, including Touchstone and Buena Vista, and Hollywood film companies, including Walt Disney Motion

Pictures, Touchstone, Caravan, and Hollywood Pictures. It also owns Capital Cities/ABC, the second largest TV network with many subsidiaries in Europe.

The third member of the US media cartel is Viacom, which owns the cable sports network ESPN, *Women's Wear Daily* and Paramount Pictures, and recently bought CBS from Time Warner. Viacom controls the worldwide youth market through its hugely popular cable network MTV, Nickelodeon, and Showtime.

Australian-born media mogul Rupert Murdoch is the owner of the fourth largest US media group, News Corporation. Murdoch owns the neoconservative-oriented Fox TV, as well as the *New York Post* and numerous other newspapers, including the neocon *Weekly Standard* of William Kristol. Murdoch's former business associate Haim Saban, a Hollywood billionaire who is close to Ariel Sharon and a pro-Israel hawk, recently bought Germany's largest TV group, Pro-7 Media.

The fifth largest media conglomerate is the Newhouse Group, run by billionaire Si Newhouse. Newhouse owns twelve TV stations, 87 cable TV systems, the largest circulation Sunday magazine, *Parade*, the *New Yorker*, *Vogue*, *Mademoiselle*, *Vanity Fair*, the Cleveland *Plain-Dealer*, Newark *Star-Ledger*, and the New Orleans *Times-Picayune*.

The striking fact about this concentration of media power is that many of these top conglomerates are controlled by CFR members.

What are the implications of this "wall-to-wall carpet" of CFR control? Because the giant media companies also control small local or regional newspapers, none of them can afford to hire or use independent journalists, let alone international news bureaus. They buy their "news" from services that are already in their networks—such as those run by the *New York Times* or *Wall Street Journal*. The NYT company publishes the *New York Times*, the *International Herald*

Tribune, the *Boston Globe*, and 15 other daily newspapers; it also owns nine television stations and two New York radio stations, as well as *McCall's* and *Family Circle* magazines, and radio and TV stations. The *New York Times* News Service sells news stories to 506 papers around the US.

The Washington Post Company, besides publishing the most influential paper in Washington, also owns TV stations, eleven military publications, *Newsweek* magazine, Cable One TV, and until recently co-published the largest foreign English language newspaper, the *International Herald Tribune*, with the New York Times Company.

Under the rules passed by the Bush administration's Federal Communications Commission chairman Michael Powell—son of former US Secretary of State Colin Powell—this handful of media giants will now be allowed to merge and control even more local TV and media across America, making their control of public opinion outside the Web virtually complete. Ever since 1996, when the communications industry pressed the US Congress to give it a deregulated open field, newspapers, radio, TV, cable, and telecommunications have all been allowed to create giant global monopolies of information control in the name of "free" enterprise, while enjoying a reputation as the bastion of the "free" press.

Full-spectrum Dominance

The US commands the world's reserve currency, the dollar, through which the assets of much of the industrial world can be controlled. Following the occupation of oil-rich Iraq, the US now appears to command a near-total monopoly of future energy resources. The guardian of that global hegemony will be the US military.

In June 2000, the US Pentagon issued the report *Joint Vision 2020*, which details US military strategy in the twenty-first century. Pentagon reporter Jim Garmore described it

as follows: "'Full-spectrum dominance' is the key term in *Joint Vision 2020*, the blueprint DoD will follow in the future." This chilling and futuristic-sounding term refers to the ability of US forces alone or operating with allies to defeat all adversaries and control all possible military scenarios.

The declaration of a "pre-emptive" war became official US strategic doctrine some months later. In September 2002, a year after 9/11, the White House issued the National Security Strategy of the United States, which immediately became known as the Bush Doctrine. The Bush Doctrine outlines America's pre-emptive stance overtly for the first time:

> The United States has long maintained the option of preemptive actions to counter a sufficient threat to our national security. The greater the threat, the greater is the risk of inaction—and the more compelling the case for taking anticipatory action to defend ourselves, even if uncertainty remains as to the time and place of the enemy's attack. To forestall or prevent such hostile acts by our adversaries, the United States will, if necessary, act preemptively.

At this point, the US is admirably equipped to do so. Even at the time of 9/11, the Pentagon admitted to having more than 800 military bases outside US borders, and those were only the ones not classified as secret. Since then, many more bases have been added around the world, allegedly to launch Washington's new "War on Terrorism." By 2004, US military power far exceeded that of any other nation. As one retired Admiral put it, "we are now competing only with ourselves in military might."

In 2004, the US had more than 237,000 troops on foreign soil and more than 50,000 personnel in foreign waters. It maintained more than 800 foreign military installations, including 60 major ones; had a military presence in 140 countries, including significant deployments in 25 countries; and held strong commitments to help defend or substantially support the defense efforts of 31 countries, and significant defense cooperation commitments with another 29.

Before 1990, the factor that had prompted this scale of peacetime military engagement was the longstanding global military standoff with another superpower: the Soviet Union. But that year the Soviet Union collapsed, and in any case the Cold War had long since ended. The question now was: What was America doing with this staggering global military might?

For the Bush Senior administration, the goal of preserving "strategic depth"—the sudden global military advantage over all others afforded by the Soviet collapse—replaced the containment of that country as the driving goal in about 1992. The Clinton administration rephrased this as "containing instability" and expanding the "democratic space" in the world. Both Bush Senior and Clinton saw America's unmatched capacity to address military security problems worldwide, wherever it might choose, as a crucial strategic asset in the effort to maintain global hegemony.

George W. Bush's administration had a comparatively rocky time attempting to convince a skeptical public that billions more were needed to swell US military forces around the world. All that changed, inevitably, after 9/11. Similarly, the 2003 invasion of Iraq, "Operation Shock and Awe" (later given the friendlier-sounding name "Operation Enduring Freedom") was not planned hastily after the fall of Kabul in 2001. It had been discussed within the Pentagon and parts of NATO for a decade. In 1999, during the Clinton administration, the Pentagon's Strategic Assessment 1999 document, issued by the military Joint Chiefs of Staff, the highest US military command body, specifically stated that an "oil war" in the Persian Gulf was a serious likelihood and that "US forces might be used to ensure adequate supplies." It went on to describe how such a war would eliminate the problem of Saddam Hussein. And in 1999, of course, the Project for a New American Century was beginning its work on making propaganda for just such future wars.

Wars waged by the US military against smaller, defenseless nations were clearly part of a long-term strategy to secure

awesome control over peoples and nations, backed by careful siting of its military bases. Using the most modern means of warfare and technology, the Pentagon warriors could carve out empires in a new way with minimum ground occupation troops—or so they thought until Iraq proved them inaccurate. Air power allowed it to strike any potential adversary using "smart bombs," "bunker busters," pilotless drone planes, and GPS satellite control.

Gulf Games

Because of the geostrategic significance of the Middle East, there has been a growth in US military presence there since the late 1970s. In January 1980, Carter effectively declared the Gulf to be within the US zone of influence, especially against encroachment from the Soviet Union. "Let our position be absolutely clear," he said, announcing what came to be known as the Carter Doctrine. "An attempt by any outside force to gain control of the Persian Gulf region will be regarded as an assault on the vital interests of the United States of America, and such an assault will be repelled by any means necessary, including military force."[15]

In the 1980s, under Reagan, the US began pressing countries in the Gulf for access to bases and support facilities. The Pentagon created a central command known as CENTCOM, a new command authority with responsibility for the Gulf and the region stretching from eastern Africa to Afghanistan. In 1987, at the height of the Iraq–Iran war, the US Navy created the Joint Task Force-Middle East to protect oil tankers in the Gulf, thus expanding a US naval presence of just three or four warships into a flotilla of 40-plus aircraft carriers, battleships, and cruisers.

By the end of the 1991 Gulf War, the US had already spent billions on a state-of-the-art air command center at Prince Sultan Air Base in Saudi Arabia. It then spent $1.5 billion for an airbase at Al-Udeid in Qatar. In Central Asia, the US acquired

bases in Kyrgyzstan, and signed base agreements with Pakistan and two former Soviet republics, Tajikistan and Uzbekistan. Most of these agreements were classified—contained within documents known as "status of force agreements"—to prevent any opposition on the part of the locals. Russian journalists reported that the US and Uzbekistan signed an agreement leasing the Khanabad base for 25 years.

The Shape of the New American Century

After the US entered Afghanistan in its so-called War on Terror, deploying troops for the first time in Central Asia and the Caucasus, the borders of a new American empire began to emerge. Using NATO and a network of alliances and bases, the US was aiming at total control of the Eurasian subcontinent, from Vladivostock in the east to Baghdad, and from Baku to Brussels—and beyond.

Firmly in the Russian and later Soviet sphere of influence since the time of Napoleon, these strategic regions, along with their Middle Eastern ramparts to the south, were now home to 60,000 US troops. Some of these soldiers were building what appeared to be long-term bases at remote Central Asian outposts, raising critical questions about America's future role.

Some 3,000 Americans were based in Uzbekistan, to run both overt and covert operations in Afghanistan from there. With 3,000 more troops, commanders were setting up new facilities in Kyrgyzstan for a combat air wing and humanitarian missions. A deal was meanwhile struck with Tajikistan. Americans have also held secret military meetings with Armenia—a key Russian ally—and talks with Kazakhstan. Hundreds of US military special forces "advisors" are helping the pro-US regime in Georgia control the unruly Pankisi Gorge region, where terrorists are suspected to be hiding. (Georgia is the route for the Baku–Ceyhan oil pipeline, which is to provide oil to Israel.)

As we saw at the end of Chapter 4, the Caspian Sea oil reserves could prove to be critical to future global energy supplies, according to the London-based *Jane's Foreign Report*: "This is in line with the doctrine of 'full-spectrum dominance' that now seems to govern American foreign policy and is manifesting itself in the Caucasus and Central Asia."[16]

One of the reasons why the US gains access to these other countries with relative ease is because it provides military training and aid incentives, run through the State Department's International Military Education and Training Program (IMET). Since 1994 official funds for IMET have increased 400 per cent, and by 2002 covered 133 countries where 100,000 top officers were trained each year, many of them in special US military camps. This practice allows the Pentagon unprecedented access, intelligence, and control over key military leaders in dependent countries.

One of the least-known features of modern US military influence and control of key strategic areas around the world is the Pentagon's increasing use of private military companies, as well as contractors operating for profit, to run its wars and build its bases. The model for this kind of privatization was the British Empire in India.

In 1857, Britain deployed an army of 300,000 to control India. More than 96 percent of them were "sepoys," that is, Sikh or Gurkha mercenaries. The US Defense Department introduced the use of private military companies, usually run by retired generals or CIA officers, in 1992, when then Defense Secretary Dick Cheney began contracting essential military functions to private companies. The goal was not cost reduction, Cheney said, but to "help the private sector." Help he did. When Cheney left the government in 1992, he was made CEO of Halliburton, where he had arranged lucrative defense contracts for its Kellogg Brown & Root construction subsidiary.

In Iraq, amid much scandal for price overruns and conflicts of interest, Halliburton officially became the largest private contractor, with an astonishing $11.4 billion in government contracts to reconstruct the country. The details are secret, but it is reported that most of this is for the construction of US military bases across Iraq. On June 14, 2004, the London *Financial Times* reported that an internal Pentagon audit had found the company had "mismanaged more than $8 billion of Iraqi contracts." The American press gave this shocking revelation little coverage.

The private American mercenary companies included Vinnell Corporation, which trains the Saudi Royal National Guard. Vinnell was owned by the large defense group, Northrup Grumman. Military Professional Resources Inc. (MPRI) of Alexandria, Virginia, founded by General Carl Vuono, a veteran of the 1991 Gulf War, employed 10,000 retired military professionals. MPRI and Vinnell and many other "private" military contract companies were engaged for their services in Iraq and Afghanistan.

Unlike the US military, the private companies were able to operate without restrictions and no requirement to adhere to the Geneva Convention, and could use banned weapons or other munitions at will.

The Iron Triangle

This huge military expenditure and expansion cannot continue without approval from Washington, of course. But how are congressional decisions made? Some neoconservative congressmen and women support them, along with the current administration, but there are other forces at work.

In this context it can be instructive to look at a case taught at the Harvard Graduate School of Business on the decision-making process in Washington. Within the congressional subcommittee, staff members control communications between

Congressmen and anyone outside the committee. They draft committee reports and introduces views in a way that makes their influence far exceed their formal role. On important issues, lobbyists arrange for their members to be hired as staff. So whereas 2–5 elected congressmen are involved in a congressional subcommittee, about 20 non-elected staff members may also be involved. In essence, this amounts to an unelected quasi-sub-government.

Lobbies representing interest groups are formally represented. The influence of a lobby is directly proportional to its financial resources—the bigger the better, of course. Also, their organizational capabilities, and whether they have the right connections to appoint staff members to serve their concerns with congressional subcommittee members, play a great role in securing the decisions they desire.

Lobbies and interest groups manage to get their people into government as well. The Harvard Business School case describes it as follows:

> In that fashion policy experts from academia or business often move into government and vice versa. This movement, together with the fluidity of issue networks both inside and outside government, often leads to the appointment at a very high level in government of people who first established their reputations as specialists in particular areas of public policy. Both political parties use these outside advisors as federal appointees and in the process create a new political bureaucracy which co-exists alongside the permanent one in government.

It can reasonably be concluded that up to 80 people out of a 100 involved in the decision-making sub-government are not elected, but are appointed directly or indirectly by monied interests. The rest, including the 2–5 congressmen in the subcommittee, owe their position to those who gave them their jobs. Political contributions are advance payment for favors. As a result, the whole system is owned by monied interests. This explains why Washington could remain silent

on the lethal effects of tobacco for more than 30 years after scientific evidence known by the US Surgeon-General revealed this, and why the tobacco lobby thought it could make a profit out of a settlement supposedly compensating for the damage done by their business.

Both major political parties, Republicans and Democrats, are engaged in a kind of mechanical democracy. Neither party plays a real role as mediator between electors and elected, nor do they participate in the formulation of policies. They act as a mail-drop for contributions at election time. If party membership is measured by those who pay their membership dues regularly, then the National Rifle Association with 2.5 million members is bigger than both major parties combined.

In a democratic country of about 300 million, a party system such as this is alarming. The Democratic Party, once thought to represent the poor, is owned and managed by lobbyist lawyers and firms. Author of the bestselling *Who Will Tell The People?* William Greider[17] lists the lobbyists and lawyers with the greatest influence within the Democratic Party—and who also happen to represent most of the country's leading banks and brokerage firms. They include Bob Strauss (Drexel Burnham, Morgan Stanley, Texas S&Ls), Chuck Manatt (California S&L, the California Bankers Association, First Bank System), J. D. Williams (First Boston), Richard Moe (Morgan Guaranty), Berl Bernhard (Investment Company Institute), Joe Califano (Bankers Trust, Fannie Mae), Stuart Eizanstat (Chase Manhattan, Association of Bank Holding Companies), O'Connor and Hannon (Merrill Lynch, Paine Webber, Securities Industries Associations), and Tommy Boggs (American Express, Bear Stearns, Chicago Board Options Exchange, Paine Webber).

Robert Strauss, Democratic Party chairman in the mid-1970s, was known as "Mr Democrat." He lobbied both parties to pass tax laws that certainly did not favor the poor, and he

was Bush Senior Republican administration ambassador to Moscow when the Soviet Union was disintegrating. Vernon Jordan, a close friend of Clinton's, works in Strauss's firm. Some 100 lobbyists work for Jordan, who is on the board of several transnational corporations.

As historian Arnold Toynbee concluded 60 years ago, the ultimate cause of imperial collapse is "suicidal statecraft." It seems that neoconservatism has mastered this craft—they have turned the American Dream into a nightmare.

8
Future Imperfect: Why America Must Change

WHATEVER ELSE OIL IS, it is a finite resource. Most experts agree that it will not last beyond the end of the twenty-first century, but the cost of transforming the energy infrastructure of the Oil Age into whatever will follow is huge in terms of time and money.

It is for this reason that the elite of America, currently represented by the Bush administration, have pursued an aggressive policy—the pursuit of oil in Arab and Muslim countries, including the Caspian Sea reserves. Here, indeed, is the problem for the US. The pillar of empires, oil, lies beneath the soil where the majority of people have their own, very different values from those associated with the globalization that feeds American capitalism. So regardless of whether the US intelligence community failed or was looking the other way for more than a year while the 9/11 hijackers prepared their attack, that incident was the start of already laid plans to dominate the world's natural resources and—most urgently and critically—international oil. Hence the declaration of the War on Terror as a way of expanding American oil interest.

"The Global Transaction Strategy"

According to at least two influential US military strategists, the occupation of Iraq "was not about settling old scores or

simply enforcing UN mandated disarmament ... Instead, the Bush administration's first application of its controversial pre-emption strategy marked a historical tipping point—the moment when Washington took real ownership of strategic security in the age of globalization."[1] So wrote Thomas P. M. Barnett, former senior strategic researcher and professor at the US Naval War College, and Henry H. Gaffney, a team leader with the Center for Strategic Studies at the independent research body the CNA Corporation, in "The Global Transaction Strategy," a May 2003 article in *Military Officer* magazine. The US, they wrote, "should expect to put in the lion's share of the security effort to support globalization's advance because we enjoy its benefits disproportionately ..."

Although the US has only 5 percent of the world population, it consumes about a quarter of the world's energy and produces a quarter of the world's pollution and waste. As Barnett and Gaffney say, the US tends "to import our energy and export our pollution. Simply put, we live way beyond our environmental means." They continue:

> As our consistently huge trade deficit indicates, we also tend to live well beyond our economic means. Basically, we count on the rest of the world to finance our sovereign debt, which most countries—like Japan—are willing to do ... There is not a whole lot we should complain about this deal—basically trading pieces of paper for actual goods. Put these two transactions together and it is easy to see why the US has benefited from the rise of a global economy.

So, since the US finds globalization and its global economy working in its favor, and as the US accounts for about half the global public spending on armament, bases, naval presence, and wars, the authors indicate that American strategy for the twenty-first century is to "import consumption and export security"—that is, export wars.

Barnett and Gaffney divide the world into countries seeking to align themselves to the rules of globalization as set by the

Pentagon and Wall Street—the "Functioning Core"—and those that do not accept the rules of globalization due to political or cultural rigidity—the "Non-integrating Gap." The Muslim world falls into the latter category. China, India, and Southeast Asia they call the "New Core" as these countries are connecting to globalization. The US, EU, and Japan are the "Old Core."

The two authors argue that as global administrator, the US must ensure the following four "flows" simultaneously. The disruption of any one of them will damage the others and disrupt globalization.

The Security Flow

According to Gaffney and Barnett, for the first half of the twenty-first century the primary areas of US military and security interventions will be in Central and Southwest Asia—to all intents and purposes, the Muslim world. They write that the US must "export security" to these countries, by which they mean bases, an increased naval presence, crisis-response activity, and military training. In the globalization equation of the US, defined as "exporting security and importing consumption," the product to be imported to the US is oil; the product to be exported is war. Further, say the authors, since the conflict between the Muslim countries and the US is a long one, "The US might well establish permanent military bases in Iraq"—as the authors say, some US military bases in Japan and Germany were established 60 years ago and are still there.

How long will US troops remain in Iraq and other "Gap" counties? The implied answer is, forever. "And here's where I get to my final point about this Administration—and every one that follows, getting level with the American public. We are never leaving the Gap and we are never bringing our boys home!"

Many American neoconservatives are happy with Ariel Sharon's proposed policy of a "Berlin Wall"-type division between Israel and Palestine, even though the wall was declared illegal by the International Court of Justice and the UN. Many in this elite group also seem unconcerned by Israel's prejudicial killings ("targeted assassinations") and feel the world and the US, as Barnett and Gaffney have it, "simply would have to wait out a couple of generations of Palestinian anger as that society ultimately is bought off through substantial Core economic aid and the Palestinians reduce their family size as they achieve some economic viability."

As communism has died out as a real force, the authors rule out "great power wars." But for the foreseeable future they see as necessary the export of "security"—and wars—"into the Islamic regions of Southwest and Central Asia as [America's] most serious international security task. We are witnessing the beginning of a long-term integration effort there, one that will ultimately rival our Cold War effort in Europe in its strategic centrality."

The Flow of Oil

As American business will mainly be the export of security rather than consumer products, America's demand for oil will increase slowly in the coming decades, while China and India, which are now manufacturing the "consumption" imported by the US, will double their oil consumption. In its role as globalization administrator and police force to the world, the US must control the flow of Middle Eastern oil to its friends and enemies. When the dangers of industrializing Japan was debated after World War II, George Kennan, architect of the Cold War containment policy, argued that Japan could industrialize as it wished, as long as the valves that can shut the oil to its industries remained in American hands. Likewise, China and India—the two fastest developing

economies in the world—can industrialize as they wish as long as America controls the flow of oil to them, and as long as Americans guard their access to the valves through the many military bases and naval posts now found in the Muslim oil-producing countries.

China now exports many products to the US. It is paid in dollars, and will accumulate billions in annual trade surpluses. As long as these billions return to the US in one form or another (such as US Treasury bills), China is considered "connected" to the Core. If China ever contemplates calling these dollars home, or stops financing the US debt through the purchase of Treasury bills, China will become a "disconnector." (As Barnett and Gaffney say, "There is not a whole lot we should complain about this deal—basically trading pieces of paper for actual goods.") This system of trading pieces of paper for oil has been going on in the Middle East ever since oil was first discovered there. The oil dollars are sent to the US in the form of investments in US Treasury bills, or in reselling to the oil-producing states the outdated stocks of arms that these countries are not permitted to use in the first place.

As oil and petroleum product use in China and India grows, the demand center for it will shift within the next 20 years from North America to Asia. According to the US Department of Energy, by 2020 Asia will buy about two-thirds of Middle East oil from the Gulf, and this will account for about 80 percent of Asia's oil imports. Any disruption to the flow of oil from the Middle East will damage the economic and political processes of globalization; and as a self-appointed globalization administrator, the US will go to any lengths to ensure it continues to exploit the world's human and material resources to its disproportionate advantage. It will not stop at the occupation of Iraq. As we have seen, the war in Afghanistan was launched to secure Caspian Sea oil and its pipeline routes through

Afghanistan and various former Soviet republics to ports on the Mediterranean—and after 9/11, a number of bases were established in those countries.

Investment Flows

For globalization to work, the flow of foreign direct investment from the US and European financers must be secured. The swelling economies of the Asian New Core will require some $2 trillion by 2020. Therefore, Asia will depend for its economic development on financing from American and European financiers, and oil under direct control by the US military from the Middle East. These two factors give sufficient leverage to ensure that surplus dollars earned by the New Core countries' economies continue to be recycled to the US to finance its sovereign debts and deficits.

The Flow of People

The flow of workers from the Gap to the Old Core—the economies of the US, Europe, and Japan—will need to become a torrent. Current UN projections indicate that, by 2050, the worker-to-retiree ratio in the Core will fall dramatically unless young people from the Gap are imported. Japan will require more than half a million immigrant workers a year to maintain its existing workforce, and the EU will have to increase its current immigration flow by about 500 per cent. While the worker-to-retiree ratio will decline from 5:1 to 2:1 in the advanced economies, it will be at 10:1 in most Muslim countries. Without a flow from the Gap to the Core, overpopulation in the underperforming Gap countries will lead to explosive situations, while the under-population of workers in the Core economies will lead to economic decline. But, say Barnett and Gaffney, the flow of workers must be regulated. They suggest that, as in the case of guest

workers in the Arab Gulf states, temporary workers should not to be granted citizenship rights or permanent residency.

The authors conclude that while US policy during the Cold War was one of containment, in the new era of American globalization, it is not sufficient to contain the Muslim world; it must shrink.[2] Kissinger thought that the US response to 9/11 would be similar to the way it reacted to Pearl Harbor, and said he hoped the US response "will end the way that the attack on Pearl Harbor ended—with the destruction of the system that is responsible for it." If it was publicly alleged that Islam or radical Islam was the system behind 9/11, as many of his associates indicated, then Kissinger was advocating war against Islam in no uncertain terms. The war of civilizations was thus declared, with Islam as the first target.

Barnett and Gaffney create a convincing future scenario, saying, "If a country is either losing out to globalization or rejecting much of the content flows associated with its advances, there is a far greater chance that the US will end up sending forces at some point."

A New Global Map?

In 2004, Barnett published the bestseller *Pentagon's New Map: War and Peace in the Twenty-First Century*.[3] Barnett's division of the world into Gap and Core countries is reflected in this book, and the Gap countries on this map include, as we have seen, most of the Muslim world in addition to a few South American countries with majority Catholic populations whose ethics differ from the pro-Israel evangelism that prevails among the American power elite.

Barnett defines how he would divide these two types of state: "In the Era of Globalization, we draw the line between these parts of the world that are actively integrating their national economies into a global economy ... and those that

are failing to integrate themselves into that larger economic community are all the rule sets it generates ..." This is astonishingly close to Lord Palmerston's nineteenth-century dictum "trade without rule where possible; trade with rule where necessary." What this implies is that other countries must buy American capitalism and its trade (as well as the World Trade Organization), its ethics, and its Wall Street rules, lock, stock, and barrel. If not, that country is an outlaw or terrorist and deserves a taste of US pre-emptive policy and its cruise missiles. But who lays down these rules?

It sounds like the stuff of conspiracy theory, but could it be the Pentagon and Wall Street? Going by Barnett's book, this seems to be the case. A series of meetings involving members of the Pentagon and Wall Street representatives were held in 2001 at the Wall Street broker-dealer firm Cantor Fitzgerald's offices on the 107th floor of World Trade Center One. In *Pentagon's New Map* Barnett writes:

> The research project I was conducting with Cantor's help involved exploring how globalization was altering America's definitions of national security—in effect, altering one calculus on risk management. The workshops we conducted jointly brought together Wall Street heavyweights, senior national security officials and leading experts from academia and think thanks ... our joint venture was called the New Rule Sets Project.

This kind of extraordinary alliance between Wall Street and the Pentagon means that when Wall Street speaks, the world will be forced to listen.

The Schism between Islam and Christianity

The relationship between Western Christendom and Islam has provoked two responses from historians and politicians. On the one hand, there are those who believe that the two civilizations coexisted, and that Western civilization has

simply outgrown "the long sequence of interaction and fusion between Orient and Occident," as Sir Steven Runciman wrote at the end of his three-volume *History of the Crusades*.[4] In Runciman's opinion, the Crusades should be viewed more as the last of the barbarian invasions than as a religious war attempting to reconquer the Christian heartland. The heirs of Greco-Roman civilization, he wrote, were not the Crusader knights, but the sophisticated and cultivated Arab Muslim Caliphates of Damascus and Baghdad, who preserved the old civilizations of the Mediterranean after their learning had all but disappeared from Europe.

Bernard Lewis, a distinguished professor of Middle Eastern studies at Princeton University, represents the other view. Lewis assumes that Islam and Christianity are two confrontational civilizations which created two fixed and opposed forces. Western civilization, he argues, is a Judeo-Christian bloc against Muslim civilization, whose ethics and values are quite different from those of the West and even hostile to them. He argues that Muslims are determined to conquer and convert the West: "This is no less than a clash of civilizations—the perhaps irrational but surely historic reaction of an ancient rival against our Judeo-Christian heritage, our secular present, and the worldwide expansion of both."[5]

It was Lewis, in fact, who coined the term "clash of civilizations," later borrowed by Samuel Huntington for his influential book, *The Clash of Civilizations and the Remaking of World Order*. Lewis's ideas became the intellectual basis for the neoconservatives' view of Islam and their policies towards Muslim countries. He is listened to in the White House.

In his essay "The Roots of Muslim Rage," Lewis wrote: "The struggle between these rival systems has now lasted for some fourteen centuries. It began with the advent of Islam, in the seventh century, and has continued virtually to the present day. It has consisted of a long series of attacks and

counterattacks, jihads and crusades, conquests and recon-
quests." Lewis, who shares the Likud-friendly pro-Israel
background of the neoconservatives who populate the Bush
administration, preached to the White House that Islamic
hostility to the US is the result of a generalized "envy" and
"rage" in the face of a rival civilization, and is unrelated to
America's support of Israel. He has said that nothing but
brute force counts when dealing with the Muslim world.

So much for the Lewis camp. Richard Fletcher, a historian
of early medieval Europe and Islamic history, perceives Islam
and its relationship with Christianity in a totally different
light. In his book *The Cross and the Crescent: Christianity
and Islam from Muhammad to the Reformation*,[6] he con-
cludes that Europe's twelfth-century Renaissance resulted
from the interaction of European and Muslim scholars. (Like
many historians, Fletcher believes there were multiple
European Renaissances, including a period of cultural revi-
talization in the high medieval period.) During this period,
many books were translated from the Arabic: editions of
Aristotle, Euclid, Plato, Ptolemy, astronomical texts by
Al-Khawarizmi, encyclopedias of astronomy, and commen-
taries by Ibn Sina (known in Europe as Avicenna). Through
Islamic Spain, "such basic facets of Western civilization as
paper-making, algebra and the abacus passed into Europe."

Fletcher emphasizes how the Prophet Mohammad did not
think he was "founding a new religion," but was instead
bringing "the fullness of divine revelation, partially granted
to earlier prophets such as Abraham, Moses and Jesus ..."
Islam accepts much of the Old and New Testaments, writes
Fletcher, who quotes from the Qur'an:

> Dispute not with the people of the book [that is, Jews and
> Christians] save in the most courteous manner ... but say "we
> believe in what has been sent down to us and what has been sent
> down to you, our God and your God is one, and to him we have
> surrendered."

To the persecuted Monophysite Christians of Syria and Egypt, Muslims could be presented as deliverers. The same could be said of the persecuted Jews ... Released from the bondage of Constantinopolitan persecution, they flourished as never before, generating in the process a rich spiritual literature in hymns, prayers, sermons and devotional work. Early theologians of the early church, including Saint John Damascene, considered Islam as merely a "sect" of Christianity. In 649 a Nestorian bishop wrote: "These Arabs fight not against our Christian religion; nay, rather they defend our faith, they revere our priests and saints, and they make gifts to our churches."

Fundamentalism in Whatever Form

In response to the stresses and excesses of modern life in a purely materialistic capitalist system, especially during the volatile days of the last quarter of the twentieth century's new financial economic order, people of all faiths all over the world returned to their religions to find solace in spirituality. As Armstrong writes, while the Western media often seem to be calling the "embattled and occasionally violent form of religiosity known as 'fundamentalism' " a solely Islamic phenomenon, every major faith has its fundamentalists. So there is fundamentalist Judaism, Christianity, Hinduism, Buddhism, Sikhism, even Confucianism. Moreover, fundamentalism first surfaced in the early twentieth century in American Christian faiths, and "of the three monotheist religions, Islam was in fact the last to develop a fundamentalist strain ... in the late 1960s and 1970s. By this date, fundamentalism was quite well established among Christians and Jews ..."[7]

In fact, American Christian fundamentalism took root at the start of the Cold War, when a two-tier war on communism was waged. One was what became known as McCarthyism (after Senator Joseph McCarthy). This period of political terrorism peaked with unfounded sensational allegations about "Reds" embedded in all the government departments. As revealed later

by William Sullivan of the FBI, the FBI fed information to McCarthy, yet publicly denied any connection. McCarthy's first chief investigator, Donald Surine, worked for the FBI. The second arm of the anti-communist campaign was the boosting of Christian fundamentalism, which was to fuel anti-communist feeling in the US.

Two figures from the leading corporate media executives heard about an obscure preacher, Billy Graham, then holding tented meetings in Los Angeles. Henry Luce, publisher of *Life* magazine, and the media magnate William Randolph Hearst decided to act. They learned that although Graham's audiences were small, he was nevertheless suited to their agenda of promoting evangelists to check liberalism and communism. They interviewed Graham and decided to give him media power. Hearst instructed his media group to "puff" Graham, and Luce had Graham on the cover of *Life*. Graham gained immediate national fame and he soon started preaching to hundreds of thousands. The fundamentalist tide began to flow.

This Christian fundamentalist movement was hijacked by TV evangelists whose personal immorality soon became public knowledge. Sex and financial scandals were revealed one after another, to the disappointment of their followers. Yet such was the power of the fundamentalist media, with hundreds of radio and TV stations and annual budgets of hundreds of millions of dollars, that their movements flourished. The evangelists may have preached from the Gospels when they started, but they eventually became *de facto* preachers of global capitalism, supporting and promoting its wars—in effect, they became the "religious police" of the system.

Later, they started to preach a new gospel, Christian Zionism—the idea that support for the state of Israel can be found in Christian theology—and they called for a war on Islam. As we have seen, they became a force in Republican Party politics. Herb Zweibon, head of "Americans for a Safe

Israel," warned the Bush White House that if only 10 percent of those 70 million evangelical Christians switched sides, they would swing political power and destroy his presidency if he did not support Sharon in his drive against the Palestinians.

But long before this—after the 1967 Six-Day War, in which Israel, with a great deal of help from the US, defeated and occupied the lands of three Arab countries—Muslims realized that the post-colonial regimes that were constructed and installed by the West were total failures. These regimes and their generals or tribal leaders imposed on them were mostly oppressors of their people, yet they couldn't wage a war. Today, they see the West preaching secularism yet building Israel on a religious foundation. They see the hypocrisy of the West in preaching democracy, yet supporting and creating the most oppressive dictatorships in the world.

There is a view among some liberals that Europe is some-how better than the US, or more benign in its dealings with Arabs and Muslims. But for the peoples of Muslim countries, the root cause of their problems lies in the decision of European powers to dismember what was a geopolitical whole for 14 centuries. The irony is that just as Europe was busy dividing up Arab and Muslim peoples, the continent's own disparate people were preparing to combine in what today is the European Union.

I would argue that it was a Western strategic imperative for Europe to unite and not to allow the unity of the Arab world or Muslims, not even to allow the slightest adjustments to the borders of the mini-states and city-states that were carved by the West during World War I. Muslims and Arabs saw that the disparity between rich and poor in their societies was increasing, that revenues from their natural resources were diverted to "their few" who in turn "handed them" to the "Western few" in the form of deposits that can be eroded, frozen, or at best be put into investments that enrich others while their countries are crying out for investments and projects.

When the whole world saw Western values and materialism for what they were, Muslims, like other peoples of other religions, turned to spirituality and religion. They began to see that Islam is the solution. What Muslims wanted to see in their society was what Islam preaches: justice, equality, the fair distribution of wealth, and also autonomy. Many Muslims realized that they have to develop the tools of *ijtihad* to modernize the ways and institutions of Islam—although not, of course, its values and codes. This seemed like bad news for the West. So Muslims in the Middle East gave up on the West.

Ironically, it was the US which helped to forge this new attitude through the war between the Soviet Union and Afghanistan (1979–89). According to Huntington, writing in *Clash of Civilizations*, this was the first civilizational war:

> For Americans, Soviet defeat was vindication of the Reagan doctrine of promoting armed resistance to communist regimes and a reassuring humiliation of the Soviets comparable to that which the US had suffered in Vietnam. It was also a defeat whose ramifications spread throughout Soviet society and its political establishment and contributed significantly to the disintegration of the Soviet Empire.

The US, through its Muslim client states, declared *jihad* and encouraged Muslims to wage a holy war against the Soviets, the occupiers of a Muslim country. Some 25,000 volunteers were recruited from a number of Muslim countries. Osama Bin Laden was one of their number. The war was directed by the CIA, the training and field liaison was done through Pakistan's CIA-linked Inter-Services Intelligence Agency (ISI), Saudi Arabia financed the campaign, and recruitment was undertaken by several Muslim–CIA-related intelligence agencies. The volunteers were sincere, sometimes naive if unselfish Muslims, who believed they were fulfilling their duty in fighting the Soviet atheists who had invaded a Muslim country. They did not realize that they were fighting a proxy war for the US. Says Huntington: "Between 1984

and 1986, the Saudis gave $525 million to the [Afghan] resistance. In 1989, they agreed to supply 61 percent of a total of $715 million, or $436 million."

In a lecture at the University of California at Santa Barbara on October 4, 2005, Kathy Gannon, author and Associated Press and *New Yorker* writer who covered Afghanistan and Pakistan for many years, explained that US-funded books prepared by US universities to teach young Afghan refugees English exploited Islamic fervor among the students in an effort to turn them against the Russians occupying Afghanistan. The youngsters were taught I is for Infidel, J is for Jihad and K is for Kalashnikov. Thus Islamic fundamentalism was funded and promoted by the US whenever it served its interests to do so.

Pakistan provided the necessary external base for the resistance and the logistics, intelligence liaison, and other support. Bin Laden and future members of al-Qaeda were recruited, trained, inspired, financed, and controlled during the Afghan War under the auspices of the US and its national security institutions. "In the end," writes Huntington, "the Soviets were defeated by three factors. They could not effectively equal or counter American technology, Saudi money, and Muslim demographics and zeal." These facts give credibility to the theory that even if Bin Laden had superhuman powers, he could not have escaped the surveillance of US intelligence and its "closely related" Pakistan ISI to organize, from the caves of Afghanistan, a high-tech operation half a world away against the world's only superpower without the knowledge and at least the tacit consent of some local American intelligence.

The True Face of Islam

We have seen how compromised and politicized Christian fundamentalism has become, and how the West has manipulated

Muslims into highly dangerous cultural clashes. How, then, does Islam compare? Karen Armstrong, who has written three books about Islam, explains that it is different from other religions because it is both a religion and a way of life. She writes:[8]

> In the modern West, we have made a point of separating religion from politics ... [but in] Islam, Muslims have looked for God in history. Their sacred scripture, the Quran, gave them a historical mission. Their chief duty was to create a just community in which all members even the most weak and vulnerable were treated with absolute respect. The experience of building such a society and living in it would give them intimations of the divine, because they would be living in accordance with God's will. A Muslim had to redeem history, and that meant that state affairs were not a distraction from spirituality but the stuff of religion itself.

Armstrong adds:

> If state institutions did not measure up to the Quranic ideal, if their political leaders were cruel or exploitative, or if their community was humiliated by apparently irreligious enemies, a Muslim could feel that his or her faith in life's ultimate purpose and value was in jeopardy ... politics was, therefore, what Christians would call a sacrament: it was the arena in which Muslims experienced God and which enabled the divine to function effectively in the world.

Armstrong's research indicates that perceived notions about Muslims and Islam are, in most instances, inaccurate and are often based on historical prejudice. As we saw earlier, Islam was the rival and, to some, a threat to the West for 1,400 years, while communism posed a risk for 70 years, then faded away. Armstrong also says Islam retained a negative image in the West, which has a long history of hostility to it even though it is, in common with Judaism and Christianity, an Abrahamic religion. "But the old hatred of Islam continues to flourish on both sides of the Atlantic and people have few scruples about attacking this religion, even if they know little about it," she writes.

Armstrong believes that this is in a way understandable, because "until the rise of the Soviet Union, no polity or ideology posed such a continuous challenge to the West." When Islam was established in the seventh century, Europe was in the depths of the Dark Ages. Islam quickly overran much of the Christian world of the Middle East and North Africa and within less than a century had established itself from southern France to China. The Crusades of the twelfth and thirteenth centuries ended in failure and Muslims recovered the occupied territories through a resurgence of Islam. In the centuries that followed, the Ottoman Empire expanded to occupy parts of Eastern Europe.

But it was not until the collapse of the USSR and communism that the West began to challenge Islam openly—before Osama Bin Laden was made famous by George W. Bush. The Secretary-General of NATO declared in 1995 that political Islam was "at least as dangerous as communism" had been to the West. One of the very senior members of the Clinton administration, according to Huntington, pointed to Islam as the global rival of the West. Huntington writes: "During the fifteen years between 1980 and 1995, according to the US Defense Department, the US engaged in seventeen military operations in the Middle East, all of them directed against Muslims. No comparable pattern of US military operations occurred against the people of any other civilization." He concludes that, to the West, the problem is not Islamic fundamentalism, it is Islam—a different way of life of whose superiority Muslims are convinced.

Huntington believes that Clinton was wrong when he argued that the West does not have problems with Islam but only with violent Islamic extremists. "Conflict was, on one hand, a product of difference, particularly the Muslim concept of Islam as a way of life transcending and uniting religion and politics." As far as Huntington is concerned, a clash of civilizations between Islam and the West is inevitable.

"So long as Islam remains Islam (which it will)," he writes, "and the West remains the West (which is more dubious), this fundamental conflict between two great civilizations and ways of life will continue to define their relations in the future even as it has defined them for the past fourteen centuries." He adds:

> Muslims fear and resent Western power and the threat which this poses to their society and beliefs. They see Western culture as materialistic, corrupt, decadent, and immoral. They also see it as seductive, and hence stress all the more the need to resist its impact on their way of life. Increasingly, Muslims attack the West not for adhering to an imperfect religion, which is nonetheless a "religion of the book," but for not adhering to any religion at all.

That Islamic values and capitalist values are different is a fact. The ultimate purpose of capitalism is material growth and the accumulation of wealth, regardless of how unevenly this wealth is distributed. Capitalism has no ethics and thus it does not matter how wealth is acquired as long as the individual is willing to pay the price if caught. Even crime, he says, is just another economic activity.

Life's purpose and economic vision in Islam are different. The Islamic model differs from capitalism in that it discourages the excessive accumulation of wealth, and from socialism in that it upholds individual rights to property and ownership. Societal harmony is therefore to be ensured through a sense of shared responsibility.

Muslims will be very willing to leave Bush and his "universal values" to his own devices as long as he leaves them and their values alone. If some Westerners interpret *jihad* as forcing others to subdue to the *jihadists'* values, how can one interpret Bush's declaration in the preamble of his National Security Strategy on September 20, 2002, that there is "a single sustainable model for national success"—America's—that is "right and true for every person in every society" because "these principles are right and true for all people everywhere"?

Islam and Politics

The Islamic concept of society stands in stark contrast to the capitalist reality. In the Qur'anic vision, the purpose of life is to please God, the creator, which means that faith is a part of the entire conduct of human affairs. It encompasses economics, politics, social life, and public and private conduct. It cannot be relegated to a set of rituals or isolated to the private sphere. This is an important reason why ordinary Muslims rejected the "secular Islam" of Kemal Atatürk, founder of modern Turkey, and Mohammed Reza Pahlavi, the last Shah of Iran; and why the modernization project of Muslim rulers such as Pervez Musharraf of Pakistan is ultimately doomed to fail.

According to Wahiduddin Khan, president of the Islamic Center in New Delhi, writing in *Islam and Peace*:[9]

> The ideal human being of the Qur'an is one who undergoes all these [life] experiences without losing his integrity. Under no circumstances is his inner peace disturbed. However untoward the occasion, he can maintain his natural balance. Success does not make him proud. Power does not make him seek vengeances in anger. At all events, he remains serene. It is such a man who is called "a peaceful soul" in the Qur'an. And it is this man who, according to the Qur'an, has achieved the highest spiritual state.

There are other fundamental differences between the Islamic system as a way of life and capitalism. In an Islamic economic system, the purpose of the economy and its rules and regulations are determined by the values and morality of the overall system.

In capitalism, growth is the purpose of economic activity and is divorced from ethics. In capitalism, happiness is acquired, supposedly, through the consumption and acquisition of goods. Money is the ultimate measure of success. The core of the Islamic economic system, on the other hand, is justice and equality. Money is not an end, but a means. The acquisition of material goods does not bring happiness.

Capital is one part in the production equation, but it is not the major part.

Money itself is also viewed very differently in the two models. In Islam, as we have seen, money cannot be used with the sole purpose of making more money for it is only a tool in the productive economy. Private ownership is permitted, but money used for speculation is not. If the financial economy is truly and justly called a casino, gambling is strictly prohibited in Islam.

Usury, or money-lending at a high rate of interest, is strictly forbidden, because it is money that is employed to make more money and is not involved directly in the productive economy. Capital owners must be involved in the risks as real partners in the productive economy.

Most religions once had injunctions against usury, which was declared a sin in the Old Testament book of Genesis. Until the medieval period, Christian teaching in most of Europe declared that charging interest at any rate was a sin against God. During the Industrial Revolution, the outlook on interest and usury changed, but usury was differentiated from interest rates and as such was banned in the US. The definition of usury was eventually modified to mean lending at ruinous interest rates. It became accepted that capital should be justly rewarded, but it was also accepted that it was not free to set conditions that guarantee the failure of the borrower.

John Maynard Keynes argued in *The General Theory of Employment, Interest and Money*[10] that: "Avarice and usury and precaution must be our gods ... For only they can lead us ... into daylight." Thus, twentieth-century economists declared officially that money, even usury, is not a sin against God, but God himself. Even after the Keynesian orthodoxy was attacked, the monetarists took over from where the Keynesians left off. In 1980, at the start of the age of deregulation, the US Congress legalized usury along with other sets of legislative deregulation. As a result, the ceiling set by

state and local governments on home mortgages was abolished. Usury, like sex, became a private affair between consenting adults in which the government has no business to intervene.

Another difference between the Islamic and Western systems is public welfare. All utilities of common interest are to be owned by the state. Sources of "water, fuel, animal feed," said Mohammad, belong to the people. The government, through the Treasury, must ensure that all basic needs are fully met.

Wealth too is handled in highly different ways between the two cultures. A wealth tax of 2.5 percent must be paid annually on all wealth other than that considered essential for normal subsistence. This is God's money. He created the wealth, He gifted it to His servants, and they should use it well. After all, people do not take money with them when they die: God's money remains on His earth.

During Western colonialism in the Middle East and after the decolonialism process, in which the Western-trained and aided regimes took power, the basis of Islamic economic vision was practically nonexistent. In a few instances the form, but not the substance, exists. Muslims, in their resurgence, aspire to live in equitable Islamic societies. Just like capitalist countries, maybe because of them, Islamic countries today are witnessing wealth disparities and an inequitable society as bad as their former Western colonial countries, and, in many instances, even worse.

Mohammad's Sword

Responding to Pope Benedict XVI's negative charge against Islam, at a German university, Uri Avnery, an Israeli journalist and head of Israeli peace movement, wrote on September 24, 2006:

> The struggle between the emperors and the popes played a central role in European history and divided the peoples. It knew

ups and downs. Some emperors dismissed or expelled a pope, some popes dismissed or excommunicated an emperor. One of the emperors, Henry IV, "walked to Canossa", standing for three days barefoot in the snow in front of the Pope's castle, until the Pope deigned to annul his excommunication.

But there were times when emperors and popes lived in peace with each other. We are witnessing such a period today. Between the present Pope, Benedict XVI, and the present emperor, George Bush II, there exists a wonderful harmony. Last week's speech by the Pope, which aroused a worldwide storm, went well with Bush's crusade against "Islamofascism", in the context of the "clash of civilizations".

In his lecture at a German university, the 265th Pope described what he sees as a huge difference between Christianity and Islam: while Christianity is based on reason, Islam denies it. While Christians see the logic of God's actions, Muslims deny that there is any such logic in the actions of Allah.

As a Jewish atheist, I do not intend to enter the fray of this debate. It is much beyond my humble abilities to understand the logic of the Pope. But I cannot overlook one passage, which concerns me too, as an Israeli living near the fault-line of this "war of civilizations".

In order to prove the lack of reason in Islam, the Pope asserts that the Prophet Muhammad ordered his followers to spread their religion by the sword. According to the Pope, that is unreasonable, because faith is born of the soul, not of the body. How can the sword influence the soul?

To support his case, the Pope quoted—of all people—a Byzantine emperor, who belonged, of course, to the competing Eastern Church. At the end of the 14th century, Emperor Manuel II Palaeologus told of a debate he had—or so he said (its occurrence is in doubt)—with an unnamed Persian Muslim scholar. In the heat of the argument, the emperor (according to himself) flung the following words at his adversary:

> Show me just what Mohammed brought that was new, and there you will find things only evil and inhuman, such as his command to spread by the sword the faith he preached.

These words give rise to three questions: (a) Why did the Emperor say them? (b) Are they true? (c) Why did the present Pope quote them?

When Manuel II wrote his treatise, he was the head of a dying empire. He assumed power in 1391, when only a few provinces of the once illustrious empire remained. These, too, were already under Turkish threat.

At that point in time, the Ottoman Turks had reached the banks of the Danube. They had conquered Bulgaria and the north of Greece, and had twice defeated relieving armies sent by Europe to save the Eastern Empire. On 29 May 1453, only a few years after Manuel's death, his capital, Constantinople (the present Istanbul), fell to the Turks, putting an end to the empire that had lasted for more than a thousand years.

...

In this sense, the quote serves exactly the requirements of the present Emperor, George Bush II. He, too, wants to unite the Christian world against the mainly Muslim "Axis of Evil". ...

The pope himself threw in a word of caution. As a serious and renowned theologian, he could not afford to falsify written texts. Therefore, he admitted that the Qur'an specifically forbade the spreading of the faith by force. He quoted the second Sura, Verse 256 (strangely fallible, for a pope, he meant Verse 257) which says: "There must be no coercion in matters of faith."

How can one ignore such an unequivocal statement? The Pope simply argues that this commandment was laid down by the Prophet when he was at the beginning of his career, still weak and powerless, but that later on he ordered the use of the sword in the service of the faith. Such an order does not exist in the Qur'an. True, Muhammad called for the use of the sword in his war against opposing tribes—Christian, Jewish and others— in Arabia, when he was building his state. But that was a political act, not a religious one; basically a fight for territory, not for the spreading of the faith.

Jesus said: "You will recognize them by their fruits." The treatment of other religions by Islam must be judged by a simple test: how did the Muslim rulers behave for more than a thousand years, when they had the power to "spread the faith by the sword"?

Well, they just did not.

For many centuries, the Muslims ruled Greece. Did the Greeks become Muslims? Did anyone even try to Islamize them? On the contrary, Christian Greeks held the highest positions in the Ottoman administration. ...

In 1099, the Crusaders conquered Jerusalem and massacred its Muslim and Jewish inhabitants indiscriminately, in the name

of the gentle Jesus. At that time, 400 years into the occupation of Palestine by the Muslims, Christians were still the majority in the country. Throughout this long period, no effort was made to impose Islam on them. Only after the expulsion of the Crusaders from the country, did the majority of the inhabitants start to adopt the Arabic language and the Muslim faith—and they were the forefathers of most of today's Palestinians.

There no evidence whatsoever of any attempt to impose Islam on the Jews. As is well known, under Muslim rule the Jews of Spain enjoyed a bloom the like of which the Jews did not enjoy anywhere else until almost our time. Poets like Yehuda Halevy wrote in Arabic, as did the great Maimonides. In Muslim Spain, Jews were ministers, poets, scientists. In Muslim Toledo, Christian, Jewish and Muslim scholars worked together and translated the ancient Greek philosophical and scientific texts. That was, indeed, the Golden Age. How would this have been possible, had the Prophet decreed the "spreading of the faith by the sword"?

What happened afterwards is even more telling. When the Catholics reconquered Spain from the Muslims, they instituted a reign of religious terror. The Jews and the Muslims were presented with a cruel choice: to become Christians, to be massacred or to leave. And where did the hundreds of thousand of Jews, who refused to abandon their faith, escape? Almost all of them were received with open arms in the Muslim countries. ...

Why? Because Islam expressly prohibited any persecution of the "peoples of the book". In Islamic society, a special place was reserved for Jews and Christians. They did not enjoy completely equal rights, but almost. They had to pay a special poll tax, but were exempted from military service—a trade-off that was quite welcome to many Jews. It has been said that Muslim rulers frowned upon any attempt to convert Jews to Islam even by gentle persuasion—because it entailed the loss of taxes ... (info@gush-shalom.org)

The Future of the American Empire

In his article "Illusions of Empire: Defining the New American Order,"[11] the Georgetown University academic G. John

Ikenberry writes:

> A half-century after their occupation, the US still provides
> security for Japan and Germany—the world's second and third
> largest economies. US military bases and carrier battle groups
> ring the world. Russia is in a quasi-formal security partnership
> with the US, and China has accommodated itself to US
> dominance, at least for the moment. For the first time in the
> modern era, the world's most powerful state can operate on
> the global stage without the constraints of other great powers.
> We have entered the American Unipolar age.

Unlike previous empires, which based their rule on the acqui-
sition of territory, the American Empire is unique in being
an empire of bases around the world with local national
client-states and proxy rulers. This is because technological
advances in transporting troops and bombs are unlike those
that existed in previous empires. A global system of naval
bases, army garrisons, airfields, listening posts, espionage, and
strategic enclaves were created in the Cold War during the
new globalization era, and now these facilities have expanded
to cover the whole globe, especially in the previous sphere of
influence which became inviting to imperial expansion.

During the twentieth century, two empires existed that
were more alike than different: the US and the USSR. Both
used client-states or satellites, the US in East Asia, the Middle
East, and Latin America, the USSR mostly in Eastern Europe.
Both were equally coercive and exploitative. "The US Cold
War Security System of alliances and bases was built on man-
ufactured threats and drives by expansionary impulses" by a
"military juggernaut intent on world dominations," says
Ikenberry. This juggernaut was and is driven by "an exagger-
ated sense of threat, and a self serving military industrial
complex."

Chalmers Johnson, president of the Japan Policy Research
Institute in California and the author of *The Sorrows of Empire:
Militarism, Secrecy and the End of the Republic*,[12] says that

the US was slowly and firmly inching towards its imperial project for many years, disguising its project under different names, one of which was globalization. The swift occupation of Iraq, Johnson wrote, only confirmed the anti-war arguments that this was "an unchallenged slaughter of Iraqis and a Mongol-like sacking of an ancient city which was the cradle of civilization." Chambers believe that America's imperial project which was spelled in the National Security Strategy will have four major consequences.

> First, there will be a state of perpetual war, leading to more terrorism against Americans wherever they may be and a spreading reliance on nuclear weapons among smaller nations as they try to ward off the imperial juggernaut.
>
> Second, is a loss of democracy and constitutional rights as the presidency eclipses congress and is itself transformed from co-equal "executive branch" of government into a military junta.
>
> Third, is the replacement of truth by propaganda, disinformation, and the glorification of war, power and the military legions.
>
> Fourth, there is bankruptcy, as the US pours its economic resources into ever more grandiose military projects and short-changes the education, health and safety of its citizens.

Those who wrote the rules in Wall Street and their protégés in Washington do not fight wars, nor do their children. Instead, they send the children of America's poor, who are disproportionately represented in the armed forces. And they suffer beyond what is reported in the media.

Let us look at the toll. In the 1991 Gulf War, 696,778 individuals, mostly American, served; 148 were killed in action, 145 were killed in accidents, and 467 were wounded in action. But that was not the end of this story. As of May 2002, the Veterans Administration (VA) reported that 8,306 soldiers had died and 159,705 had been injured or became ill as a result of aspects of their service. Further, the VA reported that about a third of General Schwarzkopf's

army—206,861 veterans—were claiming pension benefits, medical care, or compensation based on injuries or illnesses caused by their combat duties in the 1991 war. What is more striking is the fact that 168,011 applicants were classified as "disabled veterans" by the VA.

After the war, abnormal increases in childhood cancers and birth defects were witnessed in Iraq. The most likely cause of these disabilities and deaths is the use of depleted uranium (DU) ammunition during that war. DU is a waste product of power-generating nuclear reactors that was liberally used in the war against Iraq, making the country a convenient dumping ground and affecting its people—and US soldiers. The US armed forces fired 944,000 DU rounds in that war alone, and even the Pentagon admits that at least 320 metric tons of DU were left on the battlefield. It was only in mid-October 2004, however, that the Pentagon acknowledged Gulf War-related diseases.

The project of this neoconservative agenda for the Muslim world is doomed. America reached the moon and may make it to Mars and beyond, but its ideological agenda will end in catastrophe. Ten years before George W. Bush declared the West's latest crusade against Islam, as many Muslims are convinced, Karen Armstrong wrote:[13] "Now it seems that the Cold War against the Soviet Union is about to be replaced by a Cold War against Islam." She added:

> Today the Muslim world associates Western imperialism and Christian missionary with the crusaders. They are not wrong to do so. When General Allenby arrived in Jerusalem in 1917, he announced that the crusades had been completed, and when the French arrived in Damascus their commander marched up to Saladin's tomb in the Great Mosque and cried: "Nous revenons, Saladin" [We've come back, Saladin].

Many experts believe that America's own military adventures are self-defeating and will produce the very opposite of the imperial project's stated goal of fighting terrorism and

spreading democracy. The first Gulf War cost $61 billion and was paid for mostly by Saudi Arabia, Kuwait, the United Arab Emirates, Germany, Japan, and South Korea. Only $7 billion were paid for by the US. Within the first 18 months of the 2003 occupation of Iraq, some $350 billion were spent and most of the bill—90 percent—was paid for by the US. The federal deficit is nearly $1 trillion for 2006 alone.

The novelist John le Carré has written:[14] "America has entered one of its periods of historical madness, but this is the worst I can remember: Worse than McCarthyism, worse than the Bay of Pigs, and in the long term potentially more disastrous than the Vietnam War." And in *Sorrows of Empire* Chambers Johnson concludes:

> I fear, however, that the U.S. has indeed crossed the Rubicon and that there is no way to restore constitutional government short of a revolutionary rehabilitation of American democracy. Without root and branch reform, Nemesis awaits. She is the goddess of revenge, and the US is on course for a rendezvous with her.

Notes

Introduction

1. *Warrior Politics* (Random House, 2002), pp. 144–5.
2. Nick Beams, *The Iraq War and the Eruption of American Imperialism*, part 2, April 14, 2006, world socialist website.
3. Andrew Moravcsik, *Newsweek*, international edition, January 31, 2005.

Chapter 1 The Beginning of the End?

1. Kjell Aleklett, *Dick Cheney, Peak Oil and the Final Count Down*, Association for the Study of Peak Oil, 2004. Available at www.peakoil.net.
2. Harry J. Longwell, "The Future of the Oil and Gas Industry: Past Approaches, New Challenges," *World Energy*, Vol. 5, No. 3, 2002.
3. "The Lamp," *Exxon Mobil*, Vol. 85, No. 1, 2003.
4. Robert L. Hirsch and colleagues, *Peaking of World Oil Production: Impacts, Mitigation and Risk Management*, US Department of Energy, February 2005.
5. Colin J. Campbell and Jean H. Laherrère, "The End of Cheap Oil," *Scientific American*, March 1998.
6. *New Oil Projects Cannot Meet World Needs This Decade*, Oil Depletion Analysis Centre, London, November 16, 2004. Available at www.odac-info.org.
7. Toby Shelley, *Oil: Poverty, Politics and the Planet* (Zed Books, 2005).

Chapter 2 God, Geology, Geopolitics, and Geography: A Brief History of Oil

1. Napoleon Bonaparte, *Letter to the Jewish Nation from the French Commander-in-Chief Buonaparte*, General Headquarters, Jerusalem 1st Floreal, April 20, 1799. A translation from the original available a www.mideastweb.org.
2. Anthony Cave Brown, *Oil, God and Gold: The Story of Aramco and the Saudi Kings* (Houghton Mifflin, 1999).
3. Ibid.
4. Address by Lord Lansdowne to the House of Lords, Parliamentary Debates, col. 1348, May 5, 1903.

5. See Cave Brown, *Oil, God and Gold.*

6. Ibid.

7. Daniel Yergin, *The Prize: The Epic Quest for Oil, Money and Power* (Free Press, 1993).

8. See Cave Brown, *Oil, God and Gold.*

9. Peter J. Taylor, *Britain and the Cold War: 1945 as Geopolitical Transition* (Guilford Press, 1990).

10. Laurence H. Shoup, "Shaping the Postwar World," *Insurgent Sociologist*, Vol. 5, No. 3, Spring 1975. See also Laurence H. Shoup and William Minter, *Imperial Brain Trust* (Monthly Review Press, 1977).

11. Neil Smith, *American Empire: Roosevelt's Geographer and the Prelude to Globalization* (University of California Press, 2004).

12. Halford MacKinder, "The Round World and the Winning of Peace," *Foreign Affairs*, Vol. 21, No. 4, July 1943, pp. 595–605.

13. *Multinational Oil Corporations and US Foreign Policy*, Report to the Committee on Foreign Relations, US Senate, January 2, 1975 (Government Printing Office, 1975).

14. Lecture by Howard Zinn, "The Myth of American Exceptionalism," Massachusetts Institute of Technology, March 14, 2005.

15. See Yergin, *The Prize.*

16. James Risen, "Secrets of History: The CIA in Iran," *New York Times*, April 16 and June 18, 2000. For MI6 involvement, see Stephen Dorrill, *MI6: Fifty Years of Special Operations* (Fourth Estate, 2001).

Chapter 3 The Scramble for Oil in Iraq

1. A classified, 46-page document, the Wolfowitz memorandum, was prepared to set the direction for US foreign policy in light of the collapse of the Soviet Union and the first Iraq War. "Our first objective is to prevent the re-emergence of a new rival, either on the territory of the former Soviet Union or elsewhere, that poses a threat on the order of that posed formerly by the Soviet Union. This is a dominant consideration underlying the new regional defense strategy and requires that we endeavor to prevent any hostile power from dominating a region whose resources would, under consolidated control, be sufficient to generate global power. These regions include Western Europe, East Asia, the territory of the former Soviet Union, and Southwest Asia." On pre-emptive action, the memorandum emphasizes "the sense that the world order is ultimately backed by the U.S." It further asserts that "the United States should be postured to act independently when collective action cannot be orchestrated" or in a crisis that demands a quick response. For further commentary on and excerpts from the memorandum, see

Patrick E. Tyler, "US Strategy Plan Calls for Ensuring No Rivals Develop a One-Superpower World," *New York Times*, March 8, 1992.

2. Cited in Patrick E. Tyler, "US Strategy Plan Calls for Ensuring No Rivals Develop A One-Superpower World," *New York Times*, March 8, 1992.

3. Norman Schwarzkopf, Testimony before the Senate Committee on Armed Services, February 8, 1990.

4. "The Impact of War on Iraq," United Nations press release, March 20, 1991.

5. Cited in Jennifer Thompson, *The Last Gulf War, Resist!* (Democratic Socialist Party, Australia, February 1998).

6. Stephen Lee Myers, "In Intense but Little-Noticed Fight, Allies Have Bombed Iraq All Year," *New York Times*, August 13, 1999.

7. *Child and Maternal Mortality Survey 1999*, Preliminary Report, Iraq (UNICEF, Ministry of Health, July 1999).

8. In an interview with Lesley Stahl on CBS's *60 Minutes*, December 5, 1996.

9. Theodore Roosevelt first used this phrase in a letter to his friend Henry Sprague, January 26, 1900.

10. Dean Acheson, *Remarks by the Honorable Dean Acheson*, Proceedings of the American Society of International Law 13, 14 (1963). These remarks were made in the context of the Cuban missile crisis during the 1963 annual meeting of the American Society of International Law.

11. Senator Albert J. Beveridge speaks on the Philippine Question, US Senate, Washington, DC, January 9, 1900, *Congressional Record* (56th Congress, 1st Session), Vol. XXXIII, pp. 705, 711. Also cited in Howard Zinn, *A People's History of the United States: 1492–Present* (Perennial Classics, 2003), p. 313.

12. *Soldiers' Letters*, pamphlet (Anti-Imperialist League, 1899). Reprinted in Philip S. Foner and Richard Winchester, *The Anti-Imperialist Reader: A Documentary History of Anti-Imperialism in the United States*, Vol. 1 (Holmes & Meier, 1984), pp. 316–23.

13. Ibid.

14. Cited in Walter Millis, *The Martial Spirit* (The Riverside Press, 1931), pp. 383–4.

15. *Encyclopaedia of the Orient*, available at www.i-cias.com/e.o/.

16. Cited in Daniel Yergin, *The Prize: The Epic Quest for Oil, Money & Power* (Free Press, 1993), p. 188.

17. Anthony Cave Brown, *Oil, God and Gold: The Story of Aramco and the Saudi Kings* (Houghton Mifflin, 1999), p. 7.

18. *Multinational Oil Corporations and US Foreign Policy*, Subcommittee on Multinational Corporations, US Senate Committee on Foreign Relations (US Government Printing Office, January 2, 1975).

19. Henry Michaels, *How the British Bombed Iraq in the 1920s*, www.wsws.org, April 1, 2003.
20. Calouste Gulbenkian, remarks made during a Turkish Petroleum Company meeting, Ostend, July 1928.
21. Cited in Walter LeFeber, *Inevitable Revolutions: The United States in Central America* (W. W. Norton, 1983).
22. Roger Morris, "A Tyrant 40 Years in the Making," *New York Times*, March 14, 2003.
23. John K. Cooley, *An Alliance against Babylon: The US, Israel and Iraq* (Pluto Press, 2005), p. 93.
24. This article first appeared at www.consortiumnews.com, February 27, 2003.
25. Christopher Dickey and Thomas Evans, "How Saddam Happened," *Newsweek*, September 23, 2002.
26. United States District Court Southern District of Florida, United States of America, Plaintiff, v. Case No. 93-241-Cr-Highsmith, Carlos Cardoen, Franco Safta, Jorge Burr, Industrias Cardoen Limitada, Declaration Of A/K/A Incar, Howard Teicher, Swissco Management Group, Inc. Edward A. Johnson, Ronald W. Griffin, and Teledyne Industries, Inc., D/B/A, Teledyne Wah Chang Albany. January 31, 1995. Available at www.informationclearinghouse.info/article1413.htm.
27. Arnold Toynbee, "The Shot Heard around the World," in his *America and the World Revolution and Other Lectures* (Oxford University Press, 1962), pp. 92–3.
28. Bill Dillon, *The USA—A Rogue State?*, October 27, 2002. Available at www.callipygia600.com.
29. William S. Cohen, *Annual Report to the President and Congress: 1999* (US Department of Defense, 1999).
30. Arundhati Roy, "The New American Century," *The Nation*, February 9, 2004.

Chapter 4 Black Gold and the Dollar

1. Donella H. Meadows, Dennis L. Meadows, Jorgen Randers and William W. Behrens III, *The Limits to Growth* (University Books, 1972).
2. *National Security Study Memorandum 200: Implications of Worldwide Population Growth for U.S. Security and Overseas Interests*, US National Security Council, December 10, 1974.
3. The Bilderberg conference is an annual unofficial meeting of around 120 high-profile representatives from government, media, and academia. Discussions are not reported and while venues are kept secret, meetings are usually held in Europe, the United States, or

Canada. For further information, see Mark Oliver, "The Bilderberg Group," *Guardian*, June 4, 2004.

4. Robert Dreyfuss, "The Thirty-Year Itch," *Mother Jones*, March/April 2003.

5. Cited in John McCaslin, *Scotsmen in Iraq*, Townhall.com, April 11, 2003.

6. Joel Kurtzman, *The Death of Money: How the Electronic Economy Has Destabilized the World's Economy and Created Financial Chaos* (Little, Brown, 1994).

7. Ibid., p. 12.

8. Ibid., p. 23.

9. Bill Clinton, "Remarks to the National Governors Association," Washington, DC, January 31, 1995.

10. Cited in Luther Komp, "The Current Financial System is Finished," *Executive Intelligence Review*, May 25, 2001.

11. Ibid.

12. Ibid.

13. Ibid.

14. Ibid.

15. Ibid.

16. "The Next Oil Frontier," *Business Week*, May 27, 2002.

17. Kevin Phillips, *American Theocracy: The Peril and Politics of Radical Religion, Oil and Borrowed Money* (Viking, 2006).

Chapter 5 Inside OPEC, Big Oil's Invisible Hand

1. *The International Petroleum Cartel*, Staff Report to the Federal Trade Commission, released through Subcommittee on Monopoly of Select Committee on Small Business, US Senate, 83rd Congress, 2nd session (Washington, DC, 1952).

2. Daniel Yergin, *The Prize: The Epic Quest for Oil, Money and Power* (Free Press, 1993).

3. Report of the Attorney General to the National Security Council relative to the Grand Jury Investigation of the International Oil Cartel—January 1953, in *The International Petroleum Cartel, The Iranian Consortium and US National Security*, United States Congress, Senate, released through the Committee on Foreign Relations (Washington, DC, 1974).

4. M. King Hubbert, *Nuclear Energy and the Fossil Fuels*, Shell Development Company, Publication No. 95, Houston, Texas, June 1956, presented before the Spring Meeting of the Southern District, American Petroleum Institute, Texas, March 1956.

5. William Engdahl, *A Century of War: Anglo-American Politics and the New World Order* (Pluto Press, 2004).

6. Henry Kissinger, *Years of Upheaval* (Little, Brown, 1982).

7. Cited in Dankwart A. Rustow, "The Middle East: US–Saudi Relations and the Oil Crises of the 1980s," *Foreign Affairs*, April 1977.

Chapter 6 Crusading for Israel

1. Tom Segev, *One Palestine, Complete: Jews and Arabs under the British Mandate* (Metropolitan Books, 2000), p. 255.

2. Cited ibid., pp. 114–15.

3. Cited ibid., p. 38.

4. Ibid.

5. Ibid.

6. Cited ibid., p. 111.

7. Cited ibid., p. 397.

8. Cited in Stephen P. Meyer, "Moses Mendelssohn, David Ben Gurion and the Peace Process: A Lesson in Statecraft," in Executive Intelligence Review Special Report, *Who is Sparking a Religious War in the Middle East?*, December 2000.

9. See Segev, *One Palestine, Complete*, p. 386.

10. Cited ibid., p. 430.

11. William A. Eddy, *FDR Meets Ibn Saud* (American Friends of the Middle East, 1954).

12. Cited in Salvador Astucia, *The Opium Lords: Israel, The Golden Triangle, and the Kennedy Assassination* (Dsharpwriter, 2002). Available at www.jfkmonteal.com.

13. Ibid.

14. Avner Cohen, *Israel and the Bomb* (Columbia University Press, 1999).

15. Andrew Cockburn and Leslie Cockburn, *Dangerous Liaison: The Inside Story of the US–Israeli Covert Relationship* (HarperCollins, 1991).

16. Menachem Begin, Address at the National Defense College, published in the *New York Times*, August 8, 1982.

17. *Ha'aretz*, March 20, 1972.

18. Statement by Pat Robertson on the television programme *The 700 Club*, Christian Broadcasting Network, November 14, 2002.

19. *The 700 Club*, Christian Broadcasting Network, April 24, 2006.

20. In a speech at the Southern Baptist Convention Annual Meeting, St Louis, Missouri, June 11, 2002, Vines stated that "Islam was founded by Muhammad, a demon-possessed pedophile who had 12 wives, and his last one was a 9-year old girl," cited in *Biblical Recorder*, June 14, 2002.

21. Grace Halsell, *Forcing God's Hand: Why Millions Pray for a Quick Rapture—and Destruction of Planet Earth* (Crossroads International

Publishing, 1999). See also Daniel Akin, "Christian Leaders Urge 'Biblical' Vote for Bush," WorldNetDaily.com, October 10, 2004. BarbaraTuchman, *Bible and Sword* (Ballantine Books, 1984); Donald Wagner, "Christian Zionists, Israel and the 'Second Coming'," *Daily Star*, October 9, 2003.

22. Yona Malachy, *American Fundamentalism and Israel: The Relation of Fundamentalist Churches to Zionism and the State of Israel* (Institute of Contemporary Jewry, Hebrew University of Jerusalem, 1978).

23. Middle East Council of Churches, *What is Western Fundamentalist Christian Zionism?* (Middle East Council of Churches, 1988), p. 13.

24. Uri Avnery, *Two Souls*, Doublestandards.org, June 8, 2002.

25. *Christian Leaders Urge "Biblical" Vote*, WorldNetDaily.com, October 10, 2004.

26. Halsell, *Forcing God's Hand*.

27. Issa Nakhleh, *Encyclopedia of the Palestine Problem*. Available at www.palestine-encyclopedia.com.

28. Marvin Olasky, *Born-again vs Perfect,* Townhall.com, August 26, 2004.

29. Bob Woodward, *Bush at War* (Simon & Schuster, 2002).

30. Cited in Max Blumenthal, *Born-agains for Sharon*, Salon.com, November 1, 2004.

31. Ibid.

32. Remarks by President Bush to the American Israel Public Affairs Committee, Washington, DC, May 18, 2004.

33. Cited in Bill Berkowitz, *Christian Zionists, Jews and Bush's Reelection Strategy*, Workingforchange.com, May 28, 2004.

34. Ibid.

35. Victor Ostrovsky, *The Other Side of Deception* (HarperCollins, 1994).

36. Cockburn and Cockburn, *Dangerous Liaison*, pp. 254–9.

37. "Israel Accounts for 12% of World's Military Exports," *Israel High-Tech & Investment Report*, September 2004. Available at www.ishitech.co.il.

38. Jennifer Washburn, "Power Bloc: Turkey and Israel Lock Arms," *Progressive Magazine*, December 1998.

39. Norman Finkelstein, *The Holocaust Industry: Reflections on the Exploitation of Jewish Suffering* (Verso Books, 2001).

40. Statement by Minister of Defense Director-General Amos Yaron, December 2000.

41. "Secret Agreement between USA and Israel," *Pravda*, April 11, 2002.

42. Desmond Tutu, "Apartheid in the Holy Land," *Guardian*, April 29, 2002.

43. John Mearsheimer and Stephen Walt, "The Israel Lobby," *London Review of Books*, March 23, 2006.

Chapter 7 Oil and God

1. Henry Luce, "The American Century," *Life* magazine, February 7, 1941.
2. Cited in Roger Morris, *Partners in Power: The Clintons and their America* (Henry Holt, 1996).
3. William Greider, *Who Will Tell the People? The Betrayal of American Democracy* (Simon & Schuster, 1993).
4. William Polk, *The Virtues and Perils of the American Political System*, Williampolk.com, May 10, 2003.
5. F. William Engdahl, *A Century of War: Anglo-American World Politics and the New World Order* (Pluto Press, 2004), p. 199.
6. Polk, *Virtues and Perils*.
7. "Empire Builders: Neoconservatives and Their Blueprint for US Power," *Christian Science Monitor*, June 2005. Available at www.csmonitor.com.
8. The Economic and Financial Group, Council on Foreign Relations, October 1940, cited in Daniel Hellinger and Dennis R. Judd Brooks, *The Democratic Façade* (Cole, 1991).
9. Ibid.
10. Michael Crozier, Samuel P. Huntington, and Joji Watanuki, *The Crisis of Democracy: Report on the Governability of Democracies to the Trilateral Commission* (New York University Press, 1975).
11. René Wormser, *Foundations, Their Power and Influence* (Covenant House Books, 1993), p. 209.
12. Cited in Joseph Kraft, "School for Statesmen," *Harper's Magazine*, July 1958, p. 67.
13. Anthony Browne, "From beyond the Grave, Prince Finally Admits taking $1m Bribe," *The Times*, December 4, 2004
14. See Crozier et al., *The Crisis of Democracy*.
15. Jimmy Carter, State of the Union Address, January 23, 1980.
16. "America 'Advises' Shevardnadze: Bush Stirs the Caucasian Pot," *Jane's Foreign Report*, Southwest Asia and Middle East, March 7, 2002.
17. See Greider, *Who Will Tell the People?*, p. 258.

Chapter 8 Future Imperfect: Why America Must Change

1. Thomas P. M. Barnett and Henry H. Gaffney Jr., "Global Transaction Strategy: How to Win the War against the West," *Military Officer*, May 2003.

2. Ibid.
3. Thomas P. M. Barnett, *The Pentagon's New Map: War and Peace in the Twenty-First Century* (G. P. Putnam's Sons, 2004).
4. Steven Runciman, *A History of the Crusades: Volume 3, The Kingdom of Acre and the Later Crusades* (Cambridge University Press, 1954).
5. Bernard Lewis, "The Roots of Muslim Rage," *Atlantic Monthly*, Vol. 266, September 1990, p. 60.
6. Richard Fletcher, *The Cross and the Crescent: Christianity and Islam from Muhammed to the Reformation* (Viking Books, 2004).
7. Ibid.
8. Karen Armstrong, *Muhammad: A Biography of the Prophet* (HarperCollins, September 1993).
9. Maulana Wahiduddin Khan, *Islam and Peace* (Goodword Books, 2000).
10. John Maynard Keynes, *The General Theory of Employment, Interest and Money* (Hogarth Press, 1936).
11. G. John Ikenberry, "Illusions of Empire: Defining the New American Order," *Foreign Affairs*, March/April 2004.
12. Chalmers Johnson, *The Sorrows of Empire: Militarism, Secrecy and the End of the Republic* (Metropolitan Books, 2004).
13. Armstrong, *Muhammad: A Biography of the Prophet*.
14. John le Carré, "The United States of America has Gone Mad," *The Times*, January 15, 2003.

Index

Compiled by Sue Carlton

INDEX
231

MICHAEL FREEMAN

THE PHOTOGRAPHER'S POCKET BOOK

THE ESSENTIAL GUIDE TO GETTING THE MOST FROM YOUR CAMERA

An Hachette UK Company
www.hachette.co.uk

First published in the UK in 2016 by ILEX,
a division of Octopus Publishing Group Ltd
Carmelite House
50 Victoriat Embankment
London, EC4Y 0DZ
www.octopusbooks.co.uk

Design, layout, and text copyright
© Octopus Publishing Group 2016

Publisher: Roly Allen
Associate Publisher: Adam Juniper
Managing Specialist Editor: Frank Gallaugher
Senior Project Editor: Natalia Price-Cabrera
Editor: Rachel Silverlight
Art Director: Julie Weir
Designer: Jon Allan
Production Controller: Meskerem Berhane

ISBN 978-1-78157-343-3

A CIP catalogue record for this book
is available from the British Library

Printed in China

CONTENTS

Introduction

In their infancy, digital cameras were the preserve of a select group of professional photographers, or exceptionally wealthy enthusiasts. While 35mm-film cameras had reached a point in their development where there was something for everyone, regardless of their skill level or budget, the transition to sensor-based digital capture came with a price-tag that made it prohibitively expensive for the photo enthusiast. To enjoy the benefits of photography with an interchangeable lens digital camera meant investing heavily in a technology that was evolving at a phenomenal rate, with manufacturers turning out significantly superior cameras on an alarmingly regular and brief timescale; a doubling of camera resolution in as little as 12 months was common.

Today, however, the frenetic pace of camera development and the leaps in technological "breakthroughs" have slowed, although that isn't to say they have ceased altogether. Sensor resolutions continue to creep upward, with the highest resolution cameras now competing with medium-format digital backs for resolving power, and new technologies continue to be squeezed into the camera body to enhance the photographer's experience; built-in anti-shake systems to combat camera shake, in-camera dust-removal, Live View, video recording, and Wi-Fi connectivity are all common, for example. But it is not the maturing technology that has expanded the camera market so far, it is a far more material aspect: price. While hefty prices excluded most non-professional photographers (and many pros) from "going digital" a decade or so ago, the low-cost of modern "entry-level" cameras puts them within financial reach of novice photographers.

Yet while buying a camera no longer requires the same financial sacrifice, it still demands an investment in time if you want to make the most of it. Fundamental photographic concepts such as aperture, shutter speed, and ISO may not have changed since the day photography was born as a medium, but their implementation in the digital age, to a certain extent, has. In addition, there are all of the necessary digital technologies that need to be mastered or, at the very least, understood. While some photographers may be happy setting their camera to "automatic" and allowing it to determine the many and varied picture-taking parameters, to use a camera to its fullest potential there is a great deal to learn.

That is precisely the purpose of this book. What I aim to do here is to reveal how you can get the very best from your camera, and show how digital capture can, and should, change the way you think about shooting, regardless of whether or not this is your first camera.

THE DIGITAL ENVIRONMENT

You're already at an advantage—the ubiquity of digital images, regardless of the device that created them, has made the general public aware of a vocabulary of photography that, not so long ago, was little known outside of professionals and serious enthusiasts. The first step is to both expand on that knowledge, and dig deeper to understand exactly what is going on inside the camera when you take a photo.

The progress of digital imaging has been nothing short of remarkable. It seems almost inconceivable that it was only in 2000 that Canon launched its flagship DSLR, the D30, which featured a 3.1-megapixel (MP) sensor—a resolution now exceeded by most cameraphones.

Now, however, the speed of technological change has slowed somewhat. In the past, factors such as increased resolution, Live View implementation, and constantly improving high ISO performance resulted in photo enthusiasts having seriously to consider upgrading their camera body on a yearly basis as image quality and shooting convenience improved dramatically with each upgrade. A very costly business. More recently, the latest models (with one or two exceptions) have seen fewer step changes, so the need to upgrade cameras on a regular basis is much diminished.

Today, all cameras are capable of producing excellent images. However, exploiting their enormous capabilities, and imaging software to its fullest, means immersing yourself in a different world, and, after this initial chapter, starting to shoot intuitively. This means not following the manual—but it will still help to have read it first.

Interchangeable-lens Cameras

Whereas DSLRs used to exclusively occupy the "serious camera" space, innovations in sensor technology and camera manufacturing have brought about a relatively new class of "mirrorless" cameras. Both designs have pluses and minuses, and are worth understanding inside and out.

First, the similarities: large sensors, a lens mount that can fit a variety of lenses, and enough buttons and dials to give complete control over all the variables of shooting. These are the essential characteristics that make these professional-level tools rather than more casual cameras of a point-and-shoot variety.

How they go about capturing images is quite a different story, however. DSLRs take a mechanical approach, one held over from the days of film. As you can see in the diagram below, light passes through the lens, is funnelled into the camera body, where it is reflected through a series of mirrors, lenses and prisms into an eyepiece. This allows you to see Through The Lens (TTL), getting exactly the view that will be captured. When you fire the shutter, the mirror swings out of the way, exposing the sensor apparatus, and the image is recorded. This was all necessary back in the film days, because there was no way to "read" a live preview of the scene from a filmstrip— but that's no longer the case.

How DSLRs gather light

GAUSS TYPE LENS GROUPS

ASPHERICAL GLASS LENSES

IMAGING SENSOR

MIRROR BOX

HIGH INDEX LOW DISPERSION LENS

ED (EXTRA DISPERSION) LENS

MIRRORLESS

In this high-end Sony mirrorless camera, you can see the sensor sits extremely close to the back of the lens, because there is no mechanical mirrorbox assembly getting in the way. This impacts certain types of lens designs as well, allowing for smaller lenses than the DSLR equivalent (in some cases—it's not a guarantee of smaller lenses of all sorts).

You can guess the defining feature of mirrorless cameras from the name (which isn't official, by the way, but it has become the accepted nomenclature for this class). These cameras do away with the whole complicated and mechanical mirrorbox assembly, allowing the light from the lens to fall directly onto the sensor itself, which is always on (as long as the camera is powered on). It is not, however, always recording—it's simply feeding a live preview of what it's capturing to either the LCD screen on the back of the camera, or a high-resolution Electronic Viewfinder (EVF). This method allows you to see additional information while composing your shot, including a live histogram (to aid in exposure—see pages 41–43), levels to make sure your camera is upright, magnified views to check focus in detail, and so on (depending on the model).

There is also a significant difference in the method of autofocus that DSLRs and mirrorless cameras use. DSLRs use their mirror box assembly to split a small portion of the incoming light into two beams, and reflects those beams down onto a series of dedicated autofocus sensors. These sensors then calculate the difference between the beams—if they are identical, the image is in focus; if they are different, the sensors can calculate exactly how far out of focus the image is, and where the focus needs to be. That data is then transferred to the lens, which focuses at that particular distance, and focus is achieved. This method is called Phase-Detect Autofocus (PDAF).

Mirrorless cameras tend to use a different method called Contrast-Detect Autofocus (CDAF). This one is rather simpler to explain: a processor cans the image being read off the

sensor for contrast. The lens then makes a series of micro adjustments in either direction, and the contrast is then read again—if it gets less contrasty in one direction, that's going farther out of focus; if it gets more contrasty in the other direction, that's getting closer to focus, so the lens moves farther in that direction. This cycle repeats itself until moving the focus in either

direction results in a decrease in contrast; at that point, the image must naturally be in focus. That sounds like a very tedious process, and when the first mirrorless cameras came out (with less-than-impressive processors), it was indeed quite slow. But the processors in modern mirrorless cameras can perform these computations at a speed puts them on par with PDAF, at least with stationary subjects.

Compact cameras

Although manufacturers are pouring money into developing mirrorless and DSLR cameras, the majority of cameras bought today are still compact cameras. These range from the high-end models, which are distinguished from professional SLRs only in that they have a fixed lens instead of interchangeable lenses. Sensor size and resolution are comparable with serious cameras—many feature APS-C sensors and one or two boast Full Frame sensors. Being light and

small they can be carried and used unobtrusively, and so are convenient to have around on the off-chance of a picture opportunity.

At the other end of the scale are the entry-level, point-and-shoot compacts. Featuring smaller sensors, these cameras are very affordable, yet can produce good-quality images, and most will out perform cameras found on cell phones.

PANASONIC LUMIX LX100

Despite a compact design, the Lumix LX100 can produce high-quality images thanks to its large, 12-MP sensor, manual controls, and fast Leica-manufactured lens.

When it comes to moving subjects, PDAF DSLRs still lead the pack, because they can move the lens to precisely the right position based on a single reading, whereas CDAF requires multiple readings (even if those readings are taken at lightning speed). Of course, further complicating the matter is the fact that mirrorless cameras can sometimes feature PDAF sensors built into the sensor itself, offering the best of both worlds.

The important thing to take away from this is that both mirrorless and DSLR designs are extremely capable cameras, particularly when you're considering the top-of-the-line, professional models. DSLRs, due to their long lineage, may offer access to a greater range of lenses and accessories (though they may be rather dated in some cases); mirrorless cameras are usually more compact (significantly moreso in many cases).

NIKON VS. CANON

Nikon and Canon remain the "big two" when it comes to cameras, sharing over three quarters of the overall market.

Camera Controls

POP-UP FLASH

MODE DIAL

SHUTTER
RELEASE

LENS RELEASE
BUTTON

CONTROL
WHEEL

FLASH
SOCKET AND
ACCESSORY
PORT

Nikon

D810

FX

ACCESSORY
BATTERY GRIP
WITH ADDITIONAL
CONTROLS FOR
VERTICAL SHOOTING

AUTO/MANUAL
FOCUS SWITCH

VIEWFINDER

AUTOEXPOSURE/
AUTOFOCUS
LOCK BUTTON

SHOOTING
MODE DIAL

AUTOFOCUS-
ON BUTTON

DELETE
BUTTON

SECONDARY
CONTROL
WHEEL

MULTI
SELECTOR

LIVE VIEW
BUTTON &
STILL-IMAGE/
VIDEO SWITCH

PLAYBACK
BUTTON

MENU, LOCK,
MAGNIFY,
ZOOM-OUT,
AND OK
BUTTONS

INFO BUTTON

LCD DISPLAY

There's no such thing as a standard set of camera controls; they vary between manufacturers, and even among the models of a single manufacturer. But regardless of their specific placement on the camera, the controls shown here are likely present in one form or another—which includes them possibly being available as a setting in the menus.

The Digital Sensor

As sensory technology is still evolving, gradual improvements in dynamic range capture and noise reduction are ongoing, and although increases in resolution are not as frequent as they once were, both Nikon and Canon made quite dramatic leaps with their D800 (36MP) and 5DS (50MP) models respectively.

A sensor is an array of photoreceptors embedded on a microchip, along with the circuitry and components necessary to record the light values. The circuits are etched into the wafer by repeating the photolithographic process of light exposure and chemical treatment, with extreme precision. The width of circuit lines is typically between 2-4μm (2-4 microns). As an indication of the complexity, Canon's 50-megapixel CMOS sensor has approximately 3,000 feet (900 meters) of circuitry. The individual unit of a

Sensor development

All sensor manufacturers are seeking to improve sensor performance—and one of the more recent innovations is backside-illuminated (BSI) CMOS sensor technology. In a traditional CMOS sensor (see page 18), the wiring and circuitry that carries signals from the sensor to the processor are on the front of the sensor. With BSI sensors this circuitry sits at the back of the sensor behind the all-important, light-gathering photosites. This allows more light to reach the photosites, making the sensor more light receptive, and thereby improving its low-light performance. Early BSI sensors were small in size, but more recently Sony began making full frame BSI sensors.

Capturing color

Photosites are not able to distinguish between different wavelengths of light, and as such are unable to record variations in color; color is added by filtering the light. The entire sensor is covered with a Color Filter Array (CFA)—a mosaic of red, green, and blue filters, one for each photosite. The camera's processor then interpolates the missing two-thirds of the color information from the surrounding pixels—at least the neighboring block of eight. The CFA pattern, as illustrated here, is not an even distribution of the three wavelengths. In order to better correspond with human vision, which is most sensitive to green-yellow, there are usually twice as many green filters as red and blue.

sensor is the photosite, a minuscule well that is occupied principally, though not exclusively, by a photodiode. The photodiode converts the photons of light striking it into a charge—the more photons, the higher the charge. The charge is then read out, converted to a digital record, and processed. Each signal from each photosite becomes the light and color value for one pixel—which is the basic unit of a digital image.

Photodiodes record light rather than color, so this has to be added by interpolation in the vast majority of sensor designs. The usual method is to overlay the sensor array with a transparent color mosaic of red, blue, and green. As in color film and color monitors, these three colors allow almost all others to be constructed. The difference here, however, is that the color resolution is one-third that of the luminance resolution. Oddly, perhaps, this doesn't matter as much as this figure suggests. Interpolation is normally used to predict the color for all the pixels, and perceptually it works well.

Recent advances in sensor technology, however, have seen the introduction of "pixel-shifting", in which the sensor actually shifts as the camera captures as a number of shots (either 4 or 8) in quick succession. The result is that each pixel captures red, green, and blue light dispensing with the need for interpolation. Naturally this only works effectively with a tripod-mounted camera shooting static subjects, and you need proprietary software to blend the images together, but sharper-looking, color-faithful images are possible with this technology. Olympus and Pentax are pioneering this technology, but it's sure to filter throughout the rest of the industry over time.

Photosites

Photosites create an electrical charge when struck by light. An absence of light means no electrical charge, resulting in black. On the other hand, if light continues to strike a photosite beyond its "holding capacity" the result is pure, featureless white. This accounts for the linear response of digital sensors to light rather than the subtle fall-off that allows film to capture a relatively wide dynamic range.

Photosite collects light photons

Readout from the photosite

Light photons travel from lens

Sensor types and size

Digital cameras utilize one of two main types of sensor—CCD (charge-coupled device) or CMOS (complementary metal oxide semiconductor). Chips of all kinds are made in wafer foundries, but as CCDs are a specialized variety, they are more costly to produce. CMOS foundries, however, can be used to manufacture computer processors and memory, and so CMOS sensors can take advantage of economies of scale. This makes them much cheaper than CCDs to produce, although some of this saving is offset by the need to overcome some performance problems, notably noise, which means additional onboard processing. In other words, CCDs are inherently better for high-quality imaging, but once data processing has been factored in there is little to choose in performance at the top end of digital cameras. In fact almost every camera made today uses CMOS chips.

In terms of sensor size, most cameras feature either an APS-C (22.2 x 14.8mm for Canon and 23.5–23.7 x 15.6 mm for the rest) or a Full Frame (26 x 24mm) sensor, apart from the Micro Four Thirds mirrorless cameras, which feature 17.3 x 13mm sensors.

CMOS chips are produced as part of a silicon wafer, like other computer chips, and are cut into individual chips using a diamond-edged saw.

Once cut into separate pieces, the chips can be placed onto circuits like any other computer chip.

The problem of moiré

Light from certain subjects, such as fabrics or materials with a tight weave, can occasionally only activate certain rows of the sensor's pixels, leaving neighboring rows inactive, or "dark." This results in an effect known as moiré, which usually manifests itself as wavy patterns, and is an interference effect caused by the overlapping of tight, fine patterns.

In digital photography, this special kind of artifacting is particularly common because of the grid pattern of photosites on the sensor. If a second pattern with a similar spacing is shot, such as a textile weave, it can interact to create a moiré pattern, as shown here. The camera's low-pass filter helps to reduce the effect, although only to a certain degree as strong correction softens the image overall. The lenses, sensor, and software in a camera system are all designed for high sharpness and accuracy, and this makes moiré more likely. Even more so with the more recent cameras, such as the Sony A7Rii, which have dispensed with the low-pass filter altogether.

To avoid or reduce moiré:
- Change the camera angle or position.
- Change the point of focus and/or aperture.
 (Moiré is a function of sharp focus and high detail.)
- Vary the lens focal length.
- Remove with processing software.

Warning: always inspect for moiré at 100% magnification. At smaller magnifications you can often see a false moiré, which is the interaction of the image with the pixels in a camera's LCD screen or a computer monitor.

Picture suffering from moiré

Combating moiré

To combat moiré, light is passed through a low-pass filter that effectively spreads light by the width of a pixel, both horizontally and vertically. This results in more accurate data separation. The filter illustrated here is Canon's three-layer filter, in which a phase plate—which converts linearly polarized light into circularly polarized light— is sandwiched between two layers that separate image data into horizontal and vertical directions. Another substrate cuts infrared wavelengths by a combination of reflection and absorption to further improve color accuracy.

DICHROIC MIRROR
Reflects infrared light

INFRARED ABSORPTION GLASS
Absorbs infrared light

CMOS SENSOR
Light received as individual RGB pixels

LOW PASS FILTER 1
Separates subject data horizontally

PHASE PLATE
Converts linearly polarized light into circularly polarized light

LOW PASS FILTER 2
Separates subject data vertically

Data Transfer

Once the sensor has captured the light from the subject and generated a charge, the data has to be transferred in a readable form to the camera's processor as quickly and as accurately as possible, and there are different ways of achieving this.

The original method, which gave the CCD (charge-coupled device) its name, relies on reading out the charges row by row, linking the end of one row to the beginning of the next. In this way, the charges are "coupled."

Improving speed

One of the key issues is the speed at which the image data can be moved off the sensor so that it is ready for the next exposure. This decides the shooting speed—an important factor for sports and news photographers in particular—as well as creating the ability to bracket images, compile HDR images and shoot super slow-motion video.

Historically, there were three methods used by sensors—interline transfer, full frame transfer, or X-Y addressing. CCD sensors use the former methods, while the latter method is employed by CMOS sensors. All have advantages and disadvantages, and different manufacturers favor one or the other according to what the sensors are designed to do. However, as CMOS sensor technology has advanced in recent years, particularly in areas such as improved high ISO performance, much faster transfer rates, reduced cost, and less power consumption, X-Y addressing is emerging as the default data readout method of choice, leaving the other two increasingly for niche uses.

Data readout

Improving the speed and efficiency of data transfer remains a critical area of development. There are three methods of transferring the data from an exposed sensor:

Interline transfer
In this basic, original method (which gave CCDs their name) the data from the photosites is shunted to one side of the sensor so that the rows can be read one at a time, with the end of one linked to the start of the next. The readout is therefore sequential. Originally developed for video, its disadvantages for still digital capture are the time it takes to shunt the data across the array, and the need for transfer channels adjacent to the photodiodes, which reduces the aperture ratio at the photosite.

X-Y addressing
Each photosite is read individually, which cuts down the transfer time and offers potential processing advantages. It requires individual switches for each site, which potentially reduces the area available for the photodiode, reducing the aperture ratio. This method is used in CMOS sensors and some others (such as the Nikon LBCAST, which has been gradually phased out).

Full-frame transfer
All of the data is moved at once down onto an area the same size as the sensor. This adds another layer of the same area as the sensor, but as the transfer channels can be underneath the photosites, the photodiodes can occupy a larger area. It also addresses the issue of transfer speed.

The creation and storage of an image

1 Light strikes the active area of the photodiode.

2 The photodiode converts the quantity of light into an accumulated charge.

3 The charge is moved off the sensor (with all the other charges from other photosites) through transfer channels to an amplifier.

4 The amplified charge is moved to the ADC (analog-to-digital converter).

5 The signal is processed by the ADC into digital data.

6 The imaging engine processes the image in a number of ways, including applying user settings, compressing, and reducing noise.

7 The data is transferred to the memory card or direct to the computer's hard drive (if the camera is connected).

The Imaging Processor

Acamera's imaging processor works behind the scenes, turning the data received from the sensor into a viewable digital image. As such, it is responsible for all the computation of the data from the sensor, from the signal received by the ADC (Analog-to-Digital Converter) to the transfer of a completed image to the memory card.

There is a great deal of hidden work going on here, not only because you have no direct access to it (other than through the menu settings), but because the proprietary algorithms that are at the heart of the processor are kept secret. As with software applications used on desktop computers,

algorithms are the mathematical procedures for performing actions, and those for imaging are complex. Not only that, but there are differences in the quality of the programming—which can only be judged in the appearance of the final image. There is more to do with image quality, in all its aspects, than the simple specifications of the sensor.

In high-end cameras, the design of the sensor and the imaging engine traditionally proceeded in tandem, with major camera manufacturers developing their own sensors and processors as a way of improving imaging performance. However, more recently for

A processor engine

Your camera's onboard electronics can make decisions for you, should you choose, but it will only ever be able to see the scene from the point of view of "averages" or "most people."

varying reasons, primarily no doubt financial, some camera manufacturers have started using sensors manufactured by third-parties. For example, Nikon use Sony sensors in many of their camera models; whether Nikon designed the sensors and use Sony to manufacture them is not clear. What is clear, however, is that it is essential that sensor and processor work together to produce the best possible imaging results. For example, Nikon's high-end models use the processor to carry some of the burden of suppressing color aliasing (false coloration), which is normally the job of the optical low-pass filter immediately in front of the sensor. Increasing the birefringent index of this filter suppresses the color artifacts better, but it also lowers resolution. The Nikon filter has a lower birefringent index because the imaging engine takes on some of the task.

A great deal of sensor technology involves compromise, and the imaging engine can solve many of the problems. You can experience something of this (in a much more limited way) by shooting in Raw format and optimizing your images later. It's important not to try to make comparisons between cameras based on the specifications that are usually published. Properly designed, a sensor and processor combination with a modest megapixel size can ultimately produce images that have a higher resolution and better sharpness than a larger, more primitive sensor.

The processor is primarily responsible for the following tasks:

The memory buffer As frames are captured they are moved immediately to the buffer, from where they are transferred one at a time for processing. Buffer size has an impact on the shooting speed (capture rate).

Creating color Pixels are sampled in relation to their neighbors, taking into account the color array pattern, to fill in the missing color information. Color gradation across the image needs to be smoothed, and color artifacts (false colors and fringing) removed.

Resolution and sharpness A number of aspects affect sharpness and resolution, including noise, aliasing (jaggies), and color artifacts.

Reducing noise An extremely important operation, as the various kinds of noise are obstacles to capturing a clean image from a sensor.

User settings Applying the choices offered in the menu to the image.

Image creation Combining all of the sensor data and processing to produce a readable image in one of several formats.

Compression In the case of JPEG and some Raw images, applying compression algorithms.

Updating firmware

Firmware is the term used to describe various programs already encoded in the camera, and it will occasionally need updating as the manufacturer makes new versions available. There will be an option in the camera menu that lets you check the firmware version installed; make a note of this and every few months check the manufacturer's website to see if there are updates. If so, you may be able to perform the operation yourself, depending on the make of your camera (with some makes this must be done by an authorized service center). With user-installed updates, pay careful attention to the instructions as this is an operation that can damage the processor if it goes wrong. In principle, the sequence is:

1 Download the firmware update installer to your computer from the manufacturer's website.

2 Copy the installer to a blank memory card, using either a card reader or the camera.

3 Run the install operation from the memory card. This takes several minutes, and during this time the camera must under no circumstances be powered down. Either ensure you the battery is fully c

4 Erase the installer from the memory card.

Camera Menus

Because a digital camera can be set up with an often bewildering number of user preferences, from significant shooting settings such as ISO sensitivity to convenience options such as how files are numbered, all cameras need a comprehensive menu.

The options are grouped more or less logically, and a typical division is into set up, shooting, and playback, with an extra sub-menu for custom settings in some instances.

Some of the settings can be accessed via dial and button controls on the camera body for ease and speed of operation—this may be instead of being on the menu or in addition. The menu structure varies from brand to brand, but is likely to cover the following:

Standard options

..

Set up (may be subdivided)

LCD brightness, time on
Date and time
Language
Folder creation, assignment
Add information
Mirror lock-up
Format card
Video output
Cable connection protocol
File numbering
Noise reduction
Auto features on/off
EV steps
Bracket steps
Focus settings
Grid display
Flash mode
Assign dials and buttons
Shoot to computer

Shooting

File format
Image size
White balance
ISO
Contrast
Hue adjustment
Color mode
Sharpen
Print specification
Live View
Movie

Playback

Image size on screen
Data displayed
Zoom
Delete
Image protection
Hide image
Folder selection
Slide show

CANON

Shooting settings

Autofocus settings

Playback settings

Camera setup

NIKON

Shooting settings

Playback settings

Camera setup

Custom settings

Built-in retouching options

Image Resolution

In the digital environment, an image's resolution is governed simply by the number of photosites or pixels sited on the sensor: the greater the number of pixels, the more detail the sensor is capable of capturing.

However, it's important not to think of resolution as the defining factor in image quality, as more pixels don't necessarily make for a better image. It's the quality of the pixels that count, and not the quantity.

Camera sensor technology has evolved to such a point that today all cameras are capable of producing high-quality tabloid- or A3-sized prints, and a few cameras can easily exceed this. For the vast majority of us this is quite sufficient. However, for some this may still not quite enough, and so we need to be aware of what the limits are—and which techniques are available to help push the envelope.

The way to deal with resolution is to work backward from the end use. What looks good on a 22-in monitor will not necessarily look good as a normal print, but if the screen view is all you need, that doesn't matter. Professionally, the main uses for images are prepress, display prints, and the Web. For both prepress and display prints, digital files should be at twice the resolution at which they will be printed. A high-quality web offset press, for example, has a line-screen resolution of 133 and 150, so the digital file should be 300 ppi. This is the standard, default resolution for printing.

What ultimately counts, of course, is the number of pixels that goes into making the image. Simply expressed, you need a 22MB file for an 8 × 10 in print, and about the same for a full page in most magazines. Each camera megapixel gives 3MB of image (that is ×3 for the three RGB channels), which means that 7 megapixels will do the job perfectly and a 6-megapixel camera will be adequate. In terms of use, a full page is one of the most basic professional units, while a double-page spread—twice the size—takes care of any possible use that an editorial client might

DIGITAL

This view of an old windmill on the beautiful Greek island of Mykonos was shot using a digital camera with a 6-megapixel resolution.

FILM

This shot was taken immediately after (in the same conditions) with a traditional film camera. Film is believed to be equivalent to about 20 megapixels of detail.

Resolution: digital vs. film

Although it's a question often asked, it's almost impossible to compare resolution between digital and film because the measurement systems are different, and because digital images are in principle "cleaner" than film images. Digital images can be measured by the density of pixels, but other factors creep in, particularly the quality of the lens. The usual measurement is pixels per inch or per centimeter along a straight line. A full-frame 36 × 24mm sensor with 20 megapixels, for example, will have a resolution of 5470 × 3650 pixels.

Digital 100%

Digital 200%

Film 50%

Film 100%

want to make. Stock libraries are in the best position to know the demands of the market, and Corbis, for instance, set the following specifications for their own images: 40MB for editorial sales, 50MB for commercial. This may sound high, but in a side note they add that, with good interpolation methods, a camera with 11 megapixels should be able to create a 50MB file, and nearly all cameras now exceed this megapixel count. How successful interpolation is depends on the algorithm used, and this is highly technical. It also depends on how much deterioration you are prepared to accept. No interpolation

method, however sophisticated, can equal a higher resolution original, but on the other hand the differences can be surprisingly small. Resolution, together with sharpness and noise, are also matters of judgment. If you have a unique or important photograph by virtue of its content, image quality takes second place. This regularly happens in news journalism and in art, too, and always has. Compare, for example, an early Bill Brandt print (many are technically sub-standard) with an Edward Weston print from an 8 × 10 in negative (Weston was known for his technical perfection).

File sizes and resolution for common print and monitor outputs

Prepress and display prints	Millimeters (w x h)	Inches (w x h)	MB @ 300 ppi
Magazine full page (Time magazine size)	190 x 260	7.5 x 10.1	19.5
US Letter	216 x 279	8.5 x 11	21.2
A4	210 x 297	8.27 x 11.69	25.5
8 x 10in print	203 x 254	8 x 10	21.1
A3	297 x 420	11.69 x 16.54	51.0
Magazine double spread (Time magazine size)	380 x 260	15 x 20.2	78

Monitor display (pixels)	Millimeters (w x h)	Inches (w x h)	MB @ ppi
17-in full screen (1024 x 768)	345 x 259	13.6 x 10.2	2.3 @ 75 ppi
20-in full screen (1280 x 960)	406 x 305	16 x 12	3.5 @ 80 ppi
20-in cinema display (1680 x 1050)	432 x 269	17 x 10.6	5.1 @ 100 ppi
23-in cinema display (1920 x 1200)	495 x 310	19.5 x 12.2	6.6 @ 100 ppi
27-in cinema display "XD" (2560 x 1440)	582 x 363	22.9 x 14.3	7.9 @ 100 ppi
iPad air (2048 x 1536)	240 x 169	9.4 x 6.67	7.0 @ 264 ppi
iPad Pro (2732 x 2048)	305.7 x 220.6	12.04 x 8.69	9.1 @ 264 ppi

(Note: software commonly assumes monitors to be either 72 ppi or 96 ppi, though in reality it varies.)

File Formats

Digital photography can be seen as just one branch or one element of the larger subject of digital imaging. Images have been created digitally, without digital cameras, for many, many years, and for this reason a number of different ways of organizing and storing digital images, known as file formats, has evolved, each with a particular specialty.

Some formats are better suited to one kind of image than another—for example, graphic illustration with solid color and hard edges as opposed to photographs containing complex detail and shading. Some formats are aimed at delivery—such as for the Web. By now, a few standard formats are accepted as useful for photographic images, primarily TIFF (Tagged Image File Format) and JPEG (Joint Photographic Experts Group). These two are readable and interchangeable by all

imaging software that deals with photographs. In addition, there is the native application format that each software program uses for its own internal workings, such as Photoshop's .psd files. These may or may not be readable by other applications.

Most cameras offer two kinds of format: JPEG and Raw. JPEG, pronounced "jay-peg," is computing's longest-established system for writing images. It has two powerful advantages: it is optimized for transmitting images, and so is the universal format for the Web, and also compresses images so that they occupy less digital space. The amount of compression is chosen by the user—to more than 90%—and typical compression ratios are between 4:1 and 40:1. The compression method used is Discrete Cosine Transformation, which works on blocks of

Bits and colors

One bit (a contraction of binary digit) is the basic unit of computing, and has two states, on or off—black or white. A byte is a group of 8 bits, and as each of these has two states, one byte has a possible 256 combinations—that is, 256 values from black to white. An RGB image has three channels, so at 8 bits per channel has a color accuracy of 256 x 256 x 256—that is, 16.7 million possible colors. This is well beyond the ability of the human eye to discriminate, and is standard. Why then, do higher-end scanners and cameras make much of higher bit-depths, such as 12-, 14-, and 16-bit? This is because, first, it makes smoother and better graduated tones in a gradient (such as a clear, blue sky), and second, it improves the accuracy of interpolation when images are altered or manipulated during post-production.

Note that it is usual to refer to bit-depth (that is the number of bits) by channel, but occasionally you'll see it described as the total, all-channel bit-depth—24-bit meaning 8 bits per channel and 36-bit meaning 12 bits per channel.

eight pixels per side and is "lossy," meaning that some of the image information is thrown away. This results in some degradation, but this is quite often undetectable in normal image reproduction. It's important to run tests to assess what compression levels are acceptable to you for different purposes.

For the best image quality, and the ability to re-adjust all the camera settings after the event, there is Raw format. This is a file format that is unique to each make of camera, but what they all have in common is that settings such as white balance, hue adjustment, sharpening, and so on, are recorded and kept separately from the image data. The great advantage of this is that any of these settings can be altered during processing, with no penalty in image quality. Another benefit is that the images are available at a higher bit-depth—typically 12- or 14-bit. The disadvantage is that Raw images need extra work when opening them in your editing program, which means spending time working on them.

RAW FILES

"Raw" is a generic name for the proprietary files produced by all digital cameras. Here, a .CR2 file (Canon's Raw file format) is adjusted using Canon's software, supplied with the camera. The alternative to Raw is to have the camera output a JPEG file instead. This will embed the camera settings in the image, reducing the ability to make changes such as white balance adjustments (as shown here), as easily, although less work is subsequently needed to view or print the image.

Compression vs. Image Quality

Although storage space, primarily in the form of memory cards, is becoming less expensive, there are still advantages in being able to compress the data for a photograph, provided that the image is not noticeably degraded. The key word here is "noticeably."

The raison d'être for JPEG in the camera's menu is that it is both a compression method and a file format, and this is usually the format to choose when it is important to squeeze the maximum number of images onto a memory card. In addition, the recording time will usually

be less than it is for a Raw file, and so the images will move through the frame buffer more quickly—all good for shooting large numbers of images continuously.

Compressing a Raw image is a different matter. The space saving is in the order of 50%, but there is a time penalty, and this becomes important once the buffer has filled. This creates a potential problem when choosing whether or not to begin with compressed files—you will need to wait for the image(s) to be processed before you can change to uncompressed on the menu.

Compression and degradation

Most cameras offer a number of compression levels, ranging from high to low, and usually expressed along the lines of Basic, Normal, and Fine, with Basic offering the highest compression/lowest image quality, and Fine the lowest compression/highest image quality. However, the resulting file sizes depend on the image content. If you are going to make significant use of JPEG format, it is essential to run your own tests and judge what degradation you are happy to accept. The images will all be degraded slightly, but the key is to choose a setting that makes no visible difference. In practice, most people can detect no quality loss at normal viewing distances.

Basic Normal Fine

Compression: lossless vs. lossy

Compression can be applied in one of two forms—lossless or lossy. As their names imply, one compresses the file size without discarding any data (working instead by writing the data in a more succinct way), while the other throws away some of the information. Compression is sometimes described as a ratio (e.g. 1:4), as a percentage of reduction (e.g. 80%), or as a percentage of the original file size (e.g. 20%). The last two are easily confused.

The leading lossless compression system is LZW (named after its inventors Lempel-Ziv-Welch), used with TIFF images, and the amount of space saved depends on the image content. Typically, file sizes are reduced to about 40% to 50%, though less in high bit-depths. Raw formats can also be compressed without loss, using camera manufacturers' proprietary methods. One disadvantage of lossless compression is that it can add substantially to the recording time.

Lossy compression does degrade the image, but not necessarily to the point where it can be seen. The leading compression system is JPEG, and the amount of compression can be selected by the user. In-camera compression is normally limited to a choice of three settings, which vary among camera makes, but are typically 1:4, 1:8, and 1:16.

RAW
This photograph is the original image as photographed in Raw format.

JPEG
This is the same image compressed at the highest-quality level in JPEG format. At this size the two images are indistinguishable.

Measuring Exposure

The ability to review your images
instantly using the camera's rear LCD
screen has meant that getting accurate
exposure has never been so easy.

Even if you insist on using Manual rather
than Auto exposure, it is still quicker to guess
the settings, shoot, and check the result than
to work them out carefully.

If this sounds less than conscientious,
remember that another set of skills is required—
judging good exposure by means of the
histogram and clipped highlight warning.
Most cameras offer a choice of matrix/multi-
pattern metering, center-weighted, and spot
readings. Each has its use, but again, it is the
result on the LCD display that really demands
your attention.

The metering principles are largely the
same as for film cameras, with the possibilities
of extra precision because each pixel can be
measured. There are three principal metering
systems, and different modes that allow you
to prioritize shutter speed or aperture and
create custom combinations of both.
Exposure compensation and exposure
bracketing (in which bursts of consecutive
frames are exposed at changing increments
over and under the metered reading) are
standard. Advanced measurement in high-
end cameras takes account not just of
brightness, but also color, contrast, and the
area focused on, all in an effort to second-
guess which parts of the scene you are likely
to want accurately exposed.

Although instant review means that you
can retake the shot if you're not happy with
the exposure, there may be times when you
don't have a second chance, so getting it right
first time is always an important consideration.

Spot

The spot metering mode in most cameras allows
you to make readings from a very small central
area—often little more than 2% of the image area.
This is the in-camera equivalent of a spot meter,
in which you can measure very small parts of the
scene. This is especially useful if you want to base
the exposure on a particular precise tone.

For this scene, taking a spot reading from the
brick building prevents the shaded foreground
or bright sky from influencing the overall
exposure.

Center-weighted

Center-weighted metering gives priority to the central area of the frame, on the reasonable assumption that most images are composed that way. Less attention is paid to the corners and edges. The precise pattern of weighting varies with the make of camera, and some models allow you to choose different weightings.

A center-weighted meter reading eliminates much of the sky and foreground, giving a good tonal range. Note that overall, the exposure is lighter than the spot meter reading on the previous page.

Center-circle metering

The center-circle metering mode can be seen as a more
concentrated variant of center-weighted metering, using
a defined circle in the center of the frame. This is a great
solution to shots where the subject takes up much of the
frame, though you might find it more appropriate to use
spot metering when composing a
different kind of image. If you were
placing a figure according to the rule
of thirds, for example, this would be
less than ideal.

Here the subject takes up much of the
center of the image, so a larger circle
than spot metering is appropriate.

Matrix or Evaluative metering

The matrix, segment or evaluative metering mode is a
highly sophisticated metering system that has two
components. One is the division of the frame into
segments, which are each individually measured. The
second is a database of many thousands of picture-
taking situations based on either actual shot images or
(less accurate), theoretically derived scenes. The
pattern of exposure readings is compared with those in
the database and the appropriate algorithm is applied.
At its simplest, if there is a much brighter strip across
the top of a horizontal frame, this will be assumed to
be the sky and the exposure will be weighted more to
the darker area below. Equally, a compact dark area
close to the center of an otherwise light scene will be
assumed to be the important subject, and the exposure
will be adjusted for that.

Controlling Dynamic Range

Compared to film, digital sensors are much more sensitive to light. This sensitivity can lead to problems when there is a wide tonal variation in the scene—in these contrasting instances it's often difficult for the sensor to record detail in the highlight areas.

The larger the photodiode, the greater the sensitivity and the wider the dynamic range, but this is in conflict with the need for smaller photosites on the sensor to increase the resolution. The photodiode must fit within the total photosite area, and still leave sufficient room for other components. Moreover, typical photodiodes still reach saturation (that is, a full tonal range) faster than is ideal.

Blocked highlights

In highlight areas, digital sensors tend to compare unfavorably with film because

Dynamic range: film vs. sensor

The shape of the red curve shown here, gives us a visual clue as to why film appears to have a greater dynamic range when compared with a sensor. The curve plots the brightness of the image (on a vertical scale) against the brightness of the light striking it (on a horizontal scale). With both film and sensors, most of the middle tones in a scene fall on a straight line—not surprisingly called the "straight-line section"—meaning that the image brightness marches in step with the subject brightness. At either end, however, film reacts in a special way. It falls off in a gentle curve in the shadows (lower left) and highlights (upper right). For example, in the highlights, twice the exposure results in less

than twice the brightness, which is very useful, because it tends to hold highlight detail. The same applies to shadow detail. Sensors, however, inherently lack this smoothing out of the curve.

In a normal photograph of a normal scene, the shadows are at the lower left (the "toe") and the highlights at the upper right (the "shoulder"), with most of the tones in the middle, the "straight-line portion" of the curve. Significantly, this means that with film, highlights do not easily blow out—increasing exposure has less and less effect on the density. In other words, with increasing exposure to light, film response starts slowly (shadows) and finishes slowly (highlights). Photodiodes on a sensor, however, lack this cushioning effect. They reach saturation steadily, at which point there is no highlight detail whatsoever. In other words, film tends to be more forgiving of under- and overexposure, particularly the latter.

of their linear response. The typical film response to exposure shades off at both ends of the scale, hence the familiar S-shape of the characteristic curve.

Practically, this means that film has some latitude in the highlights and the shadows as its response is not linear. Digital sensors, however, have a linear, straight-line response, and this results in easily blocked highlights. Anyone familiar with film is used to there

being some hint of detail in most highlights, but this is not so when using digital. Once the charge in the photodiode "well" is filled up, the highlights are blocked, and it is as if you have a hole in the image—or "triple 255" when measured in RGB.

Histograms and dynamic range

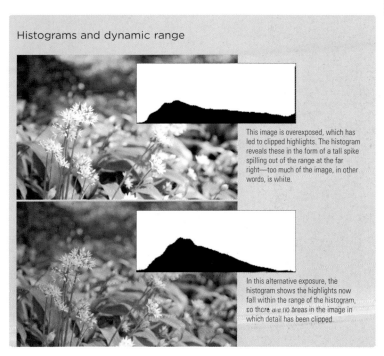

This image is overexposed, which has led to clipped highlights. The histogram reveals these in the form of a tall spike spilling out of the range at the far right—too much of the image, in other words, is white.

In this alternative exposure, the histogram shows the highlights now fall within the range of the histogram, so there are no areas in the image in which detail has been clipped.

Real World Dynamic Range

Despite often receiving requests from the photographic press and other reviewers, camera manufacturers rarely release dynamic range figures, primarily because it's very hard to create any really meaningful measuring test as there are so many factors that come into play.

One way to appreciate this is to make your own dynamic range test, as shown here. Typically, there are just-measurable, but visually insignificant differences at the shadow end of the scale.

When shooting, pay particular attention to the histogram display and to any available warning displays for clipped highlights. As long as the histogram fits comfortably within its left-to-right scale, you will have an average-to-low contrast image that can always be tweaked later. The danger lies in a histogram that spills over left or right, or both.

A dynamic range test

Begin the test by photographing a gray card or any neutral blank surface at a range of exposures, under consistent lighting. First, establish the mid-point by shooting at an average setting, either manually or automatically. Then take subsequent frames at equal intervals darker and lighter, in at least six steps in each direction, under- and overexposed. For greater accuracy, make these steps at one-half or one-third f-stop intervals, although for simplicity, the example here is at one-stop intervals. In Photoshop, assemble the images in order, and label each of the steps as shown. Use the cursor and info display to measure the values. Find and mark the step on the left-hand side that measures 5 (anything less is effectively black). Find and mark the step on the right-hand side that measures 250 (anything higher is white). These two extremes define the dynamic range. In this example, a Nikon DSLR captures nine distinct steps—that is, a range of 8 stops or 256:1. The test, however, reveals some other important characteristics. One is that the mid-point of this range is not the average exposure, but instead almost one stop underexposed. Not only this, but the increases in exposure reach saturation (255) more quickly than the decreases reach pure black. This confirms what we already expect in terms of a sensor's linear response. Note, though, that the response at the shadowy, underexposed end of the scale, is not exactly linear, but tails off more gently, as does that of film. All of this suggests that for this particular camera, it will be safer to underexpose in contrasty conditions while shooting in Raw format.

Checking channels

Clipping warnings may come into effect when just one or two channels have become saturated, and this is not a disaster. Thanks to interpolation, even blown highlights in a fully saturated photosite can be given a value of some use by the on-board processor. This is because each photosite measures one of three colors, and interpolation is used to assign full-color values to it. Some cameras display individual channel histograms, with white (the sum of all three) superimposed. The danger is when all three channels are clipped. Here, red is saturated, but green and blue are still within the frame.

RGB Red

Green Blue

Highlight warnings

Two valuable in-camera displays of overexposed areas are the histogram and a highlight indicator. When the right-hand (bright values) edge of the histogram appears like this, at least some of the tones are solid white. A more insistent warning available on most cameras displays the highlights with a flashing border. However, you should always check these in-camera clipping warnings against the values that appear when you have opened the image in Photoshop. Typically, camera manufacturers err on the side of caution, and the clipped highlights displayed in the camera's LCD are likely to be at a value less than 255. In other words, even with some parts of the image apparently clipped, there may actually be sufficient information to recover and edit.

An on-camera histogram display can reveal clipped highlights.

Alternatively, there might be a flashing warning that is similar to this.

Dynamic range comparisons

These are slightly dangerous comparisons to make, not least because the brightness range of a real-life scene is not quite the same thing as the response of sensor and film. Film, as we've already seen, has a soft shoulder and toe to its characteristic curve, meaning that there is not the same sharp cut-off point for recording details in shadows and highlights as with a digital sensor.

Scene/device/medium	ratio	exponent	ƒ-stops	density
Typical high-contrast sunlit scene	2,500:1	211	11+	not applicable
Typical sunlight-to-shadow range for a gray card	8:1	23	3	not applicable
Human eye normal full working range	30,000:1	215	15	not applicable
Human eye range when fixed on one part of scene	100:1	26-27	6+	not applicable
B/W negative film	2,048:1	211	11+	3.4D
Color transparency film	64:1 – 128:1	26 – 28	6 – 8	3.2D – 3.6D
Kodachrome transparency film	64:1	26	6	3.7D
Color negative film	128:1	28+	8+	2.8D
Typical camera at base sensitivity	512:1	29	9	2.7D
Typical camera at high sensitivity (ISO 1000)	128:1	27	7	2.1D
Typical digital compact at base sensitivity	256:1	28	8	2.4D
Typical CRT monitor	200:1			
Active matrix monitor	350:1	28+	8+	
Glossy paper	128:1 – 256:1	27 – 28	7 – 8	2.1 – 2.4D
Matte paper	32:1	25	5	1.5D

Note:
1. Range in stops is the number of intervals; thus, if 9 stops are captured, the range is 8.
2. Dynamic range reduces at higher sensitivity (ISO) settings, as it does with faster films.
3. Density is used principally for film and film scanners, and is included here for comparison.
 The optical density of film is the difference between the densest part (D-Max) and the most transparent
 part (D-Min). The formula is log10: thus a density of 2 = 102 or 100:1.
4. The density of film tends to be greater than the usable, recordable dynamic range, particularly
 with Kodachrome.
5. Dynamic range for monitor displays is normally expressed as contrast ratio.

Coping with Contrast

The optimum exposure for most images is when there is an even spread of tones, from dark shadows to bright highlights—or in other words, a fully expanded histogram.

Low contrast presents no difficulties at all, other than perhaps judgment, as it is a simple matter to drag the white and black points out to the edges. High-contrast images, on the other hand, are always in danger of being clipped, and image-editing tools need some image data to work with. This means getting the exposure right—not necessarily the same thing as getting it averaged.

High-contrast scenes always need special care, even more so than with transparency film. As we saw on the previous pages, the response of a sensor to light is linear. Crudely put, it fills up to absolute white more readily than film, and this means being constantly on guard against clipped highlights. In digital imaging, these are usually more critical than clipped shadows, for two reasons: one is that even a very little light generates some

Assessing contrast

The importance of dynamic range and contrast depends on the form of the image. The tonal range of the entire image may be different from the range within a small part that you consider important. In the case of the modern office interior here, there are two different interpretations. On the one hand, you might want to retain shadow detail in the large outer part of the image, in which case you would consider the overall contrast. On the other hand, you could legitimately ignore the dark surround and expose just for the brightly lit, glassy corridor in the center. The tonal range within is one stop less than the entire image.

Exposure ƒ/8 Exposure ƒ/10

response at the darker end of the range, the other is that perceptually most of what catches our attention is in the brighter areas.

Reducing contrast

If you are shooting JPEG, contrast and exposure are the only in-camera controls that will help you to reduce contrast. Lowering the contrast setting in the picture controls is sensible. It is safer to underexpose the bulk of the image to preserve highlights, and then lighten the shadow areas during image-editing. Bracket exposures if you have time, both for safety and in order to be able to combine exposures. Adding fill-in lighting, even if this is just from the camera's built-in flash, will also reduce contrast by raising the values of the shadows.

Knowing in advance that you can optimize the image on the computer, one of the safest precautions is to avoid clipped highlights, even at the expense of an overall darker image. In conditions that you know to be contrasty, pay most attention to the clipped highlight warning on the LCD display. If the situation allows you time, make a test exposure to check this first and then switch to the histogram to make sure that nothing has been clipped at the shadow end. If the entire histogram is within the scale, even if the bulk of it is shifted toward the shadows, then you can usually optimize it satisfactorily.

For more extreme situations, in which no exposure setting will avoid clipping at one end or the other, there is a post-production solution, which is to shoot a series of identically framed images that vary in exposure in order to create an HDR (high dynamic range) image file. Either use your camera's bracketing function, or manually adjust, changing the shutter speed so that the darkest image preserves the brightest highlights and the brightest image records the deepest shadows as mid-tone. A two-stop difference between frames is typical. Processing software such as Photoshop then easily creates a 32-bit-per-channel HDR image file, which can then be processed to recover and compress the range of contrast to look normal (too often, HDR style is a cartoon-like aberration of professional HDR processing, which aims for a normal-looking result).

Raw format

Raw format has a higher dynamic range than a screen of print can display—either 12-bit or 14-bit instead of 8-bit—and this really comes into its own in contrasty lighting conditions because it allows a kind of "recovery" of shadow and highlight data that would be lost in JPEG. During processing, this can be done globally, across the entire image by using sliders such as Photoshop's and Lightroom's Highlights and Shadows, or locally by raising or lowering the Exposure slider over selected areas. Typically, you can expect to be able to adjust the original exposure by up to two stops darker and four stops lighter, while at the same time changing the contrast. However, Raw format will not help completely lost highlights. Once photodiodes have reached saturation, no amount of processing can recover the data. However, in some overexposed, "clipped" areas of an image, the clipping may affect only one or two of the three channels (RGB), and processing software can use this to interpolate and recover information.

What's the "right" exposure?

The first image below appears at first glance to be better exposed than the lower image, because the histogram shows an even spread of tones. However, some of the highlights are clipped, and these will be unrecoverable in image-editing. The exposure for the lower image (one f-stop less) produces an image that looks darker, but the shadows aren't noticeably more clipped, and the highlights are also better controlled.

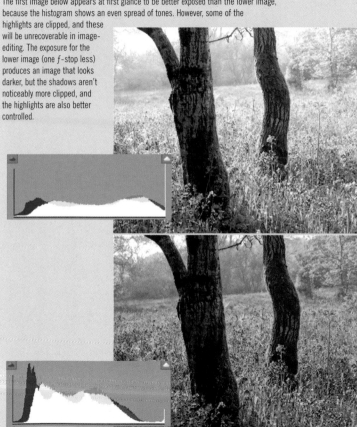

Lenses

The powerful flexibility of a the types of cameras we're discussing here is down to the fact that you can use nterchangeable lenses of varying focal lengths, from fish-eye to super-telephoto.

The types of lenses you'll be able to use depends on your lens mount—not necessarily your camera manufacturer. This is because there are a variety of third-party lens manufacturers that build lenses for multiple mounts. So don't limit your considerations to brand of your particular camera, there may be a better, cheaper option from a third party.

As it stands, there are broadly two sizes of sensors commonly used interchangeable-lens cameras: APS-C/DX sensors that are smaller than 35mm film and "full-frame" sensors that are the same size as 35mm film and used in high-end cameras. The small size of the APS-C/DX sensors affects a whole raft of image properties, including some of the standards that photographers are used to, such as using focal length as a way of describing the angle of view. 24mm, for example, was a kind of shorthand for the dynamics of one type of wide-angle image, but as a smaller sensor covers less of the image projected onto it than would a full 24 × 36mm frame, the picture angle is less.

This means that a standard 50mm "wide angle" lens mounted on a digital camera with a sensor area of 23 × 15mm (APS-C) behaves like a lens of around 78mm focal length on a full-frame, or 35mm camera. Similarly, wide-angle lenses have less of a wide-angle effect, while telephotos appear to be more powerful.

Wide-angle implications

Because an APS-C/DX-sized sensor is around ⅔ the size of 35mm film, your old lenses lose ⅓ of their covering power. On the positive side, this means that telephoto lenses have that much greater magnifying power when fitted to a smaller-than-full-frame sensor, but you lose out at the wide-angle end of the scale. This limitation has forced manufacturers to introduce new, wider lenses. If dedicated to digital cameras, these can be very wide indeed. A 12mm lens, for example, is the equivalent of an 18mm lens on 35mm (full-frame) sensor.

High-megapixel sensors make increasingly high demands on lenses, with the result that manufacturers must continually increase the resolution of newer lenses. Not only are high-density sensors less tolerant of poor resolution lenses, but the resolution needs to be smaller than the active area of the photosite. Using an old, film-optimized set of lenses on a new digital body may sound like a good, economical idea, but the trade-off is likely to be lower image resolution than you could be getting. The other problem is called "cornershading." Light from a normal camera lens diverges to cover the film or sensor, striking the edges at an angle—and with a wide-angle lens, this angle is more acute. This hardly mattered with film, but as the wells on the sensor are all parallel, light rays striking the furthest photosites—at the corners—may not fully penetrate, causing shading. This again suggests a change in lens design—one solution is a rear element combination that refracts the diverging light rays back to being more nearly parallel (a "telecentric" lens design).

Digital lenses

For some time, lens manufacturers have been producing lenses specifically for APS-C cameras. Features can include the following: no mechanical aperture ring, apochromatic (high color correction) glass, very short focal lengths for wide-angles, and a small image circle that covers no more than the sensor. This last feature enables lenses designed specifically for smaller sensor sizes to be smaller, lighter, and have larger zoom ratios.

Nikon 12–24mm zoom lens

EFL

Since the advent of 35mm cameras, lenses have been described as having focal lengths such as 20mm, 50mm, and 180mm. These labels are so embedded in the working language of photography that they will continue to be used for a long time. Indeed, for full-frame cameras, they remain perfectly valid, but the variety of smaller sensor sizes leaves us without a convenient way of describing a lens's main characteristics—its angle of view and magnification. One solution is "equivalent focal length" (efl), which is what the lens would be if the image it delivered were on a 35mm frame. Efl is found by dividing the diagonal of a 35mm film frame (43.3mm) by the diagonal of the camera's sensor, then multiply the lens focal length by this. These are the equivalent focal lengths for typical sensor sizes:

Actual focal length	efl 23 x 15mm sensor	efl 24 x 16mm sensor
12mm	18.9mm	18mm
17mm	26.8mm	25.6mm
20mm	31.5mm	30.2mm
28mm	44.1mm	42.2mm
35mm	55.2mm	52.8mm
50mm	78.8mm	75.4mm
100mm	157.6mm	150.8mm
200mm	315.2mm	301.7mm
300mm	472.8mm	452.5mm

A series of focal lengths, from 20mm at the widest end to 300mm at the longest. (The intervals are 28mm efl, 35mm efl, 50mm efl, 100mm efl, and 200mm efl.)

Bokeh

A key aspect of controlling depth of field often involves deliberately throwing certain parts of the image out of focus. The overall appearance of the out-of-focus parts of an image, judged esthetically, varies according to the aperture diaphragm and the amount of spherical aberration correction, among other design features. It comes into play chiefly with telephoto lenses used at wide apertures, and it particularly concerns portrait photographers.

This has become fashionably and unnecessarily known in the West by the word "bokeh" (pronounced bok-e, with a short, flat e), which in this context means simply "out-of-focus." A major influence is the shape of the aperture, which tends to be replicated in specular highlights—polygonal in most cases, while a mirror lens produces rings. The more blades to the aperture, the more spherical these soft highlights become. The optics also have a subtle effect.

This close-up portrait was shot using a 135mm lens with a wide aperture. The round shape of the out-of-focus elements in the background—the bokeh—are caused by the shape of the aperture blades in the lens.

Depth of field is also affected (it is increased), and this has various consequences all the way back to sharpness. Sharpness is not a precise definition, but depends partly on resolution and partly on perception. High contrast, for example, increases apparent sharpness. As the image is magnified more, depth of field increases. This is generally good to have, but a problem when you need the extremes of selective focus, as in some styles of food photography, for instance.

There is a lower "quantum" limit on sharpness set by the size of the individual pixels on a sensor. A 24 x 16mm sensor that images 6,045 × 4,000 pixels, for example, has individual photosite areas measuring $0.015mm^2$ ($15\mu m^2$). As semiconductor technology reduces this size further, it increases the demands on lenses. Most high-quality lenses optimized for film can resolve to about 10 microns, while the pixel pitch on new multi-megapixel sensors can be as low as 4 microns. One important effect is that color fringes caused by chromatic aberration must be smaller than the size of a pixel. Old lenses often fail in this, while a further issue is cornershading, although this can be corrected using processing software.

Top: A grad filter
Above: A polarizing filter

The image on the left is
the slowest shutter speed
allowed during a bright,
sunny day, and it freezes
all motion in the scene. By
adding a neutral-density
filter, the shutter speed
was able to be lengthened
significantly, and the
resulting motion blur
makes for a dramatically
different final image.

Lens Filters

Some image corrections can be taken care of digitally, but these front-of-lens
filters do, however, remain valuable:

Ultraviolet filter
Reduces haze effects by cutting some of the short wavelengths. Also valuable
for physically protecting the front lens element from scratching.

Neutral density filter
These filters simply cut down on the amount of light, without adding any color
cast (hence the "neutral" part), allowing longer shutter speeds in bright scenes.

Neutral grads
These filters can be raised or lowered in their holder and rotated. With a
landscape, align the transition zone of the filter with the horizon. Although skies
can be darkened later during image editing, a grad filter at the time of shooting
preserves more tonal data when positioned so that it covers the brighter part of
the frame.

Polarizing filter (circular)
Cuts polarized light, so is particularly useful for darkening blue skies (most strongly
at right angles to the sun) and reducing reflections from glass, water, and other
non-metallic surfaces. Also has a strong haze-cutting effect.

Cutting down lens flare

In very bright conditions, light can enter the lens and reflect around the lens elements, rather than being directed to the sensor. Known as flare, this light can appear as a line of bright polygons stretching away from the bright light source (such as the sun) or as an overall light fog. Flare control means shielding the lens from any bright light outside the picture frame, and the ideal solution is to mask down the view in front of the lens to the edges of the image. Fitted lens hoods do a fairly good job, particularly if they are shaped to suit the image area, but they have the disadvantage of being close to the lens and on a zoom lens they can only mask accurately at the widest angle.

A professional adjustable lens shade is better, though slower to use, and typically features an extendable bellows and/or movable masks. This is particularly good for the special case in studio photography in which the subject is against a large bright background. The bright surface that surrounds the picture area creates a kind of flare that is not immediately obvious, but which degrades the image nevertheless. Finally, to shield against point sources of light, whether the sun or studio spots, the most precise shading is at a distance from the lens, using a black card or flag, or even your own hand held just out of frame.

- Use a lens shade—either a fitted shade designed for the particular lens, or a bellows shade that can mask right down to the image area. Some telephoto lenses have built-in shades that slide forward.
- Check the shadow on the lens. If the camera is on a tripod, stand in front and hold a card so that its shadow just covers the front of the lens.
- Keep the lens clean. A film of grease or dust makes flare worse.
- Remove any filter. Filters, however good, add another layer of glass that increases the risk of flare.
- Use a properly coated lens. High-quality, multi-coated lenses give less flare than cheaper ones.

Lens hood

Bellows shade

Flag and arm

Standard vs. wide-angle lenses

There is a standard focal length; broadly speaking it is the length that provides a view that corresponds with what we see with our eyes—neither wide nor compressed, but in reality, it is imprecise. The usual rule of thumb is that the standard focal length is equal to the diagonal of the film frame or sensor. For a 35mm frame that would be 43mm, but by convention 50mm has become "normal" with full-frame sensors. The de-restriction of format with digital cameras and replacement of prime lenses with zooms erodes this 50mm "benchmark." This is, in any case, a perceptual issue, and a realistic guide is the focal length at which the view through the viewfinder and the view with your other, unaided eye are the same.

The Canon EF 11–24mm f/4 L zoom lens is, at the time of writing, the widest rectilinear (i.e., non-fisheye) lens currently available for the 35mm format. It's so wide that when mounted to an APS-C camera (which the Canon EF-S mount allows), it's still an impressively wide 17mm.

50mm efl

Below: 20mm efl

A 20mm efl lens (in this case, 13mm on a Nikon digital camera with a sensor size smaller than 35mm film) has a diagonal angle of view of just over 90°. The vertical crop inside this frame is the 45° coverage of a 50mm efl standard focal length.

Macro & Close-up Lenses

By its very nature, macro photography (and to a lesser degree close-up photography) has always caused challenges for lens manufacturers, and this is no different for digital cameras.

However, the uncertainties introduced by the various optical calculations disappear with the instant feedback from a quality LCD screen. Digital cameras are ideal for macro shooting because the on-board processing of the image can deal with the problems of

contrast, color, and even sharpness. Also, if you shoot direct to a computer, you can use the monitor to check detail and tolerances.

If you have a cropped sensor camera, you have the choice of using a macro lens designed specifically for APS-C sized sensors or a lens designed for full-frame sensors. Remember in both cases the efl will be around 1.6x the focal length of the lens, which may determine which lens is most suitable for the macro work you intend to do.

The two most usual measurements in close-up imaging are magnification and reproduction ratio, and they are linked. The commonly accepted starting point

MACRO DEMANDS

Macro photography makes specific demands on lenses. Spherical aberration, for example, is more prominent. This is caused by the increasing angle of curvature toward the edges of the lens, which alters the focus slightly. Stopping down the lens helps to reduce it because the smaller aperture allows only the center of the lens to be used.

Conjugates

The lens focuses each point on the subject to an equally sharp point on the sensor (which is on the image plane). In photography at normal distances, the object conjugate is much longer than the image conjugate, which changes very little as you focus. But when the subject is close, the two conjugates become more similar in length.

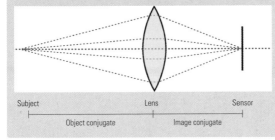

Subject Lens Sensor

Object conjugate Image conjugate

for close-up photography is between 0.1× magnification (1:10 reproduction ratio, meaning the image is one-tenth life-size) and 0.15× magnification (1:7). At 1.0×, the image is life-size (1:1). Across this range, as the lens racks forward in its barrel, the light-reaching the sensor falls off increasingly, but autoexposure takes care of this. Photomacrography, commonly known as macro, extends from 1.0× to 20× (a 1:1 reproduction ratio to about 20:1), at which point the laws of optics make it more sensible to use a microscope. (Macrophotography, incidentally, means something else entirely—photography on a large scale.) Photomicrography means photography using a microscope, for which there are a number of off-the-shelf systems for attaching a camera.

The most efficient method of magnifying an image is to extend the lens forward, away from the sensor, the way that most lenses are focused for normal photography. However, for close focusing, the lens elements need to move much further than normal, because of the relationship between the two conjugates (the distances from the principal point of the lens to the subject on one side and to the sensor on the other). When the subject is more than about ten times the focal length distant, the image conjugate stays more or less the same. Closer than this, however, and the image conjugate gets significantly larger. When the two conjugates are equal, you have 1:1 magnification and a life-size image.

This makes lens manufacture a little tricky because most lenses perform best when subjects are distant, but not so well when they are close. Aside from the mechanics of moving the glass elements inside the lens barrel, the sharpness suffers and aberrations get worse. A true macro lens is the ideal solution.

Close-up and macro lenses and accessories

Close-focusing lenses

Modern lens design makes it possible for standard
lenses to focus down to close distances. The quality of
the image at close focus, however, varies from make to
make, and is likely to be compromised—at least in
comparison to a true macro lens. The performance
of a standard lens can be disappointing.

Macro lenses

These are designed to deliver their best image quality
at close distances, and acceptable quality at normal
distances up to infinity. Some manufacturers offer a
choice of focal length between normal and long-focus;
the advantage of the longer macro lenses is that you
can use them at a greater working distance from the
subject, which is useful, for example, with insects
that might otherwise be frightened off by a close
approach.

Above: Extension rings
Below: Extension bellows

Extension rings and tubes

A standard method of increasing magnification is to
increase the distance between the lens and the sensor,
and the simplest way of doing this is to fit a ring or
tube between the lens and the camera body. The focal
length of a lens is the distance between the sensor
and the lens when it is focused at infinity. Increasing
this distance by half gives a reproduction ratio of 1:2.
Doubling the distance gives 1:1, and so on. Some, but
not all, extension rings and tubes have linkages that
connect the aperture and other lens functions to
the camera.

Extension bellows

Flexible bellows moved by rack-and-pinion offer fine
control over magnification, and are normally used for
extreme close-ups. Because magnification is relative
to the lens focal length, the shorter the lens attached,
the more powerful the effect.

Back to front lens

Most camera lenses are designed to perform well when the image conjugate is smaller than the object conjugate. At magnifications greater than $1\times$ (1:1) this is no longer true, and the image is better when the lens is reversed. For optical reasons, this only works well with lenses of a symmetrical design and with certain retrofocus lenses. Once reversed, the lens must then be stopped down manually.

MACRO LENS
Nikon's AF-S Micro Nikkor 105mm lens is a true macro lens—Nikon use the term "micro" to mean macro. It's a true macro lens in the sense that it can capture images at a 1:1 ratio (life size).

DIFFRACTION
Another optical issue that is more relevant to macro than normal photography, is diffraction. This occurs when an opaque edge obstructs the light path, causing it to bend slightly and spread. This is what the aperture blades in the diaphragm inside a lens do, and the result is unsharpness.

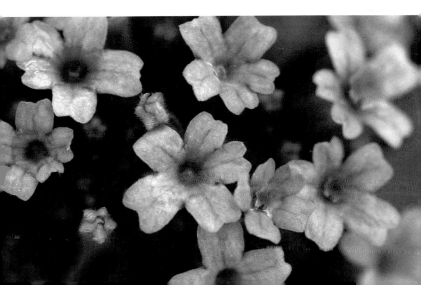

Stitching Images

Digital photography has made stitching together overlapping frames—to make a significantly larger image—a remarkably straightforward process.

The technique's most common use is to create panoramas, but there are other applications. Although this is strictly speaking a software matter, it is highly relevant to lens focal length and coverage, because in effect you are creating a wider-angle view.

Also, with this kind of imaging, even though it makes heavy use of software, all of the planning needs to be done at the time of shooting—photography and stitching are separate operations. This is known as planar stitching, and the result is a normal digital image, saved usually as a TIFF or JPEG. A quite different, but very important alternative is cylindrical or spherical images, which are usually saved as QuickTime movies.

In principle, you could combine the overlapping images manually in Photoshop, but there are two obstacles. One is that as you turn the camera to one side for the adjacent frame, objects in the frame change their shape slightly—noticeably so with a wide-angle lens—so that each frame later

needs a distortion adjustment. The other is that it is difficult to blend the brightness of adjacent frames when there are large, smooth areas such as a sky—again, particularly with wide-angle lenses. Stitching software does this automatically, in two steps. The software first finds a number of corresponding points in adjacent images and warps the images so that they fit perfectly, to within one pixel. It then equalizes the images so that there is a seamless blend of brightness at the edges.

Tiling for higher resolution

Shooting a sequence horizontally creates a panorama, with the added advantage of making a larger image file than normal. This is, indeed, the easiest solution to creating a high-quality large image file—take any scene that you have just photographed, switch to a longer focal length, and photograph it again in sections, before assembling these into a higher-resolution version. This is known as tiling. It can also fulfill another objective, which is to increase the FOV (field of view). Smaller sensors make wide-angle lenses less effective, but you can increase the coverage by tiling.

Panorama heads

Numerous QuickTime tripod heads are available, designed to assist in taking images at the exact angles required to build up a QuickTime VR scene. These are essentially 360° panoramas, which in some cases also allow the viewer to look up and down (hence the second adjustment on the Manfrotto head). In order to create panoramas, each shot should be taken from exactly the same spot. QuickTime VR technology includes specialized stitching software.

ReallyRightStuff

Manfrotto QTVR head

iShoot panorama ball head

A panorama sequence

Step 1 Decide on the area of the scene you want to cover, and the lens focal length you will use. Longer focal lengths need more frames to complete the same coverage as a wide-angle focal length: this gives a bigger final image file (good for a high-resolution image, but it takes up more space on the memory card and hard drive, and is more demanding of the processing) and less angular distortion.

Step 2 Ideally, mount the camera on the tripod and level the head. If shooting handheld, stand upright and rotate your torso when turning. This will help keep the angular distortion to a minimum, especially in tight quarters with objects near the frame.

Step 3 Make a dry run: Pan through the scene, keeping an eye on your autoexposure settings throughout. If the exposure varies, you'll need to decide on a median setting that fits the entire scene as best possible. Then either manually set your exposure, or set Autoexposure Lock at the right exposure.

Step 4 Check for movement in the scene. When it all looks still, fire off your sequence, aiming for about 30% overlap between each frame.

Step 5 Back at your computer, you have multiple stitching options, depending on your software. Bridge has long offered the Photomerge feature under Tools > Photoshop, which will port the images into Photoshop and stitch them there. Lightroom used to be similarly

dependent on Photoshop, but now offers its own Photomerge feature natively. It's a simple matter of selecting the photos, and selecting Photo > Photo Merge > Panorama. The menu shown right lets you choose how to stitch the images (or have it select a project option for you—you'll usually want Perspective in any case, to keep your lines straight). You can also use Auto Crop to automatically crop out blank areas. If you uncheck this feature, you may be able to expand the size of your panorama by filling in those blank areas in Photoshop using Content Aware Fill.

Step 6 The result is a DNG Raw file that can be edited in the usual manner.

Panorama Options

Select a Projection

☐ Auto Select Projection

| Spherical |

| Cylindrical |

| Perspective |

☐ Auto Crop

Creating HDR Images

High dynamic range imaging, or HDRI, is a way of capturing the entire range of tones in a high-contrast scene, from the darkest shadows to the brightest highlights, which is beyond the ability of a normal sensor to capture with a single shot.

For instance, a typically bright, sunlit scene containing highlights and shadows has a dynamic range in the order of 2,500:1, and while the human eye can accommodate this (though it does it by scanning the scene rapidly and building up a cumulative image), a digital sensor cannot completely manage it. This is because, while a typical 12-bit sensor shooting Raw theoretically has a dynamic range of 4,000:1, its practical range is closer to 1,000:1, mainly because of noise. If the sun appears in the shot, the dynamic range will shoot up to something in the order of 50,000:1. Another typical high dynamic range scene is an interior with a view to a sunlit exterior—a situation where the dynamic range can reach 100,000:1.

If the camera remains steady, a sequence of frames at different exposures can capture all the detail. The software exists to combine such a sequence into a single HDR file format. There are several HDR formats, but typically they are 32 bits per channel, and instead of this extra bit depth being pre-assigned to a range of values, as happens with 8-bit and 16-bit images, it is used in quite a different

HIGH-CONTRAST SITUATIONS
Bright sunlight with deep shadows is an opportune time to bracket exposures and create an HDR image.

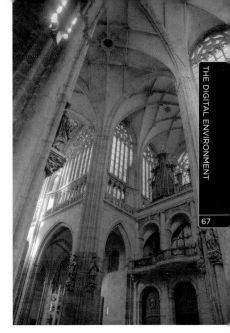

way. The bits are assigned to decimal points, so that any real-world tonal value can be given a precise digital value, and for that reason, this is known as floating point coding. Some 20 or so commercial programs exist for generating an HDR 32-bit floating point image file automatically from a sequence of exposures (normally shot about 2 f-stops apart). They include Photomatix, Oloneo, Nik HDR Efex Pro, and Photoshop and Lightroom.

The resulting HDR image contains all the information, but is essentially unviewable due to the limitations of the display media. Most monitors have a bit depth of 8 and can at best handle a dynamic range of about 350:1, while few papers do better than about 100:1. This requires a second step, which is to compress the data in the 32-bit image down to 8 bits per channel.

This is where HDRI becomes tricky, because there is in principle no ideal way to do this. Something has to go, and a satisfactory result depends on the way the tones were distributed in the original scene, on the range of exposures taken in order to create the HDR image, the algorithms and techniques used for compressing, and on top of all this the taste and judgement of the person doing it. The net result is deep unpredictability and many different appearances of output.

FULL TONAL RANGE

Created from a sequence of three exposures beginning with 1 second at $f/32$, which reveals all the shadow detail, and ending with a 1/125 second shot, which holds the brightest tones. These merge to reveal detail in both the shadow areas while holding the highlights around the windows.

HDR Workflow

For a long time, creating an HDR image required either dedicated HDR software (such as Photomatix—still a popular choice among some photographers), or delicate Photoshop work. Fortunately, a solid HDR workflow has finally been fully integrated into Lightroom itself.

Top to bottom: +2EV, 0EV, −2EV

Step 1 To create an HDR image you need to start with a number of exposures of the same scene; three is usually sufficient. What's important is that, between them, the exposures capture the full range of tones in the scene, from the brightest highlights to the darkest shadows.

All serious cameras allow you to bracket exposures, and with the camera set to Continuous shooting, it's easy to capture the various exposures you need.

Step 2 You don't even need to process your Raw files before you create your HDR image, because you'll be creating a 32-bit DNG (Raw) file as your output. In fact, any crops you make on the images before the merge will be disregarded. Simply highlight your shots, and click on Photo > Photo Merge > HDR.

Step 3 You'll be presented with the HDR Merge Preview window, containing the HDR Options panel shown opposite. Auto Align is best left checked, and Auto Tone is also useful as it will give you a better preview of the dynamic range contained in the shot (but it's no different than clicking Auto in the Tone panel once you've exported your HDR DNG. Then you also have 4 levels of Deghosting available—select your amount depending on the degree of movement in the scene between your shots. This particular bracket had no movement—even the trees were still as it wasn't windy at all.

HDR Options

☑ Auto Align
☑ Auto Tone

Deghost Amount

| None |
| Low |
| Medium |
| High |

☐ Show Deghost Overlay

Step 4 When you click Merge, Lightroom will generate a 32-bit DNG file, and now the fun begins. You now have the full range of tonal adjustments available to you, but you're manipulating vastly more data. Pulling down your Highlights and pushing up your Shadows will have considerably more effect than on a normal shot.

It's worth noting that a similar workflow exists in Photoshop—by selecting your three bracketed shots in Bridge, go to Tools > Photoshop > Merge to HDR Pro, and you'll be presented with a similar pop-up window, but offered a greater degree of control. But the result is the same: exporting a 32-bit image file (in this case, a Tiff), that can then be tonally adjusted as usual in Adobe Camera Raw.

The Zone System

The Zone System was developed by the famous 20th-century American landscape photographer, Ansel Adams, as a way of obtaining the optimum tonal range in a black-and-white print. The system combines both measurement and judgment—in other words, it amalgamates technology and opinion.

Still highly regarded by some traditional photographers as the meticulous craftsman's approach to considered, unhurried photography, it lost most of its purpose when color took over from black-and-white—particularly transparency film, which allows little to be done with it after exposure. Digital photography, however, returns image control to photographers, and the old Zone System has some valuable lessons to teach in the new context. Of course, it is at its most useful in shooting situations that allow time for reconsideration—landscape and architecture, for example, rather than reportage. However, in digital capture, providing that you are shooting in Raw format, you have the time to reconsider the image later and alter the tonal relationships. This assumes, of course, that in shooting you have not blown out the highlights or lost the shadows.

IDENTIFYING ZONES

This is an example of dividing an image into meaningful zones. Only reasonably sized areas are worth designating, as very small areas are unlikely to influence your exposure choices. However, this is not an exact procedure. In this architectural shot of a portico in quite bright sunlight, there are six obviously separated tonal blocks or zones.

Number of zones

Although Ansel Adams' original scale has ten zones, as shown here, some photographers who follow the system use nine or eleven zones. The argument for ten is that it follows the original description, but Zone V, mid-tone, is not in the center. Using an odd number of zones, Zone V is central and, with 11 zones in particular, the spacing is easy to calculate digitally—an increase of exactly 10% for each step from black to white. On the other hand, the response of many camera sensors is longer at the shadow end of the scale, which argues more for the original ten zones with Zone V off-centered.

NINE ZONES

I	II	III	IV	V	VI	VII	VIII	IX
1	2	3	4	5	6	7	8	9

TEN ZONES

I	II	III	IV	V	VI	VII	VIII	IX	X
1	2	3	4	5	6	7	8	9	10

I	II	III	IV	V	VI	VII	VIII	IX	X	XI
1	2	3	4	5	6	7	8	9	10	11

Visualizing the finished image

In the system, all of the tonal values in a scene are assigned to a simple scale of ten, from solid black to pure white, each one *f*-stop apart. The key to the process is to identify and place the important tones into the appropriate zones, and this demands what Adams called "pre-visualization." This is forward planning by another name, and means the process of thinking ahead to how you want the final image to appear—on-screen and/or in print. The great value of the Zone System, still applicable today, is that it classifies and describes the tonal structure of any image in a commonsense way. Different photographers have different ideas about how an image should look tonally, and the Zone System allows for this individuality. As White, Zakia, and Lorenz put it in *The New Zone System Manual*, success depends on "how well the print matches the mental picture, not how well it matches the original scene."

Because the Zone System classifies tones in terms of how they look and what we expect from them, it is not the same as tonal range or dynamic range. Instead, it is a tool for making sure that the image has the tones you want for the parts of it that you consider important. The three most useful values are Zones III, V, and VII. Between them they cover the readable parts of most scenes and images—in other words, the five textured zones.

The most important action in the Zone System is called placement. This happens when, having decided on the critical area of the scene, the photographer assigns it to a zone. As the examples on the following pages illustrate, this can mean choosing an area of shadowed detail and placing it in Zone III, or a more interpretive choice. In all cases, it then involves exposing accordingly—or with Raw format, adjusting the exposure later.

Making a zone ruler

The ruler shown is made in much the same way as the dynamic range test, with the addition of texture. Instead of photographing a blank surface, shoot one with texture, such as cloth, unpolished wood, or smooth stone. Alternatively, choose areas from existing images in your stock library that conform to the descriptions of the zones. Arrange them in a stepped scale and adjust the overall brightness values. There is more information on measuring average values of an area under Exposure measurement.

The zones

Zone I Solid, maximum black. 0,0,0 in RGB. No detail.

Zone II Almost black, as in deep shadows. No discernible texture.

Zone III First hint of texture in a shadow. Mysterious, only just visible.

Zone IV TEXTURED SHADOW. A key zone in many scenes and images. Texture and detail are clearly seen, such as the folds and weave of a dark fabric.

Zone V Typical shadow value, as in dark foliage, buildings, landscapes, faces.

Zone VI MID-TONE. The pivotal value. Average, mid-gray, an 18% gray card. Dark skin, light foliage.

Zone VII Average Caucasian skin, concrete in overcast light.

Zone VIII TEXTURED BRIGHTS. Pale skin, light-toned and brightly lit concrete. Yellows, pinks, and other obviously light colors.

Zone IX The last hint of texture, bright white.

Zone X Solid white, 255,255,255 in RGB. Acceptable for specular highlights only.

Applying the Zone System

The Zone System is just as relevant today as it was in the days before digital capture. The reasons for this are twofold: easy, accurate measurement and the ability to adjust brightness and contrast after the event. Using it in the run-up to shooting, as was originally intended, is even better, but in real-life situations, this may be an unattainable luxury.

To begin with, concentrate on the following three important zones: Zone V (midtones), Zone III (textured shadow), and Zone VII (textured brights). Identify them in the scene and then, if you have the time, measure them with the meter (camera's spot or handheld).

It's important to understand the differences in dynamic range between the camera and the media on which you intend to display the image. Even if a digital camera has a smaller dynamic range than film, it is still far higher than that of any paper. Basically, from the original scene through digital capture to final print, the range becomes smaller.

Placement in practice

In this dramatic architectural image, the detail in the foreground shadow area was felt to be essential to the overall composition, and so was placed in Zone III. It was also important to retain detail in the well-lit areas in the center of the image, though with a degree of choice: if they were to be only just visible, they could be in Zone VIII, but to be definite, they would have to be in Zone VII. Settling for Zone VII put the rest of the image into context. There would need to be a five-stop difference between these two areas to give the overall image suitable contrast, so the foreground area was placed in Zone II and the exposure set accordingly for the final result.

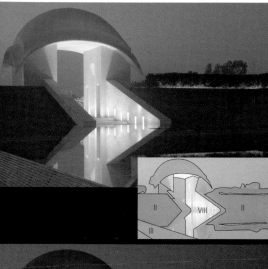

ORIGINAL EXPOSURE

First attempt at a Zone map for the original exposure

FINAL EXPOSURE A STOP BELOW

Final Zone map for exposure a stop below

High-dynamic range scenes

When confronted with a scene in which the dynamic range exceeds that of the capacity of the camera, the Zone System approach is to identify the important zone and expose for that. Indeed it is a very practical way of thinking through these situations. In practice, there are three possible options:

1 Expose for textured brights (Zone VII), and accept loss of shadow detail.
2 Expose for the midtones (Zone V), and split the loss of texture at both ends: shadow and highlight.
3 Expose for textured shadow (Zone III), and let the brighter tones go to featureless white. Visually this is usually the least acceptable option.

...expose for brights

...expose for midtones

...expose for shadows

Common Lighting Scenarios

Almost all scenes that you photograph can fit into one of several distinct types of lighting situation. The three main divisions (the three technically most important) are based on contrast, and are Average, Low Contrast, and High Contrast. Of these, the one likely to cause the most problems is High Contrast.

This is particularly so in digital capture, partly because highlights are more easily blown out digitally than with film, and partly because low-contrast images are simple to adjust.

What makes up these lighting situations is a combination of the light (bright sun,

spotlight, overcast, and so on), the subject (its color, brightness, shininess), and how you identify the subject. This last point is critical. What one photographer identifies as important in the frame may well not be the same as that chosen by someone else. "Subject" doesn't necessarily mean "object," but might instead be a patch of light or an area of shadow. Thus, you might have a scene that measures average in exposure, but the key tones are in the bright areas— say, the texture of some prominent clouds in a landscape. There are endless sub-divisions possible, but the more there are, the less useful they become.

Average contrast

Equal spread of tones

Key tones dark

Key tones bright

Key tones average

When presented with an average level of contrast, it should be no problem to select the correct exposure, bearing in mind all the usual caveats about avoiding blowing highlights as opposed to shadow detail.

High contrast

Where there is a lot of contrast, it is especially important to identify the subject and key tones, as often something has to give way. Sacrifice detail in the less important areas of your image.

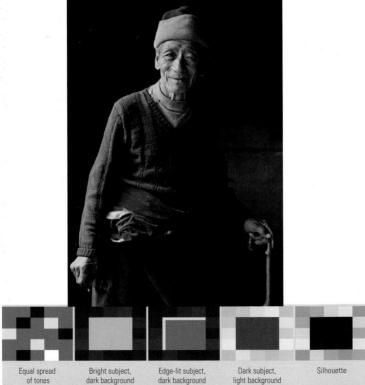

| Equal spread of tones | Bright subject, dark background | Edge-lit subject, dark background | Dark subject, light background | Silhouette |

Low contrast

In situations like this, it is important to decide if contrast should stay low, given how easy it is to increase contrast by setting black and white points.

Average High key

Noise

Numerous comparisons have been made between noise and grain, and in a sense this is understandable because of the relationship between sensitivity/ film speed and the amount of noise.

However, there the similarities end, as not only are the causes different, but so are the treatments. Indeed, the one good thing about noise in digital photographs is that it can be dealt with. Not perfectly and not easily, but there are various solutions.

In order to treat noise, we have to define it, and this isn't as simple as it might seem. Technically, noise is artifacts or errors introduced into the image by electrostatic charge, and the scientific approach to it revolves around the signal-to-noise ratio. However, this does not take into account the very important perceptual component. After all, at the pixel level, noise and detail are indistinguishable. In other words, it is largely the eye and mind of the viewer that distinguishes between subject detail (wanted) and noise (unwanted). As a parallel, any retoucher who has worked on scanned film images knows that with some subjects, such as an unswept floor or a rocky landscape, it may be impossible to decide what are dust specks and what is texture.

Noise is detail, but unwanted detail. This immediately creates a problem, because the definition of "unwanted" is completely subjective. This has major implications when it comes to treating a noisy image, and it also means that there are two distinct stages in digital photography at which noise can be suppressed. One is at capture, the other during image-editing. Noise is heavily dependent on a number of variables, and so can vary from shot to shot according to the camera settings and the conditions. You can

Variations of noise

Photon noise
This is noise caused by the way in which light falls on the sensor. Because of the random nature of light photons and sensor electrons, it is inevitable with all digital images. It appears as dark, bright, or colored specks, and is most apparent in plain mid-toned areas, least apparent in highlights.

Readout noise (or amp noise, or bias noise)
This is noise caused by the way in which the sensor reacts and the way in which the signal is processed by the camera. Similar to electronic noise in recorded music, this is generated by the processor itself, and the more it is amplified, the more prominent it becomes. Thus, increasing the ISO setting by turning up the amplifier creates more noise. It is to some extent predictable and can be reduced by in-camera processing.

Random noise
Caused by unpredictable but inevitable differences in timing and the behavior of electrical components.

Dark noise (also known as fixed-pattern noise and long-exposure noise)
Noise caused by imperfections specific to each individual sensor. Increases in proportion to the exposure time and to temperature increase, but is independent of the image, so can be reduced by in-camera processing by means of "dark-frame subtraction." This extra process takes as long again as the original exposure. Cooling also helps.

Reset noise
After each shot, the camera resets the sensor to a zero position, ready for the next exposure. Multiple clocks in the processor may cause slight differences in the timing of this, which generates noise.

In-camera noise reduction

Many cameras have a noise reduction option to deal with long exposures. It doubles the processing time, but saves a great deal of work later. This in-camera option tackles the known pattern of noise that occurs with long exposures by subtracting the predictable behavior of the sensor. The principle is to make a second exposure for the same exposure time, but with no image. The pattern of noise will be the same as for the exposed image, and can be subtracted from the noisy image by an appropriate algorithm. You could do this yourself in image editing with a lot of effort, but it is unnecessary if you choose the noise reduction option in the camera's menu—it does the same thing more efficiently.

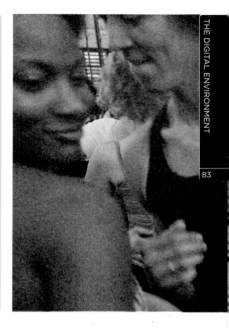

expect to encounter noise with long exposures, high sensitivity, high temperatures, and in images with large, smooth shadow areas, but it is difficult and time-consuming to check while shooting. As much as possible is controlled by the camera's processor, and this varies according to the make because it depends on the algorithms used and on the processing techniques chosen by manufacturers. Most camera menus offer the choice of noise reduction.

HIGH NOISE

This image exhibits extreme digital noise. The noise is caused by one photosite in the sensor picking up significantly more light than its neighbors. As digital sensor chips are typically arranged in a color filter array, the "rogue" pixels tend toward a single color; red, green, or blue.

The appearance of noise

Certain types of noise have a characteristic appearance,
as you can see from these enlarged examples.

LUMINANCE NOISE:
Appears as variations in
brightness—a basically
monochrome, grainy
pattern.

**CHROMINANCE
NOISE:**
Variations in hue are
prominent.

HOT PIXELS:

"Stuck" pixels appear as bright spots—very noticeable and visually disturbing.

JPEG ARTIFACTING:

Blocks of eight pixels are sometimes distinguishable— a result of the JPEG compression processing.

JPEG: artifact shows as lines Original: no artifact

White Balance

Our eyes are so good at adapting to different lighting conditions that generally we perceive white as white. But the color of light varies, and the two most important ways in which this affects photography are color temperature (between reddish and bluish) and the off-color glow of fluorescent and vapor discharge lamps.

To the human eye, white is normal, and any deviation from this appears tinted—not necessarily wrong, but not balanced. Unless you specifically want a color cast for a particular reason (the warm glow of a setting sun on sandstone rocks, for instance), it's normal to strive for lighting that appears white—that is, neutral.

With film cameras, the solution was to use an appropriately balanced film (either daylight or tungsten) and filters. Digital cameras sidestep this by processing the color information according to your choice. With a camera you can do this manually, or choose from a number of standard settings, or let the camera find the balance automatically. The manual method (also known as a "custom" white balance) involves aiming the camera at a known neutral surface, such as a piece of white paper or a standard gray card. The camera's processor then stores this information and applies it to subsequent images, making it the most accurate method when you are shooting for a period of time in a situation with unchanging light. The simpler alternatives are either to choose one of the standard settings in the white balance menu, or to select Auto and let the camera work it out.

Automatic white balance requires the camera's processor to analyze the scene, identify highlights, and adjust the overall

The color of light

The principle of color temperature is that when a material is heated, it first glows red, then yellow, increasing to white at higher temperatures (hence "white-hot"), and then blue. This applies to any burning light source, including the sun and tungsten lamps, and it gives a way of calculating the color of light by its temperature (measured in degrees Kelvin, which is similar to Celsius/centigrade but starts at absolute zero). For photography, the normal limits between reddish and bluish are from about 2,000K (flames) to 10,000K (deep blue sky). The mired shift values are a standard measure of the numerical differences between temperatures. You will need to refer to these when using certain processing software, such as Photoshop's Camera Raw plug-in.

balance, and for most situations is a good choice. Some high-end cameras supplement the sensor analysis with separate through the lens (TTL) color meters and incident meters mounted on the camera.

Bracketing white balance

Some cameras offer a bracketing option
that works in a way similar to exposure
bracketing—a burst of several consecutive
frames in which the white balance is
altered incrementally.

TOP TO BOTTOM:

In this shot, a custom white balance was
set, with a light temperature of 4,500
degrees Kelvin.

In this variant, the camera's automatic
white balance mode was used.

This shot was taken with the white balance
set to the preset "shade" option.

White balance settings

Although the actual descriptions vary from make to make, most cameras offer a similar range of choices to cover commonly encountered lighting conditions as shown in the examples below. The precise values can also be adjusted.

Auto Sunlight Cloud

Shade Tungsten Fluorescent Flash

Setting a custom white balance

This varies in practical details according to the make of camera, but what all have in common is the measurement of a reliably neutral target. White paper or card will do, but for greater accuracy consider carrying a standard gray card. This is a typical sequence of steps.

1. Photograph a neutral target that is large enough or close enough to fill the target area, in this case a large expanse of white wall.

2. Select the Custom White Balance option from the Shooting menu and press the Set button.

3 The last captured image, in this case the photo of the wall, will appear. If you're happy to use the image to set the Custom White Balance, press Set.

4 The camera will then ask you to confirm that you want to use the image to set the Custom White Balance. Press OK.

1

3

Managing Color

Getting accurate color has always been an issue with photography, and never more so with digital photography. In a way this may seem a little strange, because film photography was just as affected by color temperature and other color differences in lighting.

With digital photography, however, it can be managed, and so must be. There are two sides to color management. One is linking the different ways in which the various devices in the workflow reproduce color, from camera to monitor to printer. The other is staying faithful to the colors of the subject.

First, color-managing the devices. This involves all of the equipment, not just the camera. Ultimately, it depends on a description of how a device reads and renders colors. These descriptions, which can be read by other machines, conform to the standards of the International Color Consortium (ICC), and are known as profiles. Every piece of equipment in the workflow should have one, including the camera.

Basically, the ICC profile rules, but fine-tuning it is the key to absolute accuracy. Normally, a generic profile of the camera is automatically embedded in the image file, and major software applications like Photoshop and Lightroom can read it (with the help of additional updates).

But device performance is not always consistent, and it can drift with time. Keeping the profile up-to-date is the answer. In principle, for a camera this means checking how it copes with a standard color target and altering the ICC profile accordingly. In practice, this involves profile-building software that can compare an image with stored information. You shoot a target such as the GretagMacbeth ColorChecker under known lighting conditions,

HUE ADJUSTMENT
You can adjust the hue from a menu on your camera in much the same way that you can adjust the image later using your image-editing application's Hue/Saturation tool.

Selecting color space

Somewhere in the camera's menu is the option to select the color space, which may be called something else, such as color mode. A typical choice is between Adobe RGB and sRGB. For most serious use, select Adobe RGB. This has a wider gamut, which means that the camera will capture more colors from the scene.

SHOOTING MENU

Color space	▶ sRGB Adobe RGB

Color & the Raw format

Shoot in Raw format and the precise white balance settings do not matter. This is because the Raw format bypasses the processing that normally applies these settings in camera. All the data is kept separate in Raw format, including the white balance settings, which can be adjusted in image-editing.

and the software does the rest. See the following pages for setting up this procedure.

Using a standard target

Calibration is also affected by the subjects and scenes that you photograph—they may differ wildly in the way they are lit, and this is the second aspect of color management. The eye accommodates so well to different color casts that it may not be a great help. Under skylight from a clear blue sky, it reads what you think should be white as white, even though it actually is a definite blue. With film, even though a slide might have had a color cast, at least the image was locked into the physical transparency, and could be identified. With digital, only the photographer is in a position

to say what the colors should be and, if you can't remember, no one else is in a position to say. Setting the white balance to one of the presets, such as Cloudy or Shade, gets you close, as does a visual check of the LCD screen after shooting, but the only way to guarantee the colors is to make a test shot with a standard target—any of the same targets needed for device calibration. If you do this just once for any given lighting situation, you have the means to adjust the colors accurately in image editing. Depending on the camera, there may also be a separate hue adjustment control, allowing you to shift hues around the spectrum in a way similar to the Hue slider in Photoshop. Typically, the adjustments are measured in degrees.

Color Targets for Consistent Color

If getting color accurate is essential–to match the colors in a company logo, for example–then use a standard color target.

For normal photography, the two most valuable are the Kodak Gray Card and the X-Rite (GretagMacbeth) ColorChecker shown here. Their colors are known quantities, and so they can be used to judge and correct your captured colors. At the very least you can use them for visual reference, but the ColorChecker has the more valuable function of helping to create ICC camera profiles. Under highly controlled conditions, such as fixed studio lighting set-ups, some lighting manufacturers recommend using an IT 8.7/2 target, which is normally used for scanning.

X-Rite (GretagMacbeth) ColorChecker

Based on the Munsell System (the source of the hue, saturation, brightness model), this 24-patch mosaic of very accurately printed colors is the color chart of choice for photography. Not only is it a known industry standard, but it contains "real-life" colors such as flesh tones and the complex greens of vegetation. Importantly, the colors reflect light the same way in all parts of the visible spectrum, meaning that they are consistent, whatever the lighting, and they are printed matte to avoid reflections that would upset the readings.

The top row contains memory colors that include skin tones, blue sky, and foliage, the second row medium-saturated colors, the third row the three primaries and secondaries, and the bottom row a gray scale from "white" to "black." Note, however, that the dynamic range of matte printed colors is much less than any of the other color displays you are likely to come across, and the "black" is really a dark gray.

To preserve the color accuracy of the target, avoid fingerprints, high temperatures and high humidity, expose it to light only when using it, and replace it about every four years in any case.

GretagMacbeth™ ColorChecker Color Rendition Chart

X-RITE (GRETAGMACBETH) COLORCHECKER

The classic X-Rite ColorChecker has applications in graphic design, television, and publishing as well as photography. Its 24 colored inks are prepared accurately in the lab.

X-RITE COLORCHECKER DIGITAL SG
The ColorChecker Digital SG features 140 color squares and is specifically designed to meet the needs of digital photography. It can be used with profiling software to create an ICC camera profile for accurate color reproduction. The squares include 24 patches from the classic ColorChecker, 17 step grayscale and 14 skin tones.

X-Rite ColorChecker SG

This is the newer, more sophisticated version of the basic 24-patch ColorChecker and supersedes the ColorChecker DC. The SG stands for semi-gloss–the idea being that the matte finish of the semi-gloss squares deters reflections, although in practise this does occur occasionally. The upper center of the card features the 24 patches of the classic ColorChecker, and the colors are supposed to match the original. Like its predecessor, it is designed specifically for digital cameras. The ColorChecker SG is extremely expensive and could be considered overkill for most photography, although it does cover a wider range of colors, particularly skin tones and other memory colors than the smaller target.

Kodak Color Control Patches and Gray Scale

Less useful than the ColorChecker for photography, but better than nothing, this set of two small strips has traditionally been used as a color reference by repro houses and printers. The strips are conveniently sized for placing next to still-life subjects and paintings, and are an approximate guide for printing. The Gray Scale has 20 steps in 0.10 density increments between a nominal "white" of 0.0 density and a practical printing "black" of 1.90 density. The letters A, M, and B represent reflection densities of 0.0, 0.70, and 1.60 respectively. The Color Control Patches are based on web offset printing inks similar to AAAA/MPA standard color references, and include the three primaries, three secondaries, plus brown, white, and black.

Using a color chart or gray card

1 Place or have a model hold the chart full-face to the camera.

2 Make sure the lighting is even across the chart and avoid reflections.

3 Use a low ISO sensitivity and meter as average.

4 For profile building, follow the software instructions (normally includes turning off automatic camera settings and using either daylight or electronic flash).

5 Evaluate in image-editing.

Gray Card

The 18% reflectance Gray Card has long been a reference tool in black-and-white photography, being a standard mid-tone. In a digital image, it should measure 50% brightness and R128, G128, B128. The reason for 18% as a mid-tone is the non-linear response of the human eye to brightness. It is matte to avoid reflections, and has a reflection density of 0.70, which it maintains across the visible spectrum.

GRAY CARD

Shooting a gray card under the lighting in which you're working in order to set a customized white balance, is the most effective way of getting faithful color reproduction.

Creating a Camera Profile

For the vast majority of us, creating a specific color profile for the camera is not necessary—we're unlikely to notice any minor color discrepancy, and on the rare occasion when color really has gone awry, it's usually relatively easy to fix in post-production.

However, camera profiles can be useful when a photographer works regularly in a repeatable kind of lighting. A studio with photographic lights is the most obvious example. Personally, I do quite a lot of location shooting in low sunlight, and so find it useful to have a profile just for this. The profile is a small text file, readable by the computer, that describes the exact way in which any of these devices displays colors. As everything begins with the digital capture, the camera profile occupies the first place in the chain of events.

Cameras normally have default profiles, also known as "canned" profiles, built in to their systems and attached to the image files

The X-Rite GretagMacbeth ColorChecker in use on location.

STUDIO PROFILE
An IT8 target is typically shot in studio conditions, once the lighting has been adjusted for the subject.

they create. Photoshop, for instance, will read the attached profile automatically. So far so good, but the canned profile may only be an approximation for an individual camera working in specific lighting conditions. If, like most photographers, you begin by relying on this default profiling—in other words, doing nothing—you may come to recognize certain peculiarities. One of the traits of my current DSLR, for example, is a pink cast to light tones in sunlight. This kind of trait is correctable in image-editing, but a better solution is to create an exact profile for the camera when shooting in these conditions. The profile, in effect, compensates for the camera's color misbehavior.

Two important words of warning, however. One is that camera profiles must be specific to be of any use—specific to one camera and to the kind of lighting. The other is that total accuracy is rarely necessary, and unless you have an exact need, such as in the copying of paintings or the reproduction of a commercial product's brand colors, you may well be wasting your time fretting over minute differences in color values.

IT8 TARGET

The IT8 target is a standard pattern, with 19 columns of 13 colors, with three additional columns (20-22) which are "vendor independent," in that different manufacturers can place their own colors there. It also features a 24 shade grayscale along the bottom.

Photograph the color target

1 Place the target so that it is evenly lit and in the illumination that you expect to use. If the light source is concentrated, such as the sun or a flash, make sure that the target is angled to the light to avoid reflections.

2 Make sure that all the camera settings are at average or neutral—for instance, no hue adjustments. Select either the appropriate white balance choice or, better still, create a custom white balance by referencing either a white or gray patch (or a larger Gray Card).

3 If you can adjust the capture through the camera exposure control or lighting, aim for a gray scale range that is full but not total. Remember that the "black" on a ColorChecker is by no means zero, but a dark gray instead. Some profiling software recommends the values shown below. Note in particular how much lighter at 52 the black is than "pure" 0 black. You can fine-tune this exposure later in image-editing.

4 An added sophistication is to construct and include a light trap—a black box with a small aperture. This will be close to total black, but is probably overkill.

5 Set up the camera perpendicular to the target to avoid perspective distortion.

A light trap is a box, painted entirely with light-absorbing black on the inside and with a small hole cut in it. The black seen through the hole will have no reflections, and be close to total black.

243 207 169 131 90 52

GretagMacbeth ColorChecker Color Rendition Chart

Recommended grayscale values

Create the Profile

Once you've photographed the target, the next step is to create a profile. For this you will need camera-profiling software.

Each follows its own procedure, but the example here is the X-Rite ColorChecker Passport profiler plug-in for Lightroom. You will need to shoot and create profiles for each type of lighting that you expect to use—and for each camera.

1 Open the image of the ColorChecker chart you shot earlier in Lightroom.

2 Either right-click on the image and select Export > ColorChecker Passport or go to File > Export with Preset > ColorChecker Passport. At this stage the plug-in will automatically convert the image to a DNG file.

Enter DNG Profile Name

DNG Profile Name Canon 6D Studio Set A

Cancel Save

ColorChecker Passport
The profile has been generated successfully.
Lightroom must be restarted to activate the profile.

OK

✓ Canon 6D Studio Set A
Adobe Standard
Camera Faithful
Camera Landscape
Camera Neutral
Camera Portrait
Camera Standard

3 Lightroom will then prompt you to give the profile a name. It's important that you give the profile a readily identifiable name so that you can be sure you're applying the correct profile to your images. Here for example, a profile has been set up for a specific studio lighting set up.

4 After a short wait, Lightroom will confirm that the profile has been created. You will then need to restart Lightroom before the profile becomes available.

5 To apply the profile to the DNG converted Raw file, go to the Camera Calibration window at the bottom of the Develop module. As well as the new specific profile, here you'll also find the Adobe Standard profile along with generic profiles that mimic the picture settings of your camera.

Naming the profile

In addition to the name, there is also a Profile Description Tag (a description found inside the profile file) used by some applications to display it as a choice. If you decide to rename a profile, these applications will not recognize the change unless you use a utility to alter the Tag as well. Apple's ProfileRenamer does this. If you overwrite an existing profile (which you might want to do if, for instance, you made a mistake the first time), Photoshop may need to be restarted before it recognizes the change.

One-off profiles

If the lighting conditions for a single shot are unusual, consider making a profile for that shot alone. Simply shoot the target as part of the take and make the profile as described here—but use it only for that shot.

Adobe DNG Profile Editor

Adobe offers a free application that allows you to build custom profiles for specific cameras, and under specific lighting scenarios. This is particularly useful if you find yourself shooting in a challenging scene lit by multiple different light sources with differing color temperatures. It's for precisely such situations that keeping a color checker in your camera bag is a prudent action—you simply take a photo of the color checker in that lighting, and shoot away. Then, back at your computer, build a custom profile for that particular light, export it, and then apply it to all the other shots taken of that scene. While the full capabilities are quite exhaustive and complex, DNG Profile Editor can be a huge time saver, as many of the subtle nuances of color can't easily be recreated using the standard Raw-processing tools.

To begin with, you must export your shot of the color checker as a DNG file (if your camera doesn't already capture such files natively). Then, import it into the Profile Editor, and select the various color swatches. Each click will generate a corresponding swatch in the menu on the right. You can then adjust the exact color output of each color using the variety of tools available.

Memory Cards

The two major card formats used today are CompactFlash (CF) and Secure Digital (SD)—including the more recent SDHC (High-Capacity) and SDXC (eXtended Capacity) standards. The newest of the bunch are XQD cards, with impressive read/write speeds of 1–4 Gbits/second.

Although in terms of cost per gigabyte (GB), memory cards have dropped dramatically in price, that doesn't necessarily mean you should buy the least expensive option available. If you're intending to shoot video, storage capacity is one important consideration. Cameras these days are capable of capturing high definition (HD) 1080p video. At this resolution you can only fit around 20 minutes of video on a 16GB card; so if you intend to shoot a lot of video you may want to consider a larger capacity card, and the larger the capacity, the more expensive.

However, of greater consideration in terms of the cost of memory cards is write and (to a lesser extent) read speeds. Write speeds determine how quickly image data can be saved onto a card, while read speeds describe how fast image data is retrieved from a card. If recording video or taking long bursts in continuous shooting mode you'll need a card with fast write speeds. High-defintion video captures around 4–6MB of data per second, while a 20 megapixel camera records around 24MB of Raw data with each image, and if the camera can shoot at 6 frames per second (fps) that's almost 150MB per second in burst mode. Even taking the camera's buffer memory into account, the memory card itself must be able to write the information at a sufficiently fast speed in order to keep up. Write and read speeds are measured and presented in various ways,

CompactFlash

CompactFlash (CF) was once the most widely used type of memory card, and although still used in many professional models, an increasing number of prosumer cameras are moving over to SDHC or SDXC cards. CompactFlash cards employ flash memory technology, give non-volatile storage and can retain data without battery power. They measure 43×36mm and come in two types with different thicknesses—Type I (CF-I) is 3.3mm and Type II (CF-II) 5mm, although support for the latter is on the decline. Typical capacities range from 16GB to 256GB. Professional photographers preference for CF cards lies in their sturdy construction, long usage life (around 100 years), and the ability to operate in temperatures ranging from -13°F to +185°F (-25°C to +85°C). They are PCMCIA-compatible, so easy to read from laptop PC card slots.

CARD PROTECTION

There are numerous products on the market for protecting your memory cards—invest in at least one. Losing a film can be a tragedy, losing a memory card containing a set of digital images is a loss of both the images themselves and of the means to record more. If nothing else, you're protecting an expensive investment.

SD/SDHC/SDXC

Secure Digital (SD) cards have largely superseded MultiMediaCards (MMC). Initially utilized by camera manufacturers, who exploited their comparative small size for compact, point-and-shoot models, the latest generation of SD cards, SDHC and SDXC, have sufficiently large capacities to be used in cameras of all sizes. The micro SD versions, although not used nearly so often, offer even greater space saving options for camera makers. Typical capacities for SDHC cards range from 8GB to the maximum 32GB. SDXC cards range from 64GB to 512GB, but capacities of up to 2TB are possible. These cards are increasingly widely supported by device manufacturers so, for example, many computers and even DVD players can read them.

SD/SDHC SPEED CLASS	APPLICATION	GUARANTEED MINIMUM WRITE SPEED	EQUIVALENT X RATING
Class 2	H.263 video recording Standard definition video recording VGA Basic DSC	2MB/second	13x
Class 4	High-definition video recording MPEG-2 (HDTV) video recording DSC still-image consecutive shooting	4MB/second	26x
Class 6	Full 1080p HD video recording Professional-level camcorder Professional-level interchangeable lens camera	6MB/second	40x
Class 10	Full 1080p HD video recording High-definition still recording Professional-level camcorder or interchangeable lens camera	10MB/second	66x

so it pays to know what to look for. For example, you may see some cards advertising 45MB/sec. This is the maximum speed it can write at, but not a sustainable speed. The maximum speed is a useful guide for telling you how well the card can cope with the camera set in burst mode. The faster the speed, the longer you can use continuous shooting, and the quicker the buffer will be cleared.

SD cards often advertise a Class rating (a C with a number inside), with Class 2 guaranteeing sustained write speeds of 2MB/sec, Class 4, 4MB/sec, and so on up to Class 10 (10MB/s). Knowing the minimum sustainable write speed is important when shooting video. If the card is too slow, you will get dropped frames. For HD video and high-resolution stills, Class 10 is the optimum choice. SDHC and SDXC cards may also feature a UHS rating (a U with a number inside). There are two UHS ratings I (U1) and II (U3). The first has a minimum write speed of 10MB/sec and the second a minimum speed of 30MB/sec. The latter is really only necessary for ultra definition 4k video recording.

Many CF cards feature a multiplication factor, such as 80x, 100x, and so on. This is called the "commercial x-rating." Depending on the manufacturer the rating refers to either the read or write speed, or both; so it pays to check that the card is appropriate for your specific needs. Another rating found on CF cards is the UDMA rating. Most cards are now rated UDMA 6 or 7 and have maximum transfer rates of 133MB/s and 167MB/s respectively.

Finally, you may also see a VPG (video performance guarantee) rating on some CF cards. Like the class rating on SD cards, the VPG rating (a clapperboard symbol) indicates the minimum sustainable write speed. There are two ratings, 20 and 65 and represent speeds of 20MB/s and 65MB/s, so offer very high performance.

Before buying an expensive, fast card, however, consider your needs. If you're primarily shooting single frame stills, you won't need a particularly fast card. Also ensure the card doesn't exceed the camera's capability. Some cameras aren't UHS compatible for example, so you won't get the benefit of the card's transfer rates.

A Wireless Option

Although Wi-Fi connectivity for DSLRs was first available back in 2003, it was rudimental. It required you to attach a bulky wireless transmitter to the base of the camera and functionality was basic.

Today's wireless option is a much more sophisticated affair in two fundamental ways. First, an increasing number of cameras now feature built-in Wi-Fi (lagging some way behind numerous compact cameras). The benefits in terms of convenience are obvious, and no doubt built-in Wi-Fi will become as standard as LiveView and HD video recording is today. Secondly, thanks to advances in other mobile devices, what you can now do with a Wi-Fi-enabled camera far exceeds early iterations. When DSLR Wi-Fi was first introduced by Nikon for its D2H, it was hailed as a valuable option for any photographer who needed to deliver images quickly without leaving the shooting location. Sports events were the classic situation. And while the ability to transmit images wirelessly over the internet is certainly still valuable, with today's Wi-Fi technology it's possible to connect your camera to a tablet, smartphone or desktop computer, and as long as you have the appropriate software installed, control the camera remotely. The level of control varies depending on the camera and its associated app, but the ability to control aperture and shutter speed, set ISO and point of focus, and of course to release the shutter, are generally standard. The potential applications are endless, from landscape, through wildlife, even to street photography.

Canon EOS Remote

The Canon 6D was the first DSLR to offer built-in Wi-Fi connectivity. When connected with Canon's EOS Remote app, which is compatible with iOS and Android devices, you are presented with two options. In Camera Image Viewing you can view, sort and grade images as you shoot. The images will be stored on the device. You can also email downsized images via the phone. In Remote Shooting you can control the camera's basic shooting functions remotely, although you can't record video.

Connecting a Wi-Fi-enabled camera

No matter what Wi-Fi enabled camera you're using, before you can use the remote viewing and shooting functions, you'll need to download the appropriate, compatible app to your smart device. The apps are usually freely available to download from the internet. How you connect the camera to the smart device will vary depending on the camera and the device. You'll need to refer to the manual for specific instructions, but here are the types of step you can expect.

1 Once you have installed the appropriate software onto your device, switch on the camera and enable Wi-Fi. Depending on the make and model of your camera, there may be a dedicated button to do this. Alternatively you'll find the setting in the camera's setup menu.

2 With Wi-Fi enabled, you'll get confirmation that you can connect to a smart device or a network.

3 Before you connect to your device, you may need to check the network settings. Again depending on your camera, your device, the operating system, such as Android or iOS, and the way in which you want to connect, you may have to input access codes or passwords. For some devices you may only need to do this once, for others you may find you have to set up the connection every time. As the devices are attempting to connect, the Wi-Fi symbol will flash, becoming solid once the connection is made.

4 With the connection established, you can then select the camera from your smart device's Wi-Fi Settings screen.

5 Launch the app on your smart device. With this particular example, Nikon's Wireless Mobile Utility you have the option to either take photos or view photos.

6 When shooting remotely, you will have the option of adjusting a number of settings deppending on which mode you are in.

Processing In-camera

Traditionally, shooting and editing were separate activities, divided by the time it took to process the images. You took the pictures and later reviewed them on a light box or contact sheet, or possibly with a slide projector.

The playback menu gives you this option right away, for better or worse. The better is that it gives you the certainty of confirming the image and the chance to reshoot and improve if the first frame is not exactly as you would like it to be. The worse is that it can interfere with the flow of shooting and

even cause you to miss shots by distracting you. It can also push you into deleting images before you have given them your full attention.

The usefulness of in-camera editing depends on the kind of photography and on exactly what image quality you are assessing. In studio and still-life photography—in fact, any situation in which there is no urgency or in which you can repeat a shot—reviewing and deleting until the image is right is a sensible procedure. In unrepeatable situations, however, there is a considerable risk of making a hasty,

IN-CAMERA EDITING
A typical in-camera editing procedure. Out of a sequence of five frames, two were deleted immediately for poor framing, on closer inspection a further two were deleted for either poor composition or inaccurate focusing.

and wrong, judgment in deletions. The pressure of available space on the memory card can sometimes be a reason for doing this, but it needs to be exercised with caution. The camera's LCD screen is a useful guide but is by no means ideal for examining images, and is much less accurate in color, contrast, and resolving detail than a laptop screen or desktop monitor. In particular, checking detail—such as for camera shake or focus accuracy—involves zooming in, and this takes time that can interfere with shooting.

Data-embedding options enable different kinds of information to be attached to an image file for later use when browsing, building a database, and image editing. Some of this is automatic (e.g. file format, image size, lens, and exposure settings are common, and location coordinates are available for cameras that feature built-in GPS, if enabled), some of it user-adjustable automatic (e.g. date and time), and some manual input (e.g. subject ID and place).

Reviewing images

Check exposure accuracy

Multiple-frame option
Useful for displaying sequences.

Zoom
Check for sharpness and motion blur, and details such as facial expression.

Protection
Locking key for safety.

Delete
The most dangerous action without an on-screen computer review.

Adding data to images

Date and time
Always useful in identifying the subject. When traveling, make sure to allow for time zones.

Comments
Some cameras include the facility to add a short text comment that will later be displayed in the browser.

SETUP MENU
Time zone and date
Language
Auto image rotation — ON
Image comment — ON
Location data
Video mode — NTSC
HDMI
Remote control

ADDING COMMENTS

The comment facility in this Nikon menu is accessed via the Setup menu. The comment is added to photos taken afterward, until you ask the camera to stop. It therefore requires regular attention if used. Since cameras do not feature full keyboards for obvious reasons, text entry is limited to video-game style cursor movement. This takes time, so keep your comments short and helpful.

Power Supply & Management

Batteries are the life blood of your camera, so battery management is an important consideration, never more so than when you are traveling and are far from reliable power sources. Fortunately, there are a number of ways in which you can maximize the life of your battery.

If you shoot only stills you may get as many as 1,000 shots on one charge, it's still prudent to buy a spare battery for your camera. There are third-party battery manufacturers, some more reliable than others, that produce batteries for most camera models and which are much less expensive than proprietary batteries. However, it's certainly worth researching exactly how reliable they are before making a purchase. Some may not provide the same number of shots, others may not provide capacity information, and yet more may not recharge fully or even worse, at all.

Whether you buy proprietary batteries or third-party make sure they're of the Lithium-ion type (Li-ion). Almost all DSLRs today are powered by Li-ion batteries. They are light, powerful, and have a long life, and more importantly they don't suffer from battery memory effect. Other types of battery, notably Nickel-Cadmium (NiCd), will "learn" to have a smaller capacity if they are recharged before being fully discharged.

Wherever there is a convenient power supply, make sure you fully charge your batteries, even if they still have some charge in them. Whichever AC device you carry with you, charger and/or adapter, you must be prepared for the plug/outlet types in the countries you will visit.

AUTO POWER OFF

All cameras will power down automatically to preserve battery life, and most give you the option of choosing the length of time after which the camera will power down. Unless you have a specific reason not to, choose the shortest possible time to auto power off. This option is usually found in one of the Setup menus.

REVIEW TIME

After taking a shot, it's likely that your camera will display the image for a short period of time. The default setting will vary from model to model, and most cameras will give you the option of turning off the review altogether. This doesn't mean you can't review the image at all, you simply have to press the play back button in order to view it.

114

Mirrorless Battery Life

Battery life is an area where mirrorless cameras have a clear disadvantage compared to DSLRs. Either the LCD or the Electronic Viewfinder must be on in order to shoot (with any degree of accuracy, anyway), and these are significant power drains— and it's worth noting that, despite it being a smaller screen, EVFs actually consume more power than the regular LCD screen on the back of the camera. Extra batteries are a must for mirrorless.

Rating

The power capacity of a battery is measured in Milliamp-hours (mAh). This indicates the battery's overall charge storage capacity, and the higher the mAh, the longer the performance. Higher capacity batteries are more expensive, but valuable for digital cameras, which have a high drain. A rating of around 1800mAh is considered high.

BEEP

Wether or not you find the short "beep" sound your camera makes when it acquires focus reassuring or simply irritating, you will safe some battery life by switching it off.

AUTOFOCUS

Fast and efficient autofocus is one of the key selling points camera manufacturers like to make, and most of us rely heavily on it. But for certain genres of photography, notably landscapes and portraits, you may find that focusing manually encourages greater creativity, and it will certainly save your battery.

Know your chargers

If you are carrying more than one device, such as a laptop or stand-alone storage as well as the camera, you are likely to have similar-looking charger units or AC/DC converters. To avoid confusion, and possible damage to circuitry, label each one clearly.

UK plug to standard "8" plug

US plug to standard "8" plug

Laptop charger

Electricity Abroad

If you've traveled relatively extensively, you'll be aware that voltages vary in different parts of the world.

Generally, voltages are divided between 110–120v and 220–240v. Countries with 110–120v are principally the US and those falling under its sphere of influence for reasons of proximity or history (Latin America and Japan, for example), while those on 220–240v tend to be European and former colonies. A few countries have both, though not necessarily in the same place.

Cycles are in Hertz (Hz), usually either 50 or 60. Almost all of the plug-in electrical equipment associated with cameras and

Auto inverters

DC/AC inverters make use of one universal power supply—the lighter socket in an automobile (and also some aircraft power outlets). The output plug is often either figure-of-eight or clover leaf. It may seem odd to convert from DC to AC when devices like cameras, laptops, and accessories need DC anyway, but the variation in the voltage and cycle of transformers makes it potentially damaging to fool around with DC supplies.

PLUGS

This is just a selection of the array of plugs and sockets from the rest of the world that I have collected on my travels.

TRAVEL ADAPTERS

These socket adapters are designed to accept a number of different kinds of plugs. Neither is entirely universal, but both work with more than one kind of plug type.

computers (chargers, transformers, and so on) are designed to switch automatically between these voltage ranges, so there should be no problems on that account (but it's worth checking to make sure that you don't have a primitive single-voltage item). More of an issue is the plug-and-socket fitting, as these vary greatly. The basic solution is to always carry an adapter that will handle a good range of sockets. Beyond this, check the fittings in the countries on your itinerary and buy a specific adaptor. The fail-safe is to buy plugs locally and replace your existing ones—but there is a risk here in that equipment often has permanently attached, non-removable plugs.

There are four major plug-and-socket types, with variations within each, particularly in the 220–240v "European" group. Note that some countries have more than one plug type. Also, some sockets are incompatible with some plugs even of the same pin type and layout. Particularly obstructive are two-pin recessed sockets—you may have the right configuration of pins on your adaptor, but it won't necessarily fit.

Plug adapters

An adapter that accepts two or three of your own country's plugs saves the cost of having more than one foreign-socket adapter.

World sockets

Across the world there are four basic mains electricity socket types, and variants within all of these. When traveling it's essential to have the correct adapters. The voltage also varies from around 110v in the Americas and Japan, to the 220-240v systems common in Europe. Many camera chargers can tolerate either, but you must check.

American	British	European	Australasian

Br(M) Br(G)

Eu(J) Eu(C)

Am Br(D) Eu(F) Eu(E) Au

Eu(K)

American	British	European	Australasian
Canada	Hong Kong – Br(D, G)	Cameroon – Eu(C, E)	Australia
Cuba	India – Br(D, M)	Denmark – (C, K)	Kiribati
Haiti	Ireland – Br(G)	Egypt – Eu(C)	Papua New Guinea
Honduras	Libya – Br(D)	France – Eu(E)	Tajikistan
Jamaica	Malaysia – Br(G)	Germany – Eu(C, F)	Tonga
Japan	Myanmar – Br(D, G)	Greece – Eu(C, E, F)	Uruguay
Liberia	Pakistan – Br(D)	Hungary – Eu(C, F)	Uzbekistan
Micronesia	Qatar – Br(D, G)	Italy – Eu(F)	Nauru
Nicaragua	South Africa – Br(M)	Norway – (C, F)	New Zealand
Panama	St Lucia – Br(G)	Poland – Eu(C, E)	Western Samoa
Puerto Rico	Tanzania – Br(D, G)	Russian Federation –	
Tahiti	U.A.E. – Br(D, G)	Eu(C, F)	(Despite differences,
Taiwan	United Kingdom – Br(G)	Spain – Eu(C, F)	this plug type mates with
Trinidad & Tobago	Zimbabwe – Br(D, G)	Switzerland – Eu(J)	some used in the People's
United States			Republic of China, though
Venezuela			China also uses Br(G) and
Virgin Islands			Am types)

Caring for your Camera

The sheer quantity of electronics found in a digital camera in many ways renders them less robust than their conventional, film-based counterparts.

The convenience of not needing boxes of film on a shoot is offset by the extreme care that has to be taken of the sensor. There is only one sensor, and any significant damage to it will render the camera practically useless.

Gone are the days when a set of jewelers' screwdrivers and long-nosed pliers might get a faulty camera back on the road. When a digital camera goes wrong, you either have a spare body ready or you stop shooting. This places even more importance on basic camera care than in the days of film.

One if the key issues is how to keep the sensor clean. Unlike fixed-lens prosumer

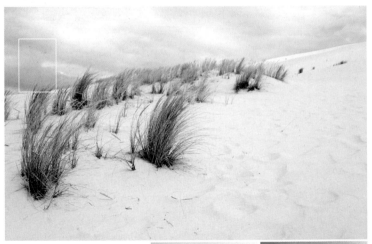

Photographing in sandy conditions is especially dusty. The images (right) show the marked area in close-up, revealing dust on the sensor. By increasing the contrast, the dust particles become easier to see, though their effect can still be perceived before the adjustment is applied.

Preventing and removing dust spots

Take the important precaution of keeping the backs of lenses and the camera's mirror box interior clean. It is relatively safe to use a compressed air can for this—but use from a distance, and horizontally, to avoid propellant contamination. For cleaning the sensor, invest in a high-pressure hand blower, and use a small battery-powered light, for example a white LED torch.

Blower

Swab cleaners

Lens Pen

models, interchangeable-lens cameras are by their nature unsealed, and dirt enters. The sensor is never directly exposed to the air, but that doesn't prevent it from collecting particles, and this happens in two stages: when you change a lens, the mirror box is exposed and if the air is anything less than laboratory-clean, particles can enter; when the mirror flips up for exposure, those particles are free to reach the sensor. The sensor itself carries a charge when in use, so it attracts particles, and if you make slow exposures, there's more time for the particles to slip past the flipped-up mirror. The shadows of small particles may well be undetectable against detailed parts of an image, and also if the aperture is wide open. Any that are noticeable can, of course, be removed with the Spot Removal tool during image-editing, but this takes time.

Most camera manufacturers have addressed this problem with varying degrees of success with various technologies that "shake" dust from the sensor, but this isn't guaranteed to work in all instances. The standard advice is to try and avoid changing lenses when there is dirt around, but as this is largely impractical, the only solution is to check regularly and then take the inevitable risks of cleaning the sensor yourself. Have it cleaned by the manufacturer or an accredited repair shop as often as is practical.

Warning!

- Compressed air is effective but dangerous because of the risk of propellant splattering the sensor. Camera manufacturers do not recommend it, but it may be the only way of removing some particles. Minimize the risk by holding the can level and use from a distance.
- DON'T touch the sensor—EVER. Don't use a blower brush.
- DON'T blow directly with your mouth. Any spittle will have to be cleaned professionally.

Make regular spot checks

At regular intervals while shooting (you have to decide how often, depending on how clean the air is and how often you are changing lenses), check for dirt by shooting a featureless subject such as a white wall or the sky. Any particles will be most obvious if the aperture is stopped down and the subject out of focus. Check initially at 100% magnification, scrolling from one corner across the entire image. When possible, also check the image on a computer screen.

Cleaning the sensor

Although the sensor itself is protected by a low-pass filter, which affords some protection, the filter itself is delicate, and scratching means expensive replacement, hence manufacturers' warnings against touching it. If you detect dirt in an image, clean the sensor as follows:

- Make a mental note of where in the frame are the obvious particle shadows. Because an SLR image is inverted, the actual particles will appear in inverted positions when you examine the sensor.
- Find a clean-air area and remove the lens. Ideally, put the camera body on a tripod so that you can work with two hands.
- Follow the manufacturer's instructions for locking the mirror up to expose the sensor. This is important, because if you simply set the shutter speed to B or T, the sensor will carry a charge that will attract even more dirt. You may need to connect the camera to an AC adapter (check your camera manual); otherwise, you'll need to have a sufficient battery charge.
- Shine a bright light, ideally a point source, onto the sensor and inspect from different angles.
- Use a hand-operated bulb blower as shown. If this weak flow of air fails to remove everything, consider (at your own risk) using a sensor swab with appropriate cleaning fluid. Sensor swabs are available in various sizes, so ensure you have the correct one for you particular camera. Carefully run the swab around the sensor once, allow the cleaning fluid to evaporate fully then check the sensor is free from dust.

On-camera Flash

Most cameras feature a built-in, pop-up flash unit, and although this type of flash is of limited use, it can be helpful as fill-in flash for backlit subjects.

On-camera flash of this kind has the inevitable drawbacks of frontal lighting (almost shadowless and falls off in proportion to the distance from the camera). At the same time, on-camera flash gives clear, crisp results with bright color, so that, for example, it often works well for close-up shooting of colorful subjects. High-end digital cameras with built-in or dedicated flash units use a variety of sophistications to improve exposure accuracy, including focus (to favor the distance to the chosen subject in a scene). It's worth noting that as flash technology increases, so does high-ISO sensor capability, and what may have required the use of flash years ago can now be captured by simply boosting the ISO.

Guide number

This is the standard measurement of light output, and varies according to the ISO sensitivity. It is equal to the aperture (in f-stops) times the flash-to-subject distance (in meters, feet, or both). A typical rating, for example, might be "Guide Number 17/56 at ISO 200," meaning meters/feet. Divide the guide number by the aperture you are using to find the distance at which you can use it. In this example, if you were using an aperture of $f/4$, it would be 14ft (4m).

On-camera flash drawbacks

1 Exposure is good for one distance only because the light falls off along the line of view. If the foreground is well lit, the background will typically be dark, while obstructions in front of the subject can easily be overexposed. *Solution*: Rearrange camera position and composition; change flash mode to fill-in so that exposure is long enough for the ambient lighting.

2 Specular reflections in shiny surfaces facing the camera. *Solution*: Change camera position; retouch highlights in image-editing.

3 Red-eye; reflections from the retina, particularly with a longer focal length lens. *Solution*: Some cameras offer a pre-flash to make the subject's iris contract, but this adds a delay; retouch in image-editing.

4 Flat, shadowless light that gives a poor sense of volume. *Solution*: Use flash as fill-in; increase ISO sensitivity to record more ambient light.

Using bounce flash

The principle of bounce flash is to aim the unit at a ceiling or wall rather than the subject, to take advantage of the much more diffused light from this reflection. It greatly reduces the light reaching the subject, and you should also check that the ceiling or wall is white, or expect a color cast. A few cameras have the facility to angle the head, but otherwise this is a feature for detachable on-camera units.

Multiple flash

Some advanced detachable camera flash units feature wireless linking. The unit mounted on the camera serves as the "commander," from which any number of other, independently mounted units can be controlled. The initial flash from this unit triggers the others via their remote sensors. With the Nikon SB-800 unit shown here, flash units are grouped, and their flash modes and output levels can then be altered from the "commander," and their channels can be assigned also.

Rear-curtain sync

A special variation of fill-in flash is streaking with rear-curtain synchronization. In this, the exposure and flash output are balanced as for fill-in, but the flash is timed at the end of the exposure. If there is movement, either in the subject or because you move the camera, there will be trails of light that end in a sharply frozen image. This works particularly well at night in locations where there are bright lights—for instance, a panning shot of a motorcycle with its lights on.

Fill-in flash

One of the most successful uses of on-camera flash is as shadow fill. In this, the shutter speed is set low enough for the ambient lighting across the scene, and a smaller-than-usual dose of flash is added. All cameras have a program for this in the menu, but as the exact balance between flash and ambient light is very much a matter of personal taste, the ideal is to try different variations and check the results on the spot on the LCD screen. For full control, use a manual exposure setting and lower the flash output by increments

Off-camera Flash

If you're after the highest-quality image in studio conditions, then you'll really need to turn to off-camera flash units.

The advantages of using professional high-output flash are: precise color temperature (daylight), short duration to freeze most movement, and a quantity that allows it to be diffused, reflected, or bounced, and yet still provides good depth of field.

Typical studio systems are split between those in which several flash heads are served by a power unit, and monoblocs designs, in which the transformer, rectifier, capacitor, and flash tube are all housed in one self-contained unit. In addition, there are portable flash systems with a much higher output than the usual detachable on-camera units, using battery packs.

With digital cameras, in-camera color balance and generally higher base ISO sensitivity admittedly reduce the value of these, but not much. The old disadvantage of flash—that you could never be absolutely certain of the result unless you did Polaroid tests—has disappeared. Digital cameras make flash a dream to use.

More than anything, it is the endless variety of light fittings that make professional flash units so useful. Not only is the output high enough to survive heavy diffusion and reflection, but the low temperature at which the lights work make it possible to enclose them without risk. The better studio flash units have a slave sync built in, to do away with one set of messy

STUDIO FLASH
Serious indoor photography will make use of daylight-balanced adjustable lights and a variety of modifiers. Most of these will feature modeling lights: a continuous light to help set-up.

cables. In a typical studio flash system, the power supply is AC at a relatively low voltage. The first part of the circuitry is a transformer to step up the voltage and a rectifier (more than one in large units) to convert the AC to DC. This uni-directional, high-voltage source then supplies the capacitor which stores the charge. When triggered, the high-voltage output in the capacitor is discharged through the flash tube. Output is measured in watt-seconds, or joules, and typical units are between 200 and 1,000 joules. To make use of the extremely high output of the mains flash capacitors, the flash tubes are much larger than in on-camera units, and one result of this is that the peak flash duration is longer than that of an on-camera flash, which is sometimes as slow as a few hundredths of a second.

Flash meters

Despite modeling lamps, which are standard on studio units, previewing the actual lighting effect is still one of the problems with flash—and calculating aperture against output even more so. Although hit-and-miss calculation is not difficult with a digital camera, it may still take a few exposures to arrive at the right settings. A flash meter is essential for regular studio photography, and the most useful method is to take an incident light reading. Incident readings are of the light falling on the subject and so are uninfluenced by the tone, color, or reflectivity of the subject itself.

SNOOT

HONEYCOMBS

SOFTBOX

Continuous Lights

One drawback with flash units is that you can't accurately predict how the image is going to look until the flash has fired.

Although in these days of instant review it's easy to adjust the units and shoot again, the advantage with continuous lights is you can see exactly what lighting effect you are getting as you adjust the lights. This also makes it easy to combine with existing, ambient light.

As for types, incandescent is the traditional source, but fluorescent and HMI are becoming increasingly popular in studios. The most efficient type of incandescent lighting is the tungsten-halogen lamp, which uses a coiled tungsten filament as in ordinary tungsten lights, but burning at a much higher temperature in halogen gas. As a result, the light output and color temperature stay more or less the same throughout their life. Available wattages range from 200 to 10,000, but for still photography 2,000W is about the highest. Used alone, incandescent lamps simply need a 3,200K "incandescent" white balance. However, used on location, they are often in combination with existing daylight, fluorescent, or vapor lighting, and in this case it is usual to filter the lamps toward daylight.

The most exciting development is certainly LED lighting, which is decreasing in cost, increasing in output, and well on its way to becoming the future of continuous lighting. The technology allows for units of all shapes and sizes, depending on your particular shooting scenario. And perhaps most interesting is the ability of certain models to adjust their color temperature on the fly without the need for gels and filters.

FLUORESCENT LIGHTING

This Lupo Quadrilight delivers light at a temperature of 5,400 Kelvin, ideal for product shots. The metallic barn doors allow control of the spread.

Flash or continuous lights

Flash: pros
Freezes movement.
Cool.
Daylight-balanced, mixes easily.

Flash: cons
Small units give no preview; others have modeling lamps that call for dim ambient light to show the effect.
Fixed upper limit to exposure, beyond which needs multiple flash.
Technically complex.
High unit cost.

Tungsten: pros
You get what you see.
Exposure adjustments simple—just change shutter timing.
Mechanically simple and easy to use.
Some makes very small and portable.

Tungsten: cons
Not bright enough to freeze fast movement.
Hot, so can't accept some diffusing fittings, and dangerous for some subjects.
Needs blue filters to mix with daylight.

High-performance fluorescent: pros
You get what you see.
Exposure adjustments simple—just change the shutter timing.
Daylight-balanced, mixes easily.
Mechanically simple and easy to use.
Low running costs.
Cool—none of the heat problems of incandescent.

High-performance fluorescent: cons
Not bright enough to freeze fast movement.
Bulky.
High unit cost.
Tube dimensions restrict light design.

HMI: pros
Exactly as for tungsten, but cool.

HMI: cons
Expensive.
Needs a bulky balast.

LED: pros
You get what you see.
Instant-on (no need to warm up).
Low heat.
Highly portable.
Durable (no delicate filaments to protect).
Highly adjustable color temperature (certain models).

HMI: cons
Not as powerful (need multiple units for high output).
Professional units are still rather expensive.

Reflector angle

Incandescent light housings have a reflector behind the lamp to increase its output and help control the beam. Most general-purpose housings have reflectors that give a spread of between about 45° and 90°. The beam pattern can often be adjusted by moving the lamp in and out of the reflector, or by moving hinged panels in front.

Daylight control and tungsten conversion filters

There is a wide range of heat-resistant gels available, that are designed to fit in front of incandescent lamps to adjust their color temperature. They are fitted either in custom holders or in an outrig frame that attaches in front of the light.

The most commonly used gel is "full blue," which is designed to change the color temperature of an incandescent light from tungsten (3,200K) to daylight (5,500K). An alternative is a dichroic filter—a partial mirror that fits to the front of the lamp, reflecting red back to the lamp and passing blue.

For partial conversion, a "half blue" will adjust the temperature from 3,200K to 4,100K to compensate for voltage reduction or retain some of the warmth of tungsten lamps when mixing them with daylight or flash.

Fluorescent lights

High-output, flicker-free, daylight-balanced tubes make fluorescent lights a realistic alternative to incandescent, with some clear advantages. The light is cool, and so convenient for still-life subjects. In these designs, several tubes are arranged in parallel with mirrored reflectors to form a light bank.

Tripods

By far the main use of a tripod is to be able to shoot at a slow shutter speed without camera shake, such as in low light, or when you need a low ISO for best image quality, or a small aperture for depth of field. It's also essential for precise framing in controlled situations like a studio, and makes a long, heavy telephoto easier to use over long periods, such as in wildlife shooting.

However, when traveling they can be awkward, so much depends on the type of shots you expect to do. Tripod efficiency depends on two things: design and materials. The first essential quality for any tripod, as for any bridge, is that it stays firm and still under average conditions. The acid test is to fix the camera, use a long focal length, and tap the front of the lens while looking through the viewfinder. Common sense will show whether the slight vibration is acceptable, but to make

sure, shoot a few times at around 1/60 sec to 1/125 sec while tapping the lens. Examine the images on the computer at 100% magnification. Torsion is another indication of tripod stability—with the camera detached, grasp the head firmly and try to twist it clockwise and counterclockwise. There should be no significant movement. Note that center-pole extensions can, if not very well built, reduce stability. This is particularly true of rack-and-pinion movements operated by a rotating lever; convenient, certainly, but not necessarily solid.

Tripod heads are as important as the tripod itself, and a weak head will destroy any advantage you have from a strong tripod. There are two basic designs: pan-and-tilt, in which each movement is separate, and ball-and-socket, which allows full play in every direction with one unlocking movement. Which is better is a personal choice.

Focal length and camera shake

Camera shake is the condition that tripods and other supports are intended to prevent, and its symptoms are a blur of a characteristic "doubled" kind across the entire image. As long focal lengths magnify images, they also magnify shake. Long focal-length (telephoto) lenses also tend to be heavy, which can be an advantage on a tripod as the weight makes the setup more solid, provided that you mount the lens near its center of gravity (use the lens's own tripod collar, ideally). Added stability can be gained by hanging a counterweight (such as a camera bag) underneath from the center column.

Using a tripod

- Low is more stable than high.
- Make sure that the surface is steady. Sand shifts, as do loose wooden floorboards.
- Adjust the legs so that the platform (immediately below the tripod head) is level. Do not level by the tripod head alone.
- With a long lens, use its tripod collar rather than that of the camera, in order to get closer to the center of gravity.
- Shelter the tripod from wind.

Shutter speeds to watch

Fast shutter speeds don't need a tripod, and at very slow speeds, such as a second or longer, the camera has time to settle down after the shutter is released. Moderately slow speeds, however, such as 1/30 sec and 1/15 sec, can produce camera shake with a long focal length, even on a tripod. Check for this.

In a studio, a heavy, solidly built tripod is an obvious choice, and for large-format cameras a studio stand is even better. Location shooting or traveling over a period, however, puts a premium on lightweight construction. Just as there is no point in even considering a lightweight tripod that is too flimsy to hold the camera firmly (or too short for normal use), neither is there any reason to have a tripod that is over-specified for a small camera. Cost enters the equation because strong, light materials are available and they are always more expensive. The material of choice for tripods is carbon fiber (30% lighter than aluminum, and more rigid), and for heads, magnesium alloy, but the price difference from standard is considerable. For all the above choices, if you are buying a tripod and head, compare models side by side for shake, torsion, weight, and so on.

There are good impromptu alternatives to tripods, depending on how slow a shutter speed you need. To hold the camera more steadily, a rolled-up cloth, jacket, or soft camera bag on a solid surface (such as a wall or part of a vehicle) works very well—if you press down on the camera or lens as you shoot, you may be able to use shutter speeds as slow as one second. Very long exposures are possible if your camera accepts an electronic cable release; find a solid surface at a workable height, prop the camera up with whatever is handy, and trigger the release. To avoid uncertainty in these conditions, shoot several times.

Head types

Ball heads allow movement in all directions, whereas two- and three-way heads offer more control in either direction.

Monopods

A single adjustable pole can improve the shutter speed at which you shoot by about a factor of two. If you are hiking, look for a walking pole that is equipped with a screw thread that will accept a small tripod head.

Mini-tripods

Surprisingly useful, and light enough to carry without noticing, mini-tripods may lack elevation, but there are often surfaces to give height, such as a vehicle roof. One good technique is to press the mini-tripod against a vertical surface, such as a wall.

Ball head

Two-way head

Three-way head

Tethered Shooting

Many high-end cameras can be tethered directly to a computer via a high-speed cable, such as USB, or wirelessly and then with the help of specific software from the camera manufacturer, the camera can be operated from the computer.

This kind of use is intended mainly for studio shooting, although with a laptop computer, there are no real limits to the kind of location. It makes most sense when the camera is set up on a tripod in front of a static subject, as in a still-life set, and in this kind of circumstance, the computer really can add a new dimension to photography.

The example on the following pages is an automobile shoot in a Nissan auto showroom, using available tungsten lighting, with muted daylight inevitably leaking in from outside. In film photography, the first steps would be to measure the light and the color, set the aperture and shutter speed accordingly, and choose a combination of filter and film (either Daylight or Type B). Then a Polaroid test or, if there were no Polaroid back for the camera (heaven forbid), wide bracketing of both the exposures and the filtration.

Digitally, the exposure and color balance issues are taken care of by the preview, but the striking advantages of shooting direct to the computer are that the image can be viewed large and accurately on the calibrated (of course) screen of the laptop. With the camera on its tripod, everything can be adjusted in comfort from the computer, using the appropriate software—in this case, Nikon Camera Control Pro 2. The control panel offers access to all the essential settings: such as shutter speed, aperture, focus, and color balance. A click of the mouse fires the camera.

The laptop's LCD screen is more accurate and convenient for judging the image than the camera's own small LCD screen, particularly in the critical areas of highlight exposure and color balance. Results can also be judged by looking at the histogram. Because the image that appears on the screen is large, the advantage of being able to go into the real set and alter things is clear. If a client is present, this is also a very useful way of having the image approved on the spot, with no uncertainty. Even if they're not present, there are many means of instant transfer.

COMPUTER CONTROL
Most manufacturers provide software to enable the camera to be used directly from the computer.

1 Half of the menu options are displayed on this first camera-control screen, titled Exposure 1, and include exposure mode, shutter and aperture settings, and compensation.

2 The Image Processing window gives access to sharpening (normally used with caution when shooting), tone compensation (affecting the contrast range), the color space, and the color mode for later image-editing. Hue adjustment allows further fine control over color, and long exposure noise reduction, which you can adjust via a pull-down menu.

3 When the Shoot or AF and Shoot button is clicked, the status window shows the downloading progress as the image is saved, not to the memory card in the camera, but to a selected folder on the laptop's hard drive.

4 In shooting a high-performance Nissan car, the technical issues are high contrast (hold the specular highlights) and color balance (mixed tungsten and cloudy daylight), calling for a carefully chosen white balance compromise.

Canon users will find a tool called EOS Utility with their application suites which can perform similar functions using a simulated LCD display. Here, for example, an aperture of ƒ/20 has been selected, but can now be adjusted by clicking on the aperture setting and clicking the arrows left or right. The large round button acts as the shutter release, after which the resulting image is passed to the Digital Photo Professional program (below).

Traveling with Equipment

On the whole, digital equipment is a little lighter than conventional kit. However, thanks to the electronics involved, digital kit requires more accessories in the form of batteries, cables, and adapters if you're traveling abroad.

This means that there is an even more marked difference between what you need to travel with and what you need for actual shooting. So it makes more sense to consider dividing the packing between a case for transportation and a bag for shooting while simply walking around. A backpack is worth considering for hiking, climbing, and other outdoor photography. For transportation, well-padded protection is a high priority, given that digital equipment tends to be delicate.

The three worst conditions for digital equipment are water, dust, and heat, and the best protection for the first two is a properly sealed case—meaning with a gasket or rubber ring of some sort. Water shorts electrical circuits and corrodes metal parts (though there are fewer of these than there used to be). Salt water is the worst of all, while light rain simply needs wiping off. Full immersion, on the other hand, is likely to cause a write-off. If it happens, remove the lens, open everything that can be opened, and dry the camera quickly.

Rigid plastic cases, like this from Pelican, are a superbly protective environment for a camera, but their padding can be limiting.

Manfrotto's Roller Bag is fitted with wheels and an extendible handle. The bag comprises shock-resistant compartments.

This Manfrotto bag has plenty of compartments, which can be adjusted to fit anything from lenses to cables to computer equipment, giving plenty of versatility for a variety of gear combinations.

SECURITY
A padlock is a vital precaution when traveling. Regrettably there are a number of places where you should be on your guard against hotel staff and even airport workers.

Packing checklist

Camera body
Spare battery
Battery charger and cable
Plug adapter
USB or Firewire cable, camera-to-computer
Laptop or image bank
Memory cards
Card reader
Lenses: zooms, wide-angle, telephoto, macro, shift
Blower brush
Lint-free cloth for cleaning
Tripod
Cable release
AC/DC converter
UV filters
Polarizing filter
Neutral grad filter
Rubber pad for removing stuck filters

The danger of dust and sand is that particles can work their way into the camera's mechanism, causing scratching and jamming of moving parts—and most immediately adhere to the sensor. Even a short exposure can be damaging, so in dusty conditions keep the camera wrapped or sealed except for actual shooting. Sand on beaches is insidious because salt makes the grains sticky.

Heat can affect the electronics at temperatures of typically 104°F (40°C) and more. A bright metal case is better at reflecting heat than any other kind. In sunlight in hot climates keep cameras in the shade when you are not using them. Where the air is humid as well as hot, pack sachets of silica gel in with cameras—its crystals absorb moisture. When the silica gel has absorbed all it can (some types change color at this point), dry it out in an oven.

Cold weather is less of a problem in itself, although batteries deliver less power and need to be replaced more frequently. Cell capacity is very low below -4°F (-20°C), and a little lower than this the electrolyte will freeze (although when it thaws, it will start functioning again). More serious potentially is condensation caused by moving equipment between cold exterior and heated rooms. After cold-weather shooting, warm the camera up slowly, or wrap it tightly in a plastic bag so that condensation forms on the outside rather than inside.

PROCESSING
& POST-PRODUCTION

In the world of conventional film photography, the photographer's responsibility in terms of the final image creation ends more or less with composition and accurate exposure. Processing the film and handling the printing is usually done via trusted and reputable third parties. With digital imaging, however, more responsibility rests with the photographer, who must be fully acquainted with a raft of digital steps and techniques to ensure images appear as they should.

These digital steps are often collectively referred to as "workflow" and need to be undertaken in an orderly fashion. Of special importance is smoothly integrating the mechanical side of photography with the various procedures on the computer. You need to have a good understanding of processing software so you can edit your images and show them off in their best light—whether for print or for screen. Perhaps the biggest change to the workflow in recent years has been the development of Raw-processing software such as Adobe's Lightroom. Formerly, the level of adjustments you could make with Raw-editing software was restricted to exposure, contrast, white balance and basic color changes. However, as the software has developed, more and more adjustments have become possible, to the point where you can now remove dust spots, sharpen images, reduce noise and much more. For many photographers software such as Lightroom is now all they need. However, for photographers who need to make more extensive adjustments at the pixel level, pixel-editors such as Photoshop are still required. It's commonsense to assume that most photographers will use one or the other (or both), and the examples in this section follow suit. The aim is to lay out the sequence for handling the image as it moves from one state to another, and from one device to another, to bring out the best in the final processed version.

The Digital Photography Workflow

Much of the digital photography workflow is concerned with preparing the image for final viewing. This involves ensuring that images have accurate colors, a full dynamic range, are sharp, free from blemishes, and so on.

Because so much can be done once the image is on a computer, it's important that you have a good understanding of each step of the workflow. It stands in marked contrast to shooting color transparencies, where very little flexibility in processing means that the photography virtually ends at the moment of shutter release. If anything, it is more akin to the kind of black-and-white photography practiced with an eye to lengthy darkroom work (think Ansel Adams). Digital workflow needs to be planned, and that implies shooting with a good idea of what can (and should) be done later, on the computer.

Comprehensive workflow

In digital photography, the image workflow typically goes like this:

1 Shooting, ideally as Raw files for later control and flexibility.
2 Transfer images from memory card to an appropriate folder on the computer hard drive: from the camera, or from the card using a reader, or via an intermediate storage step such as a portable image bank. Add filenames and captions at this time
3 Examine the images on screen, delete any obvious mistakes, rotate where necessary, rename and reorder if appropriate.
4 Basic edit to identify selects.
5* Make a contact sheet and/or low-res JPEGs to send to client for review, possibly with selected optimized images.
6* Client reviews low-res images and requests optimized TIFFs of some.
7 Process selects in Raw-processing software, adjusting, at the minimum, the lens profile, chromatic aberration, white balance, hue, exposure, contrast. Check noise, dust shadows, and carefully controlled sharpening if necessary

8 Where necessary, export images as 16-bit RGB TIFFs in order to perform more extensive image editing at pixel level using post-production software such as Photoshop or PaintShopPro. If editing procedures had been pre-planned when shooting, undertake these.
9 Proof certain images on desktop printer.
10 Embed caption information, and save and archive final images as 8-bit RGB TIFFs. Also archive Raw files. Back up both. Enter into image database.
11* Deliver final RGB images to client, who signs off on them.
12* Pre-press preparation of images, including CMYK conversion, appropriate sharpening, and dot gain.
13* Color proofs.
14* Corrections.
15* Press date.

* Professional assignment.

Flexible Raw

When you shoot Raw, the camera stores such camera settings as white balance separately, so that you are not reliant on the camera's onboard processor to convert the captured data into an 8-bit JPEG. The best practice in digital is not so different from shooting film negative, in that the exposure should be as accurate as possible for the effect you want, after which you process the Raw file to produce the best possible image result—according to your taste.

Minimum workflow
(excluding Raw files)

1 Shooting.

2 Transfer images from memory card to hard drive.

3 Examine the images in a browser, delete mistakes, rotate.

4 Identify selects, optimize, and caption.

5 Save and archive all images.

This is the thinking behind shooting in Raw format in which most of the settings can be altered later. When you press the shutter in Raw mode, as much information as possible is transferred to the file: the highest bit-depth color your camera is capable of recording, the shutter speed, exposure program, f-stop, aperture value, ISO setting, lens, flash, and so on (each camera model creates a slightly different Raw file). Even if you are shooting JPEGs, there are many steps that can be taken on the computer to get the best out of the captured image.

Typical hardware workflow

Once a picture is taken and processed by the camera, it is stored on the memory card. This is transferred to the computer via a card reader (or direct cable connection) before being processed, and then sent to the final destination medium.

Camera

Memory card
(card reader)

Computer

Desktop printer
or external hard
drive

Typical software workflow

In-camera processor

Lightroom Library module

The specific workflow route your image will follow will depend on the way you work: whether you shoot in Raw and undertake all your editing using Raw-editing software, for example, or whether you need to edit at the pixel level, and what your output medium is likely to be. The first "computing" will always take place in-camera, though with Raw this will simply be saving the information to the memory card. The final step shown here—archiving—is essential for digital photographers. The discs, or whatever storage you use, are as irreplaceable as negatives.

Photoshop

Lightroom Develop module

Long-term storage

External hard drives are fast becoming the only sensible archiving method, and capacities are increasing all the time. RAID units (Redundant Array of Inexpensive/Independent Disks) are grouped hard drives with a combination of software and hardware that preserves data integrity in case of the failure of one. A simpler alternative is mirrored hard drives. Some photographers use DVDs as an extra level of archiving safety.

Archiving to external hard drive, and backing up (possibly to a RAID)

Computer & Tablet Needs

If you intend to undertake all your own post-production work—in other words prepare your images for final viewing—you'll need a high-specification computer system. This is because digital image files are large (and getting larger), are often very complex, and require accurate rendering and powerful (memory-hungry) software to edit them.

Image editing, as we'll see, is the primary function for computers in photography, but other key software applications are for downloading, browsing, databases, printing, slide shows, scanning, archiving onto CDs or DVDs, and access to the Internet, including sending images to other computers. There are, in addition, very many plug-ins intended

to work with your main processing software—these are independently written applications that do not stand alone, but are accessed through Photoshop or whichever image-editing program you choose.

The key performance issue is processing speed, which depends on the chip and is measured in megahertz (MHz) or gigahertz (GHz). It is the main determinant of the cost of the machine, and for processing photographs, the faster the better—and with no upper limit. Multi-tasking is another strategy for improving the workflow, permitting operations such as batch processing to run in the background with little effect on other applications that you might be using. Active memory is known as RAM (Random Access Memory), and in

RAM allocation

For the highest performance in image editing, allocate the maximum RAM and a high cache size to the application, and run that alone. On the Mac go to *Photoshop > Preferences > Performance...* (the Preferences option is accessed from the Edit menu on the Windows version). For technical reasons, Photoshop is limited to accessing a maximum of about 4 GB.

MEMORY

RAM chips, in this case in the form of a DIMM (Dual Inline Memory Module), are relatively easy to fit. Cards like this simply plug into slots inside your computer.

Graphics tablet

A cordless stylus and graphics tablet allow an intuitive way of working, particularly for digital brushwork. The stylus response can be customized to the way you work, for instance, altering the angle of tilt at which it will respond, and the tip pressure from soft to firm.

A workaround to insufficient RAM is virtual memory, in which free space on the hard drive is used temporarily as memory—useful, but it slows down performance.

In choosing an operating system—which essentially means choosing the computer itself, consider the following: performance, ease of use/ease of interface, software availability, and cost. Of the normally available operating systems, Windows is by far the most common, although Apple Macintosh machines are more widely used by imaging professionals for reasons of speed, ease of use, and tradition. Photoshop and Lightroom are available for Windows and Mac and works equally well on either platform.

Peripherals are the extra pieces of hardware that connect to the computer. What you choose depends on what is already built into the computer (perhaps a DVD writer), and on your preferred way of working (such as using a graphics tablet instead of the mouse).

Tablets have evolved to the point where they can be considered serious computing devices, and can integrate quite fully into a photographic workflow. Apple's iPads have the most app support, and are widely used in both studio settings (for immediate and high-quality image review) and travel scenarios (where the organization of a shoot can begin via tags and ratings, not to mention the ease of sharing selects). There are drawbacks, of course, such as the need for accessory SD adapters, and slower processing times (proper Raw processing on tablets isn't quite here yet), but before you head out on the road, it's worth considering exactly what your needs are, and whether a tablet will suffice, at least until you get back to your proper workstation.

combination with the processing speed determines how quickly you can open and manipulate images. Like processing speed, it is almost impossible to have too much, and the ideal for image-editing is about five times the size of the image file. This file size can easily grow beyond what you might expect. Take a 20 megapixel camera. The RGB image from this will be 60MB (20×3 channels) in 8-bit colour, but 120 MB if you choose to save as 16-bit. If you then start to add layers, it will become much bigger still. And you might well want to open more than one image at a time, for comparison or compositing. At the very least, you will need RAM of three times the image size if you are to work within the active memory, because the program needs to hold copies of the image while you make changes.

Monitor Types

If you are using a desktop computer instead of a laptop, consider the monitor you buy carefully; it will be the primary interface between you and your images, and needs to be both high quality and accurate.

LCD monitors, which have now entirely replaced the older CRT (cathode-ray tube) monitors, come in three broad types, Twisted Nematic (TN), Vertical Alignment (VA, MVA, or AVA), and In-Plane Switching (IPS). TN monitors are cheap to manufacture, and while they might be sufficient for general use, for photography they offer a too narrow viewing angle and poor color fidelity. VA panels, although offering wider viewing angles, also suffer when it comes to color accuracy. IPS screens are the most expensive option (although they are coming down in price) and offer the best viewing angles and widest range of colors. When it comes to assessing a monitor's color performance good ones will cover all the colors in the sRGB color model, but even better panels will cover most colors found in the wider Adobe RGB gamut.

Associated with color is the monitor's contrast ratio—the ratio between black and white. Good contrast ratio provides bolder colors. Look for anything around 1,000:1 and above, but beware how this ratio is arrived at.

Another important consideration is size. You may find that a 24-inch monitor is just about serviceable, but with a larger, 27-inch monitor you'll have sufficient space to view your image at a good size and still be able to have your editing tools open at either side.

Monitor setup

The eye is so good at adapting to different light levels and color casts that it actually works against us in setting up the monitor. The following precautions are essential:

1 The light levels in the room should be low, meaning around half the brightness of the screen. Too bright and you will not be able to register pure black, too dark and you may end up editing the image so it is too dark.

2 The room lighting should be somewhere close to "artificial daylight"—D50/5,000K.

3 The room interior should be neutral, not brightly colored. The same applies to your shirt or blouse—it will reflect a little in the screen.

4 Set the desktop pattern to neutral mid-gray. This will give the eye a constant neutral reference.

5 An optional accessory, which you can build yourself, is a black projecting viewing hood over the monitor. This can be cut back toward the base of the screen as its purpose is to shield reflected light from above and the sides.

Palette monitor

If you have sufficient space, consider a second, smaller monitor display for the various palettes and windows needed for the software application you are using, such as Photoshop. This avoids obscuring parts of the image, and allows you to run the image full-screen. An alternative to this is a wider-than-standard cinema display, on which the palettes can be positioned to one side of the image.

Finally a word about resolution. Make sure your monitor is at least full HD (1,920 x 1,200), but higher resolutions, including the latest 4K and 5K screens, will provide more space, greater detail, and may be easier on the eye.

It is essential to calibrate monitors as a first step toward overall color accuracy. At the very least, this means representing neutral grays as neutral, and ideally this should be not only for the mid-tones but also for the blacks and whites. This is dealt with on the following pages, but the conditions under which you view the monitor are also important. There are two issues here, and both relate to the surroundings: One is the ambient light level, the other is the ambient light color. Perception is always relative, and both brightness and color are judged by the eye in relation to adjacent parts of the scene. If the surroundings, for instance, have a yellowish cast, the eye will tend to over-compensate and see the screen as more blue than it is. What matters most is consistency. The eye is very capable of accommodating to different light levels and color casts, perhaps rather too capable. As a rule of thumb, try to keep the brightness level in the room where you keep the computer at about half the level of the monitor screen. A darkened room will allow you to distinguish shadow detail, but it will also push you to edit images that will appear too dark under normal conditions. A bright room will have the opposite effect. The ideal is complete artificial lighting with daylight color-corrected lamps, but this may well be impractical. Consider translucent neutral roller blinds to cut down direct sunshine. The color temperature of daylight fluctuates also, so take this into account. For the same reasons, it is best to have neutral walls and a neutral gray desktop pattern.

10-bit color display

Really high-end monitors, such as EIZO's professional models, have 10-bit color displays using a 16-bit lookup table (LUT). This translates into over a billion colors, around 64x more than the 16.7 million colors displayed in a standard 8-bit monitor. However you will need an appropriate graphics card and software to ensure all the colors are displayed.

LED monitors

LED monitors are now the principal type of LCD monitor. Early LCD monitors used CCFL (cold compact fluorescent light) as a form of backlighting, whereas LED monitors use LED lights. LED monitors tend to produce richer colors, have higher contrast ratios and improved color accuracy, are more energy efficient, and have a longer life expectancy than CCFL LCD monitors.

Calibrating your Monitor

Calibrating your monitor is essential if you want to render color accurately and consistently.

For good color management, using system level color software (introduced by Apple in 1995 as ColorSync 2 (now ColorSync 4) and later by Microsoft in Windows 2000 and XP), your computer will automatically go some of the way to setting the displayed colors by accessing the monitor's ICC profile. This, however, is only a starting point.

At the very least, use the system's calibration setup assistant to work through the settings. The key steps are to adjust the brightness and neutrality of the black, white, and mid-points; to set the gamma (see opposite for definition); and to set the color temperature. The resulting settings are then saved with the name of your choice as a profile.

The standard gamma for Windows and Mac OS is 2.2. The standard for Macs used to be 1.8, but this changed with the release of OS 10.6, or Snow Leopard.

With Macs, there is a built-in Display Calibrator Assistant, which can be found in the System Preferences menu (under the Color tab of the Displays panel). In earlier versions of Windows there was no default monitor calibration tool. However, included with Photoshop and Photoshop Elements—but no longer automatically installed—is the *Adobe Gamma* tool. If installed, this will appear in your *Control Panel*. Simply open it up in the usual way and (depending on your version of Windows) select the *Other Panels* or *Classic views* to locate it. Windows 7 and Windows 8 do feature a built-in wizard called Display Color Calibration that makes basic calibration straightforward.

Gamma

Gamma is a measure of the slope or gradient of the response of an imaging device or medium to exposure. It is the result of plotting density against log exposure, and so is one way of representing the contrast of the middle useful section of the curve. It is therefore a good way of representing the intensity output of a monitor screen relative to the input. Raising the gamma is similar in effect to moving the midtone slider in *Levels* to the left—it brightens the image without affecting the black and white points. Lowering the gamma does the opposite—it darkens the image. Another way of putting this is that gamma is the intensity of the output signal relative to the input. The minimum input is zero and the maximum is one, so that the default value for gamma is one—output equals input in a linear curve. In practice, gamma can be set to between 0.45 (bright, weak) and 3.00 (dark, intense). Note that the human eye's response to gamma is a subjective one of brightness and contrast.

Calibration with Windows

If you're running Windows 7 or 8 you can access the calibration tool by opening the Control Panel and typing "calibrate" in the search field. This should bring up the Calibrate display option under Display. Alternatively type "dccw" in the programs and files search field to bring up the dccw.exe file. Once you've launched the calibration tool, simply follow the instructions.

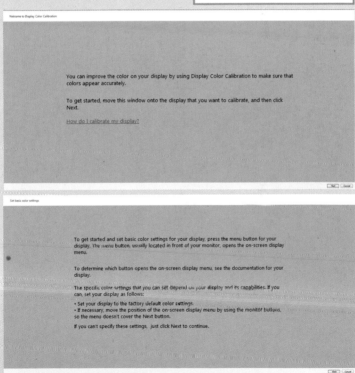

Welcome to Display Color Calibration

You can improve the color on your display by using Display Color Calibration to make sure that colors appear accurately.

To get started, move this window onto the display that you want to calibrate, and then click Next.

How do I calibrate my display?

Set basic color settings

To get started and set basic color settings for your display, press the menu button for your display. The menu button, usually located in front of your monitor, opens the on-screen display menu.

To determine which button opens the on-screen display menu, see the documentation for your display.

The specific color settings that you can set depend on your display and its capabilities. If you can, set your display as follows:

• Set your display to the factory default color settings.
• If necessary, move the position of the on-screen display menu by using the monitor buttons, so the menu doesn't cover the Next button.

If you can't specify these settings, just click Next to continue.

Gamma defines the mathematical relationship between the red, green, and blue color values that are sent to the display and the amount of light that's ultimately emitted from it.

When adjusting gamma on the next page, try to get the image to look like the sample image labeled Good gamma below.

Gamma too low Good gamma Gamma too high

To continue, click Next.

Next Cancel

Move the slider to minimize the visibility of the small dots in the middle of each circle.

Next Cancel

Find the brightness and contrast controls for your display, and then click Next.

These controls might be buttons on the front of your display, or they might be settings that are shown in the on-screen display menu. To open the on-screen display menu, press the menu button that's usually on the front of your display.

If controls for both brightness and contrast are unavailable, click Skip brightness and contrast adjustment.

Skip brightness and contrast adjustment

Where are the brightness and contrast controls on my display?

The brightness adjustment determines how dark colors and shadows appear on your display.

When adjusting the brightness on the next page, try to get the image to look like the sample image labeled Good brightness below.

Too dark Good brightness Too bright

To continue, click Next.

Next Cancel

Using the controls on your display, set the brightness higher or lower until you can distinguish the shirt from the suit with the X barely visible.

Next Cancel

The contrast adjustment determines the level and clarity of highlights.

When adjusting the contrast on the next page, try to get the image to look like the sample image labeled Good contrast below.

Not enough contrast Good contrast Too much contrast

To continue, click Next.

Using the contrast control on your display, set the contrast as high as possible without losing the ability to see the wrinkles and buttons on the shirt.

Next Cancel

The color balance adjustment determines how shades of gray appear on your display.

Move the red, green, and blue sliders on the next page to remove any color cast from the gray bars.

To continue and adjust the color balance, click Next.

Try for neutral grays

Too red	Too green	Too blue

Too much red and blue	Too much blue and green	Too much red and green

Next Cancel

Adjust color balance

Move the red, green, and blue sliders to remove any color cast from the gray bars.

Next Cancel

You've successfully created a new calibration

To compare this calibration with the previous one, click Previous calibration and Current calibration.

Previous calibration Current calibration

If you're happy with this new calibration, click Finish to save and use it.

If you want to use the previous calibration, click Cancel.

If you click Cancel, any settings that were changed using the display buttons or the on-screen display menu will be kept. These settings can't be automatically restored.

☑ Start ClearType Tuner when I click Finish to ensure that text appears correctly (Recommended)

Finish Cancel

Calibration on a Mac

To use Adobe Gamma on your Mac, open the *System Preferences* dialog from the Dock, and select the *Color* tab from the *Displays* menu (1). You can then follow the steps on screen (2). If you tick the *Expert Mode* box you will be taken through additional steps to set up the display's native gamma response, alternatively simply select the target gamma and target white point. To finish you have the option of saving your new profile.

1

2 3 4 5

6

7

8

9

10

11

Color

In digital photography there is no longer a physical reference (such as film or a transparency) to which people can refer when gauging color accuracy.

When it comes to color, digital imaging allows us undreamed-of freedom to make the scene look just how we perceived it at the time of shooting. Managed properly, the freedom that digital photography gives you to adjust the colors and brightness to suit your taste is wonderful, and it puts the photographer firmly in charge. Badly managed, it can be a nightmare.

The scenario that all of us dread is when the image has been optimized and worked on until it looks perfect on the screen, is then printed or sent for repro, and finally appears looking terrible—such as muddy, pale, unsharp,

dark, contrast, or any of the other things that you have been assiduously trying to avoid.

Be warned that this is a bottomless issue with no single consensus among professionals about the best procedure. This does not mean, however, that it can't be managed. The key is to adapt the way in which you work to the system that you have chosen. This may be a simple closed loop in your own studio or home, in which all your photographs are printed on your own printer, or it may involve sending images to a client or lab that has its own particular way of doing things. If you are a professional photographer, you will often be dealing with several different clients and this may simply mean that you have a set of different procedures. The rest of this chapter will work carefully through all of this.

Color management is the procedure for making sure that the appearance of a photograph remains the same (or as close as possible) as it moves through the workflow. This means that the picture you thought you took stays that way on your computer screen, on other people's computer screens, and on any printer that it is sent to. You may or may not want to get heavily involved in the process, but there is one uncontestable certainty in all this—the photographer is the only person who knows how the colors should look. Obvious though this may sound, it sometimes gets lost in the discussion. It means, above all, that you must deliver the images as you would like them to appear. Nobody else can do that for you. The examples here attempt to make this important point clearer. Even having

It was essential to keep the soft greens in this moss-covered Angkorean bas-relief in order to capture the sense of rain, dampness, and undergrowth.

Sunset over the Nile. A range from pale orange to mauve is set off against pale blue reflections where a breeze has ruffled the water in a muted relationship of complementary color.

Color must be carefully managed throughout the workflow, particularly in cases where the relationship between colors is important. Here, the pink of the man's robe is in almost direct opposition to the hue of the grass.

Brown, which is technically a heavily desaturated red, is the classic broken color, with earthy connotations, as demonstrated in this shot of henna being applied to a Sudanese woman's hand.

established a good color management system and having an accurate ICC profile for your camera, as described on the following pages, there still remains a wide and legitimate choice. Consider for instance color temperature. In a late-afternoon shot, would you want a white dress to appear neutral white or warm? There is a good case for either.

We already touched on color when it came to the color space settings for the camera and profiling, but the first place where you are likely to start judging it seriously is on your monitor display.

Managing Color

If you want the colors in your images to appear consistent as the images pass through the digital workflow, from camera, through computer to printer, it's essential that they are managed.

Digital imaging hardware varies in how broad a range of colors each can handle and in how each distinguish colors. Left to themselves, each device will present different color versions of your photographs. In other words, color is device-dependent.

What is needed is a procedure for keeping the appearance of colors the same from shooting to final display. The software that coordinates this is called a Color Management System (CMS for short), and for any serious photography you do need it. The good news is that nowadays color management is at least partly built into the software and devices that you are likely to be using. A perfectly sound system comprises Photoshop Color Settings, an accurate camera profile, and, of course, monitor calibration.

A CMS maps the colors from a device with one particular gamut to another. Obviously this is at its most useful when the color gamuts of the devices are substantially different. Printing presses (and desktop printers) have relatively small gamuts; certainly smaller than a high-end digital camera. A typical CMS uses a Reference Color Space that is independent of any device, and a color engine that converts image values in and out of this space, using information from the "profile" supplied by each device. The Mac OS has a particular advantage in color management—ColorSync, which is a CMS built-in at system level.

In practice, a CMS works like this. To convert screen colors to printer colors, for example, it first converts the monitor RGB color values to those in a space that is larger and device-independent, such as L*a*b*. It then converts these to CMYK values in the smaller color space of the printer, while changing some of the colors according to the render intent. The render intent determines the priorities in the process, in which inevitably some colors will change.

All of this sounds, and can be, complex. In print production a full knowledge is critical, but for several reasons it is not something for most photographers to get too worked up about. First, the industry is gradually taking care of color management in ways that make it less necessary for individuals to get involved. Color management depends heavily on each device (camera, monitor, scanner, printer, and so on) having a profile. Camera profiles are known, particularly the high-end models that most professionals use. Preserve the profile in the images you save and send, and the client or repro house will be able to deal with it. Second, ask yourself how much you want or need to immerse yourself in print

Color management components

1 A working color space that is independent of the device.

2 ICC profiles for the devices. These describe to the computer the characteristics of each.

3 A Color Management Module (CMM). This interprets the information in the ICC profiles and acts on it.

Color profile workflow

A color profile workflow should ensure that every piece of color information that passes through the computer is translated for the target device using profiles.

Monitor

Monitor profile

Printer

Printer profile

Scanner

Scanner profile

Camera

Camera profile

Press profile

PostScript Imagesetter (CMYK)

Computer

production. Given all the software tools available, and the now seamless workflow from camera through to final printing, you may think you ought to, but many photographers think their time and energy is better focused on taking pictures. Third, the default settings for the camera will already be close to standard, every bit as much as a normal film camera with normal film. Moreover, you can measure the important color variables, meaning that as you edit the images on the computer you can check that neutrals are neutral and that specific colors have the right RGB numbers. If you use one make of digital camera, very little will change, and you will become increasingly familiar with its color characteristics. In other words, as

long as you deliver an optimized image, with the shadows and highlights where they should be, and with no distinct color cast (unless intentional), you will have fulfilled your normal photographer's duties. What follows are the basic core skills to do just this.

The only important qualification is that the monitor is calibrated, because this is the color space in which most of the work on a photograph gets done. Calibration is important, fairly straightforward, and nothing to lose sleep over. And there is one golden rule—if for any reason you find yourself making major overall changes to images from a digital camera, something is wrong. You shouldn't have to, and the problem is likely to be in the monitor calibration.

Regular Downloads

The fact that digital images exist as a hugely complex series of binary 1s and 0s renders them extremely fragile in a number of ways.

First, as they have only a digital presence, not a physical one, this puts them at a considerable risk of being altered unintentionally, deleted, or corrupted. The very simplicity and immediacy of recording digital images, which revolutionizes photography in certain ways, also makes them intangible and temporary—until they are processed and stored.

Second, there are no unique originals in digital photography, although Raw files can be regarded as such. Instead, there are versions. In film photography, the exposure onto one frame of film is a unique event, and that film becomes the master image—this simplifies the issue of handling. In digital photography,

there will typically be several versions of any good, useful image, including corrections and small, low-resolution images to send out for easy viewing. To avoid confusion, it is important to set this production train in motion as soon as possible.

At a convenient break in shooting, such as at the end of the day, the initial step is to download the images to a convenient and secure location. In most situations this will be your computer's hard drive, either your main studio machine or, if shooting on location, a laptop. The two usual methods are by either connecting the camera to the computer, or by connecting just the memory card through a card reader. In either case, it is important to choose appropriate software to control the downloading. There are a number of dedicated browser programs available, such as Photo Mechanic, but Lightroom is fast becoming the

164

Modern cameras, with their high-resolution sensors, create large image files. No matter how large the storage capacity of the memory card, sooner or later you'll have to download the images from the card to a more permanent device.

industry standard. It aims to cover the entire workflow from import, through optimization, to output in one place. The example on the following pages shows a typical import workflow using Lightroom. The software can be set up to launch as soon as the camera or memory card is connected. Part of the import process should be filing renaming, following a standard file naming system you have previously devised—and the sooner, the better. The camera will already have numbered the images in its own way, and although on a high-end camera you can alter this to your own preferences, the file-names are unlikely to be exactly what you would like. Changing or adding to the file-names while you are shooting takes time and distracts from actually taking pictures. The time and place to do this is on the computer, and if you do not rename the image files, there is a risk of overwriting them. It is common to have different images from different shoots sharing the same file-name—and it's a recipe for disaster.

A daily download to a portable computer provides an excellent opportunity to back up your photographs and type up notes. Laptops can be very lightweight, so are ideal for traveling photographers.

Backing-up

Step three is to put into practice your back up regime. Depending on how you plan this, you may want to make an immediate back-up, typically onto an external hard drive. It is important to remember that at this stage you are securing the raw, unedited image files, not retouched or corrected versions. That comes later. The browser software should allow you to rename files, even automatically

(although be very careful with this if it does not allow you to undo or revert).

The procedures up to this point are the basic minimum for safety. The workflow sequence continues, although how much you choose to do daily is up to you. If you are shooting professionally for a client, you will need to present the images in a viewable way. In the first instance, it would be normal to prepare low-resolution files in a universal format, such as JPEG. If you are shooting in Raw format, the simple solution is to take the selected images that you want to deliver, and batch-process them to create smaller-sized copies in a new folder.

Download workflow

Before downloading your first set of images to Lightroom, use the Edit Metadata Presets panel to input copyright and camera information, your address and so on. This information will then be applied to all the images you subsequently download to Lightroom.

1 Once you've set up your metadata preset, start downloading your images. Go to *File > Import Photos and Video* and navigate to the images in the *Source* panel.

2 Before clicking Import, use the *File Handling* panel to instruct Lightroom to create a second copy of the images to a backup drive if you have one installed. Here you can also decide on the type of previews you wish to view and whether or not to create Smart Previews.

3 The *File Renaming* panel gives you the option of automatically renaming the image files in more meaningful ways should you wish.

4 The *Apply During Import* panel allows you to apply a limited number of Develop Settings to the images as well as giving you the option to select the metadata preset you set up earlier. Here you can also introduce keywords to the images' metadata, making it easy to search for images later.

5 Use the *Destination* panel to select the folder (or a new subfolder) into which you want the images to import.

6 Finally, click on the Import button at the bottom of the screen and Lightroom provides a progress bar indicating the time left for the import to complete.

Intermediate Storage

When shooting digitally on location for more than a day or two or when traveling for any length of time, you need to give careful consideration about how you're going to store your images temporarily before you can transfer them to computer hard drives.

Essentially, this means having a sensibly worked out "production flow" of image transfers that will keep pace with the way you shoot; and this is particularly relevant if you shoot HD video along with stills.

Exactly how much digital storage you need will vary, but the numbers are easy to calculate, and start with the file size of one of your typical images. You also need to take into consideration your individual way of shooting and the kind of subjects that you expect to

come across on a trip—parades and special events, for instance, tend to consume images faster. Memory cards, particularly fast, reliable ones, are a relatively expensive storage media, so the faster you can transfer the images to less expensive media, the better.

This shines the spotlight clearly on portable long-term storage, and the most immediately obvious answer is to carry a laptop and download images onto its hard drive. However, while a good procedure is to have a laptop in your hotel or hostel room that you can download to at the end of a day's shoot, there may be occasions, such as when trekking or camping over two or three days or longer, for example, when a laptop takes up more space than you have available and simply weighs too much—particularly if

On the Road Backup

You shouldn't consider your files backed up until they're stored in at least two separate places—in this case, Lightroom is copying files from the SD card onto both the laptop's SSD, and the attached portable hard drive. Maintaining a common file structure within your image folders between the two devices makes things much easier down the road if you need to restore your catalog.

you already have a backpack of gear to carry. In this case the answer may well lie in a portable, external hard drive with memory card ports. There are a growing number of these on the market, and capacities of 1–2TB are common. Some even feature wireless connectivity, while others offer a small review screen. Alongside capacity, other criteria to consider when looking to purchase this type of portable hard drive are size and weight, construction and reliability, how long the device runs with a single charge and whether or not it takes standard batteries.

Once back at your accommodation, download your images and video from your portable drive to your laptop. For additional security, it's also sensible to aim to transfer the images, or at least those selected, onto non-digital media, of which the cheapest and most practical are CD-ROMs and, for larger quantities, DVDs. This makes a laptop with CD- or DVD-burning ability a useful piece of equipment.

In digitally developed countries, you may find electronic stores or camera dealers that offer inexpensive copying from memory cards onto CD-ROMs. If you check in advance that this service is available at your destination, it saves time and effort and removes the need to carry your own storage media. Even in less sophisticated places, if you have a card reader you could look for an Internet café or computer center, or even the business center of a hotel, that would be willing to download your images and then burn them for you onto a CD-ROM or even a DVD.

Portable hard drives

There are a number of portable hard drives with ports for memory cards. With capacities of up to 2TB, these drives are ideal if you're out in the field for any length of time and don't have access to a laptop. Most are powered by a rechargeable battery and provide fast USB 3.0 output that allows the images to be downloaded to a computer at the end of a trip. This particular model by Western Digital also features wireless connectivity so can interact with your tablet, smart phone, or Wi-Fi enabled camera. It's about 5in (13cm) long and 3.4in (3.7cm) wide, small enough to fit in a rucksack or camera bag.

Image Browsers

Image browsers are an important and integral part of the digital software workflow. They allow you to organize images into folders, give the files meaningful names, and view them.

Browser software is normally supplied free by the camera manufacturer, but may not be as useful and well-designed as standalone software designed to work with all standard cameras and formats. With the increasing use of Raw shooting, it is important that the browser you use is capable of reading this manufacturer-specific file format, and that the software designers are committed to keeping pace with updates and new camera models.

In normal shooting the images are downloaded from the memory card to the computer through an interface cable that is normally USB. This can be done either directly from a port on the camera, or by removing the card and inserting it in a card reader

Naming and numbering

Even if you accept the default method, your images will be given a name or number identification as they are transferred. Typically, there are three parts to this—a prefix, an identifier, and a suffix, the latter separated by a period. You may choose to assign a permanent file-name that fits into your long-term filing system as you download, or deal with this later when you have more time. In the latter case, the browser has an automatic batch-renaming program.

Rename file(s) (112 files)

Choose method:

○ Add suffix to the original file name

 Suffix: Rename

 Sample: imgRename.jpg

● Rename with new numerical sequence

 Prefix: Apri10.

 Number of digits: ◀ ●——————▶ 3 digits

 Sample: Apr10.001.jpg

(Cancel) (Start)

File-naming conventions

Windows

Although in the past Windows allowed only 8-letter file names, these days there is just one practical restriction on file naming: never use a period (.) since Windows traditionally uses these as the divider between the file-name and extension (for example name.jpg is a JPEG file). In Windows 7, 8, and 10, where long file-names are supported, the maximum length is 255 characters.

Macintosh

The maximum length for legacy systems (before OS X) is 31 characters. More non-alphanumeric characters are allowed than for Windows (for example the period), but if images are to be used cross-platform or transmitted by e-mail or FTP, it is better to stick to the conventions mentioned above.

which is plugged into the computer. The transfer software, which is either part of the browser or linked to it, allows you to select which images to transfer, to choose transfer options, specify the destination folder, and choose how the images are to be numbered or named. Take care to avoid over-writing image files with the same name, although the software will probably anticipate this and either give a warning or else assign different file-names. Some cameras are equipped with a dedicated transfer button.

Browsing

A browser such as Adobe Bridge (included with Photoshop), or external software such as Photo Mechanic, allows you to view images, and make changes to file information, including the metadata.

Rotating images

Some cameras are able to sense when they have been turned to shoot a vertically composed image, and embed this data so that the browser can automatically rotate the image. Otherwise, you can identify and rotate vertical images manually in the browser. There is a slight risk of image degradation if you do this with JPEGs, but some browsers compensate for this by rotating JPEGs without decompressing them first. Check the browser manual for the recommended procedure.

The importance of metadata

Metadata is embedded file information, some added by the camera, some by the user. It includes the following:

File Properties
Characteristics that include size, creation, and modification dates.

Camera Data (EXIF)
Added by the camera, EXIF information includes the camera settings that were used when the image was taken, such as the time, date, ISO, shutter, aperture, and other extended details. EXIF (Exchangeable Image File) format is an industry

standard developed by JEIDA (Japan Electronic Industry Development Association).

GPS
Some digital cameras have GPS (Global Positioning System) technology that allows the location of a photograph to be recorded.

Edit History
A log of changes made to an image.

IPTC
The only user-editable metadata, this allows you to add caption and copyright information to an image.

IPTC Information

Caption
Modern Japanese dining table inset with underlit cast glass. Designer Takeshi Nagasaki cast the heavy glass

Caption Writer: Michael Freeman
Headline: Glass light inlaid in ta
Instructions:

Keywords

Recorded Keywords:
lighting
food
design

Origin
City: Tokyo
State/Province:
Country: Japan
Title(Object Name):

Simple... Save... Load... All

Categories
Category: DJ
Supplemental Categories: Add
Delete

Urgency: Normal

None
High
2
3
4
✓ Normal
6
7
Low

Credit
Author: Michael
Author's Position:
Credit: Michael
Source:
Copyright Notice: ©Michae

Da
9/12
Transm

Editing the IPTC metadata.

Viewing the EXIF camera data in the Nikon browser.

Shooting Data
Nikon D100
2004/01/21 10:51:58.8
RAW (12-bit)
Image Size: Large (3008 x 2000)
Lens: VR 24 - 120mm f/3.5 - 5.6 G

Focal Length: 66mm
Exposure Mode: Aperture Priority
Metering Mode: Multi - Pattern
1/400 sec - f/8
Exposure Comp: 0 EV
Sensitivity: ISO 200

White Balance: Cloudy -1
AF Mode: AF - S
Tone Comp: Less Contrast
Flash Sync Mode: Not Attached

Color Mode: Mode II (Adobe RGB)
Hue Adjustment: +6°
Sharpening: Low
Noise Reduction: OFF

Image Comment:

Databases

Databases differ from browsers in that although it's possible to view images with database software, their primary function is to help you manage a large collection of photographs.

Digital asset management (DAM) and workflow software such as Lightroom and Capture One Pro provide good cataloging as well as Raw conversion options as we shall see later. However, there are also dedicated databases that provide alternative solutions which you may find more appropriate for your specific way of working. In order to make the most efficient use of a database, you will need to plan from the start exactly how you allocate file names. There are many possible ways, but whatever you choose it must be logical and allow easy searches. Most large image databases use a numerical identifier, but you can add a secondary description.

Database tools can rename your files in batches, and add serial numbers. Media Pro's thumbnail view is an efficient browser.

Editing EXIF data

EXIF data is embedded in the image by the camera, and includes time, date, ISO, shutter, aperture, and more. There is limited software available for altering it, because in principle this is useful information that other programs can use, such as databases, noise reduction software, and others that rely on knowing the precise settings. Nevertheless, there are reasons for wanting to make changes, and the most common is to correct the time and date—it is all too easy to forget to change the camera time and date settings when crossing time zones. Some databases permit limited adjustments; Phase Pne's MediaPro, for example, has a time and date change function. Otherwise, use command-line instructions in a specialized program such as EXIFutils, but use with extreme care, as changes are non-reversible.

Searching is normally performed on keywords. There may be occasions when you need to save different versions of an image, and these will need either a different suffix (for instance, .jpg and .tif if you save an image in two file formats) or some extra identifier. For instance, you may want to keep both an unsharpened and sharpened version, in which case you could use something similar to the following: "15624_flamingo" and "15624_flamingo_usm". Check how your database handles attempts at duplicating filenames, as it is essential to avoid overwriting original images unintentionally. Workflow software may avoid the need by means of its non-destructive editing features.

There are several contenders, and the one featured here is Phase One's Media Pro). There is a considerable amount of work involved in using a database, and it is continuing work, so selecting one demands some thought. Unless you opt for workflow software that incorporates database functions, your database should be the core of your picture-managing operations. The more it allows you to do, including selection, captioning, moving and copying files, and so on, the more useful it will be.

One decision to make early is whether to use the database for importing/uploading/ingesting images from the camera or memory card, or whether to do this with a browser. The advantage of using the database is that it keeps one more operation under a single roof. The possible advantage of using a browser to do this is that the browser may be quicker and more flexible.

Workflow Software

Workflow software has evolved dramatically in recent years and there are now programs that offer a "one-stop shop" solution to imaging workflow.

Examples of such software include Adobe's Lightroom and Phase One's Capture One Pro. What such software aims to replace is the workflow model that relies on a browser to download, an image database to

LIGHTROOM

Lightroom's Develop mode offers all the same features as Adobe Camera Raw, which is no accident. Edited, the image does not affect the original file; instead a list of changes is kept in Lightroom's database. When the image is exported the changes can be implemented, or saved as a "sidecar" file which the next application can use to apply the changes. This is why there are few pixel edits, aside from some cloning (where source and target points can be referenced).

organize, and Photoshop to do post-production. The advantage of one-stop software is speed and neatness, and the ability to concentrate on essentials rather than pick through the many features of the latest Photoshop that are of little value to photography. Against this, they require learning a new workflow system, creating a resistance among photographers who have

invested years in learning the "traditional" photographer's workflow. In order to streamline the workflow and create an attractive visual interface and experience for users, the major workflow software programs have, to some extent, buried the workings of the post-production tools that are more transparent in Photoshop, and there are divergent views on whether or not this is a good thing. For

photographers with long experience of Photoshop and who prefer to stay firmly in control of image quality, there may be no clear advantage in changing their tried and true system, but for photographers who are either new to digital imaging, or who prefer to limit their involvement to the essentials, this kind of software may be ideal.

The main contenders in this software market vary in their approach, and are also constantly upgrading and evolving, as this is a relatively new area that still calls for user feedback. Three features that all have in common, however, are a Raw-focused approach, strong comparison and selection tools, and non-destructive processing.

Assuming that most original files will be in a Raw format is sensible, given the target audience of serious amateurs and professionals; compare-and-select procedures are essential for a program that promises to handle a large shoot which must eventually be whittled down to a few selects; and non-destructive processing, while not breathtakingly new, is one way of preserving the original files while

Workflow

Import Images
Workflow software will generally allow a wide range of options when importing images, including whether you create a copy of the file, move it into a folder organized by the application, or simply reference it. You can also add your copyright presets and any keywords for the batch of images you are importing.

Organize
As with database applications, a fully featured browse view allows you to sort through your images, add and search on keywords, perform renaming operations on your files, and so on. Although renaming is permanent, most information about your images is stored in the database rather than altering the files.

Review, rank, and select
Viewing images full-screen and adding ratings is a quick way to isolate good shots.

Process
This is perhaps the key differentiator between

workflow software and databases: that it is posssible to enter into an edit mode and make changes to the image, both wholesale fixes and some local repairs.

Distribute
Lightroom, for example, can generate HTML or Flash web pages, slide shows, and of course various prints including contact sheets.

Re-Order
It is always possible to go to the browser and re-arrange or sort the database.

allowing them to be processed. Key technical issues still being addressed are performance speed for various operations, open architecture, and the development of third-party plug-ins in the future. As it stands, these can be very efficient and intuitive tools, if for no more than the ability to scan quickly through images at full-screen, identify the best, and begin that work without leaving the program. The full range of tools, all of which are non-destructive and light on storage consumption, is a huge bonus.

A few more words on non-destructive processing—in principle, this simply means keeping the various steps in post-production, such as setting black and white points, curve corrections, sharpening, and so on, as separate instructions, and there are other ways of doing this. It happens in the camera, of course, whenever you shoot Raw. Raw converters such as Camera Raw save the settings last applied to an image as a sidecar file, while Photoshop has a *Smart Filters* feature that can be applied to a *Smart Object* layer.

Captions & Keywords

An important part of managing your images is using captions and keywords. These can be added at any stage of the workflow, and help to make accessing and retrieving images quick and easy.

The standard for doing this is called IPTC (International Press Telecommunications Council) and it includes entries for descriptions, keywords, categories, credits, and origins. This is important not only for cataloging, but also for selling reproduction rights in images. Captioning images may seem like a chore, but now that stock sales play such an important part in the business of photography, it is essential. Noting the key details of what you shot is useful for your own records, but the real reason is so that other people can find your images. This is very much a feature of being digital and online because the descriptions that are easily attached to the image file can be used by search engines. In pre-digital days, there were only two ways for a picture researcher or art director to find a specific photograph: call up stock libraries and ask, or look at the printed catalogs from the same libraries. Now stock-agency websites allow the people who want pictures to search for themselves, and understanding how that happens in practice helps to sell images.

Captions sell photographs. At least, they sell content-based photographs, and the more specialized the subject matter, the more important it is to know exactly what you shot. The best time to do this is on the spot, while you can still ask, and before you forget. A notebook or tape recorder are the easiest means; inputting directly into the camera seems efficient, but takes longer. As part of a normal workflow, captioning fits most easily into the image editing, either before or after

The Five Ws

Who Name if famous, newsworthy, or relevant. Ethnic origin. Job or position if relevant. Gender if a baby.

What Decide first whether action or object is the subject (consider what motivated you to take the picture). If action, describe it in first sentence. If object, give name (if a known building, landmark, geographical feature), description, and if a plant or animal, give the scientific name. In some cases, the concept will be appropriate—that is, an idea that you were trying to express (such as harmony, love, security).

Where Location as precisely as possible, ideally with a hierarchy (e.g. Montmartre, Paris, France).

When Date.

Why If the action is not immediately obvious to a viewer, explain it (usually in the second sentence).

optimization. A successful caption is informative, focused, and succinct, and the first skill is to identify the salient facts and then prioritize them. With stock images, the aim of the caption is to present all relevant information to other professionals rather than general readers, while the keywords add to the searchable information. All this information can be extracted by image-management programs and other databases. The time to enter the caption information is

Creating keywords

- Keywords supplement the caption for the purpose of searching.
- There is no need to repeat a word that is already in the caption/description.
- Too many keywords is as bad as too few. Aim for no more than 10.
- Think of what words your target audience is likely to use (for example, a natural history picture researcher may use the scientific name).
- Include different spellings and usages (for example gasoline/petrol).
- Include the plural unless it simply has an "s" added.

as early as possible in the inevitable chain of image versions and copies. It may be worth maintaining a master caption list in a word-processing program as a reminder of which images have already been captioned and also as a source for cutting and pasting. Several images may share the same basic information, or at least some of it—you could then copy parts of entries from the master list into Photoshop's File Info for each new image. Alternatively, save the metadata where it can be retrieved from another image's File Info dialog (*see Metadata in Photoshop,* below).

Metadata in Photoshop

Metadata can be viewed and edited either in the Metadata palette of the File Browser or in the various windows of File Info (*File > File Info...*). Having entered the IPTC information (caption under Description, keywords, copyright information, and so on) you can save this for future use in other, similar images, either save as a Metadata Template or as an XMP (Extensible Metadata Platform) file from the *Advanced* tab of the *File Info* window in Photoshop.

Keywords

Being able to retrieve images quickly and easily is the core function of any image database. As images accumulate in the database, it becomes increasingly difficult even for the person who took them to remember the details. If you want other people to be able to search through your library of pictures, for instance if you are selling them as stock photography, you will certainly have to anticipate how they might search. The software issues are highly technical, but common to all is the concept of keywords. These are words describing some aspect of an image; when someone enters a word in the search box of the database, the program will look for images that have the same word attached. The more varied yet relevant the set of keywords attached to each photograph, the better the chance of matching the searcher's request. The trick is in imagining what other people might look for, beyond the obvious description. Where there is competition, it is of great benefit to have spent just a little more time and energy adding keywords than your competitor, though obviously it's important that your database doesn't "cry wolf" by using keywords that don't describe the picture.

In this database, the fields to complete are: Short Caption, Long Caption, and a list of Keywords. The short caption, "Dashimaki Tamango, a Japanese egg roll" does not tread on the toes of the Keyword list: cooking, eggs, omelette, cuisine, food, yellow.

Long-term Storage

Although digital files, being a series of "1"s and "0"s are in many ways fairly robust, we know they can easily become corrupt or even lost, so it's important to make copies and keep them safe.

Your computer's hard drive, no matter how large, will eventually fill up, and for this reason alone it is important to move the files to other media. Moreover, having a backup is a part of good computer housekeeping—remember that the high-volume solution for most people is an external hard drive, and preferably more than one. Mirrored hard drives, meaning one carrying an exact copy of the other, are standard insurance for many professional photographers. In addition, depending on the volume you shoot, yet another backup on a DVD has the advantage

of being a different medium, and non-magnetic. DVDs are also universal and compatible. The various flavors, as they are known, are described on the next page. Backup policy involves two actions: make an identical copy of everything you store, and keep it in a different physical location.

There are many backup programs available. The simplest, but least efficient method is to simply copy all the files onto the destination. True backup software allows you to perform incremental additions, making it unnecessary to copy existing files over again. As a general rule, backup software that devotes a lot of energy to making the interface comfortable and idiot-proof performs more slowly than stripped-down, leaner programs.

Backup to the Cloud

Traditionally, the hardest aspect of creating secure backups was off-site storage. Of course it's possible periodically to burn DVDs and take them to another location, but not necessarily convenient. Today there are a number of companies offering online photo backup storage. For serious amateur or professional use it's likely that you'll need to pay an annual fee for the amount of space and the size and type of files you'll want to store, but it's a competitive market and prices are improving all the time. Upload times will vary depending on the speed of your internet connection.

Writing DVDs and Blu-ray disc

Although external hard drives offer an efficient, cost-effective
way of backing up your photos, they're not an ideal long-term
storage solution. Optical media such as CDs, DVDs, and Blu-ray
discs are compact, non-magnetic, and are likely to be better
longer-terms storage solutions. Although dual-sided, dual-
layered DVDs with capacities of 17 GB are no longer widely
available, you can still buy single-sided, double-layered
discs with a capacity of 8.5 GB. Blu-ray disc technology is
constantly evolving and muli-layered examples exist with
capacities of 200 GB, although they are not at present as
compatible as CDs and DVDs.

- DVD-5 - 4.7 GB single-sided, single-layered disc.
- DVD-9 - 8.5 GB single-sided, double-layered disc.

Newer Blu-ray disc
writers, such as this
one from Samsung,
are powered by a USB
connection and are
capable of writing to
CDs and DVDs, as well
as Blu-ray discs.

DVD-RAM
The first rewritable DVD format, DVD-RAM uses phase-change technology
similar to that in CD-R. Of all the DVD formats this is the least compatible
with different players. It has some distinct advantages in terms of rewriting
and data recording, however, since it does not need to record a lead-in and
lead-out each time the disc is used.

DVD-R and DVD-RW
Similar to CD-R, DVD-R (or, DVD-Recordable) is write-once. Recording takes
place on a dye layer that is permanently altered by a highly focused red laser
beam. As with CD-R, there are three areas: lead-in, user data, and lead-out.
Also, as with CD-R and CD-RW, the write-once -R format is compatible with
more DVD read-only drives than its -RW counterpart. (This is the format used
by Apple's built-in DVD writer, the "Superdrive.")

DVD+R and DVD+RW
This third rewritable DVD format has the highest compatibility. Like DVD-R it
comes in write-once and rewritable flavors with varying degrees of compatibility.
Some drives can now write to both +R and -R formats, and are typically
designated ±R. If you're buying a DVD writer, this is a good way of hedging
your bets. At the moment, only DVD+R supports dual-layer burning.

RAID

RAID stands for Redundant Array of
Inexpensive (or Independent) Disks, and
is a hardware-plus-software technology
designed for high-storage safety. A RAID
device is a stack of hard drives (typically
four or five) that function as a single unit.
Depending on the RAID level you choose
to implement, the device can store files
in such a way that if one disk crashes,
all the information can be rebuilt from
the remaining drives. The safer the RAID
level chosen, the less the total capacity.
Individual drives are hot-swappable,
meaning that you can pull them out
safely while the device is connected
and running.

Also worth mentioning is DROBO, a
proprietary system that benefits from
allowing you to use multiple drives of
varying sizes (RAID requires each drive
be the same size, which can lead to
wasted space).

File formats and compression

While there are a number of file formats in which you can save images after
optimization—see the list available in Photoshop's Format drop-down menu
in the Save As... dialog—there is little reason for photographic images to stray
beyond the two most widely recognized: TIFF and JPEG. Universal readability is
important if the images are likely to be seen and used by other people, and if you
want to open them in different applications. TIFF offers a lossless compression
method, LZW, and this can typically reduce the file size by more than half. This is
for 8-bit images; it does little for 16-bit. JPEG is both file format and compression
system, and ideal for transmission. You can choose the degree of compression in
the dialog box as you save, but beware of saving JPEGs more than once—this
simply multiplies the artifacting.

Basic Optimization

Optimizing an image during processing means bringing out the fullest range of tones, from black to white, and without any obvious color cast, and is a standard procedure. It aims very simply to give the image the appearance that a broad audience would expect.

This seemingly straightforward idea hides the issue of how you define the best appearance, and in practice this is a combination of objective technical standards and the subjective ones of your personal preference. As the person who saw the scene, only you are qualified to decide what the optimal brightness, contrast, and color should be, and for this reason it is always best to perform these adjustments as soon as possible, while your memory is fresh.

The key here is the sequence—the order in which you make the several different adjustments to the image. The aim is to avoid making a change that will later be changed again, as would happen for instance if you first altered a specific hue and then made a global color change. The most logical approach is to work from global corrections to selective, and the following four stages do this:
1 Balance the overall color, eliminating any unwanted cast. Either identify this bias by eye and use any of the usual tools (Color Balance sliders in Photoshop, Tint or Temp sliders in Lightroom, individual channels in Levels or Curves), or use a Gray Point "dropper" on any tone that you think should be neutral.

Quick optimization

It is possible to make an independent, objective adjustment that traces and eliminates a color cast, closes up the ends of the histogram to make the range from black (0) to white (255), and performs a pre-set saturation. This takes no account of the content of the image, but is a useful starting point as an unbiased suggestion of how the image might be improved. One of the reasons it works so well has to do with the psychology of perception—in a side-by-side comparison, most people prefer brighter, richer, crisper versions of an image. In Photoshop, tools to consider are those in the *Image > Adjustments >* menu, such as *Auto Levels* and *Shadows/Highlights*. There are also third-party applications that can help, such as I-Tricks 2, a standalone color-repair program.

Subjective assessment

The process of optimizing for color has one serious built-in flaw. It tacitly assumes that every image deserves the same basic standards of brightness, a full contrast range, neutral grays, and so on. Most of the time this is true, and "automatic optimization" nearly always looks instinctively better. Yet this may not suit the purpose of the shot. For example, if part of the appeal of a landscape is its limited range of muted colors and softness, there is no point in closing up the *Levels* to give it a range from black to white. The very first step in optimizing any image is to assess it from a creative viewpoint. What was the effect you were aiming for when you shot? Will it suit the image to be other than normal?

2 Set the black and white points. The simplest way is to close up the ends of the histogram in Levels in Photoshop or using the Blacks and Whites sliders in Lightroom. Otherwise, use Black Point and White Point "droppers" on the darkest and brightest parts of the image.

3 Adjust brightness, contrast, and saturation overall. Curves gives excellent control over brightness and contrast, while saturation is most easily adjusted in the Hue/Saturation (HSB) dialog in Photoshop or the Saturation and Vibrance sliders in Lightroom.

4 Adjust individual color ranges, for instance by using one of the hue ranges in HSB.

In many cases, optimization involves making subjective judgements as to the final appearance of the image. Both of these shots of elephants under a tree in the African savannah are perfectly valid. The lighter top image perhaps evokes more strongly a sense of bright heat, while the lower image plays more on contrast and color.

Advanced Optimization

Every image requires its own level of optimization; some will simply need tweaking in terms of, for example, contrast, others may require a lot more work.

Even if you think you have a duty to do everything possible, in the real world there may simply not be enough time to work on every photograph. In any case,

optimizing is subject to the law of diminishing returns—lengthy tweaking of details may not have a significant impact. Nevertheless, the recommended procedure for a full optimization is as described here. Remember, however, that this is not cast in stone, but just an example of one reliable sequence.

A Raw adjustment

For anyone serious about good image quality, the first step is to shoot Raw. Both the Photoshop Raw adjustment window and Lightroom's Develop module offer an exceptional range of controls, where it is possible to do almost all of your image-optimizing work. As both image editors share many of the same algorithms, if you're familiar with one, you'll know your way around the other.

B Assign profile

This is best seen as an alternative to Raw adjustment, and it is not practical to make full use of both. If color precision is important, you may want to adjust the tonal range in the Raw dialog, and then assign a prepared profile.

C Levels

Again, if you have made good use of Raw adjustment, in particular the Blacks and Whites sliders, going to *Levels* may not be necessary other than to check the histogram. Otherwise, the key procedure in *Levels* is to set the black and white points. Any adjustments to the tones between these points, however, is better left to the *Curves* dialog. Moving the midpoint slider alters the brightness around the exact midtone only, while *Curves* allows you the flexibility of biasing the lightening or darkening toward the shadows or highlights.

...en the precision tool for tonal
...t now has two strong
...om's Tone Curve panel (A)
...ws/*Highlights* dialog (E).

E Shadows/Highlights

This extremely useful control is slider-based in operation, designed for photographs, and actually exceeds the ability of *Curves* to manipulate contrast in the midtones. Because of its unique method of working, this is almost always worth looking at before finalizing an image.

F Hue/Saturation

While saturation can be manipulated in *Curves*, the simplest control
for it is the *Hue/Saturation* dialog. Once again, however, Raw adjustment
also allows great control over hue and saturation, and may make this
one unnecessary.

G Distortion, correction and cropping

Distortion may occur because of tilting the camera in a situation that calls for vertical verticals, or through over-enthusiastic use of an extreme wide-angle lens, or because of lens barreling or pincushion distortion. Correction usually leaves some gaps that need cropping, so that if you plan to crop the image for compositional reasons, it is best to run these two operations together. Photoshop's distortion-correction tools are either those under *Edit > Transform*, or the *Lens Corrections* filter (also found in Lightroom), and there are many third-party plug-ins for dealing with lens distortion of the barreling and pin-cushion varieties.

...H Retouch

...nally, and there is little point in doing this before the above procedures,
...ove artifacts. The specific tools will depend on your software: in Adobe
...era Raw, it's the Spot Healing Brush; in Photoshop, you also have the
... Brush, Patch tool, and the Content-Aware Move and Fill tools.
... culprits are dust particles on the sensor, but you might then
... move on to more elaborate image-editing, such as removing
... from a landscape, or skin blemishes on a portrait.

Optimization Tricks and Tips

Image-editing tools, particularly those such as Photoshop, Paint Shop Pro, and so on, are immensely powerful programs that offer a number of ways of achieving almost identical results.

For this reason the steps outlined on the previous pages are no more than my recommendation. This is partly because there are so many ways of making similar corrections, but also because any evaluation of a photograph is ultimately subjective and part of the creative process . Allied to this is the concept of "tips and tricks," which in other circumstances would just be sloppy methodology. Yet in optimization and image-editing generally, tips and tricks are—strange though it may seem—a part of the methodology. Here are some key ones.

Edit at high bit-depth

Despite the fact that normal 8-bit color can display 16,777,216 separate colors in an image—well beyond the eye's ability to discriminate—any major change to the contrast, brightness, or colors, such as you might make with the *Curves* or *Levels* tools will destroy some of these as it shifts certain pixel values. The tell-tale sign is in the histogram—after an adjustment there will typically be white line gaps and black spikes above, instead of a smoothly curved, solid-black mass. The way to avoid this is to edit in 16-bit. It's double the file size and overkill for a final image, but there are sufficient color steps (well over 281 trillion of them) to accommodate any changes. If you shoot in Raw, Photoshop and Lightroom will automatically convert the image into 16-bit. Otherwise, if you have an 8-bit image, it is still worthwhile converting it to 16-bit for editing. But in this case, convert to Lab mode and edit the Lightness channel for the least damage.

Before

After (8-bit)

After (16-bit)

Use Photoshop profiles

If part of your workflow includes managing color in Photoshop, you will need to calibrate your monitor, using either the visual method or by using a colorimeter. The first time you launch Photoshop after installing, you're asked "Do you wish to cutomize the color settings?" The default setting is Web Graphics, which is designed to maintain color graphics consistently on screen. It may be that you don't need to alter this at all; however, if you're planning another kind of workflow, click *Yes* to be taken to the *Color Settings* dialog. If you're not installing Photoshop for the first time, you can access the dialog via *Edit > Color Settings…* (or on older Mac versions via the Photoshop menu). In order to maintain consistency, make sure that you use the same settings in any other color-managed applications that you use. Colors might also seem different in non-color managed software.

Go to *Color Settings* and make sure that the highlighted fields are as shown here. Adobe RGB (1998) is in any case the working space of choice for photographs. Under Color Management Policy, for RGB choose *Convert to Working RGB*; this ensures that images always appear in this standard color space. The two options at the bottom of the window give you the opportunity to discard unwanted profiles and to assign the one of your choice.

Evaluating a color chart

If getting accurate color is paramount, photograph a test that includes a color chart (such as the GretagMacbeth ColorChecker below). Ideally, do it once for any given lighting situation. For easy reference, crop into the chart and save this image as a check file. Its appearance in Photoshop should be as follows; if not, use the Raw editor so that it does—and note the settings.

1 The white square should be 250-245 and no higher in all channels.

2 The black square (darkest neutral) should be 5 and no lower in all channels.

3 You can distinguish all the neutrals from each other.

4 No RGB values in any square are lower than 5 or higher than 250.

5 The RGB values in the neutral squares are within 5 points of each other (e.g. 126, 130, 127, not 124, 132, 121).

Shooting Raw

Apart from the fact that it requires additional post-production work that will take a little more time, shooting in the Raw format provides many benefits.

The simple reason for this is that the data and settings are stored separately on capture, meaning that you have complete access to the original, "raw" data in your image-editing program. Moreover, this image information remains at the maximum bit-depth of which the sensor is capable (typically, 12-bit, 14-bit, or 16-bit). If you have any need to optimize or alter the image, Raw is the obvious choice.

However, there are some decisions you need to make about fitting Raw adjustments into your workflow. The first is which software to use? One possibility is the image editor offered by the camera manufacturer, with the advantage that this should be thoroughly integrated with the camera's sensor and processor. Alternatively, as we have seen earlier, Photoshop (and Photoshop Elements) has a powerful Camera Raw Editor, which shares many of the same controls as Lightroom. These Raw editors are likely to offer more sophisticated controls than most camera manufacturer software, odd though this may seem. Ideally, test the two side-by-side with different images and then decide for yourself which one you prefer to use to work on your Raw files.

LIGHTROOM RAW CONTROLS

Lightroom offers extensive control over your Raw files. Many of the adjustments are made using sliders, making the program relatively intuitive to use. The adjustments are made in real time, so you can see the changes as you make them. It is sensible to use these tabs according to the order of adjustments.

EXPOSURE ADJUSTMENT
This image is originally slightly overexposed, but taken using the Raw format. When opened in Lightroom, the program allows changes to be made to the exposure, white balance, and numerous other settings. The final shot (left) has had its exposure reduced by 1/5 stop, and changes made to the settings including a custom white balance to enhance shadows.

Raw adjustments

Another decision is which adjustments to make when you are converting the Raw file, and which ones to make later with Photoshop's pixel-editing tools. Much of this will depend on the types of image you work on, but as a general rule, the more you can do in the Raw editor, the better. As I touched upon earlier, Raw-processing software such as Lightroom, ACR, DXO Optics Pro, and Capture One Pro doesn't alter images at the pixel level, rather via sets of instructions or parameters (hence the alternative name PIEware–Parametric Image Editing software). This non-destructive form of editing not only ensures that your original file remains untouched but it also keeps file sizes small. However, if your work involves a lot of retouching, it's unlikely that

you'll be able to achieve everything you want in a Raw processor, and this is when you'll need to turn to Photoshop. Adobe, however, have made switching from Lightroom to Photoshop and back again quite seamless.

Once you've completed optimizing your image in Lightroom—tweaking exposure, white balance, highlight and shadow adjustment, and noise reduction for example—should you need to undertake further retouching work you can export the image to Photoshop (with the Lightroom adjustments baked in), complete the work in Photoshop, save and reimport the file back into Lightroom. It's an efficient way of working and helps you maintain an effective image library.

Potential Raw workflow

Camera Calibration window
1 Compensate for errors in reading the camera's profile, ideally by loading a pre-prepared profile.

Basic window
2 Set *White Balance*, adjusting with *Temperature* and *Tint* sliders.

3 (optional) Choose *Auto adjustment* to see what the software recommends, but don't necessarily use this.

4 Adjust *Exposure* for the overall brightness, favoring the high values and paying attention to highlight clipping (set the clipping warning on).

5 Adjust *Contrast,* if necessary, to darken shadows and brighten highlights.

6 Adjust *Highlights*, which uses tone mapping procedures to reveal more highlight detail. Be careful not to overdo this, as it also can create a flattened "illustrated" look. Consider going back to increase Contrast if you move this slider more than ~30%.

7 Adjust *Shadows,* if necessary, to open up shadows, being careful not to overdo this. This too uses tone-mapping procedures, like Highlights, to reveal more, and overuse can also create a flattened look. Consider going back to increase Contrast if you move this slider more than ~30%.

8 Adjust *Blacks* and *Whites* by dragging each slider until the darkest area in the image is just lighter than clipped, and the lightest area just darker than clipped. Keep the highlight and shadow clipping warnings switched on for this.

9 Adjust *Clarity* only if necessary and ideally not. It too uses a tone-mapping procedure to increase contrast in a particular way in mid-tones, but runs the risk of looking "illustrative" and even cartoon-like. Lower Clarity has a corresponding softening effect, which can occasionally be useful with skin tones.

10 Adjust *Vibrance* and/or *Saturation* only if necessary and ideally not. It may be tempting to increase colourfulness, but it easily looks extreme and false. If you do, favor the *Vibrance* control, which has built-in protection against clipping when particular hues approach full saturation.

Tone Curve window (optional)
11 If necessary, make fine adjustments to the tonal distribution after working in the Basic window.

HSL/Grayscale window
12 Tweak individual colors if necessary.

Detail window
13 Adjust *Sharpness* only if aiming directly for a specific output.

14 Reduce noise in a high-ISO image using the *Luminance* slider to control luminance (grayscale) noise and the *Color* slider to control chrominance noise. The effect of the both the *Luminance* and *Color* sliders can be fine-tuned using the *Detail*, *Masking*, and *Smoothness* sliders. Otherwise, perform this with a specialist noise-reduction program.

Lens Corrections window
15 Correct color fringing due to lens defects with the *Purple Hue* (red/cyan) and *Green Hue* (blue/yellow) sliders and associated *Amount* sliders for both. Here you can apply predetermined profile corrections to known lenses, fixing vignetting, using the *Vignetting Amount* and *Midpoint* sliders, and changing vertical and horizontal perspective. However, Adobe Camera Raw has a simple Remove Chromatic Aberration check box that works independently of an applied lens profile, because Adobe believes they have a superior correction algorithm.

Working with Lightroom & Raw

Adobe has worked hard to make sure that editing Raw files in Lightroom is as intuitive and seamless as possible.

The *Basic* panel, from top to bottom in the order in which you would normally use them, are the white balance controls—*Temp(erature)* and *Tint* sliders—*Exposure*, *Contrast*, *Highlights*, *Shadows*, *Whites*, and *Blacks*, and finally the three *Presence* sliders, *Clarity*, *Vibrance* and *Saturation*. Together these provide all the optimization tools you need to cover white balance, exposure, shadow and highlight detail, tonal contrast, and color saturation.

The image when first opened in Lightroom (left) and the final image, after adjustment (below).

Setting white balance

This is why it doesn't matter which white balance setting you choose when shooting Raw—simply set it here. There are three ways of doing this, offering much greater control than in-camera. The simplest is the dropdown *Custom* menu that replicates the choice in the camera menu, and the default is *As Shot*.

Alternatively, you can use the color temperature slider, which operates on the Kelvin scale. Once you have got close to the white balance setting, fine-tune it with the *Tint* slider—this adds magenta when slid to the right (+) or green when moved left (–).

Finally, you can also use the white balance dropper tool at the top left of the *Basic* panel to select a tone in the image that you know or want to be neutral gray. The sliders can then be used to make any further adjustments.

Midtone adjustments

Following the all-important exposure adjustments, use the *Contrast* slider to darken shadows and brighten higlights. Any over large or over bright highlight areas can be darkened with the *Highlights* slider (assuming there is some information there), while over dark or over large shadow areas can be brightend with the *Shadow* slider. Both run the same risk of false appearance if used too aggressively. The *Saturation* control has a partner called *Vibrance*, which minimizes clipping as full saturation in any one hue is approached, so this is generally a safer alternative for photography than the *Saturation* slider.

Adjusting exposure

This feature alone makes Raw editing worth it: the ability to re-visit the shot and select an exposure setting up to 2 f-stops brighter or darker—a total of 5 stops real range. Ideally, work from the top down through the adjustment sliders. Watch the highlights as you drag the *Exposure* slider first. Also consider holding down the Option/Alt key as you move the slider. This reveals any highlight clipping as colored areas out of a black base, and so is an ideal way of setting the white point—in the same way as you would do it in *Levels*, but better, as here it is on more of the image data. Typically, for a normal image, show just the beginnings of clipping. As the colored areas show individual channels, only pure white (the combination of all three) indicates complete (255,255,255) clipping. As long as only one or two channels are clipped in the highlights, the *Highlights* slider can restore pixels by reconstructing from the remaining channel(s). Follow with the *Shadows* slider, where holding down Option/Alt shows shadow clipping out of a white base.

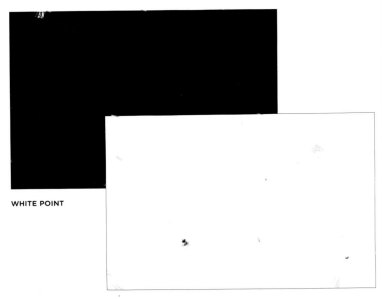

WHITE POINT

BLACK POINT

Advanced Raw Adjustment

With shooting Raw proving to provide the best option for creating optimum image quality, software manufacturers are working hard to produce Raw converters that allow you to undertake more and more post-production tasks.

Raw editing software now goes way beyond the basic exposure, brightness, and color adjustments, with Lightroom and Capture One Pro now offering sharpening, lens aberration adjustments, noise reduction, rotation, and even black-and-white conversion. A sign of the direction being taken toward comprehensive post-production within the Raw converter dialog is the arrival of retouching tools, which work at much more localized levels. Expect more features and more sophistication to be added.

Choosing a Raw converter

Although Lightroom is probably the best-known Raw processing software, camera manufacturers provide their own converter software bundled with their cameras. This may have the advantage that it is designed to work with their specific Raw files. This is offset by weaker software engineering relative to, say, Adobe. The market for Raw conversion has expanded and become more competitive recently, and there are now many choices including DxO Optics, Photo Ninja, Irident Developer, AfterShot Pro, and Capture One Pro. Ideally, download demo versions of different Raw converter software and compare the results for your camera. Because Raw format allows alterations to be made to the original exposure data received by the sensor, use it before image-editing tools.

Retaining Raw adjustments

Once you've made adjustments to a Raw image, you have to save it into a different format—with TIFF being the usual choice. In other words, you cannot overwrite the original, which is a good thing. An open-source Raw format, DNG, promoted by Adobe, is a saveable format, but there are differences of opinion as to its usefulness. It can be seen as a step away from the original Raw, but in a different direction from TIFF and JPEG. As for the adjustments you make during opening, these can be saved, and in such a way that they can be re-applied to other images if you like. There is a choice of two places in which to save them. The default is the Camera Raw database. In Windows this is usually located in the user's Application Data folder as *Document and Settings/user name / Application Data/Adobe/Camera Raw* (Windows), and in Mac OS in the user's Preferences folder as *Users/user name/Library/Preferences* (Mac OS). The advantage of saving here is that the images are indexed by file content, so the settings stick to the image even if you rename or move it. The alternative is in a sidecar ".xmp" file, which uses the same name and is stored in the same folder. If you want to archive the Raw image files with their settings, this is the better choice. With sidecar files stored on a CD or DVD, make sure that you copy them to your hard drive along with the images before opening.

Local-area adjustments

There was a time when Raw processing was for global adjustments—overall color balance, exposure, noise reduction, etc. If you wanted to make an adjustment to a limited area of a photo, you exported a Tiff and worked on it in Photoshop (or similar). But those days are long past. Every new iteration of Raw-processing software seems to include new tools for local-area adjustments that increasingly allow us to do almost all of our work entirely within the processor itself, and export a finished file directly from the processed Raw file. Working this way ensures a 100% nondestructive workflow, and is a huge time-saving advantage.

These tools in Adobe Camera Raw (ACR) will look familiar to Lightroom users because they're virtually identical. ACR is the default Adobe Raw Engine, and while here it's being used as part of Adobe Bridge, it is also built into Lightroom, just with a workflow-oriented interface.

Here, I've selected the Gradient tool in Adobe Camera Raw, set Exposure to -0.55, and pulled down from the top of the image to the horizon, thus darkening only the sky and leaving the foreground untouched—essentially a digital graduated ND filter. In the tool panel, you can see there are numerous other settings that can be applied locally, and you can also switch to the Brush tool to apply them to a very small area.

Tone with Histograms & Levels

A histogram is a visual representation, in the form of a graph, of all the tones present in a digital image.

In digital photography, a standard 8-bit scale of 0–255 shows 256 columns from pure black at left (0) to pure white at right (255), and normally, in camera displays and Photoshop, they are packed together so that they join and there are no gaps. Pixel brightness is plotted across the bottom on the X axis while the number of pixels that contain a particular tone is plotted up the vertical Y axis.

At all stages of the photography workflow, this is the single most useful representation of the tonal qualities of an image. In Photoshop it appears as a palette (*Windows > Histogram*), and as an image-adjustment dialog (*Image > Adjustments > Levels*). In Lightroom the histogram can be viewed at the top of the Develop module in the Histogram window. A reasonably exposed (that is, problem-free) photograph has a nice, smooth distribution to the shape of the histogram, peaking somewhere near the middle and tailing off toward the left and right; these tails almost reach, but do not crush up against the edges.

Typically, the first time a digital photograph is opened on-screen you would check the distribution of tones by viewing its histogram. Indeed, for any non-Raw image this is the first port of call for optimization. Unless you are looking for a special tonal effect, such as a flat effect with limited tones (for example a delicate landscape on a foggy day) or a graphic high-key treatment (for example, a fashion shot that deliberately washes out skin tones to emphasize lips and eyes), then the key procedure in *Levels* is to ~~s~~et the black and white points. This stretches ~~or~~ compresses the tonal range so that the

Using Levels

From this original, follow the route to image correction using the *Levels* dialog. You can reach the dialog using *Image > Adjustments > Levels* ... or by adding an adjustment layer to your image. Two alternative methods are shown on the following pages.

Look at the histogram and move the white input slider left to the first group of pixels and do the same (to the right) with the black slider. It will then look like the histogram below.

You can fine-tune the *levels* by holding Option/Alt as you drag each slider, revealing the "clipped" areas where detail has become pure black or pure white.

Final

darkest shadows are located close to black, and the brightest highlights (excluding light sources and specular reflections) close to white. I say "close to" because it's customary to set these limits to slightly less than full black and white.

After this operation, which aims to fill the scale with the range of tonal values, you can use the *Midpoint* (gray) slider to do two things. One is to remove any color cast. To do this, click on the gray point dropper to activate it, then click on a point in the image that you know should be neutral or that you would like to be neutral. The second action is to adjust "brightness." In fact, what it adjusts is gamma, by re-locating the midtone (128) to a darker or brighter position; all the other tones are dragged in proportion automatically, but the end-points stay the same. As a rough guide, move the *Midpoint* slider toward the center of the bulk of the histogram. However, there is more flexibility if you do this in *Curves*, and it may be worth moving to that dialog for the next step in optimization, where you can also use the gray point dropper to remove a color cast. Note that if you have opened and adjusted a Raw image in the Camera Raw plug-in, there should be no need to make any adjustments in *Levels*—and possibly not in *Curves* either.

Input Levels: 0 1.00 255

Click Auto in the Levels dialog, or skip this dialog altogether by clicking *Image > Adjustments > Auto Levels*.

Final

Input Levels: 0 | 1.00 | 255

This method involves selecting the light point, dark point, and midtone from the image using the eyedroppers at the bottom right of the *Levels* dialog. Start with dark point.

Input Levels: 0 | 1.00 | 255

Input Levels: 0 | 1.00 | 255

Input Levels: 0 | 1.00 | 255

As you select the dark and light points, the histogram will adjust accordingly. Finally, click on the Midpoint dropper and click on an area of the image that should be a neutral gray to adjust the color.

Final

Tone Adjustments with Curves

For more precise and more localized tonal adjustment turn to the *Curves* command in your image-editing suite.

The characteristic curve plots exposure against density on a graph, and the shape of the curve reveals such things as how contrasty the response is. In the *Curves* dialog, this is changed to a graph in which the horizontal is the Input (the original density of pixels) and the vertical axis is the Output (the changes you apply). The curve appears by default as a straight diagonal line. Because you can select any number of points on the curve and then drag them toward darker or lighter, this is a more flexible tool than *Levels*. Open it by going to *Image > Adjustments > Curves*.

Clicking on any part of the image shows on the graph as a small circle, which is a useful way of seeing how the tones are distributed. Command-clicking (Mac) or Ctrl-clicking (Windows) adds these points to the graph, so you can then use them to drag that part of the curve lighter (higher) or darker (lower). Midtones are in the center, shadows are down to the left, and highlights up to the right. Dragging points alters the shape of the curve and, just as with a characteristic curve, an S-shape indicates a more contrasty image, and a reverse S the opposite—a flat image. This is much more easily understood visually than in a description, and the selection of sample curves best explains the possible corrections.

Curves presets

Recent versions of Photoshop have introduced preset Curves. Clicking on the *Curves* dropdown menu provides a choice of basic but potentially useful settings to try. These include Darker, Lighter, three strengths of Contrast, and more artistic settings, such as Cross Process, Negative, and Color Negative.

Curve adjustments with samples

In this example, Cmd/Ctrl-clicking is used to sample the tones in this image that we want to adjust. The three control points are added, and are then dragged to make the highlights brighter and shadows darker—in other words, to increase the contrast.

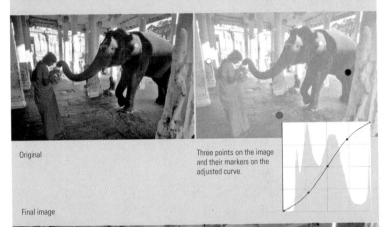

Original

Three points on the image and their markers on the adjusted curve.

Final image

Typical tonal adjustments with Curves

The Curve graphs shown here are can be used as the starting points for some common corrections. Individual images, however, should always be assessed on their own merits, and these curves may need tweaking. Note that all the variations shown here are within the set black point and white point limits. Although these can be adjusted using the *Curves* tool, by dragging the endpoints, I prefer to use *Levels*.

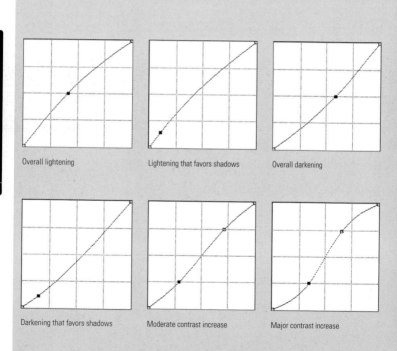

Overall lightening

Lightening that favors shadows

Overall darkening

Darkening that favors shadows

Moderate contrast increase

Major contrast increase

Lightening shadows while
holding other tones

Lightening that favors
bright areas

Lightening bright tones while
holding other tones

Darkening shadows while
holding other tones

Darkening that favors
bright areas

Darkening bright tones while
holding other tones

Slightly less contrast

Much less contrast

Shadows/Highlights Tool

The *Shadows/Highlights* tool was one of the major new features to be released with the first version of Photoshop CS.

The tool uses sliders, and so carries the advantage of being quick and easy to use, although with the possible disadvantage of "hiding" some of the information.

In particular, it works differently from the other optimization tools, such as *Curves* and *Levels*, with algorithms to control effects across specific tonal ranges. Its primary intent as designed by Adobe is to lighten shadows realistically, in particular for backlit images. However, its algorithms for altering the contrast in the midtones alone are possibly more important for many photographers.

What makes this dialog special is that the lightening and darkening that you can apply is based not simply on a range of tones but also on a sample drawn from the surrounding pixels. All adjustments need to be judged visually, rather than by values. To get the most out of this powerful tool, first assess the image and the changes you would like to see made. Then work down through the slider controls from top to bottom, if necessary going back to tweak the effects. Beware of over-correcting, as artifacting is likely— halos around edges and banding, as well as unrealistically light shadows. Open by going to *Image > Adjustments > Shadows/Highlights...*

Shadows/Highlights controls

Amount
This adjusts the strength of the effect, and has to be used in conjunction with the next two sliders.

Tonal Width
This specifies the range of the shadows. 50% takes it up to the mid-point, which will usually be too much. Decide from the image itself which shadows need lightening or highlights darkening. Too high a width will cause artifacting and also look unnatural.

Radius
Until you have experience with this control, it is the least intuitive of the three. It sets the radius around each pixel that is sampled, in order to decide whether it belongs in the shadow group or the highlight group, and is measured in pixels. Moving the slider to the right enlarges the sample area. Adobe recommends a radius approximately equal to the size of the subject of interest.

Adjustments

Color Correction
This affects only the areas that have been changed with the sliders above, so the strength of its effect depends entirely on how strong an adjustment you have made. Move the slider right for more color saturation, left for weaker.

Midtone Contrast
For many of us, this is the most important control, because it achieves an important effect not possible any other way. In most photographs, the middle range of tones contains the important elements. You can easily find many images in which you would like to

increase the contrast in this zone without deepening the shadows or lightening the highlights. There is a limit to how closely you could achieve this with *Curves* (*see pages*). With the *Shadows/Highlights* dialog, however, you can treat the groups of sliders as a way of protecting them—the *Midtone Contrast* slider then works on the remaining parts of the image.

Black Clip and White Clip
Normally you will not want to clip shadows or highlights, as this simply loses image data.

In this image the *Shadows/Highlights* tool has been applied to bring out detail in the shadowy foreground while at the same time introducing a little more warmth to the bright highlight areas in the background.

Sharpening

Perhaps out of all the controls that digital imaging put into the hands of today's photographers, sharpening has been most widely abused.

The reason for this is that sharpening is a subjective impression and not a measurable detail of the photograph. A high-contrast image, for example, tends to look sharper at a glance than a photograph with muted tones. There is also no good measurement of sharpness. Most evaluations are in terms of "too sharp" and "not sharp enough." This isn't to say that these are poor descriptions, just that they don't transfer well from one viewer to another. It reinforces the principle that the photographer should make the judgment.

The factors that give an impression of sharpness are acutance, contrast, resolution, and noise. Acutance is how abruptly one tone changes to another across the image, and the more abrupt the edge between one area of pixels and another, the higher the acutance. Contrast has an effect in that an edge between black and white looks sharper than an edge between two gray tones. Resolution is the degree of detail, and more detail looks sharper than less. Finally, noise breaks up the image and reduces the overall detail, although sometimes it can have the opposite effect and add to the sharpness simply by being itself sharp and definite.

Because sharpness and sharpening are such perceptual issues, we have to consider how the photograph is going to be seen—under what conditions, at what distance, and what size. Because some of the sharpening controls are measured in pixels rather than percentages, the size and resolution of the digital image do matter—a 1-pixel radius has a much greater effect on a screen-sized

Sharpening and third parties

Whenever an image moves out of your direct workflow control, it is absolutely essential that other people know whether or not it has been sharpened. If it has not, you and they should agree on how it will be sharpened. Because of all the variables (*see Factors governing sharpness, below*), it is clearly better not to sharpen before delivery, but take no chances that this is understood. In repro, the image may go through several people, including the picture editor, designer, and printer, and there is a risk that the sharpening information gets lost, with the result that the image finally appears soft.

Factors governing sharpness

1 Image size.

2 Quality of image detail.

3 Reproduction size.

4 Printer quality and settings.

5 Viewing distance.

6 Your taste.

640 × 480 image than on a high-resolution 3,000 × 2,000 image. The condition of the original image is also a factor. A detailed, high-quality image, for example, needs a different kind of sharpening technique (finer, more detailed) than does an image that suffers from, say, low resolution, slightly soft focus, or noise.

Varying degrees of sharpness

Sharpening an image should ideally add to its overall impact, not make it appear unnatural or add artifacts to it. Tell-tale signs of over-sharpening are high levels of what appears to be grain, even in areas outside the image's main focused areas, and pixelation around detailed areas.

| Original | Sharpened | Oversharpened |

Ultimately, two things stand out. The first is that every photograph needs to be sharpened in a way that is appropriate to it, so judge every photograph—or every set of similar photographs—on its own merits. The other, important point, is that sharpening should be the last action you perform on an image before it is displayed—whether as repro, fine art print, or on the Web. Sharpening can only be judged on its appearance as intended, and never sharpen an original, only a copy. If you are shooting Raw, then the Raw files are your true originals, but their optimization represents an investment of time and skill, and you may consider saving the finished TIFF in its unsharpened form. Sharpened versions for various purposes can be given a slightly amended file-name (such as adding "sh"). Note that repairing focus blur and motion blur involves sharpening, but should not be confused with the sharpening discussed here.

Basic Sharpening

As discussed, sharpening is concerned more with subjective judgement than a measurable process.

Certainly there are obvious artifacts to look out for, such as the dreaded halos, but ultimately what and how much you sharpen is down to your personal taste. You may, for example, disagree with some of the results here and on the following pages, and that is as it should be. Your taste is the final arbiter.

Although Photoshop has *Sharpen*, *Sharpen Edges*, and *Sharpen More* filters, these are rough and ready, and allow no fine-tuning, so are best ignored. The usual professional sharpening tool is the *Unsharp Mask*. As a way of increasing sharpness, this sounds like an oxymoron, but the apparent illogicality is because the term is a holdover from pre-digital days. In film-based repro, an out-of-focus copy of the image was sandwiched with it as a mask, and the result, as if by magic, was a sharper image. The expression, often shortened to USM, has stuck.

The digital process, however, is quite different, and works by resampling pixels so the contrast between neighbors is increased. At a pixel level, an edge looks like an area of dark pixels against an area of light ones. Increasing the transition between them—making the dark pixels darker, and the light pixels lighter—is the key way of heightening the contrast, or sharpening. Most sharpening techniques, including USM, can be adjusted to suit different images by three variables: amount, radius, and threshold.

In practice, getting these right for a particular image is complicated by a set of factors that include the size and quality of the image, the viewing distance, and your own taste, which is subjective. Proprietary sharpening applications such as Power Retouche Sharpness Editor and Nik Sharpener Pro take a more sophisticated approach than USM, include more variables, and can protect sensitive areas of a photograph such as intricate detail.

Unsharp Mask controls

The three standard settings are *Amount*, *Radius* (also known as *Halo Width*), and *Threshold*, and between them they provide good, though not perfect control over the sharpening. Be aware that there are a number of sharpening algorithms (of which Photoshop's USM is just one), and most aim to heighten local contrast.

Amount
This, expressed as a percentage, is the intensity or strength of the sharpening. Opinions vary, as this setting depends very much on personal taste, but for high-resolution images, values between 150% and 200% are normal.

Radius
This is the distance around each pixel that is used for calculating the sharpening effect. A small radius will sharpen a narrow edge, a larger radius a broader band. It affects the coarseness of the sharpening and is measured in pixels. The wider it is, the wider that edges will appear, and if it is set too wide, a "halo" appears along edges (hence the alternative name Halo Width). For high-resolution images, a radius of between 1 and 2 is normal.

Threshold

This controls the level of difference between adjacent pixels that will be sharpened, and serves as a kind of protection for smooth areas with fine texture and little detail. With the threshold at 0, everything is sharpened. Raising it a little prevents the sharpening being applied to areas in the image where the difference between pixel values is small, such as sky and skin. It concentrates the sharpening more on the distinct edges, which are usually considered more important, and without it, the smooth areas can appear "noisy." It is measured in levels between 0 and 255. Setting the threshold to 4, for example, restricts the filter to areas where the difference between adjacent pixels is greater than 4—for instance, neighbors 128 and 133 would be sharpened, but 128 and 130 would not. For a high-resolution photograph, values between 2 and 20 are typical, reflecting the difference in image content.

The result of sharpening with a *Threshold* setting of zero.

The result of sharpening with a *Threshold* setting of 10.

When sharpening goes wrong

Oversharpening is responsible for ruining many thousands of photos each year. Undersharpening is also an error of a kind, but difficult to measure because it relies on personal judgment. Common faults are as follows, and can be avoided by readjusting the *Amount*, *Radius*, or *Threshold*, or by using one of the more advanced techniques covered later.

Halo
Also known as negative contour, this is an edge effect in which a too-bright or too-dark band of one or more pixels separates two tonal areas.

Aliasing
Anti-aliasing is the well-known software technique for softening the "staircase steps" that occur on diagonal lines and edges in digital images (due to the square structure of pixels). Sharpening can remove the anti-aliasing.

Color artifacts
Unwanted colors appear at the margins of other colors, particularly in high-contrast and low-quality images.

Local extreme artifacts
Clumps of almost-black or almost-white pixels.

Halo effect

Color artifact

Advanced Sharpening

When it comes to sharpening, not only is every image unique, but different areas within the same image may well require differing levels of sharpening.

Ultimately, what this means is that to achieve successful sharpening—that is the impression of sharpness but without any artifacts—you need to apply selective sharpening. The *Threshold* control shown on the previous pages is the standard means of applying selectivity, but there are others.

Typically, the most sharpening is wanted along edges and in areas of fine detail, and the least (indeed, often none) is wanted in smooth areas and especially in zones that are out of focus. An important caveat is that some areas may have such intensity of detail that they react badly to sharpening—brightly lit foliage is a particular case.

Having identified the areas to select, you can do this in a number of ways. One is manually, by airbrushing in a masking layer

Smart Sharpen

With the introduction of Photoshop CS2 in 2007, an additional *Sharpen* filter was added—*Smart Sharpen*. This filter offers greater flexibility than *Unsharp Mask*. First, *Smart Sharpen* provides a variety of sharpening options, found under the *Remove* menu—*Gaussian Blur*, *Lens Blur*, and *Motion Blur*. *Lens Blur* usually provides the best results for standard sharpening. Additional flexibility comes in the form of the *Fade Amount*, *Tonal Width*, and *Radius* sliders located under the *Shadow* and *Highlight* tabs once *Advanced* is selected. Together these options provide much greater control than the *Unsharp Mask* filter.

to create a selection. Another is to use another filter to find the areas to be sharpened—the example shown opposite uses the *Find Edges* filter. Because the level of detail usually varies between channels, another technique is to apply sharpening to one channel only. An extension of this is to protect colors from sharpening by switching modes from RGB to Lab and applying the sharpening filter to the *Lightness* channel only. Finally, and most conveniently, consider third-party sharpening software that is usually available as plug-ins to Photoshop. Two specialist programs in particular, nik Sharpener Pro and Intellisharpen, use advanced algorithms.

Another advanced approach to sharpening is to apply the filters twice or more at a low level. Multipass sharpening, as it is known, is the best way to apply any sharpener for high-quality results, because it reduces the risk of artifacts. It calls for experiment, but once you are familiar with its effects, it becomes easy to execute. Batch processing makes it more convenient.

Sharpen twice

One way of reducing the risk of sharpening artifacts is to perform two (or more) sharpening passes. Additionally this allows you to aim the sharpening at different parts of the image. For instance, the first pass could be gentle but with no threshold, to subtly improve fine texture, followed by a second pass that is stronger and aimed at the edges, while setting a threshold to protect the smoother areas. This works with whatever sharpening technique you use, but clearly needs experiment and experience. The advantage of doing this is that the second pass multiplies the sharpening effect, while only adding to the artifacting. So, if you sharpen once at 100% and a second time at 125%, the sharpening effect will be $100 + (2 \times 2 \times 125) = 600\%$. The artifact generation, however, will be only $100 + 125 = 225\%$.

Convert to Lab

High levels of sharpening can often lead to color artifacts, particularly along edges. A good solution, worth considering as your default sharpening technique, is to convert the image to Lab and sharpen just the Lightness channel. This, as you can see by looking at the a and b channels, contains almost all the textural detail. The gentleness of the color gradations in the two color channels is preserved. Convert back to RGB when finished (Lab is also used by Photoshop as its conversion color space, and switching between the two loses no quality).

Sharpening with the Find Edges filter

It's the edges of an image that can provide the greatest impression of sharpness, yet the *Unsharp Mask* filter does not pay any particular attention to these. The *Threshold* setting with a high radius will concentrate sharpening, to some extent, on the edges, but there are more focused techniques.

1 Using the *Channels* palette, identify the channel with the most contrast in. In this photograph, the dancers are most clearly distinguished by the red channel. Duplicate the channel you identified by dragging it to the *New Channel* (turning paper) icon at the bottom of the *Channels* palette.

2 Working on the newly copied layer, select the *Filter > Stylize > Find Edges* filter. This will highlight the edges only, and by working on the new channel, it won't affect the image itself. Since we're looking to highlight the edges, not the majority of the image, click *Image > Adjustments > Invert* before clicking the Load Channel as Selection button (dotted circle) at the bottom of the Channels palette.

3 Switch back to the *Layers* palette and click on the background layer to make it active again. You should see your newly made selection imposed on top of the original image, rather than the altered channel.

4 With the selection still active, apply the *Filter > Sharpen > Unsharp Mask (USM)* to the image. It will only work on the selected areas.

5 The final image, with extra sharpening applied to the selected areas.

Sharpening in Lightroom

When dealing with Raw images, the principal process of sharpening is concerned with counteracting the softening effect of the antialiasing filter that sits in front of the camera's sensor.

When shooting Raw, no in-camera sharpening is applied as it is when shooting JPEGs. Again, how much you sharpen a Raw image in Raw processing software is entirely subjective, but the idea is to achieve a crisp-looking image on-screen that has no ugly, visible artifacts.

This image of an entrance gate's iron numerals and railings is not out of focus, but appears soft.

Lightroom's sharpening tools are found in the Detail panel of the Develop module. The tools take the form of four sliders, Amount, Radius, Detail, and Masking. The default settings are 25, 1.0, 25, and 0 respectively. The default settings have a value intended to automatically counteract the softening effect of the antialiasing filter. However, these are just a starting point and achieving a crisper looking image is usually possible. The exclamation mark in a black circle is to remind you to view the image at 100% before sharpening. Click it, and you'll be presented with a 1:1 view.

228

The Amount slider applies an overall sharpening effect. Here the slider has been pushed too far and artifacts, primarily in the form of noise (most apparent in the dark tones) and an ugly looking halo effect are visible.

The Radius slider, as with Photoshop, determines how far the sharpening effect is distributed. By holding down the Option key as you move the slider the image is converted to grayscale, making it easier to assess the effect. Increasing the slider from default 1.0 (left) to maximum 3.0 (right) applies sharpening to a greater area around the edges of the image, clearly revealing the unwanted halo effect.

The Masking slider restricts the areas of the image to which sharpening is applied. Lighter tones indicate areas with no mask, while darker tones indicate areas masked from sharpening. With the Mask slider set to near 0, in this case 6 (left), only small areas of the image are protected from sharpening, while with the slider set to 100 (right) much of the flat areas are protected resulting in sharpening being applied only to the edges. This is an effective way of suppressing sharpening noise in flat shadow regions.

The Detail slider determines the thickness of the edges to which sharpening is applied. With the setting set to 0 (left) only the thickest edges are sharpened, while the maximum setting of 100 ensures that sharpening is applied even to the smallest edges. In practice, the Detail slider is an effective way of suppressing halos, allowing you to set a high sharpen Amount without necessarily introducing halos.

Using a combination of the sharpening sliders, Amount and Detail, with the controls that suppress and modify where and how sharpening is applied, it's possible to achieve a crisp looking image with no unwanted halo or noise artifacts.

Increasing Image Size

As sensor resolution has been steadily increasing year on year, the issue of increasing the size of an image—upscaling—has become more and more redundant.

However, even if your camera has a 20+-megapixel sensor, there may still be times when the close crop you want will not fill the size of the desired print.

And so the question still arises, how much is it possible to enlarge a digital image and still have an acceptable level of detail? There is a 300 dpi rule of thumb in repro, but it is no more than that—a safe industry standard. The two principal factors are the line frequency (line screen) of the printer, and the percentage of this that the digital image should be. Newspapers print at 85, most magazines at 133-150, high-quality illustrated books at 200, and a few art books higher still. The percentage is very much a matter of opinion, but generally between 150% and 200%. In other words, even excluding the low quality of newspapers from the calculation, the acceptable resolution for a digital file could be between 200 and 300. And this determines the size.

Interpolation

Going beyond these limits involves interpolation, and there are good arguments for doing this yourself so that you can check and guarantee the result. The important choice is the method, meaning the interpolation algorithm. Within Photoshop, the choice is simple for photographs—*Bicubic*. It gives a smoother tonal gradation than the other two (*Nearest Neighbor* and *Bilinear*) and also better suits the complex structure of a photograph, usually lacking exact straight edges. It's important to realize that there is always a loss of quality in upscaling. How much is acceptable is a matter of opinion. Some users believe that incremental upscaling (say, 10% at a time) gives superior results, as with sharpening, although I have seen no side-by-side comparison that bears this out.

Going beyond Photoshop, there are proprietary applications that promise better results. One approach is a suite of algorithms

Resolution and sharpness

The relationship between resolution and sharpness, while superficially distant, is in fact close and intricate. Resolution in an image is the amount of detail recorded and so is objective, while sharpness is the appearance of definition, and so is perceptual and even a matter of opinion. That would seem to set them apart, but in upscaling they converge. The confusion arises because the whole process of creating a larger image from a smaller version involves guesswork and optical tricks. Digitally, both processes use interpolation, which means re-calculating the values of existing pixels. Sharpening can certainly help in creating the impression of greater detail around edges, but it needs the usual care, and adds to the variables. In practice, upscaling with sharpening can take time and involves multiple choices.

Photoshop's interticolation options

When it comes to rescaling, Photoshop provides three core interpolation algorithms. *Nearest Neighbor* is the simplest, expanding pixels into square blocks of pixels, which can be quite ugly. *Bilinear* and *Bicubic*, on the other hand, soften the edges using data from the surrounding pixels, creating smoother edges similar to anti-aliased text. *Bicubic* is further subdivided into *Bicubic (for smooth gradients)*, *Bicubic Smoother (best for enlargement)*, and *Bicubic Sharper (best for reduction)*, which are all self-explanatory.

Nearest Neighbor

Bilinear

Bicubic Smoother

that analyze the detail in an image and apply different methods to different areas—maintaining sharp edges, for example. PhotoZoom is one of these.

Another approach is to convert the image to a dimension-free image format so that it can be output at a larger scale. Genuine Fractals is an example of this. Comparisons between these different methods vary depending on the image. There is, however, a difference in quality between interpolation algorithms, and the best do not blindly apply the same techniques to every part of an image, instead discriminating according to the tonal, color, and textural differences.

Filling in the gaps like this tends to create unsharpness. Upscaling is analogous to stretching, and most methods fail to hold edge sharpness. In enlarging an edge, normal resampling adds an intermediate value between the dark and light pixels, which softens the appearance. After upscaling, a second sharpening operation may be necessary, although proprietary upscaling techniques can complicate matters if they also incorporate edge-sharpening.

Frame composite

With a static subject and time, there is a simple workaround to increase resolution when you're shooting—take a series of overlapping images with a longer focal length, and then stitch these tiled images together.

Overlapping images before trimming.

Resizing Software

There are fewer examples of dedicated upscaling software on the market than there used to be, with perhaps the need for such programs decreasing.

The most popular two cross-platform programs are Ben Vista's PhotoZoom Pro (a reincarnation of the Dutch software S-Spline), and Genuine Fractals.

Genuine Fractals is not, strictly speaking, dedicated to upscaling, but was developed as a scaleless image file format. Nevertheless this is probably its most valuable use. What both have in common is that the algorithms they use for interpolation are much more complex than that for Bicubic—the Photoshop default for photographic images.

A simple 200% scaling

Genuine Fractals

OnOne's Genuine Fractals' Photoshop and Lightroom plug-in is designed to be used either to scale up images, or as an alternative and space-efficient way to save files. In the former case, it is especially good at creating larger files from smaller originals, at up to 600% without serious loss in quality. In the latter case it can create lossless archives of your image files.

PhotoZoom

Formerly marketed as S-Spline, and still using the same S-Spline algorithm, PhotoZoom is designed solely for image enlargement. It uses adaptive interpolation so that the parts of the image that need sharpening the most (with detail) are given more sharpening than featureless areas, and it does this by analyzing the structure of the image. As the designers say, it "works, so to say, more 'aggressively' in areas with high contrast (and this is exactly where details need to be preserved most), while it interpolates more gently in smoother areas."

Digital Color Spaces

The colors available for use in a digital image are determined by color space. A color space is a model for describing color values, and has a "gamut," or range of colors that it is capable of recording or displaying. By convention, the usual way of illustrating this is as shown on the opposite page.

Some spaces are bigger than others, with obvious advantages. A perfect illustration of why color space matters and why it is sometimes less than ideal is the very problem of showing what it looks like on a printed page. The combination of paper and printing inks actually shows fewer colors than in real life, which makes CMYK the smallest color

Which color space?

Adobe RGB (1998)
A fairly large range, and the most commonly recommended space at the moment for photography. Good for images that will later be converted in prepress to CMYK for printing (as most professional photographs are).

ProPhoto RGB
Developed by Kodak specifically for use in color photography, this provides the largest gamut of all the RGB color spaces, covering around 90% of the colors provided by Lab.

sRGB IEC61966-2.1
This stands for Standard RGB, but it is smaller than Adobe RGB (1998) and so not recommended for professional photography that will be used for prepress. Its advantage is that it matches the average PC monitor, and is standard for low-end printers and scanners.

Color modes

Briefly, color spaces are the theory, color modes are the practice, and can be selected in an image-editing program (*Image > Mode* in Photoshop). Because the four modes normally available—RGB, HSB, Lab and CMYK—separate the qualities of color in different ways, they each have certain advantages for particular photographs:

RGB
The standard mode, by virtue of being used in all digital cameras. Widely accepted. The three colors are highly familiar, so easy to manipulate channel by channel, using *Curves* or *Levels*.

HSB
Separates the colors into the three dimensions of Hue, Saturation, and Brightness—the method most similar to the way in which we see. Therefore, highly intuitive.

Lab
The largest color space available, and useful in that its three channels are divided between Lightness (L), a color axis from red to green (a), and another from blue to yellow (b). The Lightness channel is especially useful for adjustments independent of hue.

CMYK
Used in printing, with a fourth black channel added to make up for the lack of ink density on paper. The smallest color space, and so not particularly good to work in.

space in normal use. The diagrams here are, of necessity, inaccurate. The area outside the marked spaces contains color subtleties that are impossible to show in print.

Because RGB is standard for digital cameras and computer displays, the most commonly used color spaces are variants of this. A high-end camera allows you to choose which space to work in—Adobe RGB or sRGB (although this is irrelevant if shooting Raw). Until relatively recently there was just one recommended space for professional photography, Adobe RGB. The reasons were that it had a larger color range than sRGB. However, ProPhoto RGB, introduced in 2011, provides an even wider gamut than Adobe RGB, and is an available working color space option in numerous editing suites. If you shoot Raw it's likely that you can utilize the benefits of the wider ProPhoto RGB color space in your workflow by selecting ProPhoto RGB in the color setup settings of your image editing suite. Remember, however, when preparing your image for output you'll need to convert to sRGB for screeen, and Adobe RGB for print (depending on the printer).

RGB may be standard, but there is a larger color space available for digital imaging, and it has striking advantages. This is CIE Lab (strictly speaking, L*a*b*), developed in 1976 by the Commission Internationale d'Eclairage, and

COLOR SPACE

Two color spaces compared: Adobe RGB (wireframe) and CMYK Press (solid), represented in 3D and viewed from different angles. You can see that in some places, the CMYK space—which is generally smaller— exceeds the RGB, for example in the yellows.

designed to match human vision as closely as possible—at least in the way we perceive and appreciate color. Thus, it uses three channels, one for brightness and the other two for opposing color scales. L* stands for luminance (that is, brightness), a* for a red-green scale and b* for a blue-yellow scale. Being a large color space, it is also useful for converting colors from one model to another, as nothing is lost. Indeed, Adobe Photoshop uses L*a*b* internally for converting between color modes. With all this going for it, L*a*b*'s only drawback is that RGB just happens to be more widely used. You can use it in image editing, and convert RGB to and from it with impunity— it allows some special procedures, such as noise reduction.

As for CMYK, which is where most professional photographs end up, the advice is straightforward; don't use it to edit or archive images. If you do, the image will just lose color information. As with sharpening, CMYK conversion is best done from RGB at the last step and, incidentally, is best done by prepress professionals.

Adjusting Colors

Although getting colors as you want them is part of the optimization process described earlier, it may be that for creative reasons, you want to change specific colors in an image. As usual, there are several methods for achieving this.

There are many tools and dialogs for making color adjustments within Photoshop (from the *Image > Adjustments* menu), and in LIghtroom (in the Color panel) through third-party plug-ins (such as nik Color Efex Pro) and other software applications. All rely on a basic operation, which is to select a range of pixels and then map these values to a new range of values. To do this in one step—through one tool—there needs to be a method of selecting pixels based on their values: hue, saturation, and brightness.

To make any other kind of selection, such as on the shape of an object in the photograph,

Hue/Saturation

Photoshop's *Hue/Saturation* dialog is one of the most intuitive ways of making color adjustment. This is because the tool uses the color mode most closely related to the way we judge colors—hue, saturation, and brightness. It helps to keep in mind that the color bar is a straightened-out version of the color wheel. By default, the entire color range—called *Master*—is selected, but the changes can be restricted to individual colors. Lightroom works in a similar way. It identifies eight broad colors and gives you the option to change the hue, saturation, or luminance of each. The B&W option visually converts the image to grayscale. You can then adjust individual gray tones of the grayscale image based on their RGB values as these are still available in the image data—another advantage of editing through parameters.

The *Hue/Saturation* dialog presents a number of options. You can adjust the colors in the image using these tools, or apply a color to them by checking the *Colorize* button.

Lightroom's HSL/Color/B&W panel is a powerful color adjustment tool that allows you to work either by color or Hue, Saturation, and Luminance.

you would first need to use one of the selection tools. You may find the *Select > Color Range* facility in Photoshop very useful if you are looking to alter regions of color. Unlike the *Hue/Saturation* tool's color range selection, its *Fuzziness* can be altered.

PHOTO FILTER

The Photoshop *Image > Adjustments > Photo Filter...* tool allows you to simulate the effect of certain filter colors, or create a color of your choice using the standard color picker. This is a very photographer-friendly approach, since the is one long-established film photographer benefit of a

Memory Colors

...een grass, captured here under the clear, even light of an
...cast sky. Grass and plants—and even some animals—
...rucial memory color, especially in temperate climates
...he United States and much of Europe. In the mind,
...olors tend to become slightly more saturated—
...ds, the grass is always greener.

Depending on our geographical and
cultural upbringing, there are colors
that are strongly fixed in our consciousness.
Often referred to as memory colors, such
colors are so familiar to us that we are able,
with a fair degree of certainty be able to say
whether or not they are correctly rendered in
a digital image.

They are known as memory colors
because they seem to be embedded in
our visual memory. Naturally, they play an
important role in image-editing because they
are an immediate key to assessing the color
accuracy of a photograph. For memory colors,
we can say whether they are "right" or "wrong,"
and to what degree, and we can do this
intuitively. Measurement is important in
optimization, as we saw, but as color is
ultimately a matter of perception, never
underestimate the importance of subjective
judgment. If it looks right, it is right.

The two most important memory colors
are those with which we have most familiarity:
neutrals and skin tones. Following this, there
are green vegetation and sky tones. Your color
memory also depends on the environment in
which you grow up—if you live in New Mexico
or North Africa, you will be more attuned to
the colors of sand and rock than if you live
in northwest Europe. Adjusting the memory
colors in a photograph involves matching
them to known samples. At it simplest, this
means relying on your memory at the time of
correction, but you can refine the process by
referring to samples that you already accept
as accurate. One way is to open a second
image that is already well-adjusted and
use it for reference.

Memory colors are only understood by the mind in the context that we see them in. Place the red from this image somewhere on its own and it is simply a red color, but in this image, the red (and indeed yellow and black) clearly need to appear strong, since they represent commonly understood warning colors.

This shot was taken indoors, with the background seen through a window looking onto a daylit street. Therefore two color temperatures are present—the warm interior and the cool exterior. The skin tones under the tungsten light, however, are much more important to get right. The eye can accept a cool exterior palette, but if the skintones were neon orange, the eye would immediately reject the image.

Fixing Noise

Advances in sensor technology have seen ISO sensitivity settings reaching previously undreamed-of scales (ISO 25,600 is common) and at such high settings, noise will continue to be a problem.

Noise is complex and comes in a variety of forms, which makes it difficult to tackle at the time of capture. In practice, some noise is best dealt with in the camera—notably fixed-pattern noise—but the most useful place for noise reduction is here, in post-production.

To repeat the key characteristic of noise, it is embedded in the image perceptually—that is to say, it can be distinguished from subject detail only by judgment, and that differs from

person to person. Not only this, but noise does not even necessarily damage a photographic image. Photographs are not slices of reality; they have their own textural qualities, and one of these that has become accepted is a certain amount of graininess from film. There are many well-known images (to name one example, the sequence of D-Day landing photographs by Robert Capa) that draw some of their power from graininess.

One implication of this perceptual relationship with detail is that noise reduction has side effects on the rest of the image, usually softening, and the creation of artificial-looking textures. Because of this,

Photoshop Noise Reduction

Photoshop's Noise Reduction filter is found under Filter > Noise > Reduce Noise... It has two options Basic and Advanced. In Basic mode noise reduction is applied to all three color layers—red, blue, and green. The Strength slider applies a smoothing, noise reduction algorithm designed to tackle luminance noise— the grain-like, speckled effect that becomes more noticeable at higher ISO settings. Slide this to the right until you've eradicated most of the noise. The Preserve Details slider suppresses the noise reduction by reintroducing detail. The Reduce Color Noise slider fixes color or chroma noise, small areas of ugly-looking, miscolored pixels. The Sharpen Details slider controls the effect of the Reduce Color Noise slider by protecting areas of color that would otherwise be desaturated by the Reduce Color Noise slider. Click the Remove JPEG Artifact button if you're working on a JPEG image that shows signs of blocky JPEG compression. The Advanced option allows you to apply noise reduction to the worse affected color channels.

Lightroom Noise Reduction

Lightroom's Noise Reduction filter is located in the Details panel along with the Sharpening filter. This is deliberate, as the more you sharpen a noisy image the more apparent the noise becomes. The filter has two distinct elements to it, Luminance and Color. The Luminance slider smooths out luminance noise. Be wary of setting Luminance too high as you'll lose image detail. The Detail slider controls the Luminance slider threshold, preserving image detail. The Contrast slider reintroduces edge contrast that may have been lost due to the application of the Luminance slider. The Color slider reduces the effect of color or chroma noise. It's default setting is 25. This setting will correct any native color noise without visually altering the image. The Detail slider (default setting 50) sets the Color slider threshold. The higher the setting, the more color detail is preserved. The Smoothness slider (default setting 50) removes larger areas of color noise. Remember to view your image at 100% before experimenting with the sliders' effects. When dealing with noise, you're aiming to reduce unwanted noise artifacts while at the same time retaining as much details as possible.

Before After

most noise-reduction filters incorporate some kind of threshold setting to protect detail below a certain level. The problem is that a hard threshold, which leaves finer detail untouched, works on size rather than visual importance, and this can create an even more unnatural effect, and draw attention to the repair process.

The algorithms used in different software vary. One common procedure is blurring (see Average vs. Median box, opposite). Another

is frequency analysis, also known as the Fourier Transformation, in which the image is converted into frequencies: these can then be searched for structures that don't conform to known ones representing lines, edges, and patterns. None of these methods can work alone, however; all need guidance from the user. In other words, when using any noise-reduction filter, the best you can hope for is to adjust the settings and choose the best-looking compromise.

Make a selection

Noise is more apparent in flat, more uniformly colored areas than it is in areas containing lots of detail. This gives us a handy get-out clause, since these are also the areas that the filters have a harder time coping with. To achieve this:

1 Duplicate the layer you wish to apply the filter to.

2 On the higher layer, with a soft-edged brush, erase those areas to which you would like to apply the filter. (It is a good idea to turn off the visibility of the background while doing this.)

3 Apply the noise reduction filter to the lower layer. The effect will only be visible through those areas you erased from the layer above.

Fixing Lens Distortion

Lens technology is improving year on year. However, as the technology improves the desire for producing zooms with a greater range, from wide angle to long telephoto, have resulted in lenses that often display geometric distortion.

Gone are the days when prime lenses were obviously superior in image quality, but it is more difficult to correct distortion in a zoom—on a lens with a large range, it's quite likely that there will be barrel distortion at the wide-angle end, with pincushion at the other, longer-focus end. Wide-angle zooms are understandably popular, but the penalty is distortion. Because distortions can be corrected digitally, there is no excuse for ignoring them, and this becomes yet another addition to the workflow. Lens distortion can

be corrected with software, although currently the choice is small. Because lenses have individual distortion characteristics—and more important, with zoom lenses the distortion varies with the focal length—correction software has to be able to interpolate several parameters, including the radial amount of distortion. Of course, lens distortion matters only if it is noticeable, as it is chiefly along long, straight lines close to the edges of the picture. If it doesn't disturb you visually, there may be little point in correcting it.

In principle, both barrel and pincushion distortion are corrected digitally by applying the opposite radial distortion, and to an extent you could use one of the basic tools, such as Photoshop's *Distort* filters. These,

Three common corrections

There are three main kinds of correction that you may need to make to the geometry of an image:

Type	Characteristics	Procedure
1 Lens distortion	Bowing inward or outward around the center (radial).	Lens correction plug-in filter that applies the opposite radial distortion, weighted appropriately between center and edges.
2 Perspective distortion	Convergence of parallels, vertically or horizontally.	*Edit > Transform > Perspective* filter.
3 Rotation	Tilted clockwise or counter-clockwise (around the z axis).	*Edit > Transform > Rotate* filter, or *Image > Rotate Canvas*.

It may not be immediately clear in which order to apply these, and much depends on the specific image. However, in principle, correcting lens distortion first will leave straight lines that are easier to judge for perspective and rotation.

however, do not allow for the variation in the amount between the inner and outer parts of the frame. Lens-distortion correction filters can allow for the different optical characteristics of different makes of lens. The degree of distortion always increases outward from the center, but the way this progresses varies from lens to lens. Without taking this into account, you can end up with corrected straight lines at the edges but under- or over-correction nearer the center.

Using correction software

Correction software is judged by its effect on straight lines and, to a lesser extent, on symmetrical shapes such as circles. A grid overlay is essential, either in the filter window or on the applied result in Photoshop or Lightroom —or both. Adjust the spacing of the grid so that the lines are close to those lines in the image that are most important. Image distortion is very demanding of processing ability, and final image quality depends on good interpolation algorithms.

The ideal method is to analyze each lens, map its distortion (and, if a zoom, at every focal length), and then reverse its effect in the program. Essentially this is what DxO Optics Pro and PTLens do, and it is completely effective. The only drawback is that it is entirely dependent on the time-consuming analysis that the software manufacturer makes, and there is no way of adjusting, tweaking, or creating a user profile for any other lens. An alternative approach is taken by Andromeda's LensDoc, which works by defining points along a line in images that ed to be straightened, then straightening t curve. Andromeda also has a method for s to profile distortions for themselves, h this is very time consuming.

Lightroom Lens Correction

Lightroom's Lens Correction panel is found near the bottom of the Develop module's toolbar. Lightroom holds data of the optical characteristics of hundreds of popular lenses, and if you tick Enable Profile Corrections in the Basic tab Lightroom will apply a lens correction if it recognizes the lens. Information about the lens will be embedded in the image's metadata. The default Auto setting under Upright usually does a pretty good job of fixing any lens distortion. If you want to make further corrections to the image, to fix converging verticals for example, click on the Manual tab and you're presented with a number of sliders that address most optical distortions.

This image (left) was taken with a zoom lens set at its longest focal length, resulting in clear pincushion distortion. This is easily corrected (below) by using Photoshop's *Lens Correction* filter (*Filter > Distort > Lens Correction*).

Glossary

ARCHIVE

The process of organizing and saving digital images (or other files) for ready retrieval and research.

ABERRATION

The flaws in a lens that distort, however slightly, the image.

APERTURE

The opening behind the camera lens through which light passes on its way to the CCD.

ARTIFACT

A flaw in a digital image.

BACKLIGHTING

The result of shooting with a light source, natural or artificial, behind the subject to create a silhouette or rim-lighting effect.

BANDING

An artifact of color graduation in computer imaging, when graduated colors break into larger blocks of a single color, reducing the "smooth" look of a proper graduation.

BIT (BINARY DIGIT)

The smallest data unit of binary computing, being a single 1 or 0. Eight bits make up one byte.

BIT-DEPTH

The number of bits of color data for each pixel in a digital image. A photographic-quality image needs 8 bits for each of the red, green, and blue RGB color channels, making an overall bit-depth of 24.

BRACKETING

A method of ensuring a correctly exposed photograph by taking three shots: one with the supposed correct exposure, one slightly underexposed, and one slightly overexposed.

BRIGHTNESS

The level of light intensity. One of the three dimensions of color in the HSB color system. See also Hue and Saturation.

BUFFER

Temporary storage space in a digital camera where a sequence of shots, taken in rapid succession, can be held before transfer to the memory card.

CALIBRATION

The process of adjusting a device, such as a monitor, so that it works consistently with others, such as a scanner or printer.

CCD (CHARGE-COUPLED DEVICE)

A tiny photocell used to convert light into an electronic signal. Used in densely packed arrays, CCDs are the recording medium in most digital cameras.
Channel Part of an image as stored in the computer; similar to a layer. Commonly, a color image will have a channel allocated to each primary color (e.g. RGB) and sometimes one or more for a mask or other effects.

CLIPPING

The effect of losing detail in the lighter areas of your image because the exposure was long enough for the photosites to fill (and record maximum values).

CLIPPING PATH

The line used by desktop publishing software to cut an image from its background.

CMOS (COMPLEMENTARY METAL-OXIDE SEMICONDUCTOR)

An alternative sensor technology to the CCD, CMOS chips are used in ultra-high resolution cameras from Canon and Kodak.

COLOR TEMPERATURE

A way of describing the color differences in light, measured in Kelvins and using a scale that ranges from dull red (1,900K), through orange, to yellow, white, and blue (10,000K).

COMPRESSION

Technique for reducing the amount of space that a file occupies, by removing redundant data.

CONJUGATE

The distance between the center of the lens and either the subject or the sensor.

CONTRAST

The range of tones across an image from bright highlights to dark shadows.

CROPPING

The process of removing unwanted areas of an image, leaving behind the most significant elements.

DELTA E (ΔE)

A value representing the amount of change or difference between two colors within the CIE LAB color space. Industry research states that a difference of 6 ΔE or less is generally acceptable.

DEPTH OF FIELD

The distance in front of and behind the point of focus in a photograph in which the scene remains in acceptably sharp focus.

DIFFUSION

The scattering of light by a material, resulting in a softening of the light and of any shadows cast. Diffusion occurs in nature through mist and cloud cover, and can also be simulated using diffusion sheets and soft-boxes. See Soft-box.

DYNAMIC RANGE

A measure of image density from the maximum recorded density to the minimum, so an image with a DMax (maximum density) of 3.1 and a DMin (minimum) of 0.2 would have a dynamic range of 2.9. Dynamic range is measured on a logarithmic scale: an intensity of 100:1 is 2.0, 1,000:1 is 3.0. The very best drum scanners can achieve around 4.0.

EDGE LIGHTING

Light that hits the subject from behind and slightly to one side, creating flare or a bright "rim lighting" effect around the edges of the subject.

EXTENSION RINGS

An adapter that fits into an SLR between the sensor and the lens, allowing focusing on closer objects.

EXTRACTION

In image editing, the process of creating a cut-out selection from one image for placement in another.

FEATHERING

In image editing, the fading of the edge of a digital image or selection.

FILE FORMAT

The method of writing and storing information (such as an image) in digital form. Formats commonly used for photographs include TIFF, BMP, and JPEG.

FILTER

(1) A thin sheet of transparent material placed over a camera lens or light source to modify the quality or color of the light passing through.
(2) A feature in an image-editing application that alters or transforms selected pixels for some kind of visual effect.

FOCAL LENGTH

The distance between the optical center of a lens and its point of focus when the lens is focused on infinity.

FOCAL RANGE

The range over which a camera or lens is able to focus on a subject (for example, 0.5m to Infinity).

FOCUS

The optical state where the light rays converge on the film or CCD to produce the sharpest image.

FRINGE

In image editing, an unwanted border effect to a selection, where the pixels combine some of the colors inside the selection and some from the background.

F-STOP

The calibration of the aperture size of a photographic lens.

GAMMA

A fundamental property of video systems which determines the intensity of the output signal relative to the input. When calculating gamma, the maximum possible input intensity is assigned a value of one, and the minimum possible intensity (no input) is assigned a value of zero. Output is calculated by raising input to a power that is the inverse of the gamma value (output = input (1/C)).

GRADUATION

The smooth blending of one tone or color into another, or from transparent to colored in a tint. A graduated lens filter, for instance, might be dark on one side, fading to clear at the other.

GRAYSCALE

An image made up of a sequential series of 256 gray tones, covering the entire gamut between black and white.

HALO

A bright line tracing the edge of an image. This is usually an anomaly of excessive digital processing to sharpen or compress an image.

HISTOGRAM

A map of the distribution of tones in an image, arranged as a graph. The horizontal axis goes from the darkest tones to the lightest, while the vertical axis shows the number of pixels in that range.

HMI (HYDRARGYRUM MEDIUM-ARC IODIDE)

A recently developed and popular light source for photography.

HOT-SHOE

An accessory fitting found on digital and film cameras and some high-end compact models, normally used to control an external flash unit.

HSB (HUE, SATURATION, AND BRIGHTNESS)

The three dimensions of color, and the standard color model used to adjust color in many image-editing applications. See also Hue, Saturation, and Brightness.

HUE

The pure color defined by position on the color spectrum; what is generally meant by "color" in lay terms. See also Saturation and Brightness.

INVERTER

A device for converting direct current into alternating current.

ISO

An international standard rating for film speed, with the film getting faster as the rating increases, producing a correct exposure with less light and/or a shorter exposure. However, higher speed film tends to produce more grain in the exposure.

KELVIN (K)

Used to measure the color of light based on a scale created from the color changes that occur when a black object is heated to different temperatures. Normal midday sunlight is considered 5,000K. Lower temperature light (less than 5,000K) is more red or yellow, while higher temperature light is more blue.

LASSO

In image editing, a tool used to draw an outline around an area of an image for the purposes of selection.

LAYER

In image editing, one level of an image file to which elements from the image can be transferred to allow them to be manipulated separately.

LOCAL CONTRAST

The contrast range found in smaller areas of a scene or an image.

LUMINOSITY

The brightness of a color, independent of the hue or saturation.

MACRO

A mode offered by some lenses and cameras that enables the lens or camera to focus in extreme close-up.

MASK

In image editing, a grayscale template that hides part of an image. One of the most important tools in editing an image, it is used to limit changes to a particular area or protect part of an image from alteration.

MEGAPIXEL

A rating of resolution for a digital camera, related to the number of pixels output by the CMOS or CCD sensor. The higher the megapixel rating, the higher the resolution of images created by the camera. Midtone The parts of an image that are approximately average in tone, falling midway between the highlights and shadows.

MODELING LAMP

Small lamp in some flashguns that gives a lighting pattern similar to the flash.

MONOBLOC

An all-in-one flash unit with the controls and power supply built in. Monoblocs can be synchronized to create more elaborate lighting setups.

NOISE

Random patterns of small spots on a digital image that are generally unwanted, caused by non-image-forming electrical signals.

PENTAPRISM

Abbreviation for pentagonal roof prism. This prism has a pentagonal cross-section, and is an optical component used in SLR cameras. Light is fully reflected three times, so that the image displayed in the viewfinder is oriented correctly.

PHOTOMICROGRAPHY

Taking photographs of microscopic objects, typically with a microscope and attachment.

PIXEL (PICTURE ELEMENT)

The smallest unit of a digital image—the square screen dots that make up a bitmapped picture. Each pixel carries a specific tone and color.

PLUG-IN

In image editing, software produced by a third party and intended to supplement the features of a program.

PPI (PIXELS-PER-INCH)

A measure of resolution for a bitmapped image.

PRIME LENS

One with a fixed focal length. See also Zoom lens.

RECTIFIER

A device for converting alternating current into direct current.

REFLECTOR

An object or material used to bounce available light or studio lighting onto the subject, often softening and dispersing the light for a more

attractive end result. Resampling
Changing the resolution of an image
either by removing pixels (lowering
resolution) or adding them by
interpolation (increasing resolution).

RESOLUTION

The level of detail in a digital image,
measured in pixels (e.g. 1,024 by 768
pixels), lines-per-inch (on a monitor), or
dots-per-inch (in a half-tone image,
e.g. 1,200 dpi).

RGB (RED, GREEN, BLUE)

The primary colors of the additive
model, used in monitors and
image-editing programs.

SATURATION

The purity of a color, going from the
lightest tint to the deepest, most
saturated tone. See also Hue and
Brightness.

SELECTION

In image editing, a part of an
on-screen image that is chosen and
defined by a border in preparation for
manipulation or movement.

SENSITOMETER

An instrument for measuring the light
sensitivity of film over a range of
exposures.

SHUTTER

The device inside a conventional
camera that controls the length of time
during which the film is exposed to
light. Many digital cameras don't have
a shutter, but the term is still used as
shorthand to describe the electronic
mechanism that controls the length of
exposure for the CCD.

SHUTTER SPEED

The time the shutter (or electronic
switch) leaves the CCD or film open to
light during an exposure.

SLR (SINGLE LENS REFLEX)

A camera that transmits the same
image via a mirror to the film and
viewfinder, ensuring that you get
exactly what you see in terms of focus
and composition.

SNOOT

A tapered barrel attached to a lamp in
order to concentrate the light emitted
into a spotlight.

S/N RATIO

The ratio between the amplitude of the
signal (S) to be received and the
amplitude of the unwanted noise (N) at
a given point in a receiving system.
Soft-box A studio lighting accessory
consisting of a flexible box that
attaches to a light source at one end
and has a diffusion screen at the other,
softening the light and any shadows
cast by the subject.

SPOT METER

A specialized light meter, or function of
the camera light meter, that takes an
exposure reading for a precise area of
a scene.

TONAL RANGE

The range of tonal values in an image.
The histogram feature in an
image-editing application displays
tonal range. When an image has full
tonal range, pixels will be represented
across the whole of the histogram.
Analyzing variation and deficiencies in
the distribution represented in the
histogram is the basis for making tonal
corrections.

TELEPHOTO

A photographic lens with a long focal
length that enables distant objects to
be enlarged. The drawbacks include
both a limited depth of field and angle
of view.

TRANSFORMER

A device that converts variations of
current in a primary circuit into
variations of voltage and current in a
secondary circuit.

TTL (THROUGH THE LENS)

Describes metering systems that use
the light passing through the lens to
evaluate exposure details.

VALUE

A particular color tint. Also a numerical
value assigned to a variable,
parameter, or symbol that changes
according to application and
circumstances.

WHITE BALANCE

A digital camera control used to
balance exposure and color settings
for artificial lighting types.

ZOOM LENS

A camera lens with an adjustable focal
length giving, in effect, a range of
lenses in one. Drawbacks compared to
a prime lens include a smaller
maximum aperture and increased
distortion. See also Prime lens.

Index